Dec. 2016

Mirror Affect

Algonquin Area Public Library
2600 Harnish Dr.
Algonquin, IL 60102
www.aapld.org

Mirror Affect

Seeing Self, Observing Others in Contemporary Art

Cristina Albu

University of Minnesota Press
Minneapolis
London

Published by the University of Minnesota Press
111 Third Avenue South, Suite 290
Minneapolis, MN 55401-2520
http://www.upress.umn.edu

Printed in the United States of America on acid-free paper

The University of Minnesota is an equal-opportunity educator and employer.

22 21 20 19 18 17 16 10 9 8 7 6 5 4 3 2 1

Library of Congress Cataloging-in-Publication Data
Names: Albu, Cristina, author.
Title: Mirror affect : seeing self, observing others in contemporary art / Cristina Albu.
Description: Minneapolis : University of Minnesota Press, 2016. | Includes bibliographical references and index.
Identifiers: LCCN 2016003060 (print) | LCCN 2016005798 (ebook) | ISBN 978-1-5179-0005-2 (hc) | ISBN 978-1-5179-0006-9 (pb) | ISBN 978-1-4529-5259-8 (epub)
Subjects: LCSH: Visual perception in art. | Reflection (Optics) in art. | Art, Modern—20th century—Themes, motives. | Art, Modern—21st century—Themes, motives.
Classification: LCC N7430.5.A33 2016 (print) | LCC N7430.5 (ebook) | DDC 701/.18—dc23
LC record available at http://lccn.loc.gov/2016003060

Contents

Introduction

Seeing Ourselves Seeing

*The diverting of attention from that which is meant to compel it,
i.e., the actual work on display, can at times free up a recognition
that other manifestations are taking place that are often difficult
to read, and which may be as significant as the designated objects
on display.*

—Irit Rogoff, "Looking Away: Participations in Visual Culture"

As we walk through art museums and galleries, more and more contemporary artworks enhance our awareness of belonging to a shared spectatorial space. We actively observe not only the objects on display but also our movements and the reactions of other visitors. Artworks that include mirrors, live video feedback, and sensors frame contexts for seeing ourselves seeing and acting as part of precarious collectivities. They call our attention to the interpersonal dimension of perception and invite us to develop affective affiliations toward other visitors concomitantly engaged in mirroring processes as they discover how their reflections are encompassed in infinity rooms or how their movements expand the sensory potential of responsive environments. Under these circumstances, individualistic aesthetic rituals give way to interpersonal and collective modes of observation and behavior.

What has led artists from the late modernist period onward to challenge the autonomy of the isolated, self-involved art viewer by highlighting the public character of the display context? Do works that stimulate mirroring acts simply deepen our passive immersion in visual spectacle, or can they actually

disrupt purely contemplative attitudes by cultivating interpersonal aware-
ness and performativity? To what extent can they help us reconsider our posi-
tion and limited degree of freedom in social systems? In this book, I seek to
connect these key questions about reflective and responsive artworks with
current debates on participatory art while tying loose knots among minimal-
ist sculpture, performance art, installation art, and new media. I suggest that
a significant number of contemporary artworks with mirroring properties
enable us to perceive ourselves and others as if from a third distance, inter-
twined in a complex social fabric that alerts us to the critical need for recon-
sidering who we are, how we act, and what consequences our choices have
on others.

Mirror Affect charts the historical trajectories of reflective artworks and
the emergence of increasingly public modes of art spectatorship across mul-
tiple media since the 1960s. My account starts with this decade because it
is marked by an extensive use of materials with mirrorlike properties (e.g.,
Mylar, Plexiglas, stainless steel) and a firm contestation of modernist modes
of art viewing that imply a relation of parallelism between an individual be-
holder and an autonomous art object, shielded from all external influences
that might disrupt the privacy of the aesthetic experience. This idealized
spectatorial relation is not a very long-standing convention, but it is a staple
of the encounter with abstract expressionist and color field paintings, which
situate the viewer in a presumably neutral and secluded plane of optical ab-
sorption. Interestingly, on the occasion of the *Abstract Expressionist New York*
exhibition of 2011, the Museum of Modern Art was so keen on reifying the
aesthetic experience associated with this stylistic tendency that it asked staff
members to adopt introspective attitudes in front of individual paintings for
a set of photographs meant to accompany the *New York Times* review of the
show. The documentary photographs were so clearly staged that the news-
paper published a disclaimer a week later, announcing that it found this ap-
proach unethical and explaining that MoMA officials had offered guidelines
for the photo shoot.[1]

Yet modern art did not imply only introspective modes of engagement.
The futurists organized events that provoked audience members into violent
actions in order to make them abandon their roles as spectators and partici-

pate in destructive actions that were no longer limited to the space of the stage. Similarly, the Dadaists were determined to denounce prevailing modes of spectatorship associated with high culture and take participants in their events outside their comfort zones. Their events at Cabaret Voltaire were purposefully aggressive toward the audience, as they were meant to disrupt and destroy social and theatrical norms. Although they were less intent on generating chaos and destruction than the Dadaists, the surrealists also took an interest in instigating public reactions through visceral and aggressive imagery. Well known are the unruly responses of cinemagoers to Luis Buñuel's *L'Age d'or* (1930) and the voyeuristic experiences envisioned by Salvador Dalí. Eager to erode both the boundaries between the conscious and the subconscious and the differences between the public and the private, the surrealists often conceived modes of art spectatorship that placed the beholder in the limelight. For the *Exposition Internationale du Surréalisme* of 1938, Marcel Duchamp came up with the idea of creating a system of lights that would switch on and illuminate the paintings as visitors approached them, hence setting the visitors on display along with the artwork. Continuities between these earlier challenges to aesthetic autonomy and the growing contestation of introspective modes of spectatorship in the 1960s and 1970s speak to the complex crisscrossing trajectories of modern and contemporary art, which defy all attempts to impose neat chronological boundaries.

Recent contemporary artworks that gather large crowds around visual or interactive interfaces have been increasingly associated with the numbing spectacle of neocapitalism that subordinates individuals and perpetuates egotistic behavior. Accused of providing fake images of democratic consensus and serving the interests of service economies, they have been pushed outside the circle of participatory artworks, which take social relations as their main medium and usually catalyze communal ties based on verbal exchanges. Olafur Eliasson's *The Weather Project* (2003), which drew large masses of visitors to Tate Modern to see themselves seeing while immersed in the light of a gigantic sun, was both hailed as a sublime landscape showcasing human vulnerability and condemned as complicit with art museums' commodification of sensory experience. More recently, Marina Abramović's *The Artist Is Present* (2010) performance at MoMA and James Turrell's *Aten Reign*

(2013) installation at the Guggenheim Museum were both accused of fueling the desire for spectacular encounters with others in the public eye without offering a potential for disruption or critique.

Writing a book about mirroring processes in contemporary art in the midst of growing opposition toward perceptually engaging artworks that draw large public audiences has felt at times a self-defeatist task, encumbered by the unavoidable admission that such practices are indelibly connected to spectacle. Nonetheless, the simplistic equation of reflective sculptures, video works, installations, and new media environments with illusionistic devices that lure the senses yet daze the minds has driven me to examine the complex interpersonal dynamics such works set on display and the implicit messages they convey about surveillance, consumerism, and social relations. Familiar with the spectacle of both communist and neoliberal countries (I am a Romanian citizen who has been living in the United States since 2005), I cannot entertain the illusion of complete autonomy from the society of the spectacle or the myths of individualism and collectivism that often underlie the criticism of artworks that incorporate participants' images and kinetic gestures within their visual fields. Even Claire Bishop, the most fervent advocate of a definition of participatory art in terms of artworks that take social relations as their privileged medium, admits that in order to maintain the necessary tension between aesthetics and politics, artists may need "a mediating third term—an object, image, story, film, even a spectacle—that permits this experience to have purchase on the public imaginary."[2] I will return to her views on the politics of spectatorship at a later point in this introduction in order to discuss the dichotomies that permeate the discourse of critics of participatory art despite their proclaimed desire to debunk modern binaries and acknowledge the significance of the nebulous field of affective responses.

This book presents the contingent relations spurred among art participants by reflective art practices, which epitomize the growing uncertainty and complexity of the world we share with others. Far from liberating spectators from individual responsibility, these works encourage them to conceive themselves simultaneously as viewers and as active producers of a highly variable field of reflections and responses that eludes individual control. Rather

than simply preaching individual detachment and inspiring escapism, such works place spectators in uneasy circumstances: beholders find themselves in close bodily proximity to numerous others concomitantly exposed to a mirror interface, a video lens, or a sensor-based environment that enables them to see themselves as if from another space or time. These art practices offer the promise of a collectivity mediated by images or similar behavioral acts yet deny access to a communal identity; they offer temporary intimacy in an unpredictable spatiotemporal interval yet take away privacy, keeping spectators in a state of limbo between multiple unfulfilled possibilities. Above all, such works encapsulate our attachment to the potential for change, whether personal or social, without offering any guarantee of its felicitous realization. They expose the vulnerability of individuals by giving them access to images that show them to each other as part of diffuse collectives held together by fleeting reflections and shared affects. Their reflective lenses create a sense of physical distance from oneself and offer a view of one's belonging to a multitude that is always in formation. In such a perceptual scenario, the need for an ethics of the gaze and interpersonal behavior becomes conspicuous. These works echo the precariousness that permeates contemporary societies, since accelerated interconnectivity proves both alluring and potentially dangerous for a planetary system threatened to be thrown out of balance by irresponsible resource exploitation and deepening social inequities.

In this book, I focus on the affective impact of visual or kinetic interactions among art viewers to unveil a facet of participatory art genealogies that has long been disregarded because of the persistence of binaries such as seeing and acting, feeling and thinking, subjectivity and collectivity. Starting from the idea that powerful interpersonal exchanges are not restricted to literal conversations and explicit forms of collaboration between art participants, I examine artworks that expose audience members to disorienting sensory experiences in order to call their attention to the presence of others and the complex material and social systems that influence their behavior. Key artworks serve as anchor points for linking the history of object-based works and new media to participatory art: Robert Morris's minimalist sculptures and Lucas Samaras's mirror mazes, which disrupt the parallelism between the individual beholder and the autonomous art object; Michelangelo Pistoletto's

mirror paintings and Joan Jonas's performances, which introduce spectators' reflections into a variable visual field analogous to the shifting ground of social relations; James Seawright's and Robert Rauschenberg's cybernetic systems modeled by art participants' movements and sounds, which reveal the complexity of information networks transforming in tandem with human responses; Les Levine's, Frank Gillette's, and Ira Schneider's closed-circuit video installations, which raise questions about the potential disjunction between the viewpoint of spectators and that of television producers; Dan Graham's and Lynn Hershman's installations from the 1970s, which subversively infiltrate commercial venues to disclose the manipulation of consumer desire and the ubiquity of surveillance; Anish Kapoor's, Olafur Eliasson's and Ken Lum's reflective artworks, which highlight the impossibility of defining oneself in isolation from others; and David Rokeby's, Christian Moeller's, and Rafael Lozano-Hemmer's responsive environments, which trigger affective and behavioral attunement between art participants to indicate the contingent relations mediated by cybernetic systems that surpass individual control. Each and every one of these artworks casts doubt on visual perception and representation as it invites spectators to consider the ebb and flow of interpersonal dynamics.

The central concept of this book is *mirror affect,* a term I have coined in order to explain the intense bodily experience triggered by reflective or responsive artworks, which encourage participants to take note of their collective physical presence as well as of their interpersonal perception and behavior. I contend that the more or less conscious attunements that emerge between participants' acts contribute to an increased consciousness of contingent relations and the importance of agency in the context of systems in which absolute individual control and autonomy are unattainable. The affective connections established between spectators interacting with reflective and responsive artworks may be extremely ethereal and may not always contribute to a critical consideration of social norms or surveillance implications, but they hold a disruptive force that suspends individuals' sense of self-sufficiency and opens up new possibilities for interpersonal alliances. This book looks into the artistic, social, and technological factors that have led contemporary artists to frame spatiotemporal intervals that catalyze public

manifestations of affective impulses and encourage spectators to see them-
selves seeing and acting as part of diffuse collectivities.

The reflective and responsive works I discuss here inspire not only posi-
tive emotions (e.g., surprise, joy) but also social tensions, owing to the com-
petitive behavior and the disjunctions in participatory roles they unveil. They
set on display both convivial situations and strained relations even though
their aesthetic qualities may appear to dismiss the potential for conflict. I
vividly remember the occasion when I was quite abruptly asked to step out
of the silver archway of Anish Kapoor's *Cloud Gate* to allow a couple to take
a picture only of their minuscule mirror images swirling in the seemingly
abysmal space of the sculpture. Similarly, I recollect the conflicting tension
I experienced as I wondered whether the labor of illegal immigrants is taken
into account in the computation of the estimates for the total number of paid
work hours in Austria displayed in Ken Lum's *Pi*, a mirror-based public instal-
lation that brings into perspective the approximations and fallacies implicit
in any attempt to convey an objective representation of local and global con-
ditions. Since individual participants' inclination to colonize the space of the
artwork is generally considered outside the norms of museum conduct, and
the empathetic relations prompted by artworks often remain restricted to
participants' mental projections, such responses to reflective and responsive
artworks are often disregarded or considered too marginal to be worthy of
critical attention. However, they are neither incidental nor meaningless, and
they show that the space of participation framed by reflective and responsive
artworks is by no means free of social constraints, being constantly molded
by visible interpersonal exchanges and performative acts, as well as by seem-
ingly inconspicuous relations of reciprocity and antagonism.

Across the Divides of Participatory Art Theories

In this book, I seek to expand current theories of participatory art and over-
come the disjunctions most of them perpetuate between contemporary art-
works that strengthen the collective engagement of spectators through discur-
sive means and artworks that prompt affective affiliations among beholders
through variable sensory stimuli influenced by the beholders' presence. I aim

to counterbalance these unproductive hierarchies of implicit and explicit interpersonal relations between art participants by building on theories from psychology, sociology, and neuroscience that show the interdependence among affect, perception, cognition, and behavior. Even though some participatory art theorists have acknowledged the need to account for interpersonal connections that are not shaped only by verbal exchanges or affiliations to sociopolitical agendas, they have clearly avoided inquiring into contemporary art practices that build emotional ties between participants via shared sensory experiences, as if these connections were too insignificant or precarious to elicit social awareness.

Nicolas Bourriaud's concept of "relational aesthetics," formulated in the 1990s, is the seminal reference point for all subsequent participatory art theories. Applied to a set of art practices that take "human relations and their social context" as their conceptual and even material framework,[3] the term has become closely associated with the micro-utopian events conceived by artists Liam Gillick, Philippe Parreno, Rirkrit Tiravanija, and Dominique Gonzalez-Foerster. Intent on singling out the uniqueness of this tendency, Bourriaud denies the correlations between the neo-avant-gardes of the 1960s and the relational art practices of the 1990s, arguing that the latter were informed by the deeper realization that art cannot drive large-scale transformations, but it can offer appropriate substitutes for weakening social exchanges. The ties of relational artworks with earlier art projects that called for an enhanced awareness of the social systems in which art viewers are imbricated are stronger than Bourriaud is willing to admit. In the anthology she edited on the topic of participation, art historian Claire Bishop extends the sphere of relational art to a full range of works from the late 1950s and 1960s, including Allan Kaprow's happenings, Hélio Oiticica's *Parangolés*, and Graciela Carnevale's actions. She also exposes the utopianism implicit in Bourriaud's claim that spatiotemporal art interstices that welcome audience involvement invite only convivial social relations. Bishop contends that relational aesthetics perpetuate the misconceived ideals of a democratic space of encounter freed from social tension.[4] Instead, she proposes, art projects that bring to the surface concealed hierarchies and suppressed conflicts are better able to turn spectators into responsible participants in social exchanges.

Despite her prior interest in rendering the category of participatory art more inclusive, Bishop offers a more restrictive definition of such practices in her most recent book, *Artificial Hells*. She applies the term *participatory* only to art projects in which "people constitute the central artistic medium and material, in the manner of theatre and performance."[5] More closely aligned to radical political goals than Bourriaud's theory, her approach imposes more clear-cut boundaries between object-based art practices that challenge inter-personal ties and art projects that establish immediate exchanges between individuals as they step into "artificial hells"—confrontational situations that provoke more or less ethical responses. Bishop's sharper distinction between projects informed by a political agenda and art objects or environments that catalyze social ties is quite surprising given her prior investment in the study of installation art, which has contributed significantly to the enhanced public dimension of contemporary art spectatorship.[6] Even more baffling is the fact that she seems to consider the experience of such works to be representative only of "art interaction," which she equates with a form of "one-to-one relationship," inferior to the complex relations generated by participatory art projects.[7] Nonetheless, it is quite clear that numerous installations encourage viewers to contemplate how their collective presence and behavior modify the parameters of the artworks.

Interestingly, the divide between the terms *interaction* and *participation* can be traced back to the 1960s. According to Frank Popper, *participation* started to be applied at the time to works that actively engaged the audience "on both the contemplative (intellectual) and the behavioral level," whereas *interaction* became associated mainly with two-way exchanges of information between spectators and technology-based artworks.[8] The divide identified by Popper persists to the present day and has become even more pronounced in conjunction with the rise of participatory art theories. Although it is quite obvious that technology-based works do not always merely challenge individual inter-action with technological apparatuses but actually have the potential or even the explicit goal of heightening connectivity among participants, they generally remain outside the well-guarded boundaries of participatory works. This divide is informed both by technological biases, which I will further discuss in this section, and by artificial separations between sensing and thinking.

Bishop's dismissive attitude toward participatory responses triggered by objects, installations, and responsive environments stems from an anti-retinal attitude associated with the Debordian critique of the manipulating society of the spectacle.[9] The notion that artworks that privilege visual encounters are irredeemably guilty of perturbing critical thinking and impeding interpersonal connection is as fallacious as Bourriaud's argument that relational art practices only stimulate conviviality. Perception is intimately intertwined with cognition and behavior; in fact, these processes cannot be rigorously separated from each other, since human beings are neurally wired to sense, think, and make decisions simultaneously as a result of the parallel processing of information within the brain. Bishop concedes that the mediation of social relations is unavoidable and that visual elements may even help with maintaining the much-needed tension between aesthetics and politics, but she is hesitant about conferring "participatory" status on works that trigger interpersonal awareness through collective sensory engagement with environments. In *Artificial Hells*, she places the situationists' explicitly political interventions of the 1960s in dialectical opposition to Groupe de Recherche d'Art Visuel's labyrinths of the same decade, which called for spectators' involvement in modifying the visual and kinetic parameters of publicly displayed environments. Thus, Bishop furthers the dichotomies between sensing and acting, passivity and activity, that she otherwise vows to debunk when she expresses her affiliation with Jacques Rancière's philosophy of emancipated spectatorship, which encourages us to move past the binaries that contribute to artificial hierarchies.[10]

Bourriaud shares Bishop's skeptical outlook on visual engagement, although he is less adamant about the radical political goals underlying relational artworks. He argues that minimalist art catalyzes merely "ocular participation" and does not manage to stimulate bodily awareness and personal reflection as intensely as Félix González-Torres's relational work, which invites viewers to join a dance arena or commemorate the death of González-Torres's partner by taking away candies from a diminishing pile.[11] While it is undeniable that most minimalist sculptures cannot generate the same degree of intersubjective intimacy as the situations and objects shared with viewers by González-Torres, they can in fact mediate interpersonal ties be-

tween beholders, calling attention to more than just the physical properties of impersonal objects. Robert Morris's transition from displaying sculptural objects to encouraging beholders to manipulate them in the context of his retrospective at London's Tate Gallery in 1971 indicates the significant role played by minimalism in the shift toward an increasingly open field of participation. Bourriaud's focus on the opticality of minimalist works despite these works' exposure of contingent relations among perception, movement, and spatial coordinates reflects this persistent belief that visual participation is inferior to the convivial exchanges triggered by relational art.

Among participatory art theorists, Grant Kester is perhaps the one most open to accepting that artworks that challenge visual and empathetic exchanges among viewers are as capable of raising significant questions about social identity and ethics as art practices that prompt literal conversations and collaborative actions between participants. He avoids establishing a dichotomy between interaction and participation by introducing the term *dialogical aesthetics* to delineate the rise of modes of art spectatorship that imply a shift in orientation from an immediate encounter with an artwork that unveils its aesthetic potential in isolation from intersubjective considerations to a durational experience that entails empathetic alliances with its producer and possible collaborators simultaneously interacting with the work.[12] Kester associates this departure from an introspective relation to art objects with the conceptual art turn and the diminishing control exerted by the artist over the content of the work, which becomes increasingly contingent on a fluctuating social field. He focuses primarily on process-oriented artworks that prompt dialogical relations in the absence of finished objects, yet he acknowledges that there are cases in which intersubjective engagement and collaborative performativity can be prompted by works consisting of more long-lasting material components. Even though Kester does not banish visual relations and imaginary processes of identification with others, his theory is mainly applied to contemporary art practices that emphasize discursive exchanges and community engagement.

This book extends the scope of participatory art theories by addressing works based on both traditional and new media that engender affective relations between spectators who do not necessarily form a collectivity driven by

common activities or by the exchange of sociopolitical views yet feel intensely connected to each other as a result of shared impulses and perceptual experiences. Empathetic relations prompted by visual encounters can be as important in triggering intersubjective exchanges between people as invitations to perform similar activities, such as dancing or eating together. Like the relational art practices delineated by Bourriaud and the participatory artworks defined by Bishop, the works with reflective and responsive properties that I discuss in this book underline the contingency of social relations and are symptomatic of the need to consolidate interpersonal ties at a time of deepening individual alienation. Contrary to expectations, they do not merely catalyze perceptual pleasure but can also contribute to a greater awareness of the mechanisms of control and segregation embedded in society.

A mistrust of visual spectacle is not the only cause for Bourriaud's and Bishop's circumspect outlook on artworks that put viewers in touch with others through shared sensory experiences. These critics establish strict binaries between immediate social exchanges and communicative acts mediated by technological systems. Wary of any use of new media that is not driven by an inquiry into the very nature and influence of technology, both Bourriaud and Bishop are averse to the suggestion that relational or participatory art could encompass works that entail social exchanges between people using responsive interfaces. In their view, technological media are deepening the objectification of individuals and their submissiveness to the demands of consumer societies. In contrast with the theory of "system aesthetics" proposed by Jack Burnham in the 1960s to explain the growing contingency between artworks and other variable cybernetic systems,[13] Bourriaud's and Bishop's approaches are completely human centered and do not allow for the confluence of human networks with nonhuman networks. Bourriaud suggests that artists should import only the operational vocabulary or syntax of digital technology into their art practices, just as impressionist artists started to frame pictorial compositions differently under the influence of photography. Similarly, Bishop argues that the impact of the digital revolution on the art world needs to be assessed primarily in terms of the transformations it has brought to analog media and sculptural practices. She states that digital art belongs to a separate field of study that "rarely overlaps with the mainstream art world."[14] Bishop is

right about the existing divide between these practices, yet she provides no valid rationale for maintaining this separation.

All in all, Bourriaud's call for a critique of technology to avoid the transformation of art into "an element of high tech deco" and Bishop's insistence on maintaining the separation between art and new media are reminiscent of the anxieties voiced by art critics in the 1960s in response to art and technology projects.[15] This is fairly strange given the fact that their participatory art theories are in fact synchronous and deeply interconnected with changes in new media art practices, which have been gaining in prominence in art museums and biennials and are increasingly oriented toward triggering social interconnectivity through digitally augmented real spaces. Rafael Lozano-Hemmer's relational architecture projects and Mathieu Briand's video-based systems, which ask participants to perceive their surroundings as if from someone else's perspective, mediate affective exchanges between exhibition visitors found in close proximity to each other. Such new media works prompt not only interpersonal engagement through sensory stimuli but also thoughtful reflection on the limited impact an individual can have on the interactive environment.

Recently, Edward Shanken has proposed a hybridization of mainstream art discourse and new media art discourse, which have grown apart precisely because of fears that technology-based art practices do not enable viewers to reflect on the consequences of their interactions with media platforms.[16] He believes that the theory of relational aesthetics opens up new possibilities for the convergence of these two discourses, even though it was originally conceived as a critical tool for counteracting the production of high-tech artworks. In this book, I take up the challenge proposed by Shanken and trace the various points of rupture and contiguity between contemporary art and new media, whose paths have repeatedly crossed and diverged since the 1960s. I contend that the forms of spectatorship generated by these separate fields have represented one of the main points of contention between them. Video works that imply a more private dialectical encounter between the viewer and the camera eye have been associated with mainstream art practices (e.g., Bruce Nauman's *Live-Taped Video Corridor*), whereas closed-circuit video systems that entail more public aesthetic experiences by incorporating

images of multiple viewers concomitantly interacting with technological interfaces have remained restricted to genealogies of new media art (e.g., Frank Gillette and Ira Schneider's *Wipe Cycle*). These distinctions are no longer productive. Both works based on traditional media and new media art practices can trigger both public and private encounters with art. They can foster connectivity not only between the singular viewer and the reflective or responsive interface but also among multiple spectators who collectively attune their emotional and behavioral reactions as they interact with the artworks.

Another aspect of the recurrent tendency to separate participatory art from new media is the fear that mass media are impinging on the territory of art, which can still serve as the last stronghold of criticality in a society overcome by spectacle. Bourriaud asserts that artists plan convivial encounters in order "to rid themselves of the straitjacket of the ideology of mass communication."[17] While he contends that art participation should be defined in sharp opposition to mass culture experience, Boris Groys argues that it is no longer possible to maintain this sharp distinction. In "Politics of Installation," he portrays the art viewer as a passerby who is constantly on the move in the midst of crowds of people engaged in exploring exhibition spaces. In spite of close similarities between art spectatorship and media spectatorship, Groys notes, at least some artworks draw attention to the mediation of aesthetic experience and render art visitors better aware of the fact that they belong to communities of spectators; such works can enable participants "to adequately perceive and reflect the space in which they find themselves or the communities of which they have become part."[18] Olafur Eliasson's mirror-based installations and Christian Moeller's responsive environments trigger precisely this type of highly mediated collective experience by purposefully channeling viewers' attention both to each other's bodily presence in the exhibition space and to the way the perceptual and behavioral situations are constructed.

Although I share Groys's opinion concerning the collective dimension of installation art spectatorship, I do not fully agree with his claim that artists are privatizing the public space of galleries by colonizing large exhibition areas or with his less direct suggestion that they authoritatively impose preset rules of interaction. Artists cannot act so independently from art institutions or the social dynamics of art audiences. They negotiate with curators

how their works are integrated into museum spaces, and they feel increasingly compelled to account for the interpersonal exchanges and performative gestures of viewers turned participants as they interact with the artworks. As far as participatory rules are concerned, some artists are indeed autocratic legislators, whereas others, especially new media artists, want participants to derive new rules of participation as a result of their encounters with the artworks or with each other. As the boundaries separating the roles of consumers and producers are eroding not only in social media space but also in museum spaces, the contingent nature of the contemporary art experience is becoming increasingly apparent. These participatory modes are not free from tension. The dynamics between art participants commonly involved in spectatorial acts bring to the surface power relations that precede their encounters in galleries and challenge the norms of conduct imposed by art institutions.

In the chapters that follow, I show that the condemnation of visual engagement with artworks based on the fact that this experience can be easily manipulated is not only artificial but also detrimental to the understanding of the complexities of contemporary art reception. More and more often, contemporary artists are encouraging participants to move in relation to art objects, interact with other viewers, and reflect on the interconnections between agency and multisensory perception. While taxonomies are much-needed tools for defining art tendencies such as participatory art, it is important to avoid imposing artificial limitations on art categories that perpetuate medium specificity and overlook the increasingly collective dimension of aesthetic experience in museums and public spaces. Just like socially engaged art practices, certain sculptures, installation artworks, and new media environments can prompt empathetic exchanges among viewers. The privileging of verbal interaction and behavioral engagement over affective and visual exchanges among spectators turned participants is conducive to a divide that can be as detrimental as the rise of opticality above all other forms of aesthetic experience. Ultimately, the emancipation of spectators praised by participatory art theorists is possible, according to philosopher Jacques Rancière, only when the dissolution of the presumed inequality between interpreters of art is accompanied by the interrogation

of equivalences between "audience and community, gaze and passivity, exteriority and separation, mediation and simulacrum."[19]

Mirroring Acts: Methodology and Terminology

This book is not meant to offer a comprehensive historical overview of the use of mirrors as a medium.[20] Instead, it explores the rise of increasingly public modes of spectatorship in conjunction with the proliferation of artworks that elicit interpersonal mirroring processes among viewers; hence the absence from this account of notable contemporary artworks that are mirror based, such as Robert Smithson's sculptures and Yayoi Kusama's reflective environments. As I further explain in the chapter 1, these omissions are not accidental. I have chosen to focus on contemporary artworks that frame highly public participatory experiences rather than primarily introspective and immersive forms of art reception. Consequently, the main protagonists of this book are artists whose works draw viewers' attention to the fluctuating relations between themselves and others in reflective settings that impede privacy or complete mastery over the interactive situation. What is at stake in these art practices is not just enchantment with intriguing perceptual and behavioral possibilities but also a realization of the limits of individual autonomy and the need for recurrent negotiation of identity in relation to complex social and technological networks.

By *mirroring acts*, I mean both an encounter with one's self-image, be it a reflection or a video projection, and a series of dynamic interpersonal concatenations between affective experiences, behavioral responses, and imaginary projections. I analyze not only works that incorporate material components with reflective qualities, such as mirrors and TV screens broadcasting live images, but also sensor-based platforms that are activated by participants' gestures. I call the responses triggered by such works mirroring acts because they imply a contingent relation between self and others that resembles the relation between one's bodily presence in front of a mirror and one's reflection. While one can adjust one's posture or move closer to or farther away from a reflective surface, one's interaction with the images is limited to the visual field encompassed by its frame. Similarly, participants' experiences in-

side sensor-based artworks, such as Robert Rauschenberg's, Howard Jones's, and Christian Moeller's environments, are quasi-dependent on the boundaries of the environments and the reactions of coparticipants interacting with them. The sensory stimuli these environments produce are ultimately part of variable systems that are modeled by individual and collective behavior. Even if participants do not actively collaborate to bring about transformations, the outcomes of their actions commingle in perpetually transforming networks where individual cause and effect cannot be easily traced.

Throughout this book, I use the term *mirroring* to refer to three different affective processes through which viewers take the presence of others as a cue for their experience: (1) observing their reflections in relation to those of other viewers; (2) purposefully or incidentally behaving in the same way as other viewers; and (3) imagining themselves in the positions of others. In none of these cases does mirroring presuppose a one-to-one match between self and other. On the contrary, the correspondences established between viewers' emotions, perceptions, and behaviors are generally imperfect, and the discrepancies contribute to an even greater surge in affective responses. Social neuroscientists are particularly preoccupied by these kinds of incongruities, since they may be essential for establishing an ethical "other-oriented" perspective that prevents individuals from projecting their own thoughts and feelings onto others. In a thorough overview of the multiple meanings of empathy, C. Daniel Batson suggests that "feeling as the other feels may actually inhibit other-oriented feelings if it leads us to become focused on our own emotional state."[21] Artworks that conspicuously show viewers to themselves as they collectively experience shared fields of sensory stimuli stage perceptual scenarios that allow for the recognition of undeniable differences in affective and behavioral responses.

In order to analyze the reception of artworks triggering mirroring acts among spectators, I adopt a phenomenological approach that enables me to investigate the impact of interpersonal reflection on personal experience. Maurice Merleau-Ponty evokes the deeply troubling moment when one realizes that one's private experience may coincide with that of someone else who communicates similar sensory impressions or thoughts about a shared object of perception. In his essays on the visible and the invisible, he asserts that

"the other's gaze on the things is a second openness" and explains that it is through our connection with the external world that we relate to others and become more conscious of our own otherness.[22] Reflective and responsive artworks cast light precisely on the interpersonal dimension of perception and identity construction, encouraging viewers to understand that what they perceive is not a completely sealed-off projection or a true-to-life image but an experience that can be shared with others despite existing incongruities. The inevitable disjunctions in viewpoint disclosed by art practices that bring into the public eye a whole range of affective and behavioral responses are not an impediment to connectivity; rather, they challenge participants to open themselves to others in order to improve their understanding of who they are. Although phenomenologists such as Merleau-Ponty have dwelled upon the process of intersubjective self-definition, their philosophy has generally been associated with a purely subjective mode of perception. With the aim of making up for this misconception, I draw connections between phenomenology and theories of interpersonal perception and group behavior from psychology and sociology. By building correlations between these different areas of study and contemporary art theories of participation, I hope to overcome the generic presuppositions concerning the binary relation between the individual viewer and the unchanging artwork. Instead of assuming the presence of a singular spectator absorbed in contemplation, I account for the potential presence of multiple participants engaged in mirroring acts that simultaneously catalyze attention and distraction, familiarity and strangeness, voyeuristic pleasure and guilt. I believe that contemporary artworks with mirroring qualities generate interpersonal exchanges that are different from those attained through online social media. By eliciting an acute sense of bodily proximity to others, these works manage to shift viewers' focus from a primary interest in gaining individual recognition to a heightened understanding of collective contingency and precariousness.

It is interesting to note the interconnections between the increasing use of reflective materials for artistic expression and the consolidation of theories of interpersonal perception and group behavior in the 1960s. During this decade, both artists and psychologists investigated the dialogue between the subjective and the intersubjective dimensions of existence, which stands at

the basis of our construction of identity. Psychoanalyst R. D. Laing argued that we are constantly assessing our behavior and thoughts based on the ideas we form about how others perceive us: "All 'identities' require an other: some other in and through a relationship with whom self-identity is actualized."[23] In this book, I turn to Laing's theories rather than formulate a Lacanian interpretation of works that prompt mirroring acts among viewers because I attempt to untangle the relations between self and others without diminishing the importance of the conscious involvement of the individual in the interpersonal negotiation of selfhood and without undervaluing the function of the collectivity in influencing experience. Thereby, my inquiry into how viewers see themselves and others through reflective and responsive interfaces is more closely aligned with Laing's approach to intersubjectivity, which highlights the need for individuals' active engagement in acquiring a sense of who they are in relation to social groups. Critical of docile social adaptation, which he considered to be the root of deepening alienation in the American context of the 1960s, Laing hoped that individuals would increasingly question their positions in society and determine ways to resist behavioral tendencies that come to be taken for granted. His approach to psychotherapy contrasted with that of Lacan. Laing believed that the analyst needs to empathize with the patient to a greater degree in order for analyst and patient to decode together the chain of interpersonal inferences that underlie experience.[24] Artists Robert Morris and Dan Graham, who were experimenting with reflective surfaces in the 1960s and 1970s, were familiar with Laing's writings and challenged viewers to acknowledge the limits of individual and artistic autonomy.[25] In recent decades, contemporary artists have continued their precursors' inquiry into negotiations of selfhood and have created artworks that open up even more complex interpersonal relations under the impact of the rise of the Internet and the increased realization of the instability of identity.

Intersubjective modes of art experience have been described repeatedly in terms of the formation of small communities of participants.[26] I believe that the relations established between art viewers interacting with works with reflective qualities can be better delineated in terms of group dynamics than in terms of community formation. A community typically involves repeated

social exchanges over an extended period of time and a shared set of values; in contrast, a group is a collective entity that is more heterogeneous and more liable to unpredictable transformations, as it is based on fairly volatile interpersonal ties between members. Upon encountering artworks modeled by their images and movements, viewers forge connections that imply intense affective impulses, but these can easily change depending on the shifting coordinates of the environment and the audience. Hence, theories of group dynamics, group behavior, and group creativity can be productively employed to explain the interpersonal exchanges and spontaneous collaborations established among viewers of reflective and responsive artworks.

The 1960s offered fertile ground both for the consolidation of art practices that prompt collective engagement (e.g., happenings, performances, environments) and for the study of how collective encounters in general affect perception, cognition, and action. At the time, American and European psychologists and sociologists developed a keen interest in examining information dissemination and collective behavioral tendencies in large groups of protesters. Whereas in the first half of the twentieth century collective behavior was explained mainly in terms of irrational impulses, under the influence of Gustave Le Bon's essay on the involuntary conduct of crowd members,[27] in the midst of social movements of the 1960s researchers were trying to come up with new ways to account for the emergence of concerted action in heterogeneous groups. Ralph H. Turner developed three different theories for elucidating collective behavior: the theory of "contagion" prioritizes subconscious drives that lead to impulsive group reactions, the theory of "convergence" explains group affiliation in terms of a collective awareness of shared opinions, and the theory of "the emergent norm" explains the development and imposition of new rules of conduct when situations become uncontrollable and group coordination needs to be strengthened.[28] These modes of group behavior are evident in participatory responses to reflective and responsive artworks. As will become evident when I discuss affective alliances established between art viewers, these art practices do not trigger merely imitative acts that are devoid of creativity and impede possibilities for acquiring critical distance to the conditions of interactivity and participation. In fact, they frame situations that elucidate the complexity of human behavior and the

need for questioning the social and environmental parameters that condition interpersonal exchanges and group conduct.

Despite increasing attempts to formulate more complex theories of group behavior that could simultaneously account for alliances based on unconscious impulses, shared beliefs, and cognitive needs, dichotomies between feeling, acting, and thinking continued to be maintained both in psychological and sociological explanations of the 1960s and in art criticism of the same period. Theorists of group behavior often distinguished between an emotional basis and a cognitive or task-oriented basis for collective formation.[29] Turner himself reiterated these bipolar categories by differentiating between "active" and "expressive" crowds, depending on how crowd members defined themselves in relation to crowd outsiders.[30] In my analysis of artworks that trigger mirroring acts between museum visitors and their surroundings, I complicate this binary theory by showing the convergence between different types of group and crowd behavior. The boundaries between "active" and "expressive" crowds collapse as viewers connect to each other both by bringing changes to their surroundings through their actions and by modifying their self-images in an expressive manner. The performative gestures of art participants staging quasi-choreographic performances in responsive environments such as Rafael Lozano-Hemmer's *Body Movies* (2005), as well as their convivial gatherings around works with reflective properties such as Olafur Eliasson's *The Weather Project*, clearly indicate the interdependence between collective action and collective expression.

In addition to group behavior theories, recent cognitive science explanations play a significant role in my endeavor to unveil and decode the complexity of less explicit interpersonal ties prompted by contemporary artworks. Neuroscientists have shown that intricate interconnections exist between areas of the brain that were previously thought to hold distinct functions in the regulation of perception, cognition, and emotion. Moreover, they are currently examining the plasticity of neural connections, which are shaped and reshaped by the societies and cultures to which we are exposed over long periods. The identification of mirror neurons in the human brain offers further evidence in support of the contingent relations established between ourselves and others even when we simply observe them without engaging in verbal

exchanges. Brain imaging experiments have shown that whether we watch someone perform a certain action or we perform that action ourselves, the same neural area in the premotor cortex is activated. Behavioral scientist Marco Iacoboni emphasizes the key function of mirror neurons in consolidating cognition and enhancing interpersonal understanding. He explains that these neurons are linked with the limbic system, which enables us to empathize with others, and argues that "mimicking others [by virtually simulating their movements in our minds as we perceive them] is not just a form of communicating nonverbally; it helps us perceive others' expressions (and therefore their emotions) in the first place."[31] While further neuroscientific inquiry is needed to determine the potential relation between mirror neurons and reasoning about someone else's experience, it is apparent that the perception of others' motion is conducive to empathetic projection.[32] Reflective and responsive artworks strongly activate the mirror neurons in our brains as they invite us to observe the movements of others in relation to interfaces that encapsulate our own images and responses, thus underlining the contingency of our behavior. The affective alliances we develop as we interact with them may appear enslaving as a result of the mental and behavioral mimicking they inspire, but they can actually provide a pathway toward inquiring into the social conditions of cognition and emotion. Ultimately, the higher-order processing of visual information is activated even more fully when we are exposed to ambiguous perceptual situations like the ones elicited by reflective and responsive environments that call on our ability to infer content and connections in order to relate to shifting images and group dynamics.

Viewers of the key artworks I analyze in this volume frequently remain anonymous to one another, yet their interpersonal ties and collective behavior are not perfunctory. Drawing on phenomenological philosophy and cognitive science explanations, I explain how these ties encourage thoughtful consideration of social contingency and control. I do not deny that the connections forged as a result of mirroring processes in the context of contemporary artworks are most often incidental and temporary, but this does not mean that they are superfluous or do not hold the potential for catalyzing social agency. After all, the spaces of such artworks have at times become sites of political protests against hegemonic foreign policies or the infringement

of human rights. Just before President George W. Bush was to visit England in 2003, a group of protesters took over Eliasson's *The Weather Project* installation in London and used their bodies to spell out "BUSH GO HOME" on the floor of the Turbine Hall at Tate Modern. Anish Kapoor's *Cloud Gate* (2004) has also been the site of political demonstrations in recent years. While it can surely be argued that protesters are simply taking advantage of the spectacular nature of these artworks to emphasize the urgency of their messages, it is undeniable that the sites constitute highly affective spaces that call upon participants to connect not only to the visual elements encapsulated in their reflective surfaces but also to each other as individuals and members of more or less precarious collectivities.

Mirror Affect

I employ the term *mirror affect* to delineate an alliance between self and others mediated by reflective images or by similar perceptual experiences and behavioral acts, which momentarily seems to collapse the distance between individuals without necessarily abolishing interpersonal tension. In this intersubjective sphere, viewers contemplate the potential for interaction or for empathetic connection with coparticipants who are simultaneously engaged in acts of affective, perceptual, and behavioral mirroring. However, the ultimate convergence between an individual's personal experience and the experience of others remains an unfulfilled desideratum. This perpetually delayed conjunction between concurrent sensations enhances the affective dimension of the encounter with others. While the mirror seems to guarantee the coincidence of the seeing subject with that subject's reflection, it actually unveils the instability of the context of the reflective act and the possibility for more or less significant discrepancies between what the subject senses and what others are experiencing. In the case of large-scale installations that encompass the moving reflections of multiple viewers and their surroundings, mirror images elude the control of the individual viewer.

Theories of affect have developed across a wide range of disciplines, including philosophy, psychology, and new media. In the field of psychology, Daniel N. Stern has proposed the notion of "affective attunement" to define

the way in which we empathetically relate to others by emulating certain qualities of their facial expressions and behavioral acts while nonetheless introducing significant variations on them.[33] Such interpersonal modes of communication are not equivalent to mimicry since they imply disjunctions in responses, which constitute signs of mutual understanding and are meant to keep the dialogue open. Stern observes that after infants reach the age of nine months, mothers start communicating with them in a different way. Not only do mothers imitate their infants' gestures in order to enhance empathetic relations, but they also translate the infants' performative acts into other sensory registers while maintaining the intensity or pace of the infants' preceding communicative acts. For example, when an infant rattles a toy, the mother moves her head almost to the same rhythm to provide an affective response.[34] Unlike Lacan, who takes a more pessimistic view of intersubjectivity, being suspicious of the unfulfilled desires perpetuated in communicative acts, Stern cherishes the role of interpersonal exchanges in shaping the awareness of individuated existence. He points out that "affective attunement" in parental relations prepares individuals for the empathetic encounter with art, which will stir in them sensations that may only imperfectly match the ones virtually experienced by the figures portrayed in a painting.[35]

Philosopher Gilbert Simondon goes one step further in defining affect in relation to intersubjectivity by comparing it to a transformative process situated on the threshold between the conscious and the unconscious, which greatly contributes to the formation of collectivities. Just as Stern emphasizes the variability implicit in "affective attunement," Simondon highlights the elusiveness of affect, which to him is not a state but a transitional interval preceding the registration of emotion. Similarly, he believes that affect is not to be equated with a purely subjective manifestation of feelings. Explaining the intersubjective dimension of this notion, he states, "Instead of talking about affective states, one should talk about affective exchanges, exchanges between the pre-individual and the individual field of the subject."[36]

The idea of an imperfect identification with others as a catalyst for intensified affect also underlies Gilles Deleuze and Félix Guattari's approach to affect, which they describe as an interval between a disquieting perception and an impulse for action associated with the desire for becoming other.[37]

According to Deleuze and Guattari, affect implies a connection to a multi-plicity because it arises from a process of imperfectly reflecting a collectivity with which one cannot fully identify in spite of desired affinities. Deleuze calls affect "a center of indetermination" in which one feels caught between sensation and motion, interiority and exteriority, contemplation and action.[38] I rely on his explanation of this convergence between noncoincident planes of being in the world in order to account for the ambivalent experience of art audiences watching themselves and others in large mirror screens, as in Kapoor's and Eliasson's installations, or collectively interacting with re-sponsive systems, as in Moeller's and Lozano-Hemmer's projects. While they encounter such artworks as part of large audience groups, viewers become engaged in producing variable acoustic and visual effects, affectively tuning their behavior to the responses of others.

The amount of contemporary art history scholarship on affect (as a no-tion distinct from emotion) is quite modest in comparison with the study of affect in the fields of new media, performance studies, and literature, prob-ably because it is problematic to judge affective responses based solely on individuals' subjective perceptual experiences or their visual observation of other museum visitors' reactions. This implies a betrayal of the detached attitude generally cherished by art historians in relation to their object of analysis and the privacy of the aesthetic experience presumably needed to pass critical judgment. It is clearly hard to provide evidence of a sensori-motor experience that is fleeting and even loses its transformative potential when it is expressed visually or verbally. Some art critics and historians are suspicious of affect because they fear that artworks that elicit strong sen-sory and emotional responses impede a thoughtful consideration of the social and political factors that shape interpersonal relations. In a 2012 roundtable discussion of the relation between contemporary art and archi-tecture, Hal Foster cringed at the suggestion that a built environment with highly affective qualities can constitute a site of resistance: "When I hear the word *affect* I reach for my Taser. An unfair reflex, I know, but affect seems to me a prime medium of ideology today—an implanted emotionality that is worse—because more effective—than false consciousness."[39] Although he quickly changed his tone and acknowledged the dichotomies underlying his

retort, Foster was unwilling to accept that affect can be as much the object of ideological manipulation as it can be the source of conflicting tension, contributing to another kind of openness toward others and a potentially critical perspective on social norms.

Despite the cautious attitudes concerning affective experience discussed above, there is a small, but significant, contingent of art historians who are taking an interest the study of affect, empathy, and identification in contemporary art. In *Empathic Vision*, Jill Bennett draws intriguing analogies between affect and trauma in contemporary art, starting from the idea that both experiences defy representation.[40] Analyzing affective relations in the context of Marina Abramović's performances, she conceptualizes audience reception in terms of a dialectical relation between the body of the performer, which concomitantly stands for the subject and object of the performative act, and the embodied viewer hesitating between an empathetic relation to the artist's corporeal presence and a contemplative relation to the bodily experiences she stages. In this book, I concentrate less on the dialogue between the artist and viewer mediated by the art object or the art process and more on the intersubjective relations that arise between spectators communicating with one another within an all-encompassing art environment or by means of a responsive platform. These affective exchanges can be both the result of empathetic affinities between art viewers and the outcome of conflicting relations prompted by the realization that one's emotional response to the artwork may differ significantly from the experience of others. Jennifer Doyle is one of the few art interpreters who take a similar interest in the branching out of interpersonal alliances in contemporary art beyond the dialectical relation between the artist and the viewer. In *Hold It against Me: Difficulty and Emotion in Contemporary Art*, she provides a captivating analysis of Ron Athey's and Franko B's provocative performances, which take viewers outside their comfort zones and direct their attention not only to the traumatized body of the performer but also to each other and the emotionally charged experience they are publicly sharing. An English professor who has written extensively on art, intimacy, and sexuality, Doyle refuses to draw clear-cut distinctions between affect, emotion, and feeling and is critical of the feeling/thinking binaries generally perpetuated in art history. She contends that emotion is wrongly

"assumed to make things easier to get and to pollute critical thought."[41] The contemporary artworks around which she anchors her argument firmly attest to the complex implications of affective experiences. Far from merely titillating the senses and triggering shock or surprise, a significant number of art practices that elicit strong emotional responses awaken social awareness by calling on viewers to consider their roles as witnesses, participants, or even potential performers in shared social spaces. Unlike Doyle, I do not focus on works that might be called difficult or controversial. Most of the reflective and responsive artworks that I analyze tend to be perceived as playful, but this does not mean that they are devoid of complexity or tension. In the affective spaces of participation framed by these art practices, some viewers experience a sense of discomfort and vulnerability as their bodies are publicly set on display. In addition, they realize that they lack individual control over the network of images, sounds, or other stimuli such works incorporate, since this sensory content is being modeled not only by their individual movements but also by the active presence of numerous others. It is in these highly ambivalent situations that spectators glance toward others and gain a deeper sense of their dependence on larger social systems and their collective vulnerability to regimes of surveillance.

The persistent dominance of models of art spectatorship that restrict aesthetic experience to the relation between the singular viewer and the singular art object, along with the idea that affect escapes visual representation, may have prevented art historians from more fully exploring the affective character of public art encounters. In contrast, new media theorists have actively sought to identify art practices that prompt affective relations, partly as a result of their desire to counteract ideas about the disembodying effect of technology and partly as a result of their interest in unveiling the potential convergence between the actual and the virtual. In *Parables for the Virtual*, philosopher Brian Massumi examines Stelarc's performances in which viewers control the movements of the performer's body through the use of technology. He outlines the shift from a focus on individual performance to collective performance, which brings out the intersubjective dimension of corporeal experience.[42] New media theorist Mark B. N. Hansen has eloquently discussed the way technology enhances our ability to reflect on the limitations and

possibilities of our body sensorium. He defines affect as a process that takes precedence over perception and enables us to envision the body's virtuality—that is, its potential for movement, expression, and self-perception.[43] But Hansen's approach to this notion is anchored in self-reflexivity more than in intersubjective reflection, as it is based in his desire to match new media projects with specific phenomenological concepts that often take precedence over the specific content or context framed by the artworks.

Starting from an understanding of affect as a threshold experience in which individuals can gain a better sense of the mutability of bodily sensations and their relations to others, this book charts the emergence of art practices that mediate perceptual reflection and prompt social connections through mirroring acts. It is organized around four different roles of reflective and responsive interfaces: as framing devices for disclosing the contingency of perception or inviting critical thinking on social inclusion and exclusion; as screens for channeling attention to surveillance and the manipulation of visual information, which contribute to enhanced social control; as intervals for disrupting habitual modes of relating to time and space while building a heightened consciousness of social and environmental interconnectivity; and as portals to technologically augmented spaces that enable interpersonal ties and performative collaborations between participants simultaneously interacting with acoustic or visual stimuli. The first part of the book follows a chronological trajectory, examining the roots of departures from binary relations between viewers and art objects in the 1960s and 1970s. The second part follows a less linear path, focusing on reflective and responsive artworks from the past three decades that encourage viewers to observe each other and participate in affective exchanges that raise social awareness.

Chapter 1 explores nascent forms of shared spectatorship fostered by artworks of the 1960s that stimulate mirroring processes. In this discussion, I consider the wide range of motivations that have led artists to use media with reflective properties, not only out of an interest in pursuing phenomenological exploration but also out of a desire to bring about social transformations. Beginning with an inquiry into the challenges brought to the autonomy of the artwork and the viewer by Robert Morris's and Lucas Samaras's sculptures and environments and further addressing the sociopolitical implications of

Michelangelo Pistoletto's mirror paintings and Joan Jonas's performances including mirror props, I show the erosion of distinctions between private and public modes of art spectatorship. Moreover, I unearth some of the frequently overlooked histories of closed-circuit video installations and art and technology projects that have generated both individual interaction with cybernetic systems and affective exchanges among art participants simultaneously engaged in modeling visual and acoustic stimuli through their movements.

Chapter 2 considers the critique of visual spectacle, consumerism, and surveillance in artworks of the 1970s. Through close analyses of Dan Graham's mirror-based performances and installations and Lynn Hershman's compelling exhibition in the windows of the Bonwit Teller department store in 1976, I discuss the two artists' investment in undermining the impact of social control and supervision by revealing the mediation and manipulation of visual information. Both artists invite viewers to adopt a quasi-performative role in order to understand the limits of their subjective construction of identity and the complex social systems in which they are engulfed.

Chapter 3 focuses on Anish Kapoor's, Olafur Eliasson's, and Ken Lum's large-scale artworks that temporarily set crowds of viewers on display. My visits to Kapoor's and Eliasson's retrospective exhibitions and my encounter with Ken Lum's public art project *Pi* have spurred my interest in the narcissistic and voyeuristic tendencies that subtly mediate the transition from introspection to collective engagement. I posit that the contradictory impulses these works generate are the outcome of contemporary artists' interest in situating us in ambiguous perceptual and social contexts that invite us to abandon certainty and consider the limited, yet potent, agency we have to define our role in relation to broader social systems.

Chapter 4 charts the reception of David Rokeby's, Christian Moeller's, and Rafael Lozano-Hemmer's responsive environments, which catalyze interaction with sensor-based platforms or video interfaces that enhance the affective qualities of public spaces. Using video and digital technology, these artists show not only the rhizomatic networks of information that seem to be expanding exponentially in the age of the Internet but also the growing complexity of social relations that are less and less rooted in strong affiliations with small communities. The responsive environments I consider in

this last chapter catalyze interpersonal mirroring acts between participants who are trying to decode and, at times, collaboratively invent rules of engagement with spaces that are shaped by their bodily presence. Simultaneously promising and denying individual control over visual and acoustic stimuli, these works delineate the indeterminacy implicit in both our interaction with technology and our exchanges with others.

This book starts from the notion that any process of self-definition implies an awareness of the coexistence of oneself with others. Works of art that invite viewers to observe themselves in relation to their surroundings constitute communicative frameworks that respond to our compelling need to seek alliances with others. I look into art practices that generate the formation of groups of spectators in order to identify a shift not only in art reception but also in social relations, which have become increasingly temporary and unpredictable in the context of the expansion of online social networks. I argue that artworks that put the behavior of visitors on display provide occasions for retrieving a sense of physical proximity to others. These small gatherings inside museums give rise to spontaneous collaborations between visitors and highlight the creative potential of any form of social interaction. By defining these encounters among people in terms of incidental group formation rather than in terms of cohesive communities of viewers, I underscore the plurality of experience and the volatility of intersubjective relations. I hope that by pinpointing the emergence of public modes of art spectatorship in conjunction with new communicative networks, this book broadens the current understanding of the web of relations among individuals and collectivities and contributes to the critical discourse on social connectivity in actual and virtual spaces.

Mirror Frames
Spectators in the Spotlight

It is assumed that meditation and privacy are possible in a gallery situation; but it should be obvious nowadays that everyone is on display as a work of art the minute they enter a gallery. One cannot be alone. A gallery is not a retreat.

—Allan Kaprow, "Video Art: Old Wine, New Bottle"

Although there is no consensus among art historians about an exact point in time when modern art transitions into contemporary art, there is a widespread sense that the transformations of the 1960s have proved deeply consequential for the current state of art practice. The 1960s have been repeatedly associated with the blurring of boundaries between art and life, the gradual dissolution of stylistic categories, and the dematerialization of the art object. These are important elements, but they do not add up to a full picture. The above-mentioned changes in art form and content were accompanied by the emergence of new modes of art spectatorship characterized by a higher degree of interconnectivity, mobility, sociability, and variability. These latter transformations are highly visible in the context of works eliciting affective, perceptual, and behavioral processes of mirroring between art participants.

The notion of a networked mode of art spectatorship actually preceded the development of the World Wide Web in the 1990s. The outdoor exhibitions and performances staged by the Gutai group in Japan in the mid-1950s, along with happenings and Fluxus events organized in the United States starting in the late 1950s, prepared the ground for opening up the presumably

autonomous field of the artwork to the bodily presence and creative responses of art participants. Yet it is also by no means coincidental that the origins of these networked modes of art spectatorship were concurrent with the foundation of ARPANET and the popularization of cybernetic theories. In this chapter, I will show that the prevalence of reflective materials in art practices of the 1960s undermined the ideal of private aesthetic contemplation. In the context of works based on mirrors or responsive technological interfaces, beholders did not merely observe each other's reflections but affectively related to coparticipants and even emulated their behavior while negotiating their relations to the artworks and the display contexts. By relying on theories of collective behavior, group dynamics, and interpersonal perception and cognition, I will analyze the complexity of spectatorial responses to artworks catalyzing mirroring acts.

During the 1960s, artists' predilection for reflective materials such as mirrors, Melinex, Mylar, Plexiglas, and polished stainless steel fostered a tendency toward rendering visible viewers' interaction with the artworks. The mirror has always been closely associated with art making because of its correlation with mimesis, but it was not until the 1960s that it was widely used as an art medium rather than just a tool for improving the accuracy of visual representation. Larry Bell, Joan Jonas, Yayoi Kusama, Craig Kauffman, Stanley Landsman, Les Levine, Enzo Mari, Christian Megert, Robert Morris, Michelangelo Pistoletto, Charles Ross, Lucas Samaras, Robert Smithson, Andy Warhol, and Robert Whitman are just a few of the artists who employed reflective materials extensively in the 1960s. Given the plethora of approaches to this medium, I have chosen to limit my discussion to reflective artworks that disrupt the perfect parallelism between the viewer and the art object while purposefully or accidentally heightening interpersonal awareness between art participants. Hence, there are at least two notable absences from this chapter: Robert Smithson's mirror works, which serve as metaphors for entropic processes in nature and human consciousness, and Art & Language members' mirror objects, which constituted strategic props in their conceptual inquiry into the relation between mimesis and art. I have omitted discussion of these seminal mirror works because they are not pivotal to the rise of networked modes of art spectatorship.

Artists' interest in triggering interpersonal acts of mirroring in the 1960s was engendered by three key factors: the desire to contest self-focused modes of art production and reception, the growing availability of technological devices for audio and video recording, and the feeling of doubt permeating society under the impact of grassroots social movements and antiwar protests. These circumstances gave rise to an increasing realization of the interpersonal construction of identity and the otherness inherent in every individual. The equivocal character of mirrors, which impartially absorb variable reflections, most likely inspired their co-optation in art at a time when the Enlightenment ideals of faith in rationality, endless progress, and absolute truth were coming under intense scrutiny. Reflective surfaces blurred differences between foreground and background, two-dimensionality and three-dimensionality, embodied presence and virtual projections. With their faithful replication of images and their incessant alteration, they simultaneously epitomized certainty and relativity. These ambiguous qualities were consonant with the paradoxical character of the 1960s, which represented both a time of violent turmoil and a time of great social change thanks to alliances between supporters of civil rights movements. In *Sixties Going on Seventies*, Nora Sayre points out that while no ultimate resolution could be found to the conflicts of the sixties, there was actually an exceptional gain in this decade as people of very different backgrounds became increasingly familiar with each other's experiences.[1] The tendency of artists such as Joan Jonas and Michelangelo Pistoletto to stage mirror-based performances that encouraged spectators to consider the subjugating effects of the gaze and the fluidity of interpersonal relations obliquely echoed the proliferation of exchanges between previously segregated groups. It became more and more evident that individual identity is never fully independent from social forces, just as mirror images are never autonomous from the body and the context of the reflective process.

The contingent and impersonal nature of mirrors was propitious for the interrogation of the autonomy of the art object and the definition of art making solely in terms of subjective expression. Mirrors were also excellent instruments for questioning medium specificity. Their blatant flatness, commingled with their illusory promise of access to a three-dimensional realm, obscured

the differences between painting and sculpture. Robert Rauschenberg and Jasper Johns incorporated reflective surfaces in their works with the aim of closing the gap between art and life by rendering differences between media less relevant. Reflective materials were used as sculptural media (e.g., Lucas Samaras's *Room No. 2*), camera-like devices (e.g., Robert Morris's *Mirror*), canvas-like surfaces (e.g., Michelangelo Pistoletto's *Mirror Paintings*), and performative props (e.g., Joan Jonas's *Mirror Piece*). Their versatile functions were made possible by their concomitant physicality as material objects and virtuality as projection screens.

This chapter is subdivided into four sections that examine the role of mirroring processes in enhancing the public dimension of art encounters in the 1960s. Each section looks into interpersonal exchanges triggered by artworks using different media. The first focuses on sculptures based on reflective materials that mediate the transition from art objects to art environments. It is anchored in the art practice of Robert Morris and Lucas Samaras, who utilized mirrors to question the autonomy of the artwork and redirect viewers' attention from the object to their bodily presence in space. The second section explores artists' use of reflective screens in paintings and performances in order to trigger empathetic mirroring processes. It addresses how Michelangelo Pistoletto and Joan Jonas encouraged beholders to define their roles in relation to groups of sketched figures or performers by integrating their reflections in mirror panels connotative of social frameworks. The third section discusses art and technology projects that invite participants to attune their behavior to cybernetic systems responsive to their gestures. It is organized around three exhibitions and programs that fostered collaborations between artists and engineers and spurred participatory responses: Ralph T. Coe's *The Magic Theater* (1968), the Los Angeles County Museum of Art (LACMA) Art and Technology program (1967–71), and the Pepsi Pavilion (1970) designed by Experiments in Art and Technology (E.A.T.) for Expo '70 in Osaka, Japan. The final section dwells on Les Levine's and Frank Gillette and Ira Schneider's use of closed-circuit television (CCTV) systems to heighten awareness of the mediation of information and the interpersonal construction of identity. It analyzes how multiple TV channels broadcasting live images cast doubt on the objectivity of televised information by exposing a

plurality of vantage points and building affective ties between spectators exposed to similar perceptual conditions.

From Reflective Objects and Self-Focused Perception to Reflective Environments and Collective Awareness

As minimalism consolidated in the 1960s, reflective surfaces became prevalent in sculpture. More or less transparent, they redirected viewers' attention from the internal relations of sculptural objects to external relations contingent on the features of the display context and the position of the observer. Mirrors represented a fitting material for sculptors exploring the phenomenology of perception. Their variable reflections exposed the relativity of vision and the interdependence between the object and the context of perception. Minimalist artists were primarily interested in the subjectivity of perception, yet the increasing scale and seriality of their works brought to the surface the interpersonal implications of perceptual encounters.

Simultaneously aligned with minimalist and conceptual art tendencies, Robert Morris relied on processes of visual and conceptual doubling to create playful conundrums concerning the relations among the artist, the art object, and the viewer. The mirror-based sculptures he created in the 1960s undermined the singularity of artistic representation and the certainty of perception. Morris's writings in this decade focused on the redefinition of sculpture through the lens of Gestalt psychology and phenomenology. At a time when objecthood and art genres were increasingly interrogated, he theorized a departure from the privileged status of the handcrafted artwork and the intimate qualities of the beholder's encounter with art.

Morris first employed reflective materials in the design of *Untitled (Pine Portal with Mirrors)* in 1961. A wooden doorway with interior edges lined with mirrors, this work turns the very concept of a portal on its head. Devoid of its function as a point of entry into another space, the doorway invites viewers to hover on its threshold and observe the elusive suspension of their reflections within the space of the art object. It cajoles beholders into an ambivalent situation: to step inside the portal implies turning themselves into objects of contemplation for themselves and others; to observe it from afar implies

losing contact with their reflections. The work unveils the contingent relation between the art object and the viewer. It transforms the private experiences of art contemplation and self-contemplation into strikingly public acts, partly devoid of the narcissistic gratification inherent in mirroring processes.

Morris's interest in staging situations that frustrate viewers' expectations by facing them with mutually exclusive perceptual alternatives intertwined with his interest in fluctuating processes of self-definition. Mirrors constitute a perfect medium for exploring the variable coordinates of experience and identity. Although he was initially wary of their illusionistic properties, Morris eventually conceded that their "very suspiciousness seemed a virtue."[2] His strategic use of mirrors was grounded not in narcissistic or voyeuristic drives but in the desire to underscore the variable qualities of physical presence. Building on George Herbert Mead's theory of mind, Morris contrasted the "I," the notion of self continuously shaped by the flux of consciousness, with the "me," the understanding of the self based on a synthesis of prior cognitive acts.[3] He explained that mirror surfaces bring these two sides of the self-definition process in close proximity, since they concomitantly denote fixity and variability, reality and virtuality, instantaneity and duration:

> Mirror spaces are present but unenterable, coexistent only visually with real space, the very term "reflection" being descriptive of both this kind of illusionistic space and mental operations. Mirror space might stand as a material metaphor for mental space, which is in turn the "me's" metaphor for the space of the world. With mirror works the "I" and the "me" come face to face.[4]

Keen on unveiling the multiple facets of the art object and the art viewer's subjectivity, Morris designed works that heighten awareness of the present tense of perceptual experience and self-definition. His works indefinitely deferred perceptual resolution even when the most salient features (e.g., shape, material) of the objects of perception were immediately identifiable. This mode of defining art experience in terms of relative parameters greatly contrasts with the privileged mode of perception of modernist sculpture, which

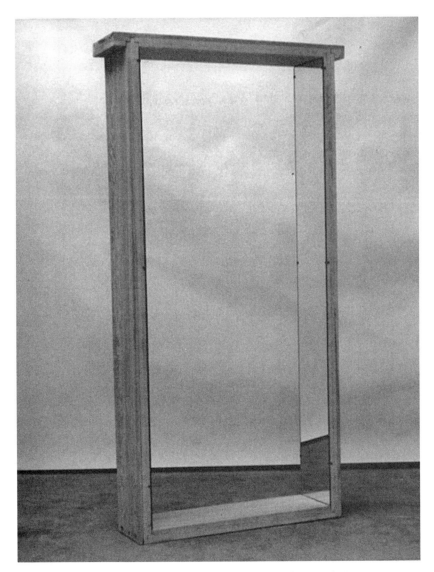

Robert Morris, *Untitled (Pine Portal with Mirrors)*, 1961. Laminated pine and mirrors, 84 × 48 × 11 inches (fabricated 1978). Copyright 2015 Robert Morris/Artist Rights Society (ARS), New York. Photograph courtesy of Castelli Gallery, New York.

generally prompts the identification of a stable set of relations between the individual viewer and the autonomous art object.

In the case of minimalist sculpture, the relativity of subjective perception is not sanctioned. Upon stepping within the frame of Morris's mirror portal, viewers acknowledge the fluctuating appearance of the object shaped by their movements and reflections. Morris describes the perception of "new sculpture" in terms of democratic modes of spectatorship. He contrasts it both with the perception of old sculpture, which calls for the decoding of relations between the internal components of the art object, and with the perception of small sculptural objects with high finishes, which engender an intimate experience.[5] There is no superior reading of "new sculpture" just as there is no abstract undifferentiated visual field. Beholders are not expected to have their perceptual impressions confirmed by others; rather, they are expected to imagine multiple ways of seeing. According to Morris, "new sculpture" banishes didactic approaches to art and liberates viewers by engaging them both physically and mentally. He concludes his third "Notes on Sculpture" essay by delineating this work's democratic potential:

Such work which has the feel and look of openness, extendibility, accessibility, publicness, repeatability, equanimity, directness, immediacy, and has been formed by clear decision rather than groping craft would seem to have a few social implications, none of which are negative. Such work would undoubtedly be boring to those who long for access to an exclusive specialness, the experience which reassures their superior perception.[6]

Mirrors represented the perfect medium for contesting exclusive access to the artwork and subverting the primacy of the object as the sole focus of attention. Their endless openness to the incorporation of new reflections highlights beholders' shared perceptual ground.

Morris's best-known mirror-based sculpture, *Untitled (Mirror Cubes)* (1965–71), testifies to his interest in suppressing the autonomy of the art object and perception. By placing four cubes covered by mirror panels at equal distances from one another, Morris frames a situation in which there is no ideal van-

tage point. The sculpture evens out the perceptual field by emphasizing its contingency on a chain of equivalent factors: the identical shapes of the units and their undifferentiated reflective qualities. Even though the work subverts perceptual hierarchies, it does not yield a perfectly congruous experience, because the strong gestalt of the cubes is at odds with the mirror images illusionistically fragmenting the cube facets. In discussing the conditions of visibility and invisibility staged by Morris's cubes, Annette Michelson has explained that "each object was dissolved as it was defined, through reflection."[7] She points out that the work integrates the presence of the viewer into the object and underlines the continuum of perceptual experience.

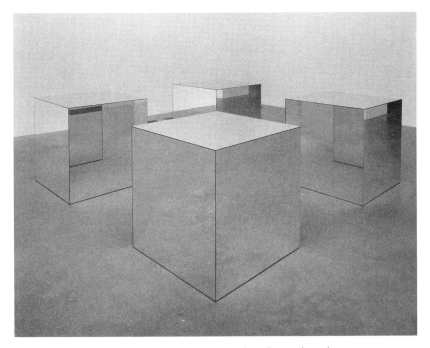

Robert Morris, *Untitled (Mirror Cubes)*, 1965–71. Mirror, plate glass, and wood, 914 × 914 × 914 mm. Tate Gallery. Copyright 2015 Robert Morris/Artists Rights Society (ARS), New York. Photograph courtesy of Tate, London/Art Resource, NY.

The mirror cubes embody Morris's theory regarding "the less *self*-important object" discussed in his second "Notes on Sculpture" essay.[8] Their literal shapes compete for attention with the reflective projections fragmenting their unitary surfaces. The seemingly camouflaged presence of the cubes within the space of yet another cube represented by the all-white gallery reveals the contingency of the art object on extrinsic factors such as the display context and the movements of the viewers. The shift away from the *self*-important art object implies a reconsideration of art spectatorship. Morris's mirror cubes encompass the reflections of the viewers, virtually turning them into an equally important focus of attention. The cubes set forth the beholders' ability to modify the images and filter them through their consciousness, but they do not grant the viewers the possibility of controlling their fluctuations fully. The individual beholder cannot perceive all the images projecting across the cubes or avoid the conscription of his or her body image within the reflective field. Moreover, at any moment, the beholder's reflections may intertwine with those of other exhibition visitors. Hence, it is worth inquiring whether Morris and minimalist artists in general prepare the ground for a less *self*-important subject of perception, who is part of a variable interpersonal network instead of occupying a privileged position in relation to the singular art object. As baffling as this may seem given the association of minimalism with subjectivity, it is clear that the suppression of hierarchies in terms of the object of perception shakes one's faith in the supremacy of a subjective viewpoint.

In his writings, Morris praises the parallelism between the artwork and the viewer, but his works tend to complicate this dialectical relation by generating competing analogical correspondences between multiple objects and viewing subjects.[9] *Untitled (Mirror Cubes)* decenters the perspective of the beholder. It encourages the beholder to consider the deeply interconnected reflections of the cubes and develop virtual ties with other participants concomitantly transforming the mirror images through their interaction. While Morris advocates for the consideration of external factors that affect viewers' relations to the art object, he avoids acknowledging the perceptual effect of multiple viewers present within the visual field of the object. Critical of the presumed invisibility of spectators in art during the 1960s, Allan Kaprow argued persuasively

against this presupposition, which Morris did not fully relinquish despite his statements on the public dimension of sculpture. Kaprow stated that viewers' "particular shape, color, density of numbers, proximity to the painting(s) or sculpture(s) and relation to each other when there are more than one person will markedly affect the appearance and 'feel' of the work(s) in question."[10] Morris's refusal to approach this issue, even though he hints at the "social implications" of changes in sculpture,[11] is probably motivated by his anxiety about the transformation of the art object into a mere subsidiary variable mediating the aesthetic experience. Curators of minimalist and postminimalist art exhibitions have seemed to share this fear. In his essay for the *Structures for Behavior* exhibition organized at the Ontario Art Gallery in 1978, Roald Nasgaard underscored the fact that in viewing Morris's sculptures "a companion gets in the way."[12] In spite of the fact that he supported the idea that minimalism leads to a redefinition of spectatorship in terms of behavioral relations, Nasgaard did not accept that this transformation also entailed a radical interrogation of private contemplation and self-oriented sense experience.

In *The Sculptural Imagination*, art historian Alex Potts amply discusses Morris's conflicting statements regarding the viewing of sculpture. He shows that the artist's views on the public quality of the encounter with the art object evoked in the "Notes on Sculpture" essays are not upheld in Morris's later statements, which unveil instead his desire to familiarize the viewer as closely as possible with the private aesthetic experience of the artist creating the work inside the studio. Potts argues that this equivocation stems from Morris's difficulty in finding a way to connect his increasingly radical political engagement at the time of the Vietnam War with his earlier formalist concerns. According to Potts, this led the artist to stage aesthetic situations that inspire contradictory responses:

If his own work shows signs of being open and extended, it could equally well be described as closed and controlled. . . .
. . . There is accessibility and also blocking, an openness and a fenced-in confinement and exclusion. The work invites a continuously repeated pattern of engagement from the viewer—moving in closer, peeping over and stepping back.[13]

This oscillation between viewing modes in the absence of a promise of perceptual or behavioral resolution creates the potential for envisioning an intersubjective negotiation of the aesthetic experience staged by the object.

Morris's disregard for a potentially collective audience of sculpture in his writings may also have something to do with the dialectical definition of sculpture in relation to performance art. At a time when artists were increasingly transgressing the fixed boundaries of media, the hierarchies and distinctions between them were far from completely dissolved. Morris was an active participant in the New York performance art circles of the 1960s. He performed along with professional dancers, staged his own performative events, and designed theatrical props. Some of these props closely resembled minimalist sculptures, and art critics treated them as such if they were designed by Morris; they failed to do the same, however, when props were created by female performers such as Simone Forti.[14] Morris may have been reluctant to discuss a spectatorial network formed around sculptures for fear of suppressing the self-sufficient character of these objects outside a performative context. This did not prevent him from eventually creating an installation that invited participants to adopt participatory roles on the occasion of his retrospective exhibition at the Tate in 1971. Viewers were given free rein to manipulate geometrical shapes, walk along inclined beams, or collaborate with others in order to set objects into motion. One of the spectators remarked that this stagelike setting "produced an electric social atmosphere; individual exhilaration [became] group exhilaration, people wanted to do things together."[15] This impression is confirmed by an attendant's declaration that the museum "wanted people to participate, the trouble is they went bloody mad!"[16] The exhibition provoked so much participation that it was closed after a couple of days, partly because the installation needed repairs, and partly because it had triggered an utterly chaotic atmosphere.

Morris's transition from a practice oriented toward objects with strong gestalts that demand a private perceptual experience to environments that imply a fragmentation of the perceptual field and an increased awareness of the public dimension of experience was mediated by his collaboration with choreographers and his experimentation with film in the late 1960s. His mirror use further catalyzed kinetic impulses and interpersonal responses. In

his film projects, Morris often paralleled reflective surfaces to camera lenses. A 16 mm film from 1969 shows the artist manipulating a mirror panel to capture panoramic images of the landscape at different angles. Morris also juxtaposed mirror reflections with film projections in his *Finch College Project* (1969). He set a camera on a platform revolving at a speed of about two revolutions per minute to record a 360-degree view of the gallery space while he and his assistant were attaching square mirrors to one wall and square fragments of a photograph depicting a movie audience to the opposite wall. As soon as the two grid compositions were complete, the performers proceeded to detach the square pieces as the camera kept rolling. Subsequently, Morris replaced the camera with a projector revolving on the same turntable in order to present the film that had just been recorded in situ. Despite the identical points of view of the two technological apparatuses, the perception of the filmed images could not match the experience of directly observing the actions of the artist and his assistant. The fragmented photograph of the group of spectators suggested that they formed a heterogeneous group rather than a homogeneous collective reacting in unison. *Finch College Project* counterposed different modes of spectatorship in order to underline the mediation of representation and the differences between witnessing live performative actions and watching recorded gestures.

As he focused more and more on creating environments toward the end of the 1960s, Morris conceived works that exemplify somewhat of a shift from a primarily goal-oriented perception to a more entropic mode of perception that departs from rigorous mental control over the focus of attention.[17] Familiar with Anton Ehrenzweig's notion of "scanning," associated with a perceptual experience that seamlessly intertwines seeing, reminiscing, and dreaming,[18] the artist created increasingly complex visual environments. *Threadwaste* of 1968 consists of an assemblage of industrial materials, such as strings, copper tubing, and asphalt pieces, distributed on the gallery floor. In this highly haptic mélange, Morris inserted rectangular mirrors in order to break the continuity of the optical field. This fractured environment impedes easy recognition of orderly patterns by displaying a wide range of equally important visual foci. This reconditioning of perceptual mechanisms in relation to perplexing visual fields brings to mind Marshall McLuhan's affirmation

in *The Medium Is the Massage*: "The contained, the distinct, the separate—our Western legacy—are being replaced by the flowing, the unified, the fused."[19] Morris shared McLuhan's belief that cognitive processes were changing as a result of electronic technology, which rendered sense experience more fluid and intuitive.[20] Frustrating the expectations of the viewer by impeding a clear choice between different modes of perceiving and reasoning, Morris's *Threadwaste* juxtaposes materials with conspicuously contradictory physical qualities—the roughness and entanglement of the thread versus the smoothness and clear structure of the mirrors. Physical disjunctions thus give rise

Robert Morris, *Threadwaste*, 1968. Felt, asphalt, mirrors, wood, copper tubing, steel cable, and lead. Dimensions variable, approximately 21½ inches × 21 feet 11 inches × 16 feet 9 inches (54.6 × 668 × 510.5 cm). Gift of Philip Johnson. Copyright the Museum of Modern Art. Licensed by SCALA/Art Resource, NY. Copyright 2015 Robert Morris/Artist Rights Society (ARS), New York.

to perceptual ambivalence and make the viewer waver between states of focused attention and immersive distraction while attempting to decode the overlapping surfaces. The artist's large-scale mirror-based installations from the second half of the 1970s perpetuate his inquiry into competing perceptual stimuli and highlight the mediation of perception. These works frame a public art encounter, since they are composed of multiple large-scale reflective screens arranged diagonally at opposite ends. They engulf viewers, bringing them into a bewildering realm of mirror coordinates that disrupt the homogeneity of the perceptual field and relativize distance.[21]

Less interested than Morris in the critical examination of the specificity of the sculptural medium, Lucas Samaras similarly contributed to the shift from objecthood to environments. He created reflective works with contradictory qualities that instill doubt and fear but also lure spectators dangerously close to their surfaces. Whether small scale or large scale, covered by pointed tacks or so visually confusing that they become quasi-invisible, his sculptures engender disorientation and invite viewers to contemplate their inherent alterity. Just like Morris, Samaras straddled multiple stylistic approaches in his work. Left out of the *New Realism* exhibition of 1962, which would have qualified him as a pop artist, and sympathizing with minimalist sculptors, he remained somewhat of an outsider to clearly labeled tendencies of the 1960s. He was well known during this period for his razor-slit canvases and his pin-covered boxes, which suggest states of psychic enclosure as well as imminent outbursts of repressed feelings.

Mirrors constitute a persistent element in Samaras's practice. Before incorporating them in sculptures, he repeatedly referred to them in his writings, first in his notes for a happening in 1961, which was supposed to take place in a setting with a mirror wall and transparent chairs, and then in a 1963 short story titled "Killman," in which the protagonist has a cube-shaped bathroom fully covered in mirrors.[22] In 1964, he came across plastic mirrors while looking for materials for his boxes and became interested in the way he could use them to deform images. Samaras's experimentation with reflective surfaces mediated his departure from fully enclosed objects and catalyzed his interest in the design of enterable environments. He used mirrors in boxes composed of hinged partitions such as *Box #40* (1965), which often resemble half-open

books or empty photographic frames. The numerous tacks attached to their facets emphasize emptiness and impose distance, arousing sensations of optical and tactile vulnerability. These boxes are analogous both to defensive shields and to subversive instruments for temporarily capturing the images of others and bringing them into the artist's world.

Because of Samaras's complex exploration of reflections and his constant manipulation of his own image, his practice has frequently been interpreted in terms of narcissistic drives. In a catalog essay, Donald Kuspit describes Samaras as someone who has "mirror hunger" and contends that for Samaras "the self is not a social construction."[23] Nonetheless, in many cases the artist's works imply reflective processes expressive of a desire for sociability. In his writings, the mirror image is an impetus for creation or a trigger for reenchantment with reality that helps one to see things as if for the first time. For Samaras, self-reflections contribute to a perpetual redefinition of oneself in relation to multiple undiscovered others. Deeply aware of the human need for sociability, Samaras was concerned about his inability to entertain social relations in the 1960s. In his notes, he earnestly pleaded with himself to acquire self-confidence: "Samaras begin to have an affection for your body. Live in a house with mirrors. Man cannot live without people or his reflection. Samaras begin to love Samaras."[24] Narcissism was a mask for the artist's unrepentant dissatisfaction with his inability to consolidate social relations. His participation in happenings organized by Allan Kaprow, Claes Oldenburg, and Robert Whitman further confirmed his yearning for belonging to a community. Samaras explained that his engagement in these projects had partly to do with a feeling of "comradeship" toward other artists.[25] He disliked preestablished roles that did not leave any room for personal creativity. This may also be the reason he failed to enact the happenings he sketched out in the early 1960s. In terms of psychological theories of self-recognition, the artist's persistent yet unsatisfactory dialogue with his own reflections corresponds to psychologist Geneviève Boulanger-Balleyguier's theory concerning the social implications of mirroring acts:

> The mirror enables us to situate ourselves in the other's place and to observe ourselves from the other's point of view; hence, our interest

in reflections never weakens throughout life. However, the hiatus between this point of view of the Other and our self-perception can be so great that we refuse to recognize ourselves in the projected image.[26]

Intuiting that empathetic ties are mediated by acts of self-mirroring, Samaras rejected a conciliatory relation between his reflection and his self-perception. His unflinching decision to maintain the hiatus between the two is also observable at the level of his construction of mirror corridors and rooms that enhance the impression of unsurpassable distance between one's physical presence and one's virtual projection.

Beginning in 1963, Samaras created drawings of reflective environments that partly replicated the geometry of his earlier mirror box sculptures. The large-scale reflective containers he later designed based on them are not sealed off—they include openings that prevent complete immersion and maintain the gap between the reflective realm and the world situated outside its cajoling frame. Samaras's first mirror room dates back to 1966. Titled *Room No. 2*, it is his second environment and was designed for Pace Gallery in New York. Two years earlier, Samaras had transplanted the very contents of his living and working space into a room with fake walls in New York's Green Gallery. While his first environment reconfigured a personal space to which Samaras was closely attached, his second environment was highly abstract. *Room No. 2* creates the illusion of an infinite space that exists beyond three-dimensionality. Viewers are invited to step into a rectangular space covered in mirror panels both on the outside and on the inside. At the center of it stand the virtually camouflaged skeletons of a mirror table and chair, which serve as markers of a livable space and heighten the confusion between materiality and immateriality. Participants do not feel at ease in this environment. They find it difficult to focus on their endlessly multiplying self-reflections, which appear either too close or too far away to enable self-contemplation. Narcissistic impulses diminish as participants examine the impact of their movements on the fluctuating reflections by modifying their distance from the reflective walls. In his notes on *Room No. 2*, Samaras remarked: "Narcissism was there in this lonely crystalline space, but not to the degree it was expected. The geometry, the abstractness, the shafts and splinters of light

had the edge over the echoing bodies."[27] In a sense, the artist replicated his personal experience in front of the mirror, since he refused to accept his complete identification with his reflection for fear that this would imply a complete annihilation of the social or performative facet of his identity.

Samaras envisioned active spectators who would playfully manipulate their reflections. In discussing his plans for *Room No. 2*, he anticipated the performative actions the work would trigger and talked about multiple viewers engaging in constructing a half-real, half-virtual composition:

> I suppose people paint with their bodies when they enter the room; you know, they inspect themselves, "paint" themselves; they scribble. Then they go away and the scribble goes away too, so that they don't leave their marks. Kind of an instant erasure.[28]

Thus, Samaras foreshadowed the types of reactions triggered by responsive environments based on digital technology that require participants to manipulate their reflections or shadows to set images in motion.[29] Even though only two people at a time are allowed to enter *Room No. 2* when it is on display at the Albright-Knox Art Gallery (Buffalo, New York), the work's performative potential does not go unnoticed. In a text delineating the phenomenology of moving into its space, literary theorist Rosemary Geistorfer Feal explains how the integrity of the visitor's mirror reflection observable in the outer walls of the environment disappears upon her entrance into the mesmerizing reflective interior, which puzzles the senses and impedes self-recognition. Feal parallels the encounter with Samaras's work with "role playing, theatricality, staging and acting."[30] Her discourse often alternates between the singular and the plural as she delineates the intersubjective reflections triggered by the environment.

Whereas in Morris's sculptures the exterior edges of mirror panels are blatantly visible, in Samaras's environments one is submerged into an abysmal world in which spatial dimensions are so relativized that kinetic involvement becomes a vital means of regaining a sense of control. In 1967, Samaras constructed a tripartite mirror corridor that folds back on itself twice and plays upon the ambiguity between the virtual depth of the reflective field and the

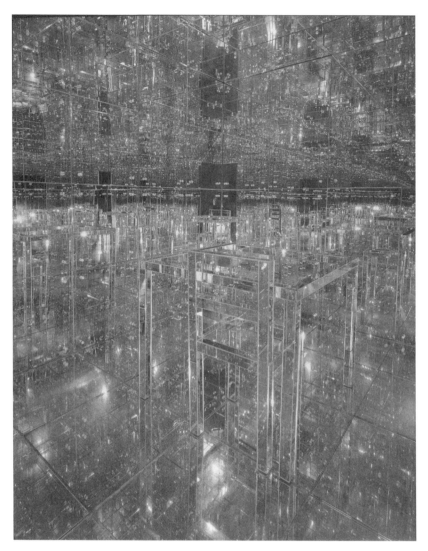

Lucas Samaras, *Room No. 2* (popularly known as the *Mirrored Room*), 1966. Mirror on wood, overall 96 × 96 × 120 inches (243.84 × 243.84 × 304.8 cm). Gift of Seymour H. Knox Jr., 1966. Albright-Knox Art Gallery. Copyright Lucas Samaras. Courtesy of Pace Gallery, Albright-Knox Art Gallery, and Art Resource, NY.

actual narrowness of the physical space. While the length and width of each passageway in the corridor are the same, the height varies. The ceiling gradually slopes down, forcing participants to bend in order to reach the end of the tunnel. Under these circumstances, the perception of virtual infinitude becomes claustrophobic, and visitors gain a heightened awareness of the scale of their bodies. In addition to disrupting orientation, *Corridor #1* (1967) subverts the notion of a private aesthetic experience. Participants are vulnerable not only to the incongruities of the reflective tunnel but also to the gaze and movements of others. In describing his experience of walking through one of Samaras's corridors in the late 1960s, Kim Levin remarked on its confining qualities: "When you look sideways, there is an endless row of yourself marching in step; another person in front or in back multiplies into another rank of marchers."[31] Inside Samaras's mirror passageways, visitors become conscious of the fact that they lack full control over their surroundings and the image of their bodies. A space that previously held out the promise of a private encounter with one's self-reflection turns out to subject the participant to a public performance.

Samaras's *Room 3* (1968), exhibited at *documenta 4*, goes one step further in disrupting contemplative experience. It violates the safe boundaries of the museum and aggressively discloses the myths of the autonomous art object and the private viewing experience. Both the exterior and the interior of this environment are paneled with mirrors, yet the illusion of infinite depth is dispelled because large mirror tacks violently pierce the floor, ceiling, and walls. Visitors can enter *Room 3* only through a small door. Once inside, they run the risk of hitting themselves against pointed shapes. They can more easily acquire a sense of orientation if they share the space with other people involved in charting the topology of the room. Unlike Yayoi Kusama's mirror rooms from the same period, Samaras's environments impede complete perceptual immersion and virtual self-obliteration.[32] They do not grant visitors the opportunity to enter into a world secluded from physical menace in which they can fully merge with their surroundings. Samaras maintains the hiatus between corporeal presence and optical projection. His mirror environments are never fully closed; the doors are always left open, constantly exposing the participants to the gaze of others.

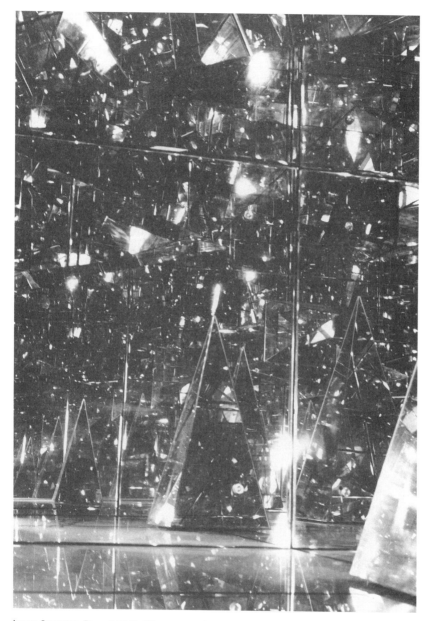

Lucas Samaras, *Room 3*, 1968. Mirrors, wood, 273 × 273 × 273 cm. Courtauld Institute of Art, London. Photograph copyright the Courtauld Institute of Art. Courtesy of Lucas Samaras, Pace Gallery, the Conway Library, and the Courtauld Institute of Art, London.

Larry Bell is another artist who started creating reflective sculptural objects in the 1960s and gradually acquired an interest in constructing environments with loose transparent boundaries. His metal-coated glass cubes situate the viewer simultaneously inside and outside the objects. Their subtly tinted surfaces act both as a physical barrier and as an invitation to an interpersonal optical and kinesthetic experience. Functioning as both objects and visual interfaces for observing others, the reflective cubes keep viewers on the edge between a contemplative and a participatory experience. Critics of the 1960s shied away from noting the way Bell's works expose the social environment of the aesthetic experience. They usually highlighted the relations between the individual beholder, the object, and the abstract museum environment, envisioning three perceptual possibilities: observing the exterior surface of the cube, observing one's self-image incorporated in the object, and observing the entropic interior void in which colorful reflections seem to acquire a material shape. Few critics of the 1960s actually indicated that the cubes could encapsulate the images of multiple viewers. For instance, Barbara Haskell noted that Bell's sculptures "are constantly changed by people passing back and forth, and fluctuations of light and shadow."[33] His translucent cubes dislocate the self-focused aesthetic experience. Their elusive visual qualities correspond to the transience of perceptual processes that always depend on the experiential context. His large-scale works from the second half of the 1960s reiterate the see-through qualities of the glass cubes. *Standing Walls* (1969), an environment made up of parallel gray and clear glass panels, was specifically built to frame a central corridor of the Walker Art Center in Minneapolis. Since the upper edges of the translucent walls are situated far above eye level, Bell's work stages a disorienting optical experience. In this transparent yet highly segmented environment, spectators acquire a better sense of orientation by taking note of each other's physical presence in relation to the nebulous wall structure.

As in the 1960s artists shifted spectators' attention from the restricted impermeable field of the sculptural work to the variable spatiotemporal coordinates of perception, they called into question the idea of the autonomous art viewer absorbed in aesthetic contemplation. In assessing transformations in sculptural practice, Barbara Rose remarked that even though it was increas-

ingly difficult to identify cohesive trends based on stylistic characteristics, one could note a clear turn toward a "new aesthetic" influenced by the use of reflective materials and a shift away from mimetic representation.[34] As we have seen in this section, the reflective environments of Morris, Samaras, and Bell transgressed stable subject–object relations and disclosed the social dimension of art experience. The following section will outline the correlations between the rise of the reflective aesthetic and the social movements of the 1960s.

The Mirror as Social Interface

Italian artist Michelangelo Pistoletto and American artist Joan Jonas employed reflective materials in the 1960s to call viewers' attention to the ways in which individual perception and value systems are shaped by interactions with others. This section discusses the social critique underlying the two artists' reflective art practices. Their use of mirrors as projection screens and props was simultaneously liberating and controlling, playful and cunning. It emphasized the complex relations between self and others and the interdependence of perception, representation, and power structures.

The social relations mapped by Jonas and Pistoletto are universal in character, but they also hold more specific meaning in the context of the 1960s, when grassroots movements exposed the contingent ties between social classes and between racial groups. Historians and theorists have warned against the utopian view that this decade represents a time of epochal changes that were enthusiastically welcomed and accepted by everyone. Fredric Jameson explains that while the sixties are currently associated with the liberation of the oppressed, the consequences of the decade's changes were not immediate, since "to speak is not necessarily to achieve a Hegelian recognition from the Other."[35] Pistoletto's and Jonas's mirror works obliquely reflect the proliferation of exchanges between previously sharply divided groups by laying the ground for empathetic connection to the roles of others. Through exposing the potentially interchangeable positions of individuals within the social framework, they destabilize the rhetoric of the self-centered gaze that subjugates others.

Pistoletto's art practice has been closely identified with mirroring processes. In addition to using reflective surfaces such as gold and silver flat planes of color, polished steel panels, and aluminum plates, the artist has organized collective performative projects that encourage participants to improvise and ponder the effects of their actions on others. He has framed spectatorial conditions that stimulate viewers to consider their relation to more than one protagonist, object, or type of representation, hence breaking the subject–object parallelism and drawing attention to the social dimension of perceptual acts.

Pistoletto first employed the mirror as an auxiliary device that enabled him to depict self-portraits devoid of the raw subjectivity and spontaneity of *art informel*, the prevailing style in Italy during the late 1950s and early 1960s. Reflective surfaces constituted for him ideal epistemological tools in his attempt to retrieve a sense of absolute veracity. Despite this search for objectivity, Pistoletto did not concentrate on depicting himself as a fixed subject apparently suspended from the flow of time. Instead, he focused on the shifting parameters of his reflection on selfhood, maintaining that "the true protagonist [of the self-portraits] was the relationship of instantaneousness which was created between the spectator, his own reflection, and the painted figure."[36] In order to highlight this fleeting character of the definition of self-identity, Pistoletto painted life-size self-portraits against reflective backgrounds that would instantaneously capture his silhouette while he was painting and also capture the reflections of the viewers when the work was on display. He was not as interested in the accuracy of figurative details as he was in the feeling of presence conveyed by the portrait. The invitation to mirror others inherent in each and every one of us is even more literally presented in Pistoletto's diptych paintings such as *Silver Self-Portrait* (1960), which includes one panel that represents the artist and another fully covered in a coat of flat silver paint that temporarily captures museum visitors' reflections. Pistoletto's decision to display these self-portraits without frames, casually reclined against gallery walls, emphasized their immediacy and undermined the distanciation between the viewer and the art object.

While Pistoletto's self-portraits stimulated primarily dialectical modes of self-definition, his art practice in the 1960s gradually came to encompass more complex interpersonal relations. The works in his series *Mirror Paintings*

(since 1962) illustrate his transition from a focus on dyadic forms of identity formation to an interest in the social construction of selfhood. Starting in 1962, Pistoletto attached cutout silhouettes drawn on semitransparent paper to the surface of large steel plates. Many of these oil and crayon sketches were based on photographs taken by his friend Paolo Bressano. Pistoletto enlarged

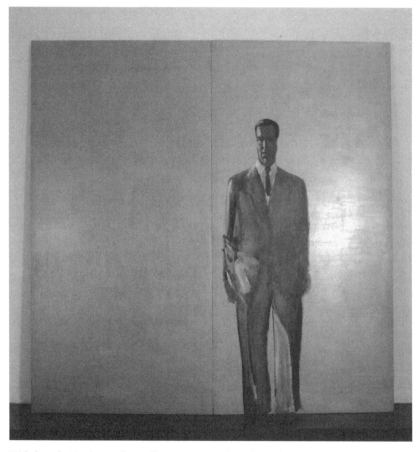

Michelangelo Pistoletto, *Silver Self-Portrait*, 1960. Oil, acrylic, and silver on wood, two elements, 200 × 200 cm. Photograph by Paolo Pellion. Courtesy of Collezione Fondazione Pistoletto, Biella.

the pictures to life-size scale and copied parts of them onto thin paper, frequently obliterating details that would emphasize the individuality of the photographed figures. The roles assigned to the silhouettes are often ambiguous because their faces are hidden or not fully contoured. Consequently, viewers need to consider multiple interpretations. At least five categories of scenarios are exemplified by the protagonists of these compositions: solitary acts of reflection, everyday acts or mundane encounters between people, acts of viewing that range from voyeuristic contemplation to aesthetic immersion, political demonstrations, and creative acts such as drawing, dancing, or taking photographs. By superimposing these scenes on the reflective screens, Pistoletto framed a quasi-narrative context for the interpretation of the fluctuating mirror images of spectators.

The *Mirror Paintings* have frequently been interpreted in terms of the viewer's intrapersonal reflection on his or her role in the composition or in terms of the viewer's interpersonal ties with the sketched figures. Rarely have these works been considered in terms of the virtual relations drawn between viewers incidentally introduced to each other via the mirror interface. This is surprising, given Pistoletto's clear support of participatory spectatorship. He considers that art can be conceptualized in terms of communicative acts through which viewers discover correlations between their experience and the experience of others. Pistoletto has stated that the "meta-message" of art is *"there is community between us."*[37] According to him, our interest in artworks does not arise simply from our seeking sensory pleasure or our need to satisfy a desire for knowledge; rather, it is an outcome of our need for communion with others.

Several of the works in the *Mirror Paintings* series directly address the public conditions of spectatorship inside museums by encouraging viewers to define themselves both in relation to the static silhouettes populating the virtual realm of the reflective screens and in relation to other beholders with whom they share the gallery space. *The Visitors* (1962–68) is a diptych that juxtaposes the silhouette of a fashionably dressed woman, who seems to have abruptly come to a stop in front of an artwork, with that of a middle-aged man absorbed in examining what could be a gallery checklist. In slight *contrapposto*, the two figures appear to be aware of each other's presence yet re-

luctant to face each other, as if they can communicate only via the art object that has captured their interest. Against the background of the galleries, this *mise en abyme* representation stages an encounter between museum visitors who vacillate between the roles of subjects and objects of perception. They could be witnesses to the depicted scene, or they could be the focus of attention of the painting protagonists and other gallery visitors contemplating the work. This web of real and imaginary interpersonal relations highlights the social construction of selfhood. In *Phenomenology of Perception*, Merleau-Ponty argues that in order to avoid solipsism and maintain a sense of ethical responsibility, we must reflect on how our personal actions affect others: "We must therefore rediscover, after the natural world, the social world, not as an object or sum of objects, but as a permanent field or dimension of existence: I may well turn away from it, but not cease to be situated relatively to it."[38] The improvised performative situations proposed by the *Mirror Paintings* hinder binary forms of identification. They keep spectators alert to the multiple analogies between themselves and others.

Although the characters that populate the virtual realm of Pistoletto's series are anonymous, their identities are not completely concealed, since their poses, clothes, and activities betray their social conditions. The reflective screen is far from constituting a neutral sociocultural ground. The works displayed by Pistoletto at the Walker Art Center in 1966 more clearly suggested this by inscribing visitors' reflections in the midst of protesters. *Vietnam* and *No to the increase of the tram fare* (1965) asked viewers to consider their potential role in antiwar manifestations and socialist rallies. Depending on their solidarity with or opposition to the marching silhouettes' cause, viewers could insert their images in the reflective field or avoid its contingent frame by contemplating the scene from an oblique angle. Either way, they could not remain innocent onlookers. Claire Gilman adroitly argues that Pistoletto's *Mirror Paintings* propose engaged modes of viewing that depart from the passivity inherent in the society of the spectacle. She also notes that the reflective panels invoke "the belief in a world inhabited by free subjects."[39]

Yet viewers' relations to the *Mirror Paintings* are far from completely liberating. The works underline the fact that individuals are never fully autonomous from power structures, just as reflections are never independent from

the display context of mirrors. These works support Pistoletto's claim that "being free doesn't mean escaping your role. The freedom is finding your own role; because if someone assigns you a role, then you are a victim."[40] *Vietnam* and *No to the increase of the tram fare* summon the viewer to adopt a position in relation to the demonstrations rather than simply remain on the threshold

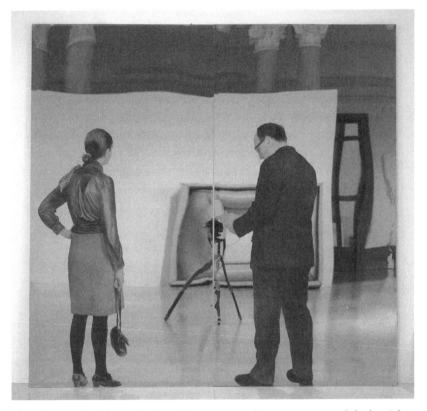

Michelangelo Pistoletto, *The Visitors*, 1962–68. Painted tissue paper on polished stainless steel, two elements, 230 × 120 cm each. Photograph by Giuseppe Schiavinotto. Courtesy of Collezione Fondazione Pistoletto, Biella, and GNAM—Galleria Nazionale d'Arte Moderna e Contemporanea, Roma. Reprinted by permission of Ministero dei Beni delle Attività Culturali e del Turismo.

between reality and virtuality. It is only by actively negotiating one's role that one can gain a greater degree of freedom, according to Pistoletto. Equally troubled by the compliant fulfillment of assigned social roles during the 1960s, psychiatrist R. D. Laing argued that individuals need to embrace the ambiguity of interpersonal relations in order to become more adept at defining who they are in relation to social systems whose influence on individual behavior and thinking cannot be ignored. Troubled by the ongoing Vietnam War and the impossibility of erasing the effects of colonialism, he decried the fact that, "having at one and the same time lost our *selves* and developed the illusion that we are autonomous *egos*, we are expected to comply by inner

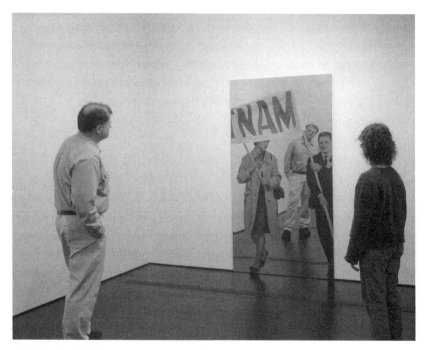

Michelangelo Pistoletto, *Vietnam*, 1965. Graphite and oil on paper mounted on stainless steel, 220 × 120 × 2.2 cm. The Menil Collection. Photograph by George Hixson. Courtesy of Collezione Fondazione Pistoletto, Biella, and The Menil Collection, Houston.

consent with external constraints, to an almost unbelievable extent."[41] The mirror frames of Pistoletto's works confronted viewers with the illusionism of autonomy by exposing them to the rigidity of visual structures that come to engulf their images just as social and political systems can absorb individuals in their midst. Movement in relation to the reflective surfaces and the silhouettes of rebelling protagonists acting in the virtual space of *Vietnam* and *No to the increase of the tram fare* became key to alerting viewers to the critical positions they can adopt even when the range of choices appears limited.

Beginning in 1967, Pistoletto's practice took a turn toward increasingly performative projects that further dissolved the distinctions between the artist as individual creator and audience members as passive spectators. Nonetheless, reflective processes remained a defining parameter of his work. In events such as *Pistoletto's End* (1967) and *Who Are You?* (1970), performers manipulated thin reflective plates to capture blurry images of the audience and produce improvised acoustic effects. The artist also invited spectators to invent roles for themselves. In 1968, he transformed the Galleria Attico in Rome into a film set subdivided into a small dark area where participants could try on costumes from the Cinecittà Studio and a large area where they could adopt performative roles and interact with each other in front of a large mirror.

By creating theatrical contexts, Pistoletto hoped to stimulate interpersonal exchanges and subvert the increased attachment of individuals to material possessions. In 1968, he founded the Zoo collective with playwright Carlo Colnaghi.[42] The group, whose members came from multiple artistic domains, improvised theatrical acts in various contexts and sought to become temporarily integrated within the village of Corniglia, where they spent about four months staging plays and helping with everyday tasks. At a time of great economic instability and social protests, the Zoo events exposed the incongruities between ideal conceptions of harmonious societies and actual struggles to restore social balance. They parodically replicated the stratification of society and presented a strikingly realistic picture of how political systems are enforced.[43] Germano Celant compared the Zoo collective to a tribe that strove to maintain its inner diversity in order to give spectators the chance to identify with its members at multiple levels. He contended that only in this way could the members "provide a sort of mirror for the audience that perceived

them."[44] The heterogeneity of the group was indeed a vital factor for enhancing creativity and enabling spectators to empathize with the performative acts. In spite of being keen on reducing the distance between the audience and the collective, Pistoletto was skeptical of fully erasing the boundaries between the two groups, as this would abolish the possibility of attaining a critical perspective. He avoided using the term *performance* to describe the Zoo's activities, since he envisioned them as social events that departed from a fixed score and inspired dialogue on sociopolitical conditions.[45]

Similarly, Joan Jonas rejected the notion of performance because she considered it unsuitable for describing the improvisational aspects of the events she staged. She preferred to call her performative works "pieces," arguing that they more closely resembled musical compositions. Not only do Pistoletto and Jonas share similar approaches to the concept of performance, but they also espouse a similar aesthetic. They both make extensive use of reflective surfaces and challenge viewers and performers to become engaged in impromptu communicative acts. Although their use of mirrors may bring to mind narcissistic acts, Pistoletto and Jonas interrogate such modes of self-focused spectatorship. They ask viewers to perceive themselves not as isolated individuals watching a performance onstage and empathizing with their favorite characters but as members of collectivities faced with perceptual and behavioral constraints that obliquely parallel potentially tense social circumstances.

Jonas's art practice has been inspired by a highly diverse range of artistic and cultural practices, including Beat generation poetry, Haitian sand painting, Greek folk rituals, Kabuki theater, and Judson Church dance. In her early performative pieces, the mirror served both as a symbolic object that granted participants access to a mystical world and as a cinematic device that disclosed the mediation of representation by capturing fragmentary reflections of body images. In *Oad Lau* (1968), a work inspired by Cretan wedding rituals, Jonas attached small rectangular mirrors to the clothes of a man and a woman slowly moving in unison as a group of spectators watched them from a distance.[46] The reflections projecting across the bodies of the performers vividly suggested an emotionally charged nonverbal dialogue between the couple and the audience witnessing their union. In describing *Oad Lau*, Jonas

mentioned that the piece gave one the chance "to see one's self as other," as well as to see oneself "among, as one with, the others."[47] Enchanted with the open-ended character of processes of self-definition in relation to others, the artist whimsically used mirrors to stimulate subtle exchanges between performers and observers and enhance their understanding of their inter-dependent roles. Douglas Crimp has expressed his admiration for Jonas's adroit enactment of performative acts that showcased the relativity of perception. He argues that at first her works received limited critical responses because they foreshadowed a departure from self-centered performances and exposed the fragmentariness of identity: "There is no centered self from which the work can be said to be generated or by which it can be received. Both the performer and spectator are shown to be decentered, split."[48] While Crimp rightly identifies the decentering of subjectivity as a major coordinate of Jonas's practice, this is hardly the only reason her works were initially disregarded. Like many other women artists in the late 1960s, Jonas faced significant challenges due to a lack of institutional support and the fairly limited critical coverage of performative art practices.

Jonas's *Mirror Piece I* (1969) and *Mirror Piece II* (1970) hinted at the tension between different social and gender groups by undermining the power of the objectifying gaze and the hierarchical relations between individuals. These works generated an indirect dialogue between dancers and spectators through the medium of mirror images. *Mirror Piece I* was staged both outdoors and indoors. It involved a group of fifteen women and two men who performed simple choreographic movements while using oblong mirror panels as props. At the beginning of the piece, the women faced the spectators while holding the mirrors parallel to their bodies. Their movements followed simple geometric patterns. From time to time, the two men disrupted the coordination between the women as they made their movements by lifting them up as if they were inanimate mannequins and taking them away from the group to another area of the performance perimeter. It appeared that just as the mirrors constituted props for the women, the female bodies were at times props for the men's choreography. The heavy reflective screens could represent the judging eyes of the patriarchal society, given the long history of prejudices against women. Paradoxically, they could also represent

an invincible armor that subdued the objectifying gaze by redirecting it to the audience via the mirror images. These ambivalent qualities of the screens indirectly pointed to the tense threshold between women's public and private lives. As the performance approached its end, all the women lay on the floor, screening their bodies with the mirrors. They appeared absorbed in mental reflection after having indefinitely suspended the game of visual reflection.

Mirror Piece I also entailed ritualistic elements associated with the cycle of life and death, the mirrors acting alternatively as symbols of presence and as symbols of absence and loss. As performers carried the reflective surfaces,

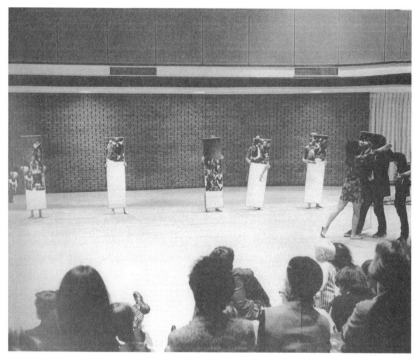

Joan Jonas, *Mirror Piece I*, 1969. Performance, Loeb Student Center at New York University, New York. Photograph by Wayne Hollingworth. Courtesy of Joan Jonas and Gavin Brown's Enterprise.

they rhythmically constructed and deconstructed representations of the people and space around them. Their manipulation of the mirrors exemplified the ebb and flow of consciousness, which, according to philosopher Alva Noë, is not a process contingent only on the workings of the brain but "something that we do" because we "enact it, with the world's help, in our dynamic living activities."[49] By shifting the angle of the reflective panels to conceal or reveal images of their surroundings, the performers showed how individuals are constantly involved in building the experience of the present by focusing their attention on different parts of the perceptual field or by bringing into awareness memories of the past. *Mirror Piece I* vividly conveyed the active construction of experience, highlighting its dependence on our interaction with others and the space we inhabit.

Mirror Piece II framed a similar phenomenological inquiry into the enactment of perception and interpersonal awareness. At the end of the 1960s, when the dynamic character of processes of self-definition in relation to others became more evident than ever against the background of activist groups' uprisings, this work captured the shifting equilibrium of power relations within society. Art critic Bruce Ferguson provides an insightful analysis of the rhetoric of the gaze in *Mirror Piece II* in relation to gender issues. He identifies the mirror images of Robert Smithson and Richard Serra in a photograph of the piece and remarks that the position of the two male artists in the art world was virtually decentered as it became subordinated to the mirror interface: "They are made mute, no longer in the underinterrogated 'discursive fellowship' of men speaking."[50] Yet the relation between men and women, as well as between performers and spectators, departed from a binary model of interaction. There was no autocratic performative subject, and there was no ideal individual viewer.

Performers and spectators contemplated their limited autonomy as they witnessed the subordination of their body images to intercorrelated gazes and movements. Like Pistoletto, who left out individuating details when transferring photographic images to steel plates in *Mirror Paintings*, Jonas eschewed individuating choreographic gestures by instructing performers to minimize self-expression. By subduing distinctive features, she undermined hierarchical relations within the performative group. These limitations placed on the

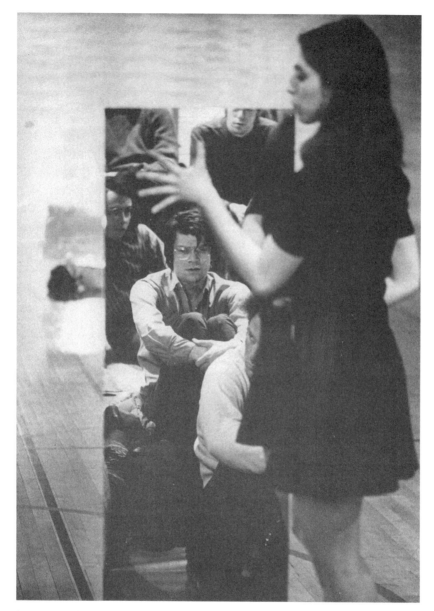

Joan Jonas, *Mirror Piece II*, 1970. Performance, Emanu-El YMHA, New York. Photograph by Peter Moore. Photograph copyright Barbara Moore. Licensed by VAGA, New York, NY. Courtesy of Joan Jonas and Gavin Brown's Enterprise.

performers' externalization of feelings made it impossible for viewers to peer into the performers' inner worlds, despite their being able to see via the reflective interfaces approximate images of what the performers could perceive from the stage. Therefore, it was evident that the audience members were constrained to project themselves intuitively into the dancers' roles without actually being able to break through the mirror panels the performers carried in front of their bodies or permeate the screens of their consciousness to gain a sense of their experience. While virtually framing the nebulous realm of intersubjective inferences made by spectators as they watched the moving field of reflections, both *Mirror Piece I* and *Mirror Piece II* also hinted at the dead ends of the communication of experience. Pondering the phenomenological underpinnings of intersubjective theories, psychiatrist M. Guy Thompson explains that one cannot fully sense the experience of someone else, despite intersubjective exchanges and shared sensations:

> This feature of phenomenology (that the object of experience can never be decisively separated from the subject who experiences it) is both intentional and intersubjective, because my experience of the other is always unremittingly mine, with all its attendant ambiguity and baggage.[51]

The slippery quality of the reflections contrasted with the fairly slow motion of the performers carrying the mirror panels and provided a vivid sense of the inevitable asymmetrical relations between the experiences of individuals engaged in this open-ended thread of interpersonal projections.

In addition to mirrors, performers in *Mirror Piece II* manipulated transparent glass panels. Pairs of men and women strove to maintain these screens in balance. Some pairs of performers rolled on the floor while keeping a glass panel between their bodies; others held a panel at an angle while pushing against each side of its surface. It was relatively unclear whether these transparent interfaces represented structures of support that needed to be stabilized or unbreakable barriers between people. Irrespective of their exact symbolic function, they were suggestive of the precarious balance of society at the end of the 1960s.

Mirror Piece I and *Mirror Piece II* concomitantly stimulated viewers to see

themselves seeing and observe others through the medium of reflective screens. Acting as interfaces, the mirrors catalyzed interpersonal relations by drawing audience members' attention to the constant restructuring of interactions between individuals and collectivities. Just as in the case of the Zoo events, Jonas's pieces maintained the distance between performers and spectators to facilitate the observation of interdependent social relations. Discussing the reflective processes framed by *Mirror Piece II*, J. L. Dronsfield suggests that even though spectators appeared to become part of the performance thanks to the mirror reflections, they remained in an inferior, passive position: "The audience is not made more active in seeing itself in this way, on the contrary it is powerless to do anything about it, for to look away would be not to see something essential about the piece."[52] However, it is arguable that just as the spectators were in a "powerless" state, the performers were highly empowered subjects. The viewers may have had no control over their mirror images, which depended on the movements of the performers, but the performers could not fully control the images either, since they were not able to observe the visual field encompassed in the reflections while holding the mirrors in front of their bodies. In addition to this, the heavy weight of the mirrors somewhat impeded the fluidity of their gestures. Jonas confessed that she capitalized on the feeling of anxiety catalyzed by the burdensome yet apparently fragile mirror props in order to underscore the interdependence between performers and spectators: "I was never afraid that we were going to break a mirror, but the audience was. And I liked that tension."[53] The artist's statement betrays the empathetic connections established between participants. As spectators watched the performers manipulate the heavy screens, their mirror neurons activated and they virtually sensed the movements of the performers struggling to maintain the balance of the props. Ultimately, the freedom of both performers and spectators was conditioned by their mutual observation and the mirror interfaces, which were subtly connotative of overarching social structures that limit individual autonomy.

Jonas's *Mirror Pieces* did not simply provide a one-way communication channel between the performers and the audience. They evoked the interpersonal construction of identity based on social exchanges. In *Interpersonal Perception* (1966), R. D. Laing and his colleagues contend that "self-identity

('I' looking at 'me') is constituted not only by our looking at ourselves, but also by our looking at others looking at us and our reconstitution and alternation of these views of the others about us."[54] The lack of coincidence between what the performers saw and what the spectators observed paralleled the incongruities between the way individuals perceive themselves and the way they are perceived by others. The fragmentation of the visual field through the interposition of the vertical mirrors enhanced the jarring impression of disjunction between perception and representation. By setting the reflective panels at an angle, performers emphasized the virtual depth of the image and the collective dimension of the spectatorial act. Alternatively, by setting them parallel to the audience, they divided the visual field more abruptly and singled out individual viewers. The aggressive segmentation of the visual field was counterbalanced by the tender gestures of the performers, who occasionally caressed the reflections captured by the mirror screens. These actions heightened affective alliances between the two groups while simultaneously underlining the frustrating distance between them.

Both Jonas and Pistoletto employed mirrors in their works to engage viewers in dynamic reflective processes that showed the irresolute disjunctions between self and other and the social construction of identity. These artists repeatedly called for a critical interrogation of power structures and a deeper consideration of personal roles within society by enacting situations in which individuals could see themselves from a third-point perspective through reflective interfaces. In the next section, I will consider how other artists relied on technological media to trigger similar departures from self-focused modes of art perception and enhanced understanding of the complex systems in which individuals are actively engaged on a daily basis.

Mirroring Others: Collective Encounters with Art and Technology Projects

Art and technology projects represent the category of reflective works from the 1960s that best illustrates the marked shift from private to public aesthetic experience. This section provides insight into the collaborative production and reception of these works. It examines the mirroring processes of open-ended cybernetic systems construed by artists in the context of *The*

Magic Theater exhibition at the Nelson Gallery of Art and the Atkins Museum in Kansas City, Missouri (1968), the LACMA Art and Technology program (1967–71), and the Pepsi Pavilion designed by E.A.T. for the Osaka Expo (1970).

In the aftermath of the atomic bombings of Nagasaki and Hiroshima in 1945, views on the impacts of technology on civilization were grim. Art emerged as one of the possible means of rehumanizing technology. In Germany, artists Otto Piene and Heinz Mack denounced the idea that scientific experimentation was solely to blame for militarism and wanted to inspire a more positive outlook on the role of technology. With this aim, they founded Group Zero in Düsseldorf in 1957 and invited exhibition visitors to transform their surroundings creatively by manipulating light beams and inflatable objects. In the late 1950s, Piene organized art events at which participants projected light through stencil screens to produce evanescent visual patterns on gallery walls. The artist described the therapeutic role of these collective encounters via the medium of technology as follows:

> The solo turned into a group performance. . . . Feelings of tranquility, suspension of normal balance and an increased sensation of space were reactions that viewers volunteered to me after finding themselves in the center of the event.[55]

Piene hoped that by encouraging viewers to experiment with light and space variables in public settings, he could enable them to grasp the creative potential of technology use.

The public character of the aesthetic experience was also important for Groupe de Recherche d'Art Visuel, or GRAV, an art group active in France from 1960 to 1968, which staged outdoor environments in order to generate spontaneous participation. The group aimed to disrupt quotidian urban activities by asking passersby to enter mazelike structures and generate luminescent effects through their movements. For GRAV members, technology represented a means of annihilating the barriers between art objects and viewers and challenging the elitism of modern art. Among their stated goals, they listed the liberation of the public "from inhibitions and warping of appreciation produced by traditional aestheticism, by creating a new social-artistic

situation."[56] Members of many other art groups active in Europe at this time (e.g., Group N, Group T, Equipo 57) shared similar objectives and invited viewers to interact with objects and environments of seemingly or actually variable shapes and colors that depended on their movements. These groups often exhibited together under the umbrella name Nouvelle Tendance. Most members of the groups were critical of the cult of individual artistic genius and believed that viewers can become active partners in the artistic act. Defining their art practice in opposition to creative acts based on subjective self-expression, Nouvelle Tendance artists often built works out of translucent materials in the hope that the works' anonymous character would entice viewers to consider their personal expressive potential in relation to art.[57]

Similarly, numerous artists in the United States took an interest in creating works that were completed or transformed through viewers' participation. Their goal of taming technology often intertwined with that of giving beholders more opportunities for self-expression and creative responses. In the 1960s, American artists such as Robert Rauschenberg and James Turrell sought the advice of engineers and scientists in order to fulfill challenging projects. The more they became engaged in these collaborative experimental ventures, the more they were inclined to design large-scale works and consider correlations between art participants' responses. This tendency toward increasingly public and interactive works coincided with the popularization of ideas concerning group creativity and interpersonal psychology. For example, Alex Osborn claimed that brainstorming activities conducted in groups are more productive than individual brainstorming, and R. D. Laing established a methodology for the analysis of interpersonal communication.[58]

In the United States, museums commissioned art and technology projects for group exhibitions that supported the design of artworks that could be completed only with the support of industrial companies. Art museums such as LACMA established collaborative programs that put artists directly in contact with centers of technological research and production in order to explore new ideas for art projects. Moreover, groups and organizations such as Pulsa and E.A.T. bridged the gaps between disciplines by bringing together members with different professional backgrounds interested in sharing expertise to create technology-based artworks. Many of the artists designing art

and technology projects within these collaborative frameworks used transparent materials in order to demystify technology by openly exhibiting the hardware that was integral to their works. Transparent media such as glass and Plexiglas were also preferred because their nonconductive properties ensured safe encounters with electronic circuits. Moreover, artists cherished the impersonal character of these materials at a time when the overpowering subjectivity characteristic of styles such as abstract expressionism and *art informel* was being challenged.

Art and technology projects did not catalyze mirroring acts only as a result of the reflective qualities of their physical components, however. Interactive environments based on photosensitive cells generated interpersonal observation and even collaboration between viewers who mirrored each other's gestures while modeling the output of the cybernetic systems through kinetic engagement. This process of behavioral attunement in relation to technological interfaces and variable social circumstances heightened participants' awareness of belonging to complex cybernetic systems that were not controlled solely by technological apparatuses or individual human agents. Writing in the 1960s on the crossovers between art and cybernetics, Jack Burnham suggested that artists were going to "deal less and less with artifacts contrived for formal value, and increasingly with men enmeshed *with* and *within* responsive systems."[59] He believed that art practices that integrate viewers into technology-based systems responsive to their behavior prepare the participants to come to terms with the idea that biological and nonbiological complexes are interdependent and evolve in tight correlation with one another. However, not all art critics were comfortable with the notion that technological variables could play a role in the shaping of aesthetic experience. Insightfully comparing the theatricality of sculpture with that of kinetic and light art, Rosalind Krauss remarked how responses to these works could differ significantly despite their similar capacity to emphasize fluctuating relations between the viewer and the artwork. She suggested that multiple media could generate reflection on the shifting notion of selfhood, yet viewers would be less inclined to come to terms with the limits of subjectivity and objective knowledge when these challenges are exposed in relation to objects and environments that are not handcrafted or imply analogies between humans and ordinary items or

machines. Comparing responses to Auguste Rodin's sculptures to reactions to Claes Oldenburg's soft sculptures, Krauss observed:

> One feels a certain terror if one thinks of the self as constructed *in* experience rather than prior to it. Terror because some notions of control have to be given up, because some certainties about the source or functions of knowledge have to be shifted or restructured. Yet the optimism in Rodin's work stems from the fact that, after all, the experience shaping the gestures is still human.[60]

To Krauss, the theatricality of machines or soft sculptures such as those conceived by Oldenburg was indisputably different from that of figurative modern sculpture, which invited empathetic attunement to the shifting consciousness of the artist or the variable qualities of the object of representation rather than prompted a confrontation between viewers and the agency of programmable machines or objects with anthropomorphic qualities. Krauss adopted a reserved attitude toward technology-based artworks because she felt that they often replicated theatrical conventions, with the sole difference that the machine was turned into the actor playing the most important role. She overlooked the variability of responsive environments that called on spectators to participate collectively in the shaping of cybernetic systems. In such contexts, neither the machine nor the viewer would become an autonomous protagonist of a seemingly scripted theatrical scenario.

Although museum visitors inadvertently became part of a public collective body upon stepping into interactive environments, most art critics in the 1960s were reluctant to discuss the reception of these works in terms of group behavior. As I will shortly show, many of them failed to recognize that participants could in fact collaboratively alter certain art and technology projects. By concentrating solely on individual interaction with such works, critics concluded that the individual viewer was increasingly subordinated to the technological apparatus, which strictly limited the viewer's behavior. I argue that the critical reception of these works needed to take into account the interpersonal dimension of the aesthetic experience and the diverse array of participatory responses that infiltrated and shaped the cybernetic systems proposed by the artists.

The Magic Theater, an exhibition organized by curator Ralph T. Coe at the Nelson Gallery of Art and the Atkins Museum (now the Nelson-Atkins Museum of Art) in 1968, posed serious challenges to art critics, not only because of the technological nature of most of the works on display but also because of viewers' convivial participation, which impeded private aesthetic contemplation and made the aesthetic qualities of the works appear secondary to the behavioral impulses they inspired. Visitors' lively interaction and astounding performative acts also put the curator in a somewhat difficult situation, since he had primarily intended to curate an exhibition that encouraged viewers to contemplate their inner experience. His decision to publish an extensive exhibition catalog two years after the opening was most likely motivated by his interest in discussing the puzzling reception of the show.[61]

A strong believer in the notion that art can offer alternatives to the accelerated tempo of modern lives and the materialistic values permeating American society, Coe aimed to organize exhibitions that would channel viewers' attention to psychic experience. He suggested that in the second half of the 1960s, "the end of art is no longer visual. The end of the voyage lies in the brain."[62] *The Magic Theater* was inspired by his desire to counteract psychedelic media-saturated experiences by offering art viewers the chance to reflect on perceptual and mental acts.[63] Coe also saw the show as an opportunity to fund the design of artworks that could not be completed without large financial resources. He persuaded local manufacturing companies to donate materials for the works and got members of local communities involved in the construction of some of the environments.

The works in *The Magic Theater* invited viewers to become engaged in mirroring processes, be they actual acts of self-reflection in translucent screens, performative acts in environments that provided acoustic feedback to participants' movements, or acts of behavioral attunement among exhibition visitors who watched each other's actions in order to adjust to bewildering spaces. All of the artists Coe invited to take part in the exhibition designed works that disrupted mundane perceptual and communicative conditions: Chuck Ross created a zigzagging screen of prisms that challenged visitors to contemplate the exhibition space from multiple vantage points; Terry Riley created a hexagonal glass pavilion titled *Time-Lag Accumulator,* which invited participants to communicate with each other across glass walls via asynchronous acoustic

recordings; Stephen Antonakos designed a stage with a transparent glass floor through which visitors could contemplate a web of colorful neon tubes; Stanley Landsman constructed a plywood box lined with mirrors and hundreds of small lightbulbs that was supposed to serve as a metaphor for the infinite possibilities of the human mind; James Seawright built a cybernetic installation that responded to participants' movements; Robert Whitman introduced visitors to a theatrical setting in which they could gaze at their distorted reflections in vibrating Mylar screens deformed by sound oscillations; Boyd Mefferd built a bewildering environment out of strobe lights that fired intermittently; and Howard Jones devised a sonic room in which participants could activate sounds by projecting their shadows over photoelectric cells. Although virtually all the works in *The Magic Theater* prompted modes of interpersonal spectatorship, I will concentrate here on the reception of the technology-based environments that triggered the most convivial responses, showing how the works of James Seawright, Howard Jones, and Boyd Mefferd intertwined social and technological networks.

Seawright's *Electronic Peristyle* emulated the interaction between the body, the mind, and the environment by involving participants in modifying the acoustic output of a cybernetic system through their movements. A transparent sphere sheltering electronic circuits had the role of an artificial brain that transmitted and received information from twelve black Formica columns surrounding it. Seawright made the technological components visible in order to encourage participants to approach the central sphere and interfere with its operations. By moving around the electronic brain, visitors could break a series of light beams that linked the central unit to the columns through a set of lamps and mirrors. As the beams were interrupted, the intensity of the low-frequency sound continuously emitted by the columns was enhanced. *Electronic Peristyle* was programmed in such a way that it could follow a cyclic mode, which could be modified by visitors' interaction with the light beams, or a continuous mode, which triggered sound variations even if visitors did not approach the work.

Some art critics considered the operations of Seawright's work too complex to allow viewers to understand the exact impact they had on its functioning. Curator and art critic Jane Livingston argued that *Electronic Peristyle*

set up a highly mediated experience that impeded intuitive interaction: "The spectator was supposed to move around between brain and receivers, thereby interrupting the circuitry and—though this was unclear to me—himself 'controlling' the sequentially programmed bombardments of sound (beeps and blips), air and blinking light."[64] By thinking about the spectator in the singular rather than considering the collective dimension of the spectatorial experience, Livingston did not account for the fact that visitors learned how to predict the type of acoustic output they could trigger by watching others interact with the electronic device. Unlike Livingston, who doubted the participants' ability to model the cybernetic system in a conscious manner, art critic Stephen Bann explained that the complex operations of *Electronic Peristyle* could be best grasped at an interpersonal level:

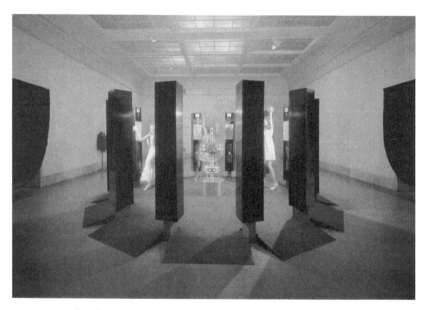

James Seawright, *Electronic Peristyle*, 1968. Twelve black Formica-covered columns surround a control center in an acrylic globe. When the movements of visitors break the electrical beams between the electronic brain in the center and the surrounding columns, light, sound, and wind are produced. Courtesy of the Nelson-Atkins Museum of Art, Kansas City.

In this case, the interaction between the spectator and the work implies committed reflection as it is not easy to identify the relation between cause and effect. In order to identify the process, one would need without doubt to observe with great attention his/her own movements and those of other assistants.[65]

Actually, the complexity of this responsive artwork did not subsist merely in its electronic components. It was characteristic of the entire open-ended cybernetic system composed of a variable technological interface and a variable audience that could include multiple participants simultaneously interacting with the light beams. The difficulty that individual viewers experienced in identifying the precise correlations between their specific movements and altered sounds pointed to the indeterminacy inherent in complex systems. By watching others interact with the electronic brain, participants could better intuit how they could collectively influence the work even though they could not be in full control of its operations. Far from underscoring perfectly parallel mirroring processes between the viewer and the object, *Electronic Peristyle* often highlighted inconsistencies between the individual viewer's movement and the expected response from the electronic brain, as well as between the behavioral acts of coparticipants in the interactive experience. In *Man's Rage for Chaos* (1965), a book focusing on the relations among biology, behavior, and art, Morse Peckham argued that while the perception of art in the modern period tended to be mostly associated with an orderly situation with rigorously established rules, encounters with art increasingly implied more variable parameters, encouraging viewers to understand their relation to art in terms of role-playing and adaptable behavior, as "generally speaking, perceivers learn from other perceivers, both consciously by precept and unconsciously by role model."[66] Seawright's work evoked precisely such an unstable aesthetic experience that challenged interpersonal cognition. Despite its title alluding to the perfect balance inherent in classical Greek architecture, the work exposed the potential disorder subsistent in all cybernetic systems.

Boyd Mefferd's *Strobe-Lighted Floor* elicited a somewhat similar feeling of loss of individual control. Visitors entered a completely dark room that was intermittently illuminated by strobe lights embedded in the carpeted ply-

wood floor and covered by Lucite panels. The flashes of light appeared to lack color at the moment they fired, but their incandescent luminescence gradually gave way to the formation of colored afterimages on the retina because each reflector case was covered with red, blue, green, and orange filters. This virtual suspension of patches of color made viewers highly aware of the instability of perceptual processes. The lights fired at random intervals in different floor areas, setting viewers in the spotlight. Participants gazed at others in order to get a better sense of how their own images appeared in relation to the flaring strobe lights. In his exhibition review, Alfred Frankenstein suggested that they could end up taking more interest in observing each other's

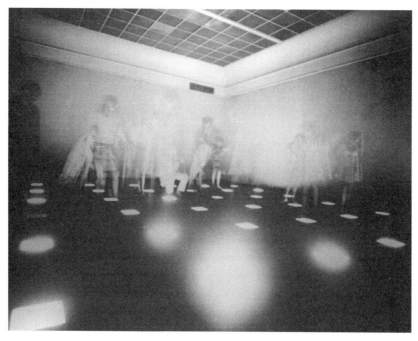

Boyd Mefferd, *Strobe-Lighted Floor*, 1968. Strobe lights under Lucite panels fire at random. Photograph by Hallmark Cards, Inc., Kansas City, Missouri. Courtesy of the Nelson-Atkins Museum of Art, Kansas City.

behavior than in studying the effects of the environment: "Mefferd's room particularly attracted the local hippies, who sat on the floor in circles around the flashing squares of light, like so many Indians around a campfire. The human reaction to all these things was often a better show than the show."[67] Whether driven by voyeuristic fascination with other participants' behavior or by the desire to understand how they themselves appeared in this mesmerizing setting, participants felt compelled to look toward others in order to overcome the feeling of disorientation. They became part of a collective paradoxically unified by destabilizing perceptual conditions. As with Seawright's *Electronic Peristyle*, individuals were deprived of control over the variability of the environment. They could negotiate their perception at an interpersonal level, but they could not keep in check the shifting visual effects.

By contrast, Howard Jones's *Sonic Games Chamber* seemed to grant participants full agency over the output of the sensor-based acoustic environment. Through their movements, they could project their shadows across photoelectric cells located in aluminum units affixed to four walls at approximately shoulder height. Whenever the photoelectric cell circuits were interrupted, sounds ranging from low tones and thumps to high-pitched noises and radio broadcasts were emitted from speakers mounted on the room's ceiling. Jones initially suggested that in this manner visitors could create acoustic "portraits," but the environment provided far more complex interactive possibilities.[68] As participants interacted with the four units, the acoustic stimuli they produced at an individual level combined, forming acoustic sequences that resembled improvised orchestral compositions. For Jane Livingston, Jones's environment proved to be too controlling, seemingly forcing viewers to regulate their movements to create certain types of sounds. While she disapproved of the indeterminacy of Seawright's *Electronic Peristyle*, she was also critical of the deterministic relations catalyzed by Jones's *Sonic Games Chamber*, which, in her view, resembled "a distasteful pseudo-scientific laboratory presumptuously set forth in the name of art."[69] Her somewhat contradictory take on the contrasting interactive potential of these works betrayed the tense relation between people and technology at a time when computer intelligence appeared threatening. Just as in the case of *Electronic Peristyle*, participants' behavior in Jones's sonic room was not limited to binary forms of interaction

with the photosensitive units. As Coe observed, visitors "became collaborators of sound."[70] They could generate complex acoustic sequences as part of spontaneously formed groups. Thus, the environment mediated social interaction in addition to fostering playful engagement with technological interfaces.

Besides being biased against collective forms of interaction with the works in *The Magic Theater*, art critics were judgmental of the hyperactive and hedonistic responses of art viewers. In their reviews, they were inclined to enforce the boundaries between the body and the mind by suggesting that sensory enchantment impeded mental reflection. In a virulent article in the *Kansas City Star*, Andrew A. Tapsony expressed his dismay at the participatory experience triggered by Coe's exhibition, proclaiming, "A man who exists on the level of perception is a savage for whom, now, a show has been dedicated."[71] Coe's

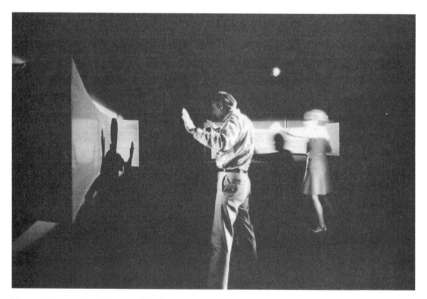

Howard Jones, *Sonic Games Chamber*, 1968. Four aluminum sound cases translate the spectator's motions into electronic sounds when these movements interrupt a light beam, thus triggering the sound-producing circuitry. Photograph by Howard Jones. Courtesy of the Nelson-Atkins Museum of Art, Kansas City, and the Bruno David Gallery, Saint Louis.

expectation that the environment would trigger psychic experience possibly deepened the consternation of art critics who found that participants' frantic movements in interactive environments such as *Sonic Games Chamber* could not possibly entail rational thinking. Despite being somewhat moved by the exhibition, art historian George Ehrlich confessed in his *Art Journal* review: "I was not involved in the way in which I was asked to be. Indeed, the 'psychic aspect' which was advanced as the major thrust of the exhibit seemed to repel me as something of a carnival 'come-on.'"[72] Most critics longed for the privacy of aesthetic experience, taking it as a stronger guarantee of mental analysis than the public expression of emotions and sensory enchantment.

Yet being part of a large group of people does not necessarily preclude personal reflection. In contemplating the full range of behavioral responses to the environments, *Magic Theater* visitors examined their thoughts and feelings at an interpersonal level. Upon hearing about Coe's concerns regarding the lack of coordination between spectatorial reactions, one of the participants exclaimed: "What's dreadful about that? . . . I don't want a coincidence with him. Another person can tell me what he feels if he wants, and I'll tell him what I feel. That way we share. Besides, there's unity in the thing itself."[73] These interpersonal exchanges that were more or less verbalized betrayed the affective ties between viewers. Whether lying on the floor in Mefferd's environment, waving their arms in Jones's sonic room, or moving around Seawright's electronic brain, participants were vividly aware of their collective impact on the works.

In the 1960s, theories of group dynamics were gaining ground in psychology and psychiatry. Initially, psychologists distinguished between groups united by affective relations and groups united by cognitive acts, respectively called "basic assumption groups" and "work groups" by psychoanalyst W. R. Bion.[74] However, it gradually became clear that the strict separation between these groups was artificial.[75] Upon entering *Sonic Games Chamber*, participants learned the rules of engagement with the environment from others, but their connection was not limited to the mimicking of tasks. They experienced an empathetic relation to those simultaneously engaged in performative acts aimed at triggering acoustic variability.

The theater of human behavior carried as much weight as the theater of

the mind in the exhibition, since participants made complex interpersonal inferences while observing each other's acts. Betsy Broun, an art history graduate student, pointed out that her experience was greatly enriched by the presence of numerous other participants simultaneously interacting with the works. Deeply cognizant of the variability inherent in human behavior that enhanced the complexity of the system-oriented environments in *The Magic Theater*, she explained:

> I went up there before 10 o'clock, and it was nice, but when I saw it later when all the people were there, it had come alive. Especially things like the strobe floor room and the time-delay machine gained by all the fortuitous events going on in and around them. That was more stimulating to me than strict cause and effect. For example, in the strobe light room you couldn't see your own shadow like you could everyone else's.[76]

According to Broun, the presence of other visitors generated more interesting outcomes because it triggered unexpected modes of participation and encouraged reflection on the ways in which interpersonal relations shape perception and cognition. Caught between a desire for individual immersion and a quasi-instinctual need for belonging to the temporary community of participants, exhibition visitors found it hard at times to decide whether to adopt a contemplative attitude or take participatory action. They loosely mirrored each other's thoughts and movements as they oscillated between a condition of absorbed reflection and an intense urge to externalize their experience just as many others around them were doing. *The Magic Theater* stimulated viewers not only to peer into their inner worlds but also to express their sensations and affectively relate to others through the medium of technology-based art projects.

Interpersonal art participation was also vital for a number of artists affiliated with the LACMA Art and Technology program, which was launched by Maurice Tuchman and Jane Livingston in 1967. The curators paired artists with industrial companies based on project proposals the artists submitted at the museum's invitation.[77] Tuchman explained that he did not want merely to organize an exhibition that featured artworks developed within

this collaborative framework; he also wished to encourage artists to establish long-term collaborations with engineers and scientists. Unlike Coe, who set up *The Magic Theater* based on the theme of psychic engagement, Tuchman did not envision a preferred mode of spectatorial engagement. He was more concerned about the possibility that the artists' fascination with technological innovation could at times diminish their attention to the aesthetic qualities of their works.[78] This apprehensive attitude probably informed his decision to invite submissions primarily from artists who had already gained sound reputations for work that did not involve technology-inspired art practices (e.g., Claes Oldenburg, Robert Rauschenberg, Tony Smith, Andy Warhol, and Robert Whitman).

Just as in the case of Coe's *Magic Theater* exhibition, the LACMA Art and Technology program publication departed from the usual format of exhibition catalogs. Released in conjunction with the museum's *Art and Technology* exhibition of 1971, which featured a small number of collaborative projects that had proven successful, the publication was presented as a program report. It included information on all the submitted proposals as well as detailed descriptions of the experimental and collaborative endeavors involved in the creation of the completed artworks. The report was better received than the exhibition, which was almost unanimously considered a fiasco at a time when the outlook on corporations was extremely negative. Art critic Max Kozloff confessed, "There was a certain pleasure to be derived from the thought of the thousands of work hours and dollars expended on these fey and whimsical contraptions."[79] Failed collaborations with corporations were in fact taken as clear proof that artists and industrial companies needed to part ways in order to avoid the corruption of aesthetic and social interests.

A few artists proposed environments that elicited mirroring processes: Avigdor Arikha wanted to build a park pavilion containing reflective mazes, Robert Whitman proposed the construction of a mirror environment that would render the mundane encounter with one's reflection eerie, Frederick Eversley aimed to design an environment out of cholesteric liquid crystals that would change color as temperature rose upon participants' approach, and Newton Harrison envisioned a forest of transparent columns containing different types of gases that would flicker when viewers activated elec-

tronic discharges in their vicinity. These artists encouraged viewers to gain a more solid understanding of the technological and social systems of which they were already a part by interacting with mirror surfaces and responsive environments.

Critical of the notion that the primary role of art and technology projects is to offer a lesson in human–machine relations, Robert Rauschenberg was one of the artists in the LACMA program who opened the field of his work to collective participation. In collaboration with Teledyne, he designed *Mud Muse*—a sound-activated installation consisting of a basin filled with mud that started to bubble in response to noises produced by participants. The work stimulated so much involvement that access to it was suspended for a couple of days after participants had made the mud spurt to the gallery ceiling. *Mud Muse* reopened, but its interactive potential was abolished; the mud bubbles were made to respond only to a fixed set of audio stimuli. Many art critics found that interactive art and technology works forced participants to act in quasi-mechanical ways in order to induce predetermined effects. Art critic David Antin asserted that environments such as *Mud Muse* indicated the controlling potential of technology and constrained the responses of the viewers instead of liberating them:

> The idea of using a human being as a power source and/or switch, which is about all that Rauschenberg is doing, is if considered seriously quite possibly humiliating. . . . For the art world it would seem that interaction with people is seen not as interaction at all but as manipulation, that is, technology.[80]

Like Jane Livingston, Antin thought about the interaction between the viewers and art and technology projects in binary terms. He did not consider the fact that *Mud Muse* participants could collaboratively produce acoustic responses in order to modify the rhythm of the mud bubbles. Unlike Antin, art critic Jonathan Benthall thought that responsive art and technology projects could facilitate artists' retaliation against the machine age. He noted that artists designing these works frequently counted on the support of unruly audiences to interfere with automatic processes: "This extra element of participation or

'feedback' breaks down the repetitiveness of purely cyclical machines, and gives the spectator (so it is contended) a more active function in the artistic process."[81] Benthall intuited that active spectatorial participation had the potential to create disorder in an otherwise seemingly stable cybernetic system.

Unpredictable complex networks encapsulating both responsive interfaces and social groups also stood at the core of artworks produced within the framework of E.A.T., the third platform for the development of art and technology programs I will consider in this section. This organization was founded after a series of productive collaborations between artists and engineers within the framework of *9 Evenings: Theatre and Engineering*, a series of art and technology events presented at the Armory in New York in 1966. Overall, the events attracted more than ten thousand spectators.[82] The reactions of audience members often became part of these events, both purposefully and inadvertently. For example, Robert Rauschenberg's performance *Open Score* incorporated live infrared projections of five hundred volunteers who, based on a list of instructions, performed simple gestures such as touching each other, moving apart, drawing rectangles in the air, and taking off their jackets. Furthermore, the technical problems that arose during the event called for long intermissions and rendered spectators aware of the public dimension of spectatorship. Reacting to the rather unnerving responses of spectators who sometimes booed and hissed in expectation, engineer Billy Klüver remarked that a sort of balance needed to be reached not only between artists and engineers but also between the producers of such events and the audience members: "There are three elements fighting. The artists, the engineers, and the audience. These three will have to come to some resolution. It seems to me that this will take several years."[83] His comment reveals that audience response represented an increasingly significant criterion for the evaluation of art and technology programs. Together with other artists and engineers involved in the organization of *9 Evenings*, Klüver founded E.A.T. with the aim of putting artists in direct contact with engineers who had already expressed an interest in such collaborations and could help with specific technological needs.

The Pepsi Pavilion was the largest collaborative project created by E.A.T. members. In 1968, the Pepsi-Cola Corporation invited artist Robert Breer to design the interior of the company's pavilion at Expo '70, the world's fair to

Robert Rauschenberg, *Mud Muse*, 1968–71. Bentonite mixed with water in aluminum and glass vat, with sound-activated compressed-air system and control, 48 × 108 × 144 inches. Prototype of the work at Teledyne as part of the Art and Technology program of the Los Angeles County Museum of Art, 1967–71. Copyright Robert Rauschenberg Foundation. Courtesy of LACMA Archives and VAGA, New York.

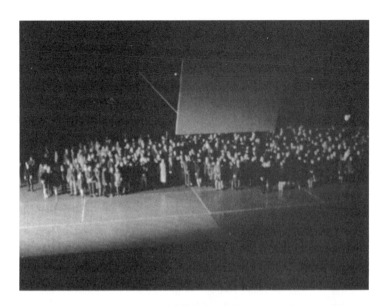

Robert Rauschenberg, *Open Score*, performed October 14 and October 23, 1966, as part of *9 Evenings: Theatre and Engineering*, Sixty-ninth Regiment Armory, New York. Stills from factual footage shot in 16 mm film by Alfons Schilling. The Daniel Langlois Foundation for Art, Science, and Technology, *9 Evenings: Theatre and Engineering* records. Courtesy of Experiments in Art and Technology and the Daniel Langlois Foundation.

be held in Osaka.[84] After several consultations with E.A.T. members, Breer enlisted the participation of the whole organization. He hoped that by undertaking this commission collectively, E.A.T. artists could negotiate more easily with the corporation and withstand its potential attempts to take control over the project.[85] More than seventy artists, engineers, and consultants became involved in the construction of the Pepsi Pavilion. Billy Klüver, the director of E.A.T. and the executive coordinator of the project, tried to maintain balanced relations between the camps of artists and engineers. After a series of brainstorming sessions, various individuals adopted well-delimited roles in the planning and design process: David Tudor was in charge of creating a sound environment, Robert Whitman conceived the optical effects inside the pavilion, Forrest "Frosty" Myers designed exterior xenon projections, and Robert Breer constructed mobile sculptures called *Floats* for the pavilion terrace.

By the time E.A.T. accepted the commission for the design of the pavilion interior, which was supposed to accommodate art events and concerts, the architectural firm Takenaka Komuten had already completed the building's support structure, which resembled a white geodesic dome. The artists disliked the architecture, finding it a poor imitation of the aesthetics of a Buckminster Fuller construction. At the suggestion of Forrest Myers, the group decided to make the pavilion disappear under a veil of fog. Fujiko Nakaya devised the technology for this atmospheric effect. Fog was released from thousands of nozzles embedded in the dome structure. Not only did E.A.T. members conceal the exterior of the building, but they also did their best to make its interior structure virtually disappear. Visitors gained access to the pavilion through a tunnel that led them to a lower level called the Clam Room, a dark, shell-shaped environment where krypton laser beams were projected. Two flights of stairs connected this space, reminiscent of a primeval womb, to the Mirror Dome, the main area of the pavilion, where light and sound events were staged. Inspired by Robert Whitman's ongoing experimentation with mirrors, this hemispherical room was constructed of silver Melinex sheets supported by negative air pressure.

In the Mirror Dome, visitors momentarily lost sense of the Cartesian coordinates of space because of the swirling field of reflections. The compelling visual effects of this hemispherical mirror environment were paralleled

by tactile and audio stimuli that contributed to an intricate multisensory experience. The floor was subdivided into several concentric sections covered with materials of different textures. such as grass, wood, and gravel. Visitors could listen to audio signals coming from the floor with the help of hand-held devices. The effects of the pavilion returned visitors to what Merleau-Ponty called a "pre-objective" state, in which they questioned the visible and abandoned their preconceived knowledge about their surroundings.[86] In the Mirror Dome, visitors became conscious of the boundaries of their perceptual field. Despite its seemingly spectacular character, the environment defied iconicity because of the unpredictable and volatile character of the visual and audio effects that depended on the movement of visitors and the changing programs operated by E.A.T. artists. Under these circumstances,

Experiments in Art and Technology, Pepsi Pavilion, Mirror Dome, 1970. Osaka Expo '70, Japan. Photograph by Fujiko Nakaya. Courtesy of Fujiko Nakaya, Experiments in Art and Technology, and the Getty Research Institute.

participants channeled their attention to the construction of perception and the impact of their corporeal presence on the environment.

E.A.T. members involved in the design of the Pepsi Pavilion criticized ocularcentrism and expressed their concerns about the overwhelming impact of media on society. Breer wanted to avoid the enactment of a spectacular multimedia environment and complained that "the usual result of multimedia is scattered razzle-dazzle without articulation and form."[87] Similarly, Robert Rauschenberg suggested that they needed to focus more on nonvisual stimuli in order to create "an invisible environment."[88] The E.A.T. artists' desire to eschew matter-of-fact optical effects was reminiscent of Coe's decision to select works for *The Magic Theater* that would channel visitors' attention to psychic experience. Visual stimuli were by no means suppressed in the Mirror Dome, but they were highly elusive.[89] Many optical effects were perceptible only over short periods or were so subtle that visitors could notice them only if they spent a sufficient amount of time inside the pavilion. The prolonged duration of the visiting experience, which was a very important factor in the psychic experience of Coe's exhibition, also played a major role in the encounter with the Pepsi Pavilion. Both exhibitions stood under the sign of "chronophobia," defined by art historian Pamela Lee as a fear of the impending acceleration of time, a fear that prevailed in the cybernetic age. Lee has adroitly observed that numerous artists of the 1960s became intent on slowing down perception and altering the temporal flow of technologically produced images.[90] The astounding reflective effects of the Mirror Dome invited visitors to pause and reflect on their perceptual experience.

Engineer Billy Klüver described the Pepsi Pavilion as "an experiment in individual experience," and art historian Barbara Rose called it "a secular temple of the self, dedicated to the individual, both as part of and as separate from the crowd."[91] The ultimate sign of this self-focused experience was a raised berm that extended from the sloping edge of the floor to the center of the pavilion. By walking along this platform, viewers could gain unique visual access to their reflections in isolation from others. Yet, as Michel Foucault remarked, one cannot envision individual freedom without considering its dependence on social organization and spatial configuration, which contribute equally to self-definition.[92] Visitors to the Pepsi Pavilion were constantly

aware that others could easily observe their reflections and behavior inside the Mirror Dome. E.A.T. members hoped that the reflective environment would stimulate participants to adopt performative roles. To their dismay, many viewers took more interest in inspecting the floor area and the sound console operated by artists than in manipulating their reflections. E.A.T. members found that participants tended to become more engaged in observing their reflections while watching the playful behavior of other visitors or the movements of dancers enacting performances inside the pavilion. On the night the pavilion opened, engineer Larry Owens was surprised to see one of the Japanese project engineers emulating the gestures of the exhibition hostesses by waving three silk scarves and improvising new movements. In the space of the Mirror Dome, acts of interpersonal mirroring between participants proved to be instrumental in stimulating individuals to choreograph their reflective projections across the mirror walls.

E.A.T. members associated the reflective environment with the human mind. They used mirrors to frame spaces of self-projection that catalyzed introspective reflection, stimulating visitors to transgress their bodily boundaries and seemingly enter a parallel universe. The artists called the inverted holographic images that appeared on the hemispherical ceiling "real images."[93] In *Expanded Cinema* (1970), Gene Youngblood argued that artists in the 1960s used new media primarily to simulate the actual workings of the mind.[94] This tendency was symptomatic of the desire to prove the superiority of human consciousness over technology. In describing the Pepsi Pavilion, Youngblood observed, "Although it developed from the synergetic technologies of computer science and poly-vinyl-chloride (PVC) plastics, it is triumphantly nontechnical as an experience."[95] Similarly, Barbara Rose celebrated the subdued presence of technology in the Mirror Dome, comparing it to an all-encompassing mind: "None of the repeated cycles and boring predictable stop-and-go hardware of machine art was to be found in the Pavilion. The entire Pavilion was in a constant state of flux, its fluid and protean character an analogue of contemporary consciousness."[96] The reflections projecting across the Mirror Dome mimicked the way images fluctuate in mental space and indicated their contingency on the perceptual and social context of experience. They emphasized the expansion of individual consciousness while

concomitantly unveiling the embodied nature of perception and the social dimension of performative behavior.

The contested terrain of interactions between humans and technology led many curators, art critics, and even artists to be suspicious of art participants' collective behavior in the 1960s, equating it with mass manipulation and overlooking its creative potential. The reflective art and technology projects discussed in this section encouraged viewers to externalize their experience and observe the way their participatory responses resembled or differed from those of others. The next section outlines how art based on closed-circuit television contributed equally to networked modes of participation and generated an ambivalent feeling of public intimacy.

Video Mirrors: Turning the Camera Eye on Art Viewers

Like reflective environments, performances incorporating spectators' mirror images, and responsive art and technology projects, closed-circuit video installations of the 1960s exposed art viewers' presence and underscored the social implications of self-reflective processes. Art critical discussions of early video art have highlighted the dialectical relations between the artist and the camera eye but have largely ignored the mirroring processes between multiple viewers watching closed-circuit TV installations. In this section, I will address some of the reasons for this lack of critical attention while examining the participatory nature of works created in the late 1960s by Marta Minujín, Les Levine, and Frank Gillette and Ira Schneider.

In the second half of the 1960s, CCTV became widespread in the United States. Cameras were installed in many institutions in order to prevent crime and consolidate work supervision. The television show *Candid Camera* enjoyed great success. Under the mask of humor, it enforced self-discipline and tamed the threatening aspects of surveillance. A growing number of American social critics were voicing their concerns about mechanisms of supervision that forced individuals to seek refuge in the private domain. In his 1964 book *Naked Society*, which described how electronic technology facilitates governmental and commercial control over American public life, Vance Packard remarked that surveillance was "inevitably exerting a significant

impact upon the behavior patterns and value systems of the millions of citizens."[97] Anxieties about diminishing privacy and passivity were also transparent at the level of critical responses to artworks, including those involving CCTV. Most artists employing this technology were keen on showing the positive roles it could play in enhancing responsibility and agency. Despite its inevitable association with surveillance, video technology also constituted a visual tool for self-empowerment because it could immediately transmit information and invite sustained reflection on both public and personal interests.

In 1965, the commercialization of the Portapak, the first portable video camera designed by Sony, cast a new light on video's role in the construction of representation and subjectivity. Although video equipment predated this moment, its high price and large size had prevented artists from experimenting with it. The state of video art crystallized in the mid-1970s when numerous art critics, such as Gregory Battcock, Douglas Davis, and David Ross, drew up taxonomies of the new medium.[98] They discriminated between video works kindred with performance and video works kindred with sculpture, which included multiple television channels. Despite these overlaps with other media, many critics emphasized the specificity of video. Rosalind Krauss's essay "Video: The Aesthetics of Narcissism" stands out as the most prominent attempt to establish the salient features of the new medium in terms of psychological aspects. Krauss argued that artists used video primarily as a mirrorlike device through which the "consciousness of temporality and of separation between subject and object are simultaneously submerged."[99] In many of the examples of self-reflective video works she provided, however, the artists did not simply portray themselves engaged in solipsistic acts but constituted themselves as subjects in relation to the imagined gaze of onlookers watching them via the camera lens.[100] Krauss conceded that there were some exceptions to this narcissistic tendency, but she completely ignored works based on CCTV that encompassed images of the audience. Actually, even when critics discussed such works in the 1960s and 1970s they tended to disregard the collective dimension of their reception, focusing instead on their immediacy and instantaneity, two qualities prominently listed among the most specific properties of the new medium.

Generally, CCTV artworks were placed in the category of video environments because they encompassed live images of the gallery setting. Youngblood associated them with "teledynamic environments," and Allan Kaprow included them in the category of "environmental open-circuit video," underlining their capacity to divulge how "people, machines, nature and environments interact, communicate, and perhaps modify each other's behavior in real time."[101] As intrigued by their complexity as was Kaprow, art critic David Ross remarked on the participatory impulses generated by CCTV artworks, maintaining that they "may be thought of as performing sculptures, or epistemological puzzles that choreograph the interaction of the viewer and the work placing the viewer unwittingly in the performer's role."[102] While critics observed the interaction between the individual viewer and the technological apparatus, they often overlooked the interpersonal ties established between performing viewers via the video medium.

In the late 1960s, American artists used CCTV installations both to stimulate highly private visual experiences and to generate shared modes of spectatorship. Bruce Nauman designed video installations that staged self-focused encounters with the viewer's own otherness via closed-circuit video images. Suspicious of unencumbered participation, he isolated the viewer from the inquisitive gaze of others and placed constraints on the interactive possibilities. For instance, he designed narrow corridors at the ends of which he embedded video monitors that broadcast live or recorded images of their interior spaces (e.g., *Performance Corridor*, 1969; *Live-Taped Video Corridor*, 1969). These installations precluded the access of more than one person at a time to the technologically mediated encounter with live images. Nauman openly asserted his skepticism about open-ended conditions of spectatorship: "I mistrust audience participation. That's why I try to make these works as limiting as possible."[103] By contrast, artists designing multichannel CCTV installations, such as Les Levine, Frank Gillette, and Ira Schneider, put into perspective the limitations of private modes of spectatorship. By breaking the unity of the visual field, they undermined the parallelism between the viewer and the monitor image and revealed the open-ended character of perceptual and social experience. Neither autonomous nor completely dependent on the video circuit, viewers of CCTV installations had no control over the pattern or

temporal rhythm of their broadcast images, but they could alter the content through bodily movement. Thus, they became conscious of another variable of the visual system: the presence of other visitors similarly exposed to the electronic eye.

Along with the increased availability of video technology, grassroots social movements and cybernetic theories were among the factors that led artists and art critics to think about art practices in terms of variable social and information networks. These tendencies were not characteristic only of U.S. art practices. Sociologist Eliseo Verón remarked that "social systems" or "systems of communication" represented the preferred medium for many experimental artists in Argentina in the 1960s.[104] Following the convergence between art and technology explored by the Madi group in the 1940s, Argentine artists staged events in which participants interacted with media-saturated environments. State funding for such avant-garde endeavors was extremely low in the 1960s, and it was only by benefiting from the support of the private Di Tella Foundation in Buenos Aires that artists could experiment with technological devices. *La Menesunda*, the first installation incorporating CCTV in Argentina, was displayed at the Di Tella Institute in 1965. Collectively produced by a group of artists including Rubén Santantonín and Marta Minujín, it was a bewildering environment composed of multiple rooms that exposed visitors to unexpected sensory stimuli. Some spaces were extremely cold or warm; others were permeated with intense odors or were deprived of proper ventilation. Inside *La Menesunda*, visitors could observe their live images on a monitor placed between two TV sets on which ordinary programs were playing. Upon exiting the installation, they had a chance to relive their experience by watching a recording of their visit. Like other avant-garde works supported by Di Tella in the mid-1960s, *La Menesunda* had a confrontational character. Noting the shocking quality of such exhibitions, art historian Andrea Giunta has argued that the message the art foundation delivered was that "the best, at that moment, was that which invaded the spectator's privacy, values, morality, and even compromised his or her body."[105] Indeed, *La Menesunda* simulated what it would feel like to be trapped in a media environment with no public or private boundaries.

After the military coup of 1966, Argentine artists worked under increasingly repressive conditions and used technology as a means of disrupting ex-

isting social circumstances. Minujín integrated CCTV into complex instal-
lations and events that brought together people from different professional
and social backgrounds. In 1966, she organized *Simultaneity in Simultaneity*,
a happening in several acts, which was part of a series of collaborations with
Allan Kaprow and Wolf Vostell. It involved the synchronization of two par-
ticipatory events, bringing together a group of well-known personalities in
a television studio and a group of randomly selected spectators watching
the others from their homes while trying to match video and acoustic in-
formation delivered through multiple information channels, including TV
broadcasts, radio programs, phone calls, and telegrams. The invasive over-
flow of information suspended communication instead of facilitating it. For
Circuit Superheterodyne, an installation created for the Montreal Expo of 1967,
Minujín staged an equally perplexing media scenario. She subdivided par-
ticipants into three affinity groups based on their responses to a newspaper
questionnaire they had completed in advance of the exhibition. Minujín

Marta Minujín, *Circuit Superheterodyne*, 1967. Expo 67, Montreal. Courtesy of Marta Minujín
and Henrique Faria, New York and Buenos Aires.

directed each group to a particular location inside or outside a theater, where members could watch images of themselves or of the other groups via CCTV. Members of one group were asked to answer a set of questions while facing their images on a TV monitor and their reflections in a mirror. Hence, they became vividly aware of the fact that others might observe their reactions and started to self-direct their behavior while having in mind a public audience.

Like Minujín, a significant number of American artists used video tools to reveal how people can take for granted televised information and lose a sense of individual agency. Les Levine relied on systems of information to alert spectators to the state of social numbness and seclusion brought about by American commercial television in the 1960s. He gained a reputation in the art world for criticizing the distribution of art as a profit-making business and actively self-promoting his art practice by organizing exhibitions in his studio and publishing press releases on his own. In 1966, Levine converted the octagonal space of the Art Gallery of Ontario in Toronto into *Slipcover*, an environment composed of a silver network of Mylar foil spread across the ceiling, walls, and floors. Within this already disorienting space, he integrated eight large bags of silver vinyl that multiplied and expanded participants' reflections in the environment. The bags inflated and deflated, forcing visitors to change their trajectories in relation to the bags' pulsating movements. The elusive qualities of the environment were further accentuated by CCTV projections and slide projections of works from prior exhibitions held in the same gallery space. The mirrorlike effects of *Slipcover* heightened participants' awareness of the mutability of self-consciousness, which perpetually adapts to external circumstances just as the Mylar foil absorbed fluctuating reflections. Levine asserted that the environment held the promise of turning the gallery visitors into its content:

The most interesting part is that people will be the work of art, because everything is going to come off those walls onto people. People will have parts of paintings on their faces, and you're going to have people who have a Picasso right across their shirt, because everything will reflect off the walls.[106]

Gallery visitors formed a symbiotic relationship with *Slipcover* as they simul-taneously acted upon it and were shaped by it. Their body images were encap-sulated into the variable visual environment, which stimulated them to take an active part in its transformation.

Levine's video installations of the late 1960s also granted viewers a partici-patory role. Encompassing multiple video channels, these works placed view-ers in the position of performers self-directing their movements in front of the camera. The works turned the tables on the private experience of watch-ing television by making spectators aware of being part of an audience group exposed to similar perceptual conditions. Composed of three cameras and six monitors encased in a vertical box, *Iris* (1968) invited participants to observe themselves simultaneously from different distances. The live video channels broke the unity of the visual field and upset the dichotomy between the viewer and the artwork. To further enhance spatial disjunctions, Levine placed col-ored acrylic sheets on the monitor screens, thus illusionistically increasing or decreasing the depth of the televised images. An intriguing optical machine, *Iris* challenged viewers to explore its technological parameters by repeatedly modifying their distance from it. Through just one move, participants could alter the visual content of all the networked video channels. Levine described *Iris* as an interface for creative engagement: "This particular type of partici-pation, in which you are consistently confronted with your image and your reaction to your image, is particularly vital today. . . . Hopefully, the spectator becomes aware of and gains an insight into the power of his own image."[107] In giving viewers a chance to self-direct their representations, the artist sought to inspire a critical outlook on passive modes of information reception and to suggest that individuals can in fact alter the cybernetic flux not merely by filtering it through their consciousness but also by modifying it through their actions.

By using closed-circuit television as an instrument for exploring a whole range of perspectives on themselves and others, participants in Levine's en-vironments acquired a heightened sense of personal agency. The plurality of video channels in *Iris* deterred them from seeking passive immersion in the flux of images through close identification with the visual output of one TV monitor. An adamant believer in the role of electronic media in facilitating

Les Levine, *Iris*, 1968. Television sculpture. Photograph taken with a fish-eye lens by Les Levine. Exhibition records of the Finch College Museum of Art, Archives of American Art, Smithsonian Institution. Courtesy of Les Levine and Artist Rights Society (ARS), New York.

intrapersonal and interpersonal cognition, the artist used CCTV to under-score the construction of perception and subjectivity.[108] Levine's *Contact: A Cybernetic Sculpture* (1969) exposed viewers to a more complex network of information than had its precursor, *Iris*. Similarly based on CCTV, it was com-posed of two multichannel video interfaces, each containing nine monitors encased in a stainless steel box. Viewers could check out the monitors by moving from one side of the box to another. The kaleidoscopic interfaces dis-played both programmed videos and live images captured by cameras with different focal lenses. Just as in the case of *Iris*, the videos were artificially in-fused with highly saturated hues by means of colored acrylic surfaces. Thus, Levine rendered the mundane images unfamiliar, implicitly encouraging viewers to perceive themselves from different perspectives. While *Iris* seem-ingly unified incongruous images of viewers by presenting only live images of the gallery setting, *Contact* held no such promise for synthesis because its visual field was much broader, including videos from more sources. It was designed as a surrogate for the television control room. In front of it, view-ers embodied the role of a technical director of the 1960s, creating connec-tions between images from different camera angles to edit visual sequences. However, their control over the information encapsulated in *Contact* was limited, since they could edit their own motions in front of the camera but could not interfere with the shuffling of the images between the monitors. In this highly variable visual context, spectators were prone to observe the presence of others and reflect on the factors that influence perception and cognition.

Through the use of CCTV systems, Levine aimed to enhance personal in-volvement in epistemological acts in order to subvert media control and so-cial passivity. *Iris* and *Contact* entailed an ambivalent reflective process: on the one hand, participants' video images denoted immediacy by becoming instantaneously entrapped in cybernetic networks; on the other hand, they connoted distance and mediation because of the different focal lenses and colored screens. This paradoxical sense of proximity and remoteness acted as an additional stimulus for viewers' engagement in altering the informa-tion flow. Describing the way he envisioned the audience reception of *Contact*, Levine asserted:

> It is a responsive mechanism and its personality reflects the attitudes
> of its viewers. If they are angry, the piece looks angry. *Contact* is made
> not only between you and your image, but how you feel about your
> image, and how you feel about that image in relationship to the things
> around you. The circuit is open.[109]

According to the artist, viewers completed the information circuit and enhanced its variability by actively negotiating between their embodied experience and the apparently detached visual information transmitted by the video channels.

Artists' growing preoccupation with viewers' responses to process-oriented works in the 1960s coincided with psychologists and sociologists' strenuous attempts to understand how the environment models the behavior of individuals and collectivities and how impersonal information is personalized and translated into meaningful experience at the level of consciousness. At the end of the 1950s, Michael Polanyi contended that it was wrongfully assumed that cognitive acts must remain impersonal in order to avoid the subjective corruption of knowledge.[110] He argued that any act of comprehension needed to imply both some degree of personal involvement, which consolidates cognitive acquisition, and some degree of detachment, which enables one to acquire a perspective that is not totally biased. Levine's CCTV installations played on this problematic junction between the personal and the impersonal. Viewers of *Iris* and *Contact* could closely observe their video images, yet the mediated character and the public dimension of the spectatorial act impeded their close identification with those images. The works invited viewers to second-guess their reflections in the electronic mirrors and alter them through their movements in order to acquire greater agency over the information flow.

By the end of the 1960s, the use of television monitors and video cameras in art was no longer such an isolated practice. However, video works were still rarely displayed in galleries, not to mention museums. Very few art institutions embarked on the endeavor of supporting and promoting video art at this time.[111] Levine, for example, first presented *Iris* in his own studio before sending it to art collector Robert Kordon in Philadelphia. Most video works,

including CCTV installations, were displayed at art events such as the Avant Garde Festival in New York or in group exhibitions focused on the relation between art and technology. *TV as a Creative Medium* was the first show dedicated solely to works based on television. Organized at the Howard Wise Gallery in New York in 1969, it included several works that encouraged viewers to imagine creative ways of interacting with television. Nam June Paik's *Participation TVs* confronted visitors with their televised images, which multiplied and metamorphosed in real time under the impact of acoustic, light, and color variations. Similarly, Earl Reiback invited participants to alter the information output through their interaction with TV sets. By manipulating a magnet, they could alter the flow of electrons in the television circuit, thus blatantly revealing the nature of the medium. Visitors' presence constituted a prerequisite for the animation of the visual field in Paik's and Reiback's works and catalyzed interpersonal observation and group behavior. Through their interaction with the prepared TV sets, participants made operational knowledge about the works available to others and revealed their expressive potential.

However, not all of the works featured in *TV as a Creative Medium* brought interaction with television into the public sphere. Paul Ryan seemed more circumspect about exposing spectators' encounters with their self-images. His video work *Everyman's Möbius Strip* revealed the interdependent relation between mental pictures and externalized bodily responses. Upon entering a private booth, the viewer heard an audio recording asking him or her to imagine well-known political figures, family members, or hypothetical situations while the viewer's facial expressions were videotaped. At the end of this exercise in cognitive performance, the participant could watch the recording. Its content remained volatile and private, since it was erased the moment another participant entered the booth and that person's reactions were taped over the existing video. Ryan compared this genre of works with a prosthetic device for enhancing self-awareness and modeling one's reactions before making them public.[112] His initial plans for this Möbius strip–like cybernetic model entailed the staging of a socializing experience. In a letter to Howard Wise preceding the exhibition, Ryan stated: "This composition would be repeated for two more people. Then the tape would have to be rewound and the

three of them would watch it together."[113] Ryan's eventual decision to restrict the viewing of the tape to the individual participant may have had something to do with increasing concern that group behavior subdues individual thought and creativity.[114]

Another work in the exhibition that disrupted visual congruence and engendered self-reflective processes was Frank Gillette and Ira Schneider's *Wipe Cycle*, a nine-channel TV collage that visitors encountered just as they stepped out of the elevator and into the gallery. If Les Levine's CCTV environments generated spatial disruption through the use of different focal lenses, this work primarily triggered temporal disjunctions. Its central monitor alternately displayed television images and live images with an almost

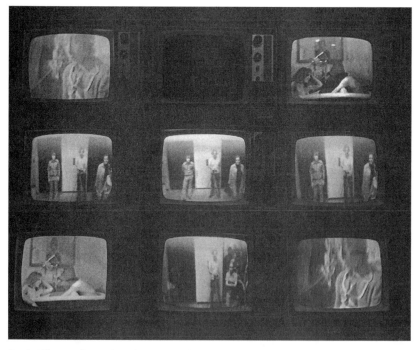

Frank Gillette and Ira Schneider, *Wipe Cycle*, 1969. Nine-monitor time-delay installation at the Howard Wise Gallery, New York. Courtesy of Ira Schneider.

negligible delay of four seconds, whereas the top and bottom corner monitors presented closed-circuit information with delay times of eight seconds or sixteen seconds. The remaining four monitors showed regular TV broadcasts, which were placed in virtual contact with what was taking place inside the gallery. Except for the images appearing on the central screen, all the other pictures migrated from one monitor to another according to preestablished cycles. The rhythm of the installation was rendered even more discontinuous by the interposition of a gray pulsating image that moved from one screen to another, temporarily suspending the information flow.

The alternation of the channels called viewers' attention to dynamic perceptual processes and interpersonal modes of self-definition. The shifting video images prevented narcissistic contemplation and encouraged visitors to see themselves seeing as others would observe them from a distance. Art critic Richard Kostelanetz described the feeling of disorientation instilled by *Wipe Cycle*: "The spectator feels caught in an intelligent watchful oblivious system whose incessant and variable observations remain compelling and mysterious even after their operation is explained."[115] Indeed, even after decoding the patterns of the video cycle, beholders did not feel in control of the situation. They were set in contact not only with the alternating television channels but also with the shifting parameters of the "reference group" represented by other visitors, who enhanced the variability of the televised content through their movements.[116] *Wipe Cycle* generated loose affiliations between participants who assessed their sensorimotor experience and behavioral acts at an interpersonal level while watching their televised images.

Nonetheless, most art critics analyzed individual responses to *Wipe Cycle* and neglected to take into account the potential presence of a larger audience whose members interacted not only with the changing images on the screen but also with each other. Since the humanization of technology was perceived as the greatest challenge embraced by artists employing television and video in the 1960s, critical attention was directed primarily to the collaboration established between the spectator and the technological device. Some art critics were disappointed that visitors were not taking a more active part in influencing the information captured by CCTV networks. Others believed that participatory implications should not take precedence over the actual

artwork, which should stay the main object of analysis. Highly conscious of the fact that viewers' responses ultimately determined the value of interactive works, David Antin was critical of the passive reception of *Wipe Cycle* that he observed during his exhibition visit. He found spectatorial responses to be at odds with Gillette and Schneider's expectations concerning the performative potential of the installation. Antin thought these artists' failed attempt at engendering active participation reflected the superfluous impact of almost all technology-based artworks:

> What is attempted is the conversion (liberation) of an audience (receiver) into an actor (transmitter), which Schneider and Gillette must have hoped to accomplish by neutralizing as much as possible the acts of "taking" and electronic transmission. If they failed to accomplish this, they were hardly alone in their failure, which seems to have been the fate of just about every interactive artwork employing significantly technological means.[117]

Antin claimed that viewers felt intimidated by expensive technological apparatuses that they did not know how to operate. However, the apparent failure of viewers to perform in front of *Wipe Cycle* did not necessarily imply a refusal to participate. Participants' reserved gestures probably spoke to an affective state of kinetic suspension intensified by the presence of other visitors or by the fear of overriding usual norms of conduct in a gallery setting. Moreover, there were considerable variations in the reception of the work, depending on the number of visitors present on site and their psychological profiles. Contrary to Antin's response, art critic Michael Shamberg found that *Wipe Cycle* set the tone for interaction with all the works in the exhibition; he opened his exhibition review with the statement "Participation is the key to the show," before proceeding to describing the components of Gillette and Schneider's work.[118]

Given that this was a period when the controlling impact of electronic media was highly apparent, it is not surprising that even the design of open-ended cybernetic networks meant to break the unidirectional flow of televised information was regarded with suspicion. Sociologist Richard Sennett

maintained that television weakened communal agency, since "shared imagery becomes a deterrent to shared action."[119] Numerous artists using television and video at the end of the 1960s pointed out that this technology in fact had the potential to elicit agency and render viewers more responsible for the ways in which they used information. *Wipe Cycle* provided an alternative to one-way communication channels and underscored the variability of information production, transmission, and reception. According to Gillette, video replaced the binary relation between the viewer and the artwork with a more complex model of communication, since "the place of *prime objects* in hierarchical aesthetic systems is filled, in the electronic media, by the concept of network."[120] The plurality of interdependent information channels in *Wipe Cycle* paralleled the heterogeneity of groups of spectators introducing new information into the endlessly fluctuating cybernetic circuit.

Some months before the Howard Wise exhibition, Gillette and Schneider had conducted an interactive video experiment that fostered interpersonal awareness and performative interaction. Four participants were asked to become witnesses to each other's presence while sitting in a room in the Antioch College Library with four video cameras, a monitor, and two oblong mirrors. The closed-circuit video information was made available via the TV set and the reflective screens positioned in different corners of the room so that they could encapsulate the televised images. The four participants were asked to sit in the middle of the room with their backs toward each other while facing the channels of mediated visual information. Gillette and Schneider noted how responses gradually shifted from self-contemplative attitudes to informal performative actions: "After an initial period of self-consciousness the subjects began to generate their own entertainment. During the session the subjects played with their mirrors and cameras, read poetry, drew, rapped, did sommersaults."[121] The experiment showed that video could foster participatory input by alerting viewers to their ability to alter video content through both creative gestures and active interpretation.

There are several reasons a large number of artists and critics during the 1960s vigorously defended the dyadic relation between the privileged art object and the singular art viewer despite the gradual emergence of networked modes of spectatorship. First and foremost among these was the fact that

spectatorial norms inside art galleries generally imposed restrictions on visitors' behavior and communicative exchanges. While art critics dwelled on the shift from object- to process-oriented art practices, they were less inclined to discuss concomitant transformations in art spectatorship because such changes brought visual art dangerously close to spectacle. It was generally believed that collective encounters with art diminished the intensity of the individual viewer's aesthetic experience and impeded self-awareness. A second reason was the compelling desire to humanize technology through the design of interactive art in the 1960s. Hence, in art critics' assessments of CCTV artworks or responsive environments, the quality of interactions between individual beholders and technology-based artworks took precedence over the quality of social relations mediated by technology. Even under these circumstances, some critics considered these art practices too similar to behavioral experiments to be worthy of the status of art.

Early theorists of video art favored an intimate perceptual experience. Artist and critic Douglas Davis decried the fact that in its inceptive state the new medium implied "a mind-to-public rather than a mind-to-mind communication, a bored and formal audience, rather than an intense and informal one." Despite the fact that he believed that "the most advanced thinking in contemporary art is public in potential," Davis thought that only an intimate encounter with video art could catalyze agency.[122] In the early 1970s, Allan Kaprow was one of the few artists who reckoned that neither traditional art media nor new media could ensure a perfectly autonomous aesthetic experience. He did not maintain that the public dimension of artworks was an entirely new artistic development, but he implied that this aspect had become more conspicuous than ever in the context of video art.[123] CCTV works such as Les Levine's *Contact* and Frank Gillette and Ira Schneider's *Wipe Cycle* abruptly disclosed the lack of privacy of art spectators and their interpersonal connections even though they were meant to reveal the permeability of cybernetic networks rather than to signal the menace of surveillance.

During the 1960s, art spectatorship underwent gradual transformations in conjunction with significant changes in art objecthood. The ideal dichotomous mirroring process between the consciousness of the artist and the consciousness of the viewer engrossed in retrieving the original intent was

supplemented by interpersonal mirroring acts between art participants simultaneously involved in modeling the content of reflective environments and responsive technological interfaces. Video technology forcefully set forth the public dimension of new spectatorial modes in the second half of the twentieth century, but, as shown in this chapter, it was hardly the only medium to call attention to an enhanced understanding of the complexity of experience and the interpersonal construction of identity. Chapter 2 discusses how these networked forms of spectatorship catalyzed by the use of reflective media acquired sharper political connotations in the 1970s, when criticism of consumerism, social control, and pervasive supervision intensified.

Mirror Screens
Wary Observers under the Radar

If we deeply and even unconsciously believe that our relation to the largest system which concerns us—the "Power greater than Self"—is symmetrical and emulative, then we are in error.

—Gregory Bateson, *Steps to an Ecology of Mind*

By the middle of the 1970s, the high hopes of the prior decade, which stood under the sign of social movements and antiwar protests, had partially been stifled. The failed utopianism of communes deepened the disappointment with contemporary conditions. Sociologists decried the growing rift between individuals and large social groups. They feared that people would seek refuge in the private sphere and become too numb to social realities to respond to them in a responsible manner.[1] In the United States, the economic recession of 1974–75 lowered morale even further. In New York art circles, there was a growing dissatisfaction with the short-lived success of the Art Workers' Coalition at the end of the 1960s and art museums' refusal to adopt more inclusive collecting and exhibition policies. In 1984, art critic Lucy Lippard remarked that by 1975 artists "were tired of waiting for the '70s to happen."[2] Under these circumstances, American artists' approach to mirroring processes became explicitly attuned to the goal of disclosing mechanisms of social control and inspiring interpersonal alliances between spectators. In chapter 1, I considered primarily how artists embraced reflective media in the 1960s to contest the autonomy of the art object and expand perceptual awareness. In this chapter, I chart the strategic modes in which they staged

mirroring acts that had concrete political and social functions. An increasing number of artists, including Vito Acconci, William Anastasi, Judith Baca, Daniel Buren, Peter Campus, Dan Graham, Lynn Hershman, Bruce Nauman, and Peter Weibel, designed visual systems that incorporated competing reflective surfaces that would vie for participants' attention and enable critical distance from the all-engulfing conditions of the society of the spectacle.

I discuss below the use of mirroring acts as an instrument for social analysis and critique in the art practices of Dan Graham and Lynn Hershman, two artists who hold similar interests in revealing how context produces content and overarching sociopolitical systems regulate behavior. During the 1970s, they were briefly acquainted through their common network of friends in New York.[3] Although they designed situations in which art viewers simultaneously occupied the roles of subjects and objects of perception, their works have not been analyzed in tandem and have only rarely been exhibited together.[4] Both artists employed reflective processes to foster interpersonal awareness and alliances. This chapter presents a comparative analysis of Hershman's site-specific installation *25 Windows: A Portrait of Bonwit Teller* (1976) and three of Dan Graham's mirror-based works: *Public Space/Two Audiences* (1976), *Performer/Audience/Mirror* (1977), and *Video piece for showcase windows in a shopping arcade* (1976). I will examine how these works criticize consumerism, surveillance, and complacency with societal expectations. Both Graham and Hershman shared anthropologist Gregory Bateson's belief—exemplified by the quotation that opens this chapter—in the need to upset perfect contiguities between individuals and social systems in order to heighten critical awareness.[5] Toward this end, they cultivated asymmetrical relations between reflection and visual representation, self and others, personally assumed roles and more or less imposed social roles. Their commitment to activating forms of cinematic and theatrical visuality simultaneously in order to stimulate critical distance corresponds to the model of media spectatorship eloquently described by Kate Mondloch in terms of being "both 'here' (embodied subjects in the material exhibition space) *and* 'there' (observers looking onto screen spaces) in the here and now."[6] The physical presence of collective audiences in Graham's and Hershman's installations renders this dualistic dynamic even more complex. In what follows, I will show that the

concomitant bodily presence of multiple viewers within their works often constitutes yet another mediating interface, which calls for interpersonal self-definition and critical inquiry into the norms of social systems.

Hershman's *25 Windows* was exhibited for a period of six days in the display windows of Bonwit Teller, an upscale New York department store. It was composed of three parts, each aligned to one street and referencing a particular temporal interval: *Past and Illusion* along Fifty-seventh Street, *Time, Identity, Transformation* along Fifth Avenue, and *Reflections and the Future* along Fifty-sixth Street. By pairing Hershman's installation components with Graham's performances and environments that similarly built on analogies between spaces of commerce and spaces of surveillance, I will elucidate how these artists subverted processes of individual objectification and collective manipulation.

From the early stages of their careers, reflective acts have held a key function in the practice of Graham and Hershman, helping them generate discrepancies between embodied presence and mirror images in order to highlight the quasi-invisible social and political systems in which individuals are ordinarily engulfed. In the mid-1960s, Hershman covered the faces and arms of the figures she sketched with Plexiglas surfaces, thus rendering them virtually anonymous while hinting at the fact that their identities were highly mutable in relation to viewers' perspective. Graham first used reflective materials in the context of his *Project for Slide Projector* (1966). He repeatedly shot photographs of the interior of a transparent box through a series of small glass panels that decreased the degree of transparency of the container while enhancing its reflexivity. The resulting images blurred the distinctions between two-dimensional and three-dimensional forms and interrogated the objectivity of perception.

Far from enchanted with the qualities of mirrors, Graham considers them symbols of stagnation and control.[7] In his view, only double mirrors or semitransparent surfaces are ambiguous enough to suggest variability and multiple viewpoints. Time and again, he has set reflective surfaces in dialectical opposition to videos and performative acts, arguing that it is only in this way that they can stimulate temporal awareness and change. Despite sharing Graham's interest in creating visual disjunctions, Hershman has a

very different perspective on the symbolism of mirrors. She believes they do not suspend time; rather, they underline its perpetual flow and call for self-transformation. While she has not found it imperative to display mirror surfaces in conjunction with other reflective media as Graham has, Hershman has used them sparingly, placing them at oblique angles or fracturing their surfaces in order to impede states of complete perceptual immersion.

Both Graham and Hershman have been intent on disrupting the smooth parallelism between the viewer and the object of perception. Their use of reflective media is informed by their desire to inspire discrepant relations that expose otherwise inconspicuous mechanisms of perceptual and behavioral control. Graham aptly enunciated his dedication to the principle of visual dissociation when he stated, "I always try to put together two things that shouldn't go together."[8] Whether juxtaposing mirrors and video, phenomenology and behaviorism, or public space and private space, he ensures that the tension between contradictory elements is maintained to resist individual contentment with the status quo. Similarly, Hershman builds on visual incongruence to criticize social disparities. In a 1976 interview with Alanna Heiss, she remarked that all her work "deals with reality discrepancies and portraits."[9] As this chapter's discussion of 25 Windows will show, her approach enables critical reflection on the construction of selfhood in relation to a shifting array of visual and social cues.

Intimately acquainted with the art market mechanisms of the 1960s and 1970s, Graham and Hershman purposefully refused to align their practice with any of the existing artistic tendencies. Graham did this in order to maintain the experimentalism of his practice. After the closure of the John Daniels Gallery, which he directed in 1964–65, he was intent on infiltrating the art world in a subversive manner. In order to unmask its operations, which he found analogous with commodity commercialization, he acted on the fringes and capitalized on the market's strategic ties with the media. Graham's well-known Homes for America project published in Arts Magazine in 1966 parodied the proliferation of consumer desire for suburban houses while indirectly alluding to the standardization of aesthetic taste through the consolidation of stylistic categories. Hershman's relation to the art world was similarly subversive. While West Coast art institutions maintained that they were open

to showing works by women artists, Hershman found that they had pre-conceived ideas about which art genres and media were worthy of display. She assumed the personas of fictive male art critics and submitted reviews of her own exhibitions to art magazines. An apt administrator, she publicized her works through TV commercials and established alternative exhibition venues inside hotel rooms, where she installed site-specific works that reflected the social profiles of potential guests.[10]

Although Hershman and Graham shared an interest in developing cunning ways of dealing with the constraints of the art world, their approaches to sites of display and audience involvement differed significantly, as will become apparent in the analysis of the reception of their projects. The added challenges that Hershman faced as a woman artist in the 1970s compelled her to entertain a more nuanced perspective on how the particular social coordinates of the art context determine who the audience members are and influence how they can critically engage with the art content. Consequently, she conceived site-specific works that focused on concrete social issues, such as the marginalization of women and people with low income. Graham, in contrast, preferred to focus on a more general picture of society, his art practice being mostly oriented toward simulating nonspecific contexts of perceptual and behavioral control.[11] Unlike Hershman, who paid close attention to the class, gender, and ethnicity of the audience members for whom her works were conceived, Graham assumed that his performances and installations would involve heterogeneous audiences that would model the art content in interesting and possibly unexpected ways. Hence, it is somewhat surprising that Graham has stated that his practice has been influenced primarily by anthropological discourse of the 1970s.[12] Hershman, for her part, usually acknowledges the influence on her work of sociological theories such as Erving Goffman's notion of the theatricality of everyday life, although her projects bear similarities to ethnographic investigations that pay close attention to the specific qualities of the display context and the demographic characteristic of the audience.[13] Irrespective of these differences, in the 1970s both artists drew on R. D. Laing's interpersonal psychology of perception as they sought to catalyze chains of inferences between spectators and performers or narrative protagonists in order to familiarize them with the plasticity of

identity and the potential for social transformation. Theories that mapped the complexity of intersubjectivity and social systems gained ground because they facilitated a more profound understanding of the way experience can be surreptitiously controlled. Thus, they opened the path toward a more careful consideration of how one can actively explore the impact of social factors on self-definition and behavior.

This chapter is divided into three sections that will show how Graham's and Hershman's works of the 1970s generated disjunctive interpersonal relations with the goal of counteracting collective complacency with social circumstances. In the first section, I will explore how the two artists enacted situations that encouraged art participants to reflect on the precariousness of their mirror images and the manipulative effect of behavioral supervision. Starting from Michel Foucault's theory of discipline and surveillance, I will explain how Graham's *Performer/Audience/Mirror* and the *Past and Illusion* component of Hershman's *25 Windows* revealed how individuals can end up performing the roles of props in regulated systems.[14] In the second section, I will discuss the two artists' subversive integration of multiple reflective frames within spaces of consumer spectacle in order to catalyze bodily motion and undermine the parallel identification between individual viewers and consumer products. The comparative analysis of Graham's *Video piece for showcase windows in a shopping arcade* and the middle section of Hershman's Bonwit Teller project, *Time, Identity, Transformation*, will unveil how these works restored the "traffic" component of the arcades, whose gradual disappearance Walter Benjamin decried in his analysis of modern trade strategies that increasingly isolate consumers from each other in order to orient their attention more fully to commodities.[15] In the third section, I will examine the affective alliances prompted by Graham's installation *Public Space/Two Audiences* and Hershman's *Reflections and the Future*, the third component of the Bonwit Teller installation, which encouraged participants to interrogate the broader sociopolitical context framing their interaction.

This chapter will illustrate the two artists' explicit use of mirroring processes for challenging the state of numbness American society was reaching in the second half of the 1970s, as social movements became subdued. I will argue that Graham and Hershman unsettled the prevailing order of social

systems by unveiling the ways in which power mechanisms restrict the autonomy of individuals while offering them the illusion of personal choice.

Docile Body Images under Refraction

In the 1970s, Graham and Hershman investigated how changes occur within social groups or environments when apparently equivalent relations are upset through the introduction of additional frames of visual reference, such as mirrors, windows, and video. In what follows, I will analyze how reflected images underwent virtual processes of refraction as they projected through the consciousness of participants in Hershman's *25 Windows* and Graham's *Performer/Audience/Mirror*. By triggering discrepant relations between viewers, the two artists unmasked and undermined the tactics through which docility and surveillance are imposed.

Plans for *25 Windows* date back to 1974, when Hershman first noticed the resemblance of Bonwit Teller's windows to Joseph Cornell's surrealist boxes and envisioned turning them into an art display space.[16] Prior designs for the store by Salvador Dalí, Andy Warhol, and Robert Rauschenberg may also have carried some weight in Hershman's choice of this location. The retrospective character of the installation, which included numerous references to her past art practice, furthered its correlations with the art historical framework. The artist has affirmed that she wanted to resist subservience to commercial purposes, "to sell ideas" rather than clothing.[17] Her installation did not simply constitute a portrait of the store or its upscale customers; it reflected the complexities of the New York social landscape.

Hershman did not manage to secure the support of the store for the installation until 1976. During this period, the competition between upscale department stores in New York was fierce, and the design of spectacular window displays constituted a significant promotional trend.[18] Delineating these new directions in store advertising in a 1976 magazine article, Rosemary Kent compared the sensationalist storefronts with "a kind of street theater, making comments on the news of the day—garbage strike, the sleeping-pill syndrome, the latest fads and hang-ups—and sometimes even mocking the very customers the windows are designed to attract."[19] In most instances, the

social commentary offered by these window designs was quite feeble and resulted mainly from the absurdity and promiscuousness of the situations in which rich protagonists were set. Hershman's Bonwit Teller installation built on these voyeuristic tendencies but compromised the proliferation of consumerist desire by shifting beholders' attention from commodity design to identity construction.

Exhibited over a six-day period, *25 Windows* benefited from the support of the Institute for Social Research and Hershman's collaboration with technicians, scientists, designers, video specialists, and fashion models. Except for being asked to include a number of Bonwit Teller clothing items, the artist faced no restrictions concerning the installation content. She composed a tripartite portrait of New York City that incorporated references to past events, quotidian happenings, and future urban transformations under the impact of new technologies. The *Past and Illusion* axis of the installation, located on Fifty-seventh Street, included three tableaux: a hotel bedroom scene that partly reconstituted Hershman's site-specific installation at the Chelsea Hotel in Manhattan in 1974, a video composed of time-lapse images recorded during installation preparations, and a maze of interwoven film strips that barely allowed viewers to catch a glimpse of a group of mannequins lined up in the store window.[20] Clearly departing from a linear narrative of the past, these scenes enticed passersby to peer beneath the surface of things, entertain hypotheses about the identities of the models, and reflect on their involvement in the construction of the past and the present. In this section, I will limit my discussion to an analysis of the bedroom tableau of *Past and Illusion* in order to examine the disjunctive reflective ties established between passersby and the mannequins. By comparing it with Dan Graham's performance *Performer/Audience/Mirror*, I will point out the critique of spectacular immersion and docility subsistent in both works.

Graham's performances and installations of the 1970s relied on cyclical alternations between verbal descriptions of intrapersonal and interpersonal observations of behavior. They were inspired by new therapy techniques that motivated individuals to reflect on how their conduct is conditioned by the immediate context. Psychoanalysts such as R. D. Laing started to question prior methods of analysis and therapy, suggesting that the impact of present inter-

personal relations and social factors on the psychology of the individual is as important as the influence of relationships with family members during childhood. Moreover, it became evident that the subjectivity of the analyst has an unavoidable influence on the patient's self-perception, and meaningful interpretations of behavior can take place only if these intersubjective connections are taken into account. Considering the intersubjective exchanges established in psychotherapy sessions, Laing assertively claimed:

> Any technique concerned with the other without the self, with behavior to the exclusion of experience, with the relationship to the neglect of the persons in relation, with the individuals to the exclusion of their relationship, and most of all, with an object-to-be-changed rather than a person-to-be-accepted, simply perpetuates the disease it purports to cure.[21]

In his performative practice, Graham built on the changes in psychoanalytic techniques suggested by Laing and gradually shifted from works emphasizing the performer's subjectivity and potential control over the image of the audience (e.g., *TV Camera/Monitor Performance*, 1970) to performances questioning the performer's sense of selfhood and his influence over the public (e.g., *Performer/Audience Sequence*, 1975). This change in the artist's approach betrayed his declining confidence in states of absolute subjectivity or objectivity that remain impervious to social dynamics. With every new performance scenario, Graham multiplied the frames of visual and discursive reference for the observation of behavioral tendencies, astutely unveiling how the agent of surveillance can turn into a victim of the visual system he regulates, since he cannot help but be transformed by it.

Performer/Audience/Mirror multiplied the perceptual cues of the performer's observations concerning personal gestures and audience reactions. In this performance, his verbal descriptions of individual and collective behavior could be checked against reflections instantaneously captured in a mirror screen situated at the back of the room. The performance consisted of four repeatable performative stages that laid bare the performer's vacillations between appearance and actuality, subjectivity and objectivity: (1) Graham's

description of himself while facing the audience, (2) his description of the audience while facing it, (3) his description of himself while observing his mirror image, and (4) his description of audience members while observing their images in the mirror screen. The reflective interface offered Graham and participants the chance to perceive themselves and others from a third-person perspective that made them highly conscious of the interpersonal nature of behavior. The artist acknowledged the mirror's role in heightening viewer engagement and revealing the distortions inherent in individual observation: "Putting a mirror at the back implicated the audience more, because I could describe the audience, where they would be seeing themselves in a kind of instantaneous time, but my description would be phenomenological."[22] The immediacy of reflections contrasted with Graham's slightly delayed and distorted observations of what was happening. The performer refracted the images he perceived through his consciousness. By filtering visual information, he disrupted the presumed seamlessness between what was taking place outside and within the reflective screen. Graham's role was analogous to that of the slightly delayed video sequences he embedded in his installations to raise viewers' awareness of the gap between perception and verbal or visual representation.

Hershman's *Past and Illusion* similarly accentuated disjunctions between contrasting viewpoints in order to disclose the way "reality" is produced through the manipulation of appearances. The bedroom tableau, reminiscent of the artist's earlier installation *Forming a Sculpture/Drama in Manhattan* at the Chelsea Hotel, had as its protagonists a female mannequin that seemed to have just woken up to discover that she was set on display in the store window and a male mannequin that appeared to be still fast asleep, with his face turned away from the viewers. Placed at an angle on the right-hand side of the display case, a TV set presented closed-circuit video images of what took place in front of the window. It doubled the frame of representation and turned the tables on the voyeuristic drives of passersby looking at the bedroom scene. It indicated that they were as exposed to supervision as the mannequins. The oblique orientation of the TV monitor increased the sensation of control exerted over the audience, conflicting with their frontal perspective on the tableau. The mirror screen in Graham's *Performance/Audience/Mirror* contributed to

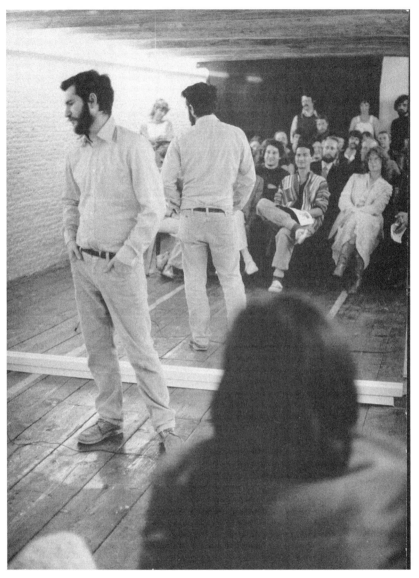

Dan Graham, *Performer/Audience/Mirror*, 1977. De Appel Arts Center, Amsterdam. Courtesy of Dan Graham and Marian Goodman Gallery, Paris.

a similar disjunction between visual cues despite the fact that it was placed parallel to the audience. Its instantaneous reflections contrasted with the performer's observations about what had already happened in the room.

By inviting participants to reflect on how they are perceived from multiple viewpoints, Hershman and Graham displaced single-focused perspective and gave vent to processes of self-reflection based on interpersonal conjectures. Both artists aimed to instill individual and social change by triggering critical observation on the intimate correlations between one's acts and their consequences. Hershman later noted that "the video and mirror encapsulation of viewers [in *25 Windows*] was about time transitioned and modified."[23] The bedroom scene in *Past and Illusion* called for participants' reevaluation of their temporal and spatial context. Their awareness of being under surveillance as their images were projected on the TV monitor made them more alert to the implications of their intrusion into the private life of the manne-

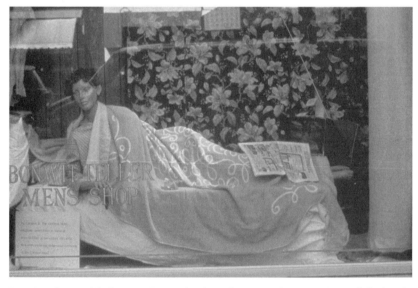

Lynn Hershman, Window 23, "Recreation in a Cheap Hotel Room" *(Past and Illusion)*, in *25 Windows: A Portrait of Bonwit Teller*, 1976. Installation. Courtesy of Lynn Hershman.

quins. The blatant exposure of bedroom intimacy overshadowed the promise of leisure and comfort otherwise guaranteed by the use of Bonwit Teller commodities. *Past and Illusion* and *Performance/Audience/Mirror* underscored the construction of identity based on interpersonal reasoning by asking viewers to consider how they would react if they occupied the position of someone else whose privacy is severely infringed.

Yet Hershman and Graham were not intent solely on engendering heightened individual awareness of transformation. Their works also enhanced audience members' group consciousness. The collective reflection of spectators in the mirror screen of *Performance/Audience/Mirror* awakened them to the power dynamics underlying their relations to the performer. Even though it is arguable that the mirror gave the audience "power within the performance equivalent to that of the performer," as Graham implied in his notes on the performance, it certainly enabled viewers to manipulate their appearance and acquire a greater sense of group belonging.[24] It also rendered visible the impact of Graham's statements on the behavior of the audience before he could get a chance to present his own subjective representation of their reactions through verbal statements. The performer observed the swift changes in audience response that inadvertently occurred as he was describing the spectators' reactions: "Some people are making eye contact; a lot of people shifted . . . and there's a kind of laughter . . . uh, a laughing and looking away."[25] The relations between the performer and the audience were out of joint because of the temporal incongruities between verbal descriptions and mirror reflections. Through their body language, participants could confirm or contradict Graham's observations, thus expanding reciprocal influences by partly orchestrating his subsequent comments. Yet the situation remained slanted in favor of the individual performer controlling the sequence of interpersonal verbal descriptions. Graham could verbalize his impressions, whereas the audience members could transmit their views only through gestures, gazes, and facial expressions. Their experience of who they were was repeatedly shaped by the performer's remarks. Graham had the option of singling out certain individuals in the audience or making generalizations about the behavior of the whole group. The spectators, however, could become involved with the larger group only through fairly limited interpersonal visual

exchanges and could share their observations solely with their seat neighbors. The performance made evident how collectives can be manipulated. R. D. Laing cautioned about the power that individuals can come to exert over large groups through the control of experience. He observed that "once people can be induced to experience a situation in a similar way, they can be expected to behave in similar ways."[26] The presence of the mirror helped diminish to a certain extent the impact of the performer on the behavior of the audience members by showing the mystifications to which they could fall prey if they were to rely on Graham's comments and fail to observe the plurality of reactions noticeable in the reflections.

Analogously, the TV monitor in *Past and Illusion* did not necessarily grant passersby more power over visual representation. The camera that transmitted video images to the store window was hidden from view, suggesting that an authoritarian voyeur may have been watching the street scene from an invisible location. The reflective qualities of the window supplemented the surveillance mechanisms of the video. Nonetheless, this mirrorlike interface enabled onlookers to regain some confidence in the potential for assuming control over their images. By interacting with the store window, participants could virtually insert their bodies in the bedroom setting and could gain sight of other passersby equally engaged in speculating on the identities of the mannequins and the role of the closed-circuit television. The multiplication of reflective frames raised skepticism instead of ensuring enchantment with the narcissistic reward granted by the surveillance apparatus. The disjunction between the life-size window reflections and the small-scale televised images of viewers gazing upon the bedroom scene in *Past and Illusion* impeded contemplative immersion, just as the differences that arose between Graham's verbal descriptions of audience members and their mirror images in *Performance/Audience/Mirror* undermined theatrical modes of spectatorship. Sociologist Richard Sennett signaled the growing personalization of information in the 1970s that led to increasing alienation and passivity. He warned that those who approached "social situations as mirrors of the self" became oblivious to their impersonal characteristics and could easily fall prey to their control mechanisms.[27] Sensitive to this danger, Graham and Hershman engaged viewers in competing reflective processes that undermined the transparent transmission of information.

Past and Illusion and *Performance/Audience/Mirror* constituted quasi-dysfunctional disciplinary apparatuses. They resembled systems of surveillance and behavioral regulation because of their sharp segmentation and close monitoring of the visual field, yet they also departed from these models of social control thanks to the oblique and asynchronous relations they generated between spectators and their representation. The docility of mannequins in *Past and Illusion* and of audience members in *Performance/Audience/Mirror* was merely apparent. The figures in the Bonwit Teller windows seemed suspended between slumber and wakefulness. Far from assertively displaying their possessions or their bodies, they looked as if they had no wish to promote new commodities. Similarly, *Performance/Audience/Mirror* did not offer a model of disciplined conduct. Graham admitted that his descriptions were easily contradicted, since he was unable to catch up with the swift shifts in the reactions of spectators. Foucault maintained that discipline is imposed through "the constitution of '*tableaux vivants*,' which transform the confused, useless or dangerous multitudes into ordered multiplicities."[28] Even though the bedroom scene in *Past and Illusion* looked like a diorama reconstituting the private life of a New York couple and *Performance/Audience/Mirror* had the attributes of a sociological experiment testing the docility of participants, both works purposefully failed to provide efficient models of social order. Instead, they conveyed portraits of perplexed individuals and collectivities that did not comply with prescribed roles or social expectations.

Both works parodically simulated the compartmentalization of society necessary for the maintenance of rigorous control and the prevention of antagonistic attitudes. The video images of passersby intruded in the otherwise idyllic realm of Bonwit Teller, which needed to remain in isolation from potential consumers in order to stir their desire for commodities. The far from enviable situation of the mannequins, waking up to discover their public exposure, compromised the idyllic dimension of the tableau, thus instilling critical distance. *Performance/Audience/Mirror* also built on tactics of information compartmentalization to consolidate surveillance. Embodying the role of a performer assiduously trying to identify any change in the behavior or expression of the audience, Graham divided spectators into multiple groups depending on how far away they were from him. Moreover, he put distracted viewers on the spot by describing their absentminded gazes or hinting at

their narcissistic observation in the mirror. Foucault contended that disciplinary training is generally targeted not at controlling the masses as a whole but at regulating the dynamics between various groups. He asserted that in the interest of active supervision, "the crowd, a compact mass, a locus of multiple exchanges, individualities merging together, a collective effect, is abolished and replaced by a collection of separated individualities."[29] Aptly following this surveillance principle, Graham implicitly coordinated the behavior of different segments of the audience while noting their distinct attitudes. Nonetheless, he often found himself at a loss upon discovering that his observations were literally dismissed by the quick reactions of spectators: "Well a moment ago they were smiling now they're very serious. Ummm . . . and now there's a half smile that comes up to a full smile in the case of a couple of people."[30] Graham remarked how some viewers came to self-police their conduct in order to react to his affirmations. By alternating between different modes of perceiving the audience and commenting on their responses, he sometimes acted as an analyst seemingly trying to suppress his subjectivity in the act of observing the behavior of individuals, whereas at other times he appeared as a skillful guard inducing certain responses through his comments. These presumably objective stances were intermittently called into question by the outbursts of affect, which betrayed the interpersonal construction of the situation and the more or less complicit roles adopted in the performance. Mimicking mechanisms of social control, yet never able to stay truly aloof, Graham gave away the potential for disruption that exists in any social system.

Surveillance power was less individuated in *Past and Illusion.* The video camera broadcasting live images of the street scene remained concealed, and the mannequins appeared more menaced by the gaze of passersby than intent on engaging with it. The tableau did not easily engender viewers' identification with the figures. The male figure had his head turned away from the window, and the female figure cast a distracted glance that departed from the alluring gaze of the reclining nudes in the paintings of the masters. The mismatch between the viewpoints of the mannequins and those of the passersby, as well as the hidden orientation of the camera lens and the oblique position of the TV set, impeded the gratification normally granted by the recognition

of oneself in the eyes of others. This purposeful subversion of voyeuristic and narcissistic pleasure encouraged reflection on the operations of the surveillance apparatus and forewarned participants about the risk of seeking comfort in the utopian displays of upscale stores. Through her careful staging of the bedroom setting, Hershman reoriented onlookers' gaze from the immersive spectacle of consumerism to the more vivid and heterogeneous scene of pedestrian traffic.

Past and Illusion and *Performance/Audience/Mirror* engendered not only an overflow of visual reflections but also a complex chain of refractive cognitive processes that interfered with the oneness of the supervision regime. The inconsistencies between viewpoints in Hershman's installation and the equivocal relations between mirror reflections and verbal descriptions in Graham's performance unsettled the participants and underscored the degree of uncertainty subsistent even in surveillance systems. The disruption of parallelism heightened affective responses. In *Past and Illusion*, the mannequins no longer served as docile props in the construction of consumer desire. They echoed the objectification of passersby whose images were integrated in the closed-circuit system but did not necessarily offer empathetic comfort, since they themselves were the victims of onlookers' intrusive glances. Hershman alerted passersby who took the time to contemplate the store window to the need for peering beneath the veil of images in order to discover the hidden apparatus of social control.

Graham was similarly preoccupied with calling for heightened states of consciousness and agency. His inability to synchronize his bodily sensations with verbal descriptions and mirror images kept spectators on the edge. Graham paused frequently as he struggled to define his experience. His perplexity confirmed that "the skin is faster than the word," as Brian Massumi eloquently observes in his discussion of affect.[31] At times, the boundaries between Graham's performative intention and spectators' expectations became fuzzy and his motion was suspended, as his description indicates: "It's funny how the feet are now splayed apart. They're always asymmetrical as if the audience, as if I deliberately want to unbalance myself; but I don't move; I'm stationary."[32] Such instances spoke to the difficulty of distinguishing between personal choices and choices one is conditioned to assume under

certain social circumstances. They slowed down the performer's flux of observations and indicated that even seemingly unassailable regimes of supervision can become volatile when behavioral dynamics become too complex to be fully charted. The positive implications of the emergence of affect in psychotherapy are more widely accepted today than in the 1970s. Peter Buirski and Pamela Haglund acknowledge that affective manifestations can contribute to significant reevaluations of a patient's behavior: "Experiences of affect in treatment provide opportunities for new organizations to form, as well as for growth in the areas of self-regulation and sharing of affect states."[33] Graham's difficulty in explaining his bodily postures and accounting for the viewers' broad range of behavioral responses prompted destabilizing affective experiences that called for a critical reassessment of the misconceived separation between self and others.

The concatenation of ties between participants ended up puzzling the performer, making him doubt the objectivity of his statements. Graham increasingly found himself at a loss when attempting to make generalizing remarks about audience groups. He ended his second performance of *Performance/ Audience/Mirror* by concluding that spectators were gradually communicating among themselves more than reacting to his presence. Hence, it was evident that he could no longer keep up with the unforeseen variations in their expressions and attitudes over time. Thierry de Duve has aptly affirmed that Graham's performance disclosed the mistaken view that collectivities can be treated as unchanging homogeneous groups: "The production of a group imaginary—whether class consciousness or hippie conviviality—cannot result in a coherent vision of the world stated from a common point of view."[34] In addition to questioning the uniformity of collectivities, *Performance/Audience/ Mirror* interrogated the unassailability of surveillance regimes by disclosing the erosion of their mechanisms of social control and the emergence of affective and behavioral alliances that defy the panoptic gaze.

Graham and Hershman deflected reflective images in order to unveil the risks of becoming absorbed in systems of surveillance that hinder social change and thwart self-reflection in relation to heterogeneous groups and environments. In the following section, I will discuss how they also undermined the control exerted by consumerism over individuals through similar strategies of intertwining conflicting frames of visual reference.

Discrepant Reflections: A Technique of Bracketing Consumer Spectacle

In this section, I will focus on how Hershman's *Time, Identity, Transformation,* the middle component of *25 Windows,* and Graham's *Video piece for showcase windows in a shopping arcade* critiqued the underlying mechanisms of the consumerist society through the design of asynchronous visual systems nested inside one another like Chinese boxes. I will show how these works insidiously replicated and disrupted the visual rhetoric of commercial display that generates commodity desire by isolating viewers from the broader social environment.

The 1976 sketch for *Video piece for showcase windows in a shopping arcade* proposed the insertion of two interconnected closed-circuit video systems in two parallel store display windows containing large mirror panels against their back walls. The left window included a camera turned to the interior and a monitor facing the exterior, which displayed delayed images transmitted from a camera situated in the opposite window. The right window included a similar setup composed of a camera turned to the exterior and a monitor facing the interior mirror wall, which displayed live images from the camera located in the other storefront. The images circulating across these closed-circuit systems were integrated into an additional visual system

Dan Graham, drawing of *Video piece for showcase windows in a shopping arcade,* 1976. Courtesy of Dan Graham, Marian Goodman Gallery, Paris, and Greene Naftali, New York.

represented by the glass facade of the stores and the parallel mirror screens flanking the window cases.

By the 1970s, closed-circuit television had already been used in the design of store display windows. In 1968, the facade of the On store in New York featured nine monitors showing live images of consumers shopping inside the store next to images of commodities.[35] Whereas this genre of closed-circuit display was meant to entice passersby to follow the example of others and buy more products, Graham's *Video piece for showcase windows in a shopping arcade* shifted viewers' attention from the merchandise to the social context in which the shopping experience occurred. In this way, Graham hoped to undermine the manipulation of consumer desire resulting from the enchantment of consumers with the promises offered by commodities. The installation functioned as an interface between various groups of spectators more or less likely to become customers of the shops yet commonly involved in interdependent economic and social networks.

Video piece for showcase windows in a shopping arcade was displayed in a shopping arcade in Groningen, the Netherlands, in 1978. According to Graham, the installation could be embedded in any two facing shops, irrespective of the type of merchandise they sold. Within the work's reflective framework, images of consumer objects underwent a process of multiplication that diminished their capacity to inspire fetishistic desire. Birgit Pelzer has remarked that the modified storefronts distanced passersby from the commodities: "The constant interchange of different reflections from both inside and outside the vitrine introduced a yawning gap, an insecurity about the image."[36] The installation bore similarities to Graham's *Video piece for two glass office buildings* (1974–76), which invited viewers to contemplate the exchange of visual information between two offices located in opposite buildings, and *Picture Window Piece* (1976), which encapsulated images from the interior and exterior of a house. By embedding discrepant visual systems in spaces with diverse functions, Graham disclosed that they were all based on sets of enclosures and openings that regulated social behavior.

Using more specific frames of reference, Hershman's *25 Windows* examined the disjunctive relations between the customers of Bonwit Teller and the social landscape of New York. The component *Time, Identity, Transformation*

approached age- and gender-related concerns. Composed of several non-linear narrative tableaux arranged along Fifth Avenue, it unveiled how the dissemination of artificial consumerist ideals distorts self-perception, impedes personal transformation, and promotes an illusory notion of endless youth. While Hershman incorporated references to the past and the future in the titles of the other installation components, she purposefully avoided including the word *present* in the title of this one because she wanted to subvert the notion of a stagnating present, which can easily be turned into a commodifiable object of representation. The artist has explained that this choice was "conscious," since "the present could never be frozen."[37] *Time, Identity, Transformation* portrayed the construction of identity as a tortuous process of negotiation between notions of selfhood at different ages.

The first window in this series included a large annotated photograph of Roberta Breitmore, a persona invented by Hershman two years earlier.[38] The image provided instructions for a twenty-minute makeup makeover. The display of this image against an architect's table evoked an intervention in the social space inhabited by the woman in addition to a cosmetic change. The tableau was completed by a set of beauty products and a cinematic sequence of images showing the transformation of the woman, impersonated by the artist, as layers and layers of makeup were applied to her face. The expression on Roberta's face resembled that of glamorous fashion models, but her knowing glance betrayed her awareness of the implications of the transformative process she had embraced. The images reflected women's compelling need to develop alternative identities in order to fit into the patriarchal social environment of the 1970s. Roberta was far from a strongly individualized female figure. Instead, she epitomized a character who illustrated the problems faced by multiple generations of women.

The subsequent windows presented a narrative of self-transformation that spanned a twenty-year period. It brought together a twenty-year-old woman called Blaze Simpson and a forty-year-old woman called Ruth Stein, who looked alike and served as alter egos of a female figure contemplating different stages of her life. Mannequins together with cutouts and illustrations of this figure populated the window display cases. They offered various glimpses into the way women reflect on their changing looks and needs. In

one window, a mannequin was engaged in contemplating what could have been a photograph of herself at a younger age displayed behind a window frame. A caption showed the thoughts of her life-size two-dimensional figure, self-assertively stating, "When I was young I had everything." The past tense of the statement was puzzling given the glamorous look of the woman in the picture, who would probably have been seen as the promise of eternal youth had her image been introduced into a different narrative context. At the bottom of the display case, the artist arranged a series of plates with images of different body parts, which appeared to undergo a process of self-destruction. They were somewhat reminiscent of Hershman's wax casts from the early 1960s and her ceramics for dinners she organized for artist friends and art critics during the 1970s. Ironically, these deteriorated plates were the only part of the installation Hershman sold as a commodity in the Bonwit Teller store during the exhibition period.

The tableaux that followed resembled comic-strip sequences and displayed images of mannequins stripping off their clothes. Captions proclaimed the liberation of women from material needs as they aged and desired to change from within rather than acquire more goods to improve their looks. One speech bubble placed near the silhouette of a naked woman appeared to further the goals of the store, since it conveyed the message "As I grew older I wanted more." However, the visual evidence pointed to the contrary, since the woman had just thrown off her clothes, thus implying that she was not yearning for materialistic values. Hershman implicitly suggested that the model desired to accumulate more knowledge instead of more material goods. Mannequins also appeared in two shower scenes that were suggestive of different degrees of visibility of women in society, as one shower stall was covered in water drops and the other was suffused with steam. The ambivalent relations between the mannequins representing embodiments of one and the same individual at different ages were further enhanced by the design of a stereoscopic visual apparatus through which spectators could gaze simultaneously at two filmstrips portraying models Blaze Simpson and Ruth Stein. The fusion of the women's images at the level of perception evoked the multiple facets of female identity. It also hinted at the shared experiences of the two women.

The final tableau of *Time, Identity, Transformation* returned the viewer to the beginning of the cycle by displaying another mannequin looking at her life-size aged picture while rhetorically stating, "When I was young I had nothing. I know now what I should have known then. Less is more (more or less)." This remark contradicted the one made by her younger self in the first tableau. Mystery also surrounded the ages of the mannequins gazing on their younger or older selves because they had their faces turned away from the viewers. Just like Graham, Hershman cultivated ambiguity and called for repeated intrapersonal and interpersonal negotiations. For both artists, doubting who one is and questioning what one can become represented strategic means for assuming more control over identity construction in a consumerist society.

By generating equivocal relations between visual representations embedded in the utopian environments of storefronts, Graham and Hershman effectively transformed these spaces into heterotopias and underscored their firm anchorage in socioeconomic circuits. Both *Video piece for showcase windows in a shopping arcade* and *Time, Identity, Transformation* featured conflicting temporal intervals through the collage of asynchronous visual or narrative representations. Enunciating the principles of heterotopias, Foucault argued that they "are linked for the most part to bits and pieces of time."[39] The barely observable five-second gap between the video images broadcast on the left-hand monitor and those broadcast on the right in Graham's installation had an unsettling effect on passersby. Their inability to perceive the two store facades simultaneously rendered the situation even uncannier. Similarly, Hershman's assemblage of female personas of different ages reflecting on their past and present identities was bewildering, making passersby ponder the fluctuations of their own desires over the course of time.

The conjunction of competing temporalities in *Time, Identity, Transformation* and *Video piece for showcase windows in a shopping arcade* shattered the impression of uniform time propitious to commercial activities, which are anchored primarily in the present and the immediate future. In *Society of the Spectacle*, Guy Debord maintained that "the time of production, time-as-commodity, is an infinite accumulation of equivalent intervals."[40] Graham and Hershman counteracted this temporal model in their respective installations.

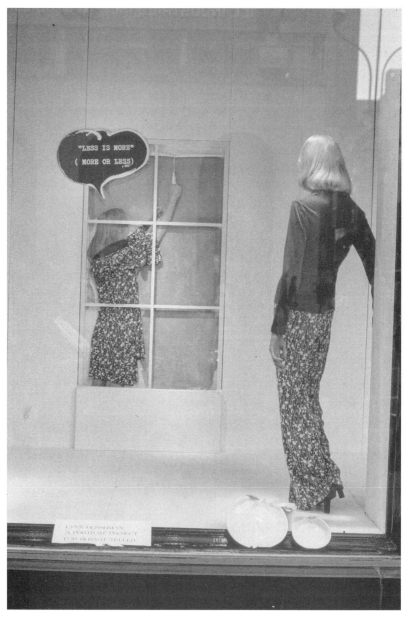

Lynn Hershman, Window 7, "Less is more (more or less)" *(Time, Identity, Transformation)*, in *25 Windows: A Portrait of Bonwit Teller*, 1976. Installation. Courtesy of Lynn Hershman and the Special Collections of Stanford University Library.

They juxtaposed temporal intervals that were at odds with each other in order to impede a seamless transition from the present to the past and vice versa. The delay of images in Graham's installation collided with the time of commodities generally conceptualized as irreversible so that consumers could be constantly tempted to purchase newer and newer products. The blatant display of the aging process in *Time, Identity, Transformation* undermined the ideal of eternal youth advanced by advertising campaigns and confronted passersby with the harsh reality of their limited life spans.

Graham and Hershman turned viewers' attention away from the cyclical renewal of consumer objects in the store windows and toward their own recurrent perceptual, kinetic, and cognitive transformations in relation to the social environment. In Debord's view, the "social absence of death" artificially constructed by the society of the spectacle is equivalent to "the social absence of life" because it prevents individuals from becoming aware of the control exerted by economic forces over their existence.[41] The confusing circulation of information among cameras, monitors, and mirrors in *Video piece for showcase windows in a shopping arcade* stimulated passersby to pay more attention to their behavior in the visual corridor between the two stores. In his installation notes, Graham also suggested that passersby could be permitted to enter the display cases if the storefront design permitted it. Hence, the distance between the potential consumers and the commodities would be annihilated and the mobility of participants would increase. In a similar attempt to emphasize the lived experience of participants, Hershman arranged for Blaze Simpson and Ruth Stein, the women who embodied the virtual protagonist(s) of the *Time, Identity, Transformation* tableaux, to be physically present on the exhibition site at certain times of the day. The signs of the aging process were thus rendered even more evident.

Both installations inspired perceptual games driven by the desire to discover the sources of discrepancies in the perplexing visual systems. Instead of seeking assimilation into the realm of reflections represented by the store windows, participants defined themselves in contradistinction to them and became better acquainted with the illusion of consumer spectacle. Viewers of Graham's installation repeatedly shifted their bodily posture to notice how they could influence the video broadcasts in the two display cases. Individuals who passed by the Bonwit Teller installation moved along its windows

in search of some sort of coherent narrative thread that linked the various portraits of female figures. The key to decoding the meaning of the tableaux lay not in unraveling the mystery of the mannequins' life trajectories but in reflecting on the social conditions that shaped their identities. Both installations set viewers of the store displays into motion and redirected their attention from the store windows to their social context. In his extensive study of arcades, Walter Benjamin noted that commercial spaces gradually came to limit the mobility of pedestrians and subdue social tensions:

> The arcade is a street of lascivious commerce only; it is wholly adapted to arousing desires. Because in this street, the juices slow to a standstill, the commodity proliferates along the margins and enters into fantastic combinations, like the tissue in tumors.[42]

Graham's and Hershman's endeavors to stimulate kinetic engagement and interpersonal awareness sprang from a set of concerns similar to those that prompted Benjamin's criticism of the social stagnation triggered by the arcades in the nineteenth century. *Video piece for showcase windows in a shopping arcade* and *Time, Identity, Transformation* set forth a *mise en abyme* of consumerism. They rendered the mechanisms of stimulating consumer demand redundant by insidiously replicating them and catalyzing mobility.

Graham argued that the public display of goods was merely another mode of concealing the social forces that contributed to their production and alienating individuals from society by strengthening their desire for a surrogate world of consumer objects.[43] The contrasting orientation of the cameras and the video delay in *Video piece for showcase windows in a shopping arcade* interfered with the parallelism between the viewer and the commodities. The complex interconnections between visual frames encouraged passersby to reassess their roles both in the puzzling visual system and in the larger socioeconomic network. The interconnections sensitized viewers to their own agency by highlighting the effects of their movements on the image flow between the two stores. The mirror walls at the backs of the store windows generated an endless chain of reflections, collapsing the boundaries between foreground and background. While the mirrors evoked infinite spatial recession, the

video images were suggestive of infinite temporal regression. The TV set on the left encapsulated both images of what was taking place in the arcade five seconds before and images of what had been presented on its screen ten seconds before. Despite the similarities between the two storefronts, there was no perfect overlap between their images. The discrepant video representations prevented viewers from becoming immersed in an egotistic contemplation of their reflections, which would have only deepened their absorption in the idealized world of commodities.

Time, Identity, Transformation staged a similar spatial and temporal *mise en abyme* even in the absence of actual mirrors. Mannequins placed in the window mimicked the viewpoint of passersby. Just like the viewers, the mannequins were looking toward a window through which they could observe images of women voicing their opinions on the relations among age, material

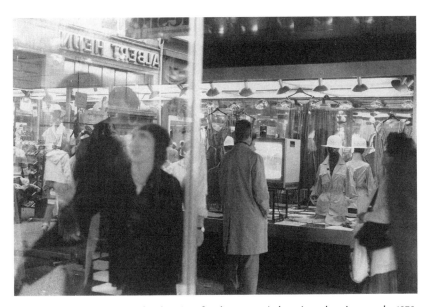

Dan Graham, installation of *Video piece for showcase windows in a shopping arcade*, 1978, Groningen, the Netherlands. Organized by Corps de Garde. Courtesy of Dan Graham and Marian Goodman Gallery, Paris.

possessions, and self-satisfaction. At first glance, the window frame in the storefront also functioned as a mirror frame that could reflect the face of the mannequin standing in front of it. Yet this parallelism remained incomplete in certain tableaux, since some of the women in the pictures spoke in the past tense about their life experience, disrupting the simultaneity characteristic of mirror reflections. The age difference between the female figures and the obscure time frame of each tableau compromised the close identification of potential Bonwit Teller consumers with the narrative protagonists.

The presence of multiple female figures in *Time, Identity, Transformation* and of multiple video channels in *Video piece for showcase windows in a shopping arcade* provided opportunities for critiques of the artificial spatial and temporal frameworks generated by consumerist societies. The works stimulated passersby to define themselves in relation to asynchronous viewpoints. While reconstituting the narratives of aging proposed by Hershman, they were asked to ponder how their self-perceptions changed as they got older. Similarly, passersby who encountered Graham's installation reflected on the way their images were embedded in the video and the mirror images at various times. They observed how their movements became reference points for other viewers interacting with the visual system. Paul Ryan, one of the artists whose cybernetic theories were well known in video art circles in the 1970s, explained that video was an instrument for exploring the process through which notions of selfhood are constituted and revised. He noted that it was also easy *"to be zooming in on 'self' to the exclusion of the environmental systems"* while watching video images.[44] In order to counteract this tendency, Ryan suggested involving others in the process of recording videos so that one would avoid developing a binary relation to the camera lens. Graham's decision to embed his video-based works in public spaces was possibly motivated by a similar realization that the presence of multiple viewers disrupts viewer identification with video images and consolidates social awareness.

Graham's and Hershman's systems of interrelated frameworks expanded not only the relations between visual representations but also the network of relations between participants. Their *mise en abyme* of processes of self-perception recalled R. D. Laing's discussion of cognitive schemata based on chains of interpersonal inferences. In order to enable people to know them-

selves better by envisioning how others perceive them, Laing eloquently suggested: "Put all possible expressions in brackets / Put all possible forms in brackets / and put the brackets in brackets."[45] Ultimately, Laing's proposition was not limited to decoding the intersubjective construction of identity. It revealed the larger social systems in which individuals participate. Graham and Hershman developed a bracketing technique that fulfilled a similar purpose: rather than take their cues from the merchandise and the mannequins in the showcase, shoppers interacting with *Video piece for showcase windows in a shopping arcade* would observe the behavior of other passersby and the social dimension of the arcade environment; likewise, rather than envision the satisfaction they would derive from purchasing Bonwit Teller commodities, passersby who stopped by the tableaux of *Time, Identity, Transformation* would imagine how their living experience related to that of the female personas epitomizing the views of different generations.

In Hershman's installation, bracketing was achieved through the presentation of multiple portraits of women, as well as through the invention of Roberta, the figure illustrated in the first tableau. Her elaborate makeover appeared to respond to the expectations of the patriarchal American society of the 1970s. Amelia Jones has poignantly suggested that Hershman "ironically pointed to both the apparent ease of such a transformation and the superficiality of such a 'cosmetic' change."[46] The resemblance of the cosmetic chart to an anatomical diagram with numbered sections further supported this idea. The makeup revealed the underlying tissue of the woman's face. It was thus implied that she was about to undergo a plastic surgery instead of a mere temporary makeover. Additionally, the discolored areas of her face in the chart hinted at her depersonalization and the commodification of her image.

Hershman conceptualized Roberta's persona in terms of a reflective interface. She argued that Roberta "was a kind of mirror for the society she reflected" and "an interactive vehicle used to analyze culture."[47] Through the public display of Roberta's makeover, Hershman invited passersby to take part in the multiplication of her persona by imitating the cosmetic procedure. Yet this invitation was clearly insidious, given the makeover's resemblance to a surgical intervention. The potential ubiquity of Roberta as a result of viewers' identification with her revealed the store's complicity in the perpetuation

of every woman's desire for a makeover that would make her fit better within the patriarchal society.

Self-transformation was a more implicit component of Graham's *Video piece for showcase windows in a shopping arcade*. The installation became complete only when shoppers interacted with its contrasting visual systems. While stores would normally encourage potential customers to imagine themselves playing well-defined roles in order to spur consumer demand, Graham was intent on stimulating them to perform variable gestures that rendered the differences between the visual systems installed in the storefronts more discernible. The viewers' initial inability to tell how the closed-circuit systems functioned, along with the discrepancies they noted between the mirror images and the video images, intensified their affective responses and oriented their gazes toward other pedestrians moving through the shopping area.

The *mise en abyme* of consumer spectacle in Graham's and Hershman's works subverted individual assimilation in the existing cultural, economic, and social systems. Furthermore, it gave vent to intrapersonal and interpersonal relations that helped viewers negotiate their roles within a broader urban context. In the pages that follow, I will offer an extended consideration of the affective ties generated by the two artists' installations.

Interpersonal Alliances across Reflective Projections

In this section, I will delineate how Dan Graham's installation *Public Space/ Two Audiences* and Lynn Hershman's *Reflections and the Future*, the third component of *25 Windows*, elicited a sense of belonging to diffuse collectivities. The two works established affective connections between spectators interacting across mirror interfaces. My use of the term *alliance* in the following analysis of interpersonal responses to these installations is inspired by the philosophy of Deleuze and Guattari, who associate this concept with a process of becoming that undermines hierarchical structures and defies perfect correspondences between an individual and a group with which that person vainly aspires to identify fully.[48] As shown in the prior sections, Graham's and Hershman's works disrupted contiguous relations between individuals and collectivities. Even when the works inspired processes resembling identification or imitation, which Deleuze and Guattari consider to thwart "becom-

ing," these acts were meant to remain imperfect or open-ended in order to catalyze change. There was no perfect coincidence between the subject and the object of desire in Graham's video installations or in Hershman's tableaux of female mannequins' self-transformation.

Specifically designed for *Ambiente Arte*, the exhibition curated by Germano Celant at the Venice Biennale of 1976, *Public Space/Two Audiences* set into motion a chain of inferences based on slightly divergent mirror images and mental reflections. The installation was composed of two rectangular spaces separated by a sound-insulating glass divider. Each of the spaces could be entered through doors located on the long side of the room. While one spatial enclosure had a single reflective component represented by the transparent divider, the other had an additional one represented by a mirror screen covering its back wall. Visitors could observe their reflections from different angles by moving between the two rooms and modifying the distance at which they stood from the two reflective interfaces. They concomitantly performed the roles of subjects and objects of voyeurism. Visitors located in the room with the mirror seemed to be more empowered because they had easier access to multiple sources of visual information that became integrated all at once in the reflective back wall. However, they were also more objectified since their body movements and reflections could be observed with somewhat less mediation through the transparent wall separating the two rooms. Ultimately, neither of the two groups had complete control over the behavioral situation. As Foucault rightly noted, the fate of the voyeur situated in the panoptic tower is intimately correlated with that of the subjects of surveillance, since the voyeur is located within the same spatial enclosure.[49] Participants on either side of the glass divider were equally exposed to the gaze of others, being part of a structure of visual control.

Public Space/Two Audiences was tantamount to an attack on contemplative aesthetic experience within the presumably neutral space of the white cube. Graham explained that the perceptual situation he proposed reversed "the usual loss of 'self'" that takes place "when a spectator looks at a conventional art work."[50] He argued that art viewers are generally invited to identify with art objects and ignore the social and institutional dimension of art galleries. This tendency, he asserted, diminishes self-awareness and renders viewers oblivious to the conditions of perception. In an interview with Rodney

Graham, the artist underlined the commercial aspects of biennials and his desire to undermine the alienation of exhibition visitors:

> And you got tote bags, Gilbert & George tote bags [in the British pavilion], so I thought because I'd done early video time-delay pieces for two showcase windows, I thought the people themselves, the spectators, should be inside a showcase situation looking at themselves perceiving each other.[51]

Graham invited viewers to enter an environment that could not be observed with detachment from an external viewpoint. Irrespective of the room in

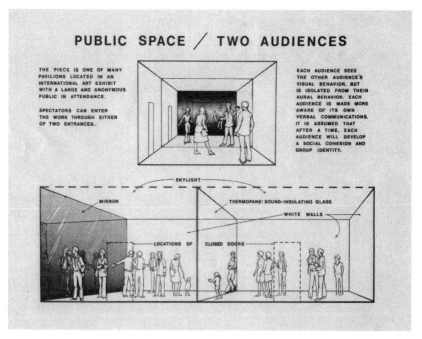

Dan Graham, drawing of *Public Space/Two Audiences*, 1976. Courtesy of Dan Graham, Marian Goodman Gallery, Paris, and Greene Naftali, New York.

which viewers found themselves in *Public Space/Two Audiences*, they could not gain access to a superior perspective on the behavioral context. Their position within the installation was analogous to that of an individual who is part and parcel of a rhizomatic social system that may offer different degrees of reflexivity but does not permit its members an impartial or omniscient viewpoint on its dynamics. Addressing the semiotics of perception, Deleuze and Guattari explain: "It's not easy to see things in the middle, rather than looking down on them from above or up at them from below, or from left to right or right to left."[52] Indeed, viewers were in the midst of a shifting maze of interpersonal observations and inferences in both rooms of *Public Space/ Two Audiences*, lacking the ability to attain control over its space. In this way, Graham parodied art venues by unveiling the lack of autonomy of the individual and the art object within the framework of institutions. In the absence of an object of representation, participants in *Public Space/Two Audiences* constituted the work through the act of actively modeling a public, potentially performative situation in the absence of any specific behavioral cues provided by the artist/director.

Like *Public Space/Two Audiences*, Hershman's Bonwit Teller installation constituted an interface among multiple participants. Their alliances were based both on communicative exchanges mediated by mirror and glass screens and on more or less imaginary projections of passersby into narratives that involved an array of characters, including mannequins, models, pollsters, and futurologists. Out of the three parts of *25 Windows*, *Reflections and the Future* was the component that provided the most venues for communicative exchanges and raised the most direct questions about pressing ecological, economic, and social concerns. The first character that passersby encountered in the windows along Fifty-sixth Street was a female mannequin reading the *New York Times* next to an enlarged version of one of the newspaper's pages that included advertisements and news from prior editions. The tableau underlined the repetition of the past and suggested that transformations can be illusory in the society of the spectacle, where a false notion of newness is constantly perpetuated. In *The Arcades Project*, Benjamin observed that such misconceptions accelerate the effacement of use value. He eloquently explained that the "semblance of the new is reflected, like one mirror in another, in the

semblance of the ever recurrent," thus weakening historical consciousness.[53] Hershman's tableau highlighted the illusory newness promoted by mass media and commodity culture, often with the explicit goal of distracting attention from urgent social issues. The next window presented the reenactment of a crime committed by a balloon seller. The story depicted was culled from a prior newspaper article. In a melodramatic pose, a female mannequin wiped away tears upon witnessing a murder. Her husband had just shot another man, whose body lay on the ground amid a bunch of balloons. Titled "Crimes of Passion," the tableau seemed to suggest that the murder had been committed out of jealousy. However, enlarged text from the newspaper story indicated that there were economic reasons for this incident, since the two men were competing balloon sellers. Oblique mirrors concealed the faces of

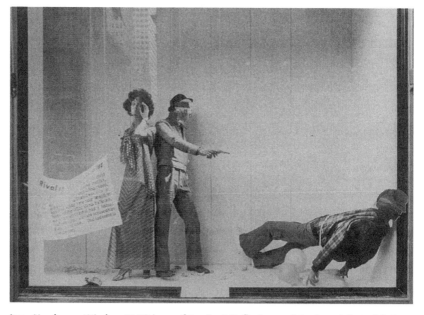

Lynn Hershman, Window 10, "Crimes of Passion" *(Reflections and the Future)*, in *25 Windows: A Portrait of Bonwit Teller,* 1976. Installation. Photograph by Christine Harris. Courtesy of Lynn Hershman.

both male mannequins, rendering the protagonists more anonymous and transposing passersby into a compromising situation by encompassing their reflections.

The following two window displays also triggered mirroring processes between viewers and mannequins. In one, a mannequin sought liberation from the storefront window as her hand broke through its glass surface. A cracked mirror panel was affixed to the presumably broken area of the window to better highlight the woman's attempted escape. The presence of this reflective interface suggested that no complete liberation was possible, because the mannequin would have found herself in another mirror-lined box denotative of social enclosure even outside the store. This notion was reinforced by Hershman's attachment to the same window of an oblong mirror out of which she had cut a silhouette of a woman to indicate the absence of another fugitive mannequin. The artist glued mirror shards to the sidewalk near the window in order to draw more attention to the escape of the models and momentarily disrupt pedestrian traffic. The parallelism that Hershman set up between the display of commercial products in storefronts and the display of the social self in public space echoed Graham's analogy between art objects and art viewers in *Public Space/Two Audiences*. Both installations suggested that there is no ultimate escape from the surveillance regime. Yet, the message of the two works was far from being one of passive contentment and resignation. Hershman later explained that the mannequin's gesture was "a metaphor for someone who was not going to be caught in the entrapment of only being looked at without being able to really participate in life."[54] Similarly, *Public Space/Two Audiences* encouraged visitors to move between the reflective screens in order to undermine their subordination to the gaze of others.

The tableau adjacent to the one unveiling the mannequins' contagious desire for escape extended the fictional narrative into public space. A note informed passersby that Bonnie, the mannequin who had previously inhabited that space, had also broken free and could be seen in various locations in New York according to a preestablished schedule. A live model, who looked like Bonnie, accompanied the mannequin during her adventures in Central Park and Soho, as well as during her visit to the Metropolitan Museum and her stop at a subway station. Nonetheless, Bonnie spoke on her own through an

audiotape implanted in her chest. In the recording, Bonnie presented her life in the Bronx and her social aspirations. Her desire to acquire Bonwit Teller clothing seemed to have prompted her irreversible transformation into a docile mannequin.

The subsequent windows of *Reflections and the Future* triggered a greater sense of urgency and collective awareness. They underscored planetary concerns rather than anxieties about self-identity. With the help of physicist Nick Herbert from the Physics–Consciousness Research Group in San Francisco, Hershman created a polarized panel that had the word "times" written repeatedly on its surface. The word became visible only when sunlight of a certain vibration projected across the panel, and the letters appeared sharper

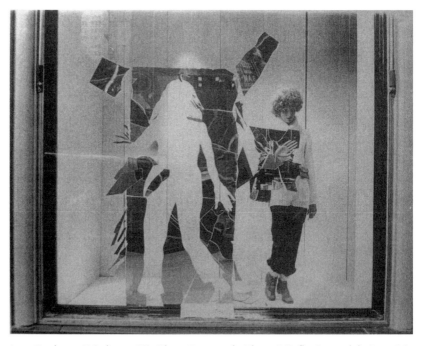

Lynn Hershman, Window 11, "Six-Phase Catastrophe Theory" *(Reflections and the Future)*, in *25 Windows: A Portrait of Bonwit Teller,* 1976. Installation. Courtesy of Lynn Hershman.

or blurrier depending on the degree of light oscillation and the viewer's perspective. The tableau evoked the interdependence of variable elements shaping our complex planetary conditions. The presence of a mannequin wearing a gas mask in the same window further emphasized the need for collective awareness of impending threats.

The next window display built on this idea of urgent need for change, presenting charts of statistical estimates for energy consumption in the New York area between 1960 and 1990. Hershman hired pollsters to ask passersby to fill in questionnaires about their views on energy use; the results were supposed to be distributed to government representatives and oil corporations. In another window, Hershman projected video snippets from interviews with young people conveying their opinions on energy resources. The interviewees equated energy with both social forces and natural resources. They expressed support for the use of alternative fuels and the reconsideration of traditional gender roles that limited women's ability to have an impact on society at large. Hershman wanted to stir conversation about the critical consequences of irresponsible energy use and social behavior. In yet another window, she created a platform for discussion by inviting some of her friends to join a "Committee of the Future" that initiated conversations about impending problems and possible solutions. The discussions had impacts far beyond the people who gathered in front of the Bonwit Teller window, since they were broadcast live over radio.

Both Hershman and Graham hoped to stimulate alternative information networks for knowledge production and identity negotiation. While *Public Space/Two Audiences* encouraged participants to generate nonverbal communicative threads in order to enter into dialogue with others, the discussions of the Committee of the Future enabled passersby to take part in the collaborative production and dissemination of information about future benefits and threats. By introducing individuals into public situations that solicited responses or at least some sort of visual interaction with variable environments or social situations, the two artists endeavored to challenge the boundaries between a seemingly autonomous private self and a socialized self.

Public Space/Two Audiences catalyzed both direct and indirect modes of interaction with the environment. Participants could enter into dialogue with

others by purposefully altering their reflections. They experienced a sense of proximity and group belonging even in relation to viewers situated in the opposite room. In his review of the Venice Biennale, Simon Wilson remarked that *Public Space/Two Audiences* inspired the groups of participants both to interact visually with their reflections and "to confront and interact with each other through glass."[55] Far from adopting a merely narcissistic attitude by concentrating solely on their own mirror images, participants challenged spatial divisions by communicating with visitors in the adjacent room through body language. Concomitantly embodying the roles of spectators and performers, they formed an interpersonal network that, in Jurgen Ruesch and Gregory Bateson's terms, consisted of "potentially equivalent parts" that were equally visible and could alternatively act as sources or destinations of information.[56] Yet participants' perceptions of the two rooms and of each other were always slightly divergent, being influenced by their bodily positions in either of the two rooms and their suppositions about the way others perceived them.

Hershman cultivated affinities between participants and the fictive figures breaking away from the store windows. Bonnie's audio recording of her life story prompted passersby to consider what socioeconomic factors shaped their consumer choices and how their biographies compared to that of the Bronx girl who yearned for the Bonwit Teller lifestyle. In addition to fostering interpersonal relations between pedestrians and mannequins, *Reflections and the Future* elicited the formation of a communicative network in conjunction with the workings of the Committee of the Future. Both spectators and futurologists could transmit information via a two-way microphone system. Passersby raised questions about the future and committee members hypothesized about upcoming changes. The relationship established between these ad hoc collectivities more closely resembled a group network than an interpersonal dyad because of the specific roles assigned to each group. According to Ruesch and Bateson, in contrast with interpersonal networks, group networks are characterized by the "restriction or specialization of function"; such networks are exemplified by large organizations where the flow of data is strictly controlled.[57] Yet the network formed by passersby and futurologists functioned differently from the networks found in such large-scale hierarchical institutions, where individuals are more rarely in di-

rect contact with each other. By constituting the Committee of the Future, Hershman personalized the transmission of information from many persons to many others. The committee members asked audience members to ponder not only the alluring new trends they elicited but also their unavoidable social consequences.

Within the framework of *Public Space/Two Audiences* and *Reflections and the Future*, participants acquired a better understanding of the interdependence between large-scale social systems and small-scale groups. Disrupting the alienating dimension of the individual shopping pilgrimage, the Bonwit Teller tableaux encouraged passersby to migrate from one window to another as part of spontaneously formed collectivities in search of interconnecting narrative threads. In her description of Hershman's installation, Moira Roth mentioned that "huge crowds thronged around looking at the multi-media environments occupied by real people and mannequins."[58] Spectators of the Committee of the Future tableau were part of a broader audience group, and they could spontaneously join or leave the group as they wished. Similarly, participants in Graham's installation could switch rooms and shift their roles in the visual rhetoric of surveillance embodied by the interconnected compartments. These congregations stood for "diffuse collectivities," which sociologist Ralph H. Turner distinguished from compact collectivities based on the divergent behavior of their members, who choose not to act in perfect unison.[59] Participants in both installations could coalesce or disperse in unpredictable ways, hence contributing to the perceptual and social variability of the systems with which they interacted. By highlighting how individuals switch from role to role and form fluctuating relations to large and small groups, the works signaled the proliferation of individuals' alliances with multiple collective entities. Emphasizing the complexity of interpersonal relations, Laing signaled the need for attunement of a person to multiple social modalities that may or may not be fully complementary: "Any one person is likely to be a participant in a number of groups, which may have not only different memberships, but quite different forms of unification."[60] In the second half of the 1960s, the affinities that many individuals had with multiple social movements with interconnected goals probably contributed to the branching out of interpersonal relations into more complex configurations.

Graham's and Hershman's works encouraged participants to establish shifting alliances with others rather than form tight groups that would engage in predictable modes of interaction and develop quasi-homogeneous identities.

Hershman impeded close identification between viewers and narrative protagonists by creating a broad range of personas that played complementary roles in the Bonwit Teller narrative sequence and generated imperfect mirroring processes. The tendency toward alliances with multiple groups was even more visible in the context of *Public Space/Two Audiences* because participants oscillated between two visual regimes that offered competing visual and social cues, thus amplifying their negotiations over interpersonal relations. According to Thierry de Duve, Graham's focus on heightening awareness of how individuals define themselves in relation to collectivities had

> much less to do with the Marxist horizon of a "classless consciousness" than with the American dream, the commune as incarnation of Walt Whitman's "transcendental I," pop music as the basis of great ritual gatherings, the "tribalism" of the media as an answer to the crisis of familialism.[61]

Even though the distinctions between the two groups interacting with *Public Space/Two Audiences* were blurred at the level of the overlapping reflections in the glass screen, participants were acutely aware of the distinctive conditions of each surveillance regime. They entertained diffuse alliances with groups in both compartments, given the fact that neither of the rooms granted more autonomy to participants.

Accounts of audience interactions with *Public Space/Two Audiences* testify to the affective impulses the installation generated. Mark Francis described participants' inclination to imitate each other's gestures and creatively combine them: "The general reaction of visitors is initially to look at each other through the glass and then to start mimicking actions as in a dance."[62] His comparison of social interactions with choreographed movements and his notes on the distinctions between spectators' perceptual observations emphasized the tension between similarities in conduct and disjunctions in subjective experience. The high degree of variability inherent in this inter-

personal system was a sign of affective attunement. From the perspective of psychoanalyst Daniel Stern, it is only the incomplete match between the gestures or expressions of two persons that testifies to the bond established between them.[63] Graham's remarks on the installation also revealed the affective alliances established between participants even when they were separated by the dividing wall: "While the glass-partition on one hand places a distance between opposing spectators, on the other hand, the co-presence on the mirror of the two groups' bodies and the visual image of their process of looking make for an extreme visual inter-subjective intimacy."[64] Through observing their self-reflections, participants sensed the contingency of their

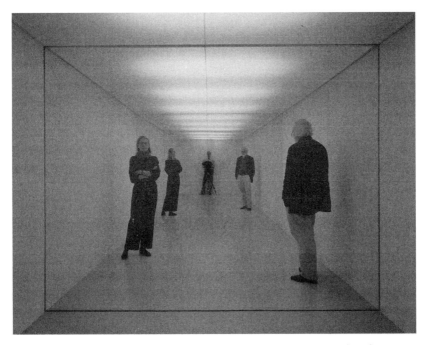

Dan Graham, *Public Space/Two Audiences*, 1976. Installation, two rooms, each with separate entrance divided by thermopane glass, one mirrored wall, muslin, fluorescent lights, wood, 220 × 700 × 220 cm. Installed at the Herbert Collection, Ghent, Belgium. Courtesy of Dan Graham and Marian Goodman Gallery, Paris.

acts. Physical separation strengthened their affective alliances. It emphasized the unsurpassable distinctions between them in spite of their shared condition of entrapment in surveillance systems.

The variability of audience groups interacting with Graham's and Hershman's works heightened affective impulses. Participants became part of congregations that could spontaneously grow or disperse. In his salient study on psychic and collective individuation, Gilbert Simondon argued that the presence of a collective reinforces emotional sensations by eliciting further affective transformations and preventing the formation of abstract representations of emotions.[65] Viewers of Graham's and Hershman's installations repeatedly needed to reassess their imaginary and actual projections in the reflective environments depending on the conduct of multiple others whose mirror images would unpredictably enter the visual system. Collectivities could form and dissolve at different paces, depending on the amount of time visitors chose to dedicate to an intersubjective inquiry into the perceptual and behavioral possibilities offered by the two rooms. Fearing the effects of too many social connections that end up placing constraints on the behavior of individuals by clouding their self-awareness and critical judgment, R. D. Laing hoped that members of collectivities would remember that "the group is men themselves arranging themselves in patterns, strata, assuming and assigning different powers, functions, roles, rights, obligations and so on. The group cannot become an entity separate from men."[66] In *Public Space/Two Audiences*, visitors found themselves in a reflective environment that constantly reminded them of their individual roles in the diffuse collectivities formed in the rooms. They were alerted to the undeniable influence of others on their public behavior, but they were also cognizant of the fact that they could resist this influence and introduce changes in the fleeting mirror images projecting across the reflective screens.

While both installations had affective qualities, Hershman's *Reflections and the Future* tableaux had a more visceral impact than *Public Space/Two Audiences*, which introduced participants in insulated abstract gallery spaces. One of the scenes in *25 Windows* with the greatest sensory intensity was the tableau in which the female mannequin appeared to have broken the Bonwit Teller vitrine, her hand emerging intact from the fractured mirror attached to

the store window. The tactility of the tableau was at odds with the culture of visual spectacle, which primarily encouraged distant observation. The mannequin seemed about to come alive and challenge the world of appearances through her embodied presence. The gesture expressed both violence and vulnerability, since the female figure had not managed to emerge fully from the vitrine. The mannequin's escape from the store stood for a process of becoming human through seeking alliance with the passersby. The artist simulated a mute yet highly affective dialogue between the mannequin and the viewers through the interposition of the broken-mirror interface, which simultaneously incorporated fractured reflections of the extended hand and mirror images of the passersby. This compelling coalescence of the inhuman and the human, the alienated individual and the social environment, the visual and the tactile enhanced affective alliances. Philosopher Brian Massumi suggests that the relations between ourselves and our physical surroundings are analogous with those between ourselves and others, both indicating the plasticity of our identity: "Just as the body has already extended beyond the skin into a mutual prosthesis with matter, from its first perception, so, too, is the individual body always-already plugged into a collectivity."[67] The mannequin's extended hand became a symbol of the subject's drive toward entering a heterogeneous social environment where relations between individuals and collectivities are repeatedly reconfigured. The broken mirror was a foil for the smooth glass facade of the store. Its fractured surface conveyed the intricacy of interpersonal relations and contrasted sharply with the spatial and temporal unity evoked by the vitrine.

Besides the diffuse collectivity of passersby gathering around the store windows, *Reflections and the Future* included a collective of mannequins about to break free from the windows or already infiltrated in the social fabric of the city. They were engaged in processes of human becoming as they attempted to form alliances with passersby empathizing with their imprisoned condition. In their theory of affect, Deleuze and Guattari contend that becoming animal implies a transgression of boundaries between different states of being and a drive toward forming connections with "a pack, a band, a population, a peopling, in short a multiplicity."[68] Becoming human in Hershman's installation implied an equally unsettling process of developing alliances

with collectivities. Neither human nor automaton, Bonnie, the fugitive mannequin, shared her story with different social groups in various parts of New York. Her desire to leave behind the role of prop in a store window hinted at the aspirations of individuals to surpass divisions between social classes. In spite of the fact that she could not become fully identical with humans and acquired only a recorded voice, Bonnie mirrored humans' lack of autonomy and their need to acquire more agency. Hershman expected that the mannequins' desire for liberation would spread like a virus not only among the fictive protagonists but also among consumers, who would contemplate how they could mold their identities and trigger social transformations.

Graham shared Hershman's desideratum even though *Public Space/Two Audiences* did not instantiate a process of becoming Other as vividly as *25 Windows* did. By interconnecting reflective screens with different degrees of transparency, he subverted one-to-one correspondences between individuals and social systems. Heavily invested in upsetting fixed roles and categories, the artist argued: "Systems of information seem to exist somewhere halfway between material and concept, without being either of these."[69] The shifting network of reflections in *Public Space/Two Audiences* impeded the formation of hierarchical systems of relations. Changes in behavioral responses to the two reflective components made the whole series of interpersonal alliances undergo transformations like a set of glass particles being rearranged inside a kaleidoscope. Closely acquainted with Bateson's theory concerning the cybernetics of the self and society, Graham upheld his belief in the inevitable links between the environment and its elements, which evolve in tandem without being strictly separated from one another. Bateson thought that we wrongly assume that a system changes based on cause-and-effect relations between its separate components and the larger whole. He proposed that "the 'self' as ordinarily understood is only a small part of a much larger trial-and-error system which does the thinking, acting, and deciding."[70] Both Bateson and Graham suggested that the boundaries of the self and social systems are expandable and permeable. Hershman also embraced this system-oriented approach. She was concerned about the complacency of individuals with fixed roles and the inability of society to react to alarming environmental and social circumstances. In an interview with Alanna Heiss, she persuasively out-

lined the need for a constant reevaluation of our relations to our surroundings: "We are all in a terminal state of time and space. It is up to each of us to determine the qualities of each day, to feel the subtleties of air change from morning to afternoon."[71] Hershman wanted to enhance participants' responsibility not only toward their local settings but also toward the broader social and ecological systems that have impacts on their existence.

Mirroring acts in Graham's and Hershman's artworks of the 1970s had the function of strengthening interpersonal relations and undermining the stability of hierarchical systems through which consumer desire and social docility are consolidated. By contrast with reflective art practices in the 1960s, which were primarily meant to inspire phenomenological investigations, these works created explicit analogies between visual systems and socioeconomic systems. Criticizing the passive immersion of individuals into controlling systems, Graham and Hershman pointed out that people need to reassess their points of view in relation to the shifting web of interconnections between themselves and their environment, since this is the only way through which they can avoid becoming mere pawns on the grid of societies of surveillance and consumerism.

Mirror Intervals
Prolonged Encounters with Others

*I am not a prisoner of history. I should not seek there for the
meaning of my destiny. I should constantly remind myself that
the real leap consists in introducing invention into existence. In
the world through which I travel, I am endlessly creating myself.*

—Frantz Fanon, *Black Skin, White Masks*

In recent decades, installation artworks and large-scale sculptures with re-
flective properties have acquired a prominent position both in public spaces
and in art institutions. The inverted eye of Anish Kapoor's *Sky Mirror* (2001)
displayed in Nottingham, the reflective ceiling of Olafur Eliasson's *The
Weather Project* (2003) at Tate Modern, and, more recently, Doug Aitken's
Mirror (2013), a work presenting live images of local landscapes against the
facade of the Seattle Art Museum, have attracted large audiences eager to
observe images of themselves and their surroundings momentarily encom-
passed in the visual field of artworks. Such artworks have been both highly
praised for their democratic value and criticized for their spectacular di-
mension. They expose participants to similar perceptual conditions while
concomitantly hinting at unavoidable incongruities between their view-
points. In contrast to cinematic or theatrical modes of spectatorship, large-
scale reflective artworks highlight the bodily proximity of audience mem-
bers gathered around shifting visual fields molded by their movements. By
fostering interpersonal relations between viewers engaged in aesthetic con-
templation, these works are anything but autonomous art objects and show

that we, as individuals, are anything but autonomous from each other or the spaces we inhabit.

In this chapter, I will focus on three large-scale reflective artworks that prolong into the present the turn of the 1960s toward system aesthetics and the critique of surveillance of the 1970s. Anish Kapoor's *Cloud Gate* (2004), Ken Lum's *Pi* (2006), and Olafur Eliasson's *Take your time* (2008) elicit interpersonal mirroring acts and invite viewers to consider their shifting roles in social networks and the potential for suspending the usual order of things. They are consonant with the increase in scale of installations and the rise of relational art during the 1990s, two factors that have contributed significantly to a forceful return to the reflective media that were so prominent in the 1960s. In recent decades, artists have employed these media less out of a desire to challenge autonomous objecthood and more out of a need to unveil the limits of individual autonomy.

Kapoor, Eliasson, and Lum belong to distinct artistic lineages, but their practices converge at the level of their belief in the perpetual becoming of individuals and the world. Their repeated use of reflective materials is informed by an interest in stimulating perceptual, affective, and mental reflection. Kapoor's sculpture has been most commonly associated with minimalist and postminimalist tendencies, Eliasson's environments have been repeatedly placed in the lineage of light and space art, and Lum's photographic series and installations have been anchored within the framework of conceptual art. These artists' somewhat distinct stylistic affinities are further complicated by their diverse cultural affiliations. Kapoor is an artist of Indian Jewish descent who currently lives in London; Lum is a Canadian artist, born into a family of Chinese immigrants, who now lives in Philadelphia; and Eliasson is a Danish Icelandic artist who has set up a large studio in Berlin but repeatedly returns to Iceland to observe the dramatic transformations of the landscape over short and long time intervals. Given these artists' different artistic trajectories and cultural backgrounds, their works have rarely been discussed in conjunction with one another, although they are equally informed by an interest in the phenomenology of perception and the plasticity of identity.

In this chapter, I discuss the intersubjective implications of Kapoor's *Cloud Gate*, Eliasson's *Take your time*, and Lum's *Pi*. These reflective installations simultaneously fuel and critique what Terry Smith has termed the contem-

porary "iconomy"—a culture and economy of spectacle based on iconic images that draw upon both private and public capital.[1] In the first section, I examine the ways in which the above-mentioned works constitute passageways between public and private spaces as well as between a personal sense of time and a sense of shared history. In the second section, I analyze the intersubjective spectatorial modes triggered by these installations, starting from psychological theories of behavioral attunement and theories of affect. In the third section, I take a closer look at how these works betray changing perspectives on individuality and collectivity. *Cloud Gate, Pi,* and *Take your time* implicitly mirror the failed ideals of both capitalism and socialism and favor modes of engagement that maintain the tension between singularity and plurality, keeping spectators on the cusp between narcissistic and voyeuristic tendencies. They call for an enhanced understanding of the world as a complex system that defies predictability and absolute control.

Unlike their avant-garde precursors from the beginning of the twentieth century, Kapoor, Eliasson, and Lum do not consider themselves agents of major changes within society. Instead, they portray themselves as catalysts of small-scale transformations that involve viewers at an individual level while at the same time enhancing their awareness of a larger picture—denoted by the mirror images of the cityscape in *Cloud Gate,* by the presence of other participants in a shared spectatorial experience in *Take your time,* and by the fluctuating local and global statistical information in *Pi.* Kapoor, Lum, and Eliasson instill doubt in perception and representation. The evanescent reflections continuously captured by their works in real time portray the endless variability of the individual and the world. Compensating for the increasingly remote connections between ourselves and others, these installations provide alternatives to online social media by building collective consciousness and group alliances in physical space.

Reflective Spatiotemporal Passageways

Kapoor, Eliasson, and Lum often situate viewers at spatial and temporal crossroads by denying them access to a set of precisely delineated aesthetic choices or participatory roles. They ask viewers to embrace the indeterminate interval between one state of being and another, thus offering them a glimpse into

the plasticity of the world and selfhood. Their reflective works constitute liminal spaces and temporalities in which differences between flatness and depth, as well as between mutability and presentness, become questionable.

Even though these three artists have followed somewhat different artistic trajectories, they share more than an interest in the use of materials with reflective qualities. Since the early stages of his artistic career, Kapoor has taken an interest in the ritualistic aspects of art, the coexistence of opposite principles, and the ambiguous nature of matter and concepts. Variously classified as a late modernist who perpetuates the minimalist tendency and as a contemporary artist who deftly appropriates "the new visual language of our digital era,"[2] Kapoor embodies in his work the contingency of multiple temporalities so characteristic of the contemporary condition.[3] His sculptures bring forth a perplexing realization of the conflicting times of lived experience. They situate viewers on the boundary between transitoriness and immanence by confronting them with perceptually ambiguous visual and material referents.

Both Kapoor's sculptures based on the motif of the void from the latter half of the 1980s and the ones based on reflective materials from the mid-1990s betray his interest in the perpetual deferral of representation. These works challenge the distinctions between blunt flatness and immersive depth and open up the space of the object to intersubjective relations. *I* (1987), one of Kapoor's first sculptures dealing with the void, presents the viewer with a boulder whose upper part is pierced to reveal its abysmal inner core, which can be easily intuited yet remains unseen. A conceptual twin of *I*, *Void Field* (1989) destabilizes the binary relation between the beholder and the object even further by multiplying the number of perceptual referents. Composed of several stone blocks staring back at the viewer through their dark oculi, the work renders the notion of an infinite emptiness perplexing by abolishing the singularity of the void and unveiling its presence at the core of all things. Moreover, it does away with the uniqueness of the individual viewer's perspective. The plurality of the similar-looking objects parallels the plurality of perceiving subjects.

Even before he started to use reflective surfaces, Kapoor envisioned the aesthetic experience prompted by his works in terms of a mirroring process:

When I started working with the void, hollowness, emptiness became my main focus. . . . The relationship with the spectator became more intimate. I was looking for a condition of emptiness, which if it was empty enough might return your gaze like some blind mirror.[4]

The lack of perfect coincidence between the perception of reflections and the embodied experience of the world destabilizes the subjectivity of the viewer. The encounter with the void or the mirror images encompassed by Kapoor's sculptures brings out states of imbalance and doubt. Kapoor described his first use of mirrorlike materials in terms of experimentation with spatial depth meant to undermine the certitude implicit in objecthood.[5] By employing concave stainless steel surfaces, he created works that not only gave the illusion of visual depth but also extended the world in front of the mirror into a swirling reflective space with its own visual and spatial logic. Such sculptures make viewers question the space and temporality of their bodies as well as the coordinates of the world they live in.

Kapoor's sculptures generally conceal all traces of the human agency involved in the manufacturing process. The mystery of their construction deepens the uncanniness of their perpetual metamorphosis in relation to the display context. Kapoor's inquiry into seemingly self-generating shapes that obscure human agency has become even more evident in installations such as *Past, Present, Future* (2006) and *Svayambh* (2007).[6] Their shapes are gradually carved out of wax through the movement of apparently unstoppable mechanisms partly hidden from view. They are literal extrapolations of Kapoor's idea of an autopoietic (self-creating) artwork, which gives shape to itself by prompting a recurrent reorganization of its content. Stainless steel objects mirror the same concept, since their images perpetually alter with the ebb and flow of people moving past them.

In contrast with Kapoor, who cherishes the mysterious oneness of the art object, Olafur Eliasson conspicuously displays how his works are assembled. Despite this significant difference, both artists embrace phenomenological interests and are intent on deconstructing the Western idea that humans stand for the primary engine of the world, having been given the supreme task of overseeing its progress. Their artworks expose the unpredictability of

lived experience, the contingency of subjects and objects of perception, and the potential for individual transformation subsistent in spatiotemporal intervals that disrupt the quotidian flow of information.

Throughout his prolific career, Eliasson has staged color and light environments as well as natural phenomena in indoor and outdoor settings. He has also created architectural configurations, conceptual photographic series, and interactive environments using old and new media. Despite the celebrity status he achieved as a result of the enormous success of *The Weather Project* at Tate Modern, Eliasson has managed to maintain the highly experimental nature of his approach by working with a large team of designers and engineers in his laboratory-like studio in Berlin. The collaborative production of his works has probably led Eliasson to envision the process of art reception as an intersubjective experience. He has eloquently explained his view of the social implications of perceptual and creative acts: "To me, the potential of an object is difficult to decipher if I'm alone, because it lies very much in the object as a social construct."[7] He regularly tests out his ideas within the framework of interdisciplinary workshops and collective afterimage experiments through which audience members can discover their ability to perceive colors and shapes that lack a corresponding index in physical space.[8] In the context of such projects, Eliasson adopts the role of a conductor, informing participants how long they need to focus their eyes on certain objects or images for optical phenomena to occur. These experiments imply an intersubjective mirroring process between participants, since each of them feels that he or she is the producer of a subjective experience that can be affectively shared, to a certain extent, with other audience members.

It is striking how much Eliasson's projects recall the aesthetics of works from the 1960s. *Room for one color* (1997) brings to mind Les Levine's *White Sight* (1969), an environment based on the use of monochromatic lamps.[9] In both cases, visitors who enter these spaces plunge into a yellow field of light in which all other colors are reduced to grayish hues. Eliasson's inquiry into the phenomenology of color perception also bears resemblances to Carlos Cruz-Diez's *Chromosaturations*, which immerse viewers in light environments that highlight the relativity and subjectivity of sensory experience in order to indicate that individuals are actively producing what they see. The list of analogies

of Eliasson's practice with works from the 1960s and 1970s is even more exten-sive than this. One can identify many close correlations between his projects and those of artists Daniel Buren, Robert Irwin, and Maria Nordman. These resemblances are not intentional or subversive, but they should not be judged merely as a set of coincidences that lack importance. They are revelatory of the extension of the temporalities of the past into the present as a result of our continuing need to contest prevailing modes of disciplined perception and acquire a greater awareness of how we actively shape our experience.

Mirrors have been prevalent in Eliasson's practice from the beginning of his career. They constitute a medium that predisposes viewers toward phe-nomenological exploration. For *Mental* (1993), one of his earliest works based on reflective materials, Eliasson placed a mirror over the full length of a gal-lery wall and played a recording of his pulse in the background. The instal-lation simulates a virtual encounter between the viewer and the artist, who are united by ethereal traces of their bodily presence: visual reflections and heartbeat oscillations. Mental reflexivity and visual reflections also stand at the center of Eliasson's *Your Compound Eye* (1996), a kaleidoscopic device com-posed of inclined mirror panels through which viewers can examine their surroundings from different angles. The installation serves as an interface between visitors since this optical apparatus is open at both ends, permitting viewers to watch each other's images within the swirling field of multilayered reflections. Eliasson has repeatedly underlined the role of intersubjectivity in assessing perceptually confusing objects or environments, asserting, "When you have people around you, they become a way of measuring visibility, depth, time and distance."[10] Whereas *Your Compound Eye* gives viewers the chance to use the work as an optical instrument detached from their bodies, *La situa-zione antispettiva* (2003) and *Multiple Grotto* (2004) ask visitors to step within kaleidoscopic devices. Inside these stainless steel environments, participants can watch their reflections in the fractured space of slanted mirror panels or gaze through small oculi at the gallery spaces lying beyond the environments' interior visual mazes. By staging ambivalent perceptual situations, Eliasson cultivates an ethical awareness of the fact that we share our surroundings with multiple others.

Ken Lum shares Eliasson's preoccupation with transforming viewers into

observers who are neither too close to nor too detached from their surroundings. He stages and represents situations that call for an active evaluation of perceptual and social possibilities in order to raise individual responsibility and intersubjective awareness. A descendant of the generation of conceptual artists of the 1970s who radically attacked closed systems of information and mechanisms of social control, Lum unpacks the subversive ways in which corporations manipulate images and language to create the illusion of a happy conformist society. Through his performances, photographic series, and installations, he underlines the need for self-involvement and interpersonal exchanges in order to counteract individual passivity. Lum is acutely conscious of the invisible boundaries that separate social and cultural groups and aims to create works that provoke encounters between people. In talking about how his identity has shaped his practice, the artist has noted that he developed an acute sense of observation while growing up in a Chinese neighborhood on the east side of Vancouver: "My movements were very, very circumscribed. I was always watching. Watching and observing situations."[11] Many of his works are suggestive of this voyeuristic experience of feeling intimately connected to the lives of others. Just as Kapoor's sculptures situate viewers on the edge of void or reflective fields that absorb them perceptually while simultaneously denying them complete access to the mirror world, Lum's practice exposes them to perplexing scenarios that encourage them to identify with others in order to assess the situations in an ethical manner.

Lum's preoccupation with exposing the suppression of individuality has been manifest since the early years of his formation as an artist. Critical of formalism and the presumed neutrality of art galleries, Lum became invested in devising strategies for uncovering the artificial separation of artworks from social systems. His sculptural works from the early 1980s bear strong connections to minimalism. Composed of furniture pieces, they are connotative of the warmth of family life, but they are deprived of functionality, being arranged in closed circular or rectangular configurations that deny viewers access to their space. While they mimic the gestalt of minimalist objects, these works contradict their impersonal aesthetics and challenge the ideal autonomy of museum visitors' experience. During the same period, Lum also built on the traditions of pop art and conceptual art, subversively appropriat-

ing the visual vocabulary of corporate advertising. He created photographic series that bluntly show how brand power is consolidated by means of individual or family identity markers.[12] Numerous works from his *Diptych* series, started in 1993, solicit the viewer to relate empathetically to the functions fulfilled by individuals within global networks of production and consumption.

Lum's first use of mirrors dates back to his residency in a Tuscan village in 1997, when he developed a community-oriented project by asking local residents to affix personal photos to a long mirror panel placed on a wall. The work had a site-specific character, being inspired by Catholic offerings.[13] It constituted a symbolic gift exchange between the artist and the community. The mirror acted as a bridge between the present and the past of the village by incorporating both reflections and photographs of its inhabitants. Building on the concept for this project, Lum created the *Photo-Mirror* series (1998), a work composed of rectangular mirrors surrounded by found photographs selected by the artist. No longer representative of a specific community, this work intertwines disparate memories of anonymous individuals. The loose ties between the people pictured in the photographs parallel the fragile relations established between viewers as their reflections invade the space of the mirror panels.

The mirror motif is reiterated in Lum's *Mirror Maze with 12 Signs of Depression* (2002), which is composed of a disorienting series of reflective panels. Short statements associated with the diagnosis of depression, such as "I feel alone in the world" and "I cry for no reason," are etched on the transparent partition walls. As visitors struggle to find their way through the reflective maze, the movements of others provide reference points for their positions in space and interfere with the state of self-absorption conducive to the deepening of depression. The empathetic alliance with other participants interacting with the work serves as a foil for the identification with the etched signs and emphasizes the mutability of psychological states under the influence of intersubjective exchanges.

Kapoor, Eliasson, and Lum explore the versatility of mirroring processes, which call for self-inquiry and interpersonal communication simultaneously. Their respective works *Cloud Gate*, *Take your time*, and *Pi* show the fluidity of spatial and temporal coordinates, which vary with the movement of visitors

whose images are temporarily encompassed in the reflective screens. In the remaining part of this section, I will explain how these works function as passageways and provide a heightened sense of presentness.

Located on the AT&T Plaza in Chicago's Millennium Park, Kapoor's *Cloud Gate* (popularly known as the Bean) confers specificity to its context of display, turning it into a key symbolic marker of the city. The work fulfills multiple roles, since it can be defined as a transitory space through which local people pass repeatedly on their way to work, as a temporary dwelling where inhabitants return during their spare time, or as a site of spectacle—a must-see icon for every tourist visiting the Midwest metropolis. *Cloud Gate* is suggestive of both transitoriness and immanence. The smooth transformation of its silver surface contrasts with the stability evoked by its massive ovoid shape anchored to the ground by two hidden pillars. The rest of its structural components are also concealed. *Cloud Gate* is made up of 168 steel plates sealed together over its skeleton. The seams where the plates are joined have been carefully polished so that the sculpture appears as an autopoietic body capable of regenerating itself perpetually with every new reflection.

The arched corridor formed under the shell of *Cloud Gate* allows visitors to gain entrance to its mirror kernel, also known as the omphalos. Despite the intimate quality of this archway and the mesmerizing reflections projecting against its virtually abysmal canopy, this space serves as a blatantly public passageway connecting different parts of the plaza. From the point of view of its functional purpose, the omphalos appears to be a "non-place"—that is, in Marc Augé's theory of spatial relations, a mere site of repeated transitions.[14] Yet from the point of view of the feeling of temporary belongingness to precarious collectivities that it inspires, the work constitutes a place of intersubjective encounters, whose history grows denser and denser as it becomes part of the affective memory of numerous visitors. *Cloud Gate* is representative both of the modern aesthetic of reflective screens and of the symbolic shape of archaic spaces built around vertical axes that mediate the connection between heaven and earth. Kapoor resents the ornamental character of most public sculptures. He intended to create an artwork that would recall the archetypal character of ancient arches and disrupt ordinary perceptual coordinates. Explaining the reasons the commissioning committee selected

Cloud Gate, project director Ed Uhlir stated: "The feeling was that Anish's sculpture really reflected the spirit of the next millennium. It was classical in some respects and very contemporary in others. It reflects the individual as well as the skyline and the clouds."[15] Hence, the work is described as a passageway not only across space but also across time, marking the entry into the new millennium and merging multiple temporalities of art.

Like *Cloud Gate*, Eliasson's *Take your time* installation frames a bewildering interval in space and time. While the work embodies the artist's phenomenological philosophy and serves as a dictum for living in the present, it also maps a very specific perceptual situation in which viewers experience a temporary delay of the current moment and a suspension of stable spatial coordinates. *Take your time* introduces museum visitors into a gallery space dominated by a circular mirror placed at an oblique angle against the ceiling. The reflective disk has a disorienting effect: it turns the image of the floor

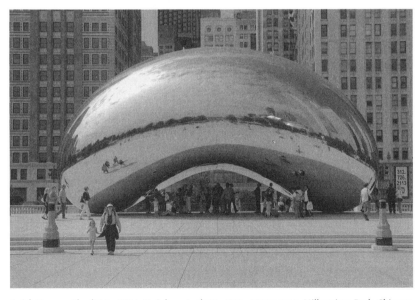

Anish Kapoor, *Cloud Gate*, 2004. Stainless steel, 10 × 20.1 × 12.8 meters. Millennium Park, Chicago. Photograph by Patrick Pyszka. Courtesy of Anish Kapoor, City of Chicago, and Gladstone Gallery.

upside down and perpetually shifts viewers' perceptual reference point by slowly revolving above their bodies.

The installation gave the title to Eliasson's largest retrospective exhibition in the United States, which toured several museums. At P.S.1 Contemporary Art Center (now MoMA PS1), *Take your time* was strategically displayed in a square gallery located in the middle of the third floor of the building. Its central location and the rounded shape of the mirror emphasized the installation's function as a public forum. Envisioned as a space of encounter with the otherness inherent in ourselves and the world we inhabit, the installation space constantly altered, as reflections of changing participatory responses rotated on the mirror disk. Just like *Cloud Gate*, *Take your time* concomitantly represented a site of transition and a site of dwelling. On the one hand, it invited viewers to inhabit its space and momentarily forget about their sequen-

Olafur Eliasson, *Take your time*, 2008. Mirror foil, aluminum, steel, motor, control unit. Installation at P.S.1 Contemporary Art Center, Long Island City, New York. Photograph by Studio Olafur Eliasson. Courtesy of Studio Olafur Eliasson.

tial trajectory through the museum; on the other, it mediated their transition by situating them at a crossroads of different exhibition areas vying for their attention. The installation functioned literally as a passageway, since it could be entered from two opposite sides. In the immediately adjacent galleries, visitors could observe numerous prototypes of geodesic spheres, rhombic dodecahedrons, and various other geometrical objects arranged along shelves. This laboratory-like setting, aptly titled *The Model Room*, was reminiscent of the *Wunderkammer* and the artist's studio, thus foreshadowing the space of perceptual interaction of *Take your time*, where visitors simultaneously became agents and subjects of sensory experimentation.

Not only was the experience of this installation mediated by its inscription in the middle of a studio-like environment, but it was also influenced by the carefully staged transition of museum visitors between the two venues of Eliasson's survey exhibition in New York: MoMA and P.S.1. The concept of *Take your time* insidiously infiltrated the space of the city. As visitors took the escalators to the subway platform, they saw along the walls square images of the studio and the exhibition title. These fairly small-scale photographs departed from the format and typographic conventions of advertising panels and were arranged in a diagonal line along the axis of the staircase, rendering passersby highly aware of their movement through the city. The visiting experience was no longer limited to the institutional framework. It became part of what Michel de Certeau calls "the practice of everyday life."[16] The journey from MoMA to P.S.1 built up anticipation and underlined the fact that one needs to take one's time on a daily basis to avoid a state of perceptual and social inertia.

Sharing Eliasson's belief that art can inspire reflection on personal agency and self-transformation, Ken Lum has also created works that span the space between museums and quotidian urban contexts. *Pi* was designed for the Westpassage of Karlsplatz Square, which links the square to the Secession Building in Vienna. The project was initiated in 2004 by Public Transport Vienna and Public Art Vienna, an organization that commissions art projects with the help of funding from the city council. The design brief invited artists to submit proposals for projects that would transform the space of advertising glass cases usually arranged along the walls of the Karlsplatz corridor.[17] It was desired that the proposed works would have a somewhat intrusive presence

in order to interfere with the flow of pedestrians through this passageway.[18] Subversively playing on the process of identification of passersby with images of satisfied consumers of commercial products, Lum created an installation composed of fourteen mirror panels, known as factoids, that confront passersby with their reflections and statistical information. Each mirror is etched with an inscription and includes an LED panel offering a numerical estimate concerning a local or global issue such as war, hunger, diseases, or ecological disasters.[19] Opposite these vertically oriented panels, which took the place of backlit advertisement cases, a series of mirror screens wraps around the passage walls and offers a quasi-representation of the mathematical symbol π, which stands for the ratio of a circle's circumference to its diameter. Although we generally assume that π is equal to 3.14, its value actually extends to an infinite number of decimal places. The first 478 decimals of π are etched onto the reflective surface of Lum's installation, with the most recently computed ten digits indicated by means of an LED board, which can be updated. Thus, this number virtually defies the fixity of representation and symbolically points to the perpetual variation of the world. The installation instills some doubt in the statistical data since Gaussian distribution predictions are based on the use of this irrational number, which remains somewhat elusive because its full sequence of decimals is unknown. Lum aptly implies that both our knowledge and our perceptions are in fact approximations of actual phenomena or life events, which alter constantly, just as reflections in the mirror change in real time.

Yet *Pi* entails additional implications. Besides the components directly related to this number, the installation includes a cylindrical glass case containing publications concerning world demographics and migration. Lum thus suggests that, just like the entire numerical value of π, human movement and diasporic networks cannot be fully mapped; they can only be approximated, transcending a fixed order. The cylindrical case and the mirror screens illustrating π were not part of the original plan for the work. Lum added these components to the factoid panels he had initially proposed, extending the installation beyond the space originally allocated to the public artwork by the commissioners.[20] Moreover, he placed a fourteen-digit LED counter right above the entrance to the passageway, confronting pedestri-

ans with a perpetually fluctuating series of random numbers lacking a signified. Lum skillfully negotiated the use of space in order to create a more all-encompassing environment that would invite passersby to question numerical values and think deeply about their position in the global and local context.

Lum's Westpassage project resists iconicity. The symbol π challenges the notion of commensurability due to the number's unending nature. Given the multiple installation components, which are systematically arranged throughout the entire passageway, no photographic reproduction of the work can convey its entire structure. *Pi* needs to be experienced in motion. It interrupts one's advancement through the corridor, but it also entices one to keep moving and discovering other numerical and visual indices. Unlike *Cloud Gate,*

Ken Lum, *Pi*, 2006. Permanent media installation (opened December 1, 2006). Westpassage of Karlsplatz/Friedrichstraße, Vienna. Photograph by Joerg Auzinger. Courtesy of Ken Lum, WIENER LINIEN (Public Transport Vienna), and KÖR Kunst im öffentlichen Raum Wien (Public Art Vienna).

Pi cannot be contemplated from a distance. It challenges proximity and rejects a unitary configuration that can be instantaneously revealed. Yet, in a fashion similar to Kapoor's sculpture, *Pi* enhances the specificity of the location in which it is inscribed. The Westpassage is transformed into a mirror space where the bodily presence of passersby is visibly incorporated into a system of information that reflects instantaneous changes in the urban landscape as well as world transformations that may affect the passersby sooner or later. The jury board that selected Lum's installation argued that thanks to "its international, global references, this work does justice to Karlsplatz, a transfer space for people of most variable origins."[21] It also commended *Pi*'s correlations with the local context, since the work includes statistical data relevant for Vienna. Alert to the way public art is put into the service of tourism, Lum subtly parodies this tendency by inserting in the installation statistical information about the number of "schnitzels eaten in Vienna since January 1."

In addition to situating viewers in liminal spaces, *Cloud Gate, Take your time,* and *Pi* disrupt the fluidity of time, virtually suspending its advancement. Their reflective surfaces delimit a field of perception and interaction apparently detached from the ordinary unfolding of time. *Cloud Gate* encourages passersby to loiter in its vicinity and become absorbed in the observation of its mutability. Reflections in its outer shimmering surface emphasize transitoriness, while the endlessly repeated mirror images projected in its archway suggest transcendence of the immediate present. Visitors note that the work calls for an expanded perceptual experience. Several people responding to a blog post including Flickr images of *Cloud Gate* have remarked on the temporal awareness generated by the sculpture. One asserted that the sculpture "entertained" him or her "for quite some time"; another mentioned that "it is so creative" that it makes him or her "look at it again and again."[22] Creativity is subsistent not only in the completed artwork but also in the act of looking and performing in real time in its proximity.

A similar promise was offered by the title of Eliasson's survey exhibition. It announced to museum visitors that what they were going to experience depended not only on the artist's work but also on their own capacity to wait for their senses to adjust to different perceptual stimuli and for their thoughts to crystallize. Eliasson's installations ask visitors to slow down for an indefinite period of time. The visitors are ultimately the ones to decide how to time their

experience. Yet their feeling of belonging to the temporality and space of the installations will also be influenced by the presence of other viewers. Upon their encounters with *Take your time* at P.S.1, visitors vacillated between looking at the rotating mirror from the doorway and stepping into the area beneath it.[23] The disorientation engendered by the recurrent slipping away of the images reflected in the rotating mirror disk compelled numerous viewers to lie down on the floor. The wall label did not indicate any prescribed form of interaction with the work, but most visitors assumed a horizontal position either in order to regain their bodily balance or in order to adapt to the behavior of others. While the impression of spatial displacement gradually diminished, the impression of temporal displacement became increasingly profound. With every rotation of the mirror disk, one sensed that the coincidence of one's bodily image with the reflections was constantly delayed.

The disk was diagonally inclined and was made up of adjoining reflective strips, the edges of which were fairly easily observed in situ. As the object revolved, the viewer's reflective image momentarily disappeared between the boundaries of the mirror bands and then reappeared in another disk segment. Unlike the perfectly neat screen of *Cloud Gate, Take your time* openly exposed its man-made nature. The oneness of self-creation denoted by the constant speed of the disk contrasted with the discontinuities observable in the mirror. Immersion in a state of presentness was deferred due to these tense relations between parts and whole. The eternal cyclic time of the mirror was in conflict with the relativity of lived time. As viewers followed the displacement of their reflections split between the edges of mirror strips, they felt trapped between a past extending into the present and an anticipated future. This paradoxical embodiment of multiple temporalities situated them in what Hannah Arendt calls a "non-time-space in the very heart of time," where thinking is liberated from the pressure of history and from commitments to a programmatic future.[24] Thinking of oneself in a metaphorical temporal interval that thrives on the unpredictability of perceptual and mental processes constitutes an exercise in assuming agency. Eliasson embraces a similar perspective, since he believes that heightened temporal consciousness activates intrinsic motivation: "Time is a tool with which to navigate the world; it makes us grasp that the subject is causally intertwined with its surroundings. This causal relation brings to the fore the notion of responsibility."[25] According to Eliasson,

awareness of the mutability of the present can enhance our active involvement in the world we inhabit.

Acquiring responsibility by contemplating one's role as a simultaneous subject and object of present time is also a guiding principle for Lum, who argues that "the purpose of art should be to offer a space for pause and reflection."[26] *Pi* frames an environment marked by multiple temporal interstices that can briefly suspend pedestrians' movement through the Westpassage. Statistical studies generally give the illusion that they can suspend or accelerate time to provide a clear picture of the current or forthcoming state of things. Lum's use of a digital program that updates the statistical data embedded in the reflective panels gives passersby the impression that they are witnesses to history in the making and suggests that they themselves are responsible for altering the numbers. Even though the statistical information is

Olafur Eliasson, *Take your time*, 2008. Mirror foil, aluminum, steel, motor, control unit. Installation at P.S.1 Contemporary Art Center, Long Island City, New York. Photograph by Christopher Burke. Courtesy of Studio Olafur Eliasson.

updated only once each year, on January 1, one cannot help but experience the desire to see the data change in real time just as the mirror images fluctuate as people pass by.

Pi references more or less simultaneous time intervals illustrated by the fourteen panels with time-dependent statistical information. Interestingly, the statistical predictions do not have the same temporal parameter. Some of them display information about the recent past and the present, whereas others offer predictions about future consequences. Moving across the West-passage, viewers feel that their existence is closely intertwined with this network of numbers. They experience time as an intricate stream whose unfolding cannot be accurately envisioned in spite of the overflow of statistical data. The mirror images reflect time's fleeting qualities in a more accurate manner than the approximate figures. The instantaneity of reflections sharply contrasts with the considerably slower transformation of estimates, entreating passersby to consider the way their existence not only belongs to time but also shapes it.

Cloud Gate, *Take your time*, and *Pi* expand participants' sense of time. In interesting ways, Kapoor, Eliasson, and Lum build on the 1960s trend toward slowing down time in art practices.[27] They respond to a similar need to challenge the compliance of individuals with the increasingly accelerated rhythm of everyday life, which impedes a careful consideration of the implications of their actions. However, these artists' installations do not simply perpetuate chronophobic impulses. They slow viewers down, but they also encourage them to move and observe the perpetual transformation of their surroundings. In this sense, *Cloud Gate*, *Take your time*, and *Pi* exemplify a contemporary fascination with chronophobia as well as an enchantment with chronomania. As our perception has increasingly adjusted to zooming in on or out of extensive visual fields and engaging with rapidly shifting spatial coordinates, we have grown to expect and even cherish images that solicit intense interaction and test perceptual limits over short spans of time. The three installations encourage repeated viewing under different circumstances and underscore our desire to alter the tempo of life experience in order to actualize perceptual experience in a society flooded with information.

The three installations under consideration in this chapter call for ethical

responsibility toward others and the spaces we commonly inhabit. *Cloud Gate* displays the hybridity of groups congregating around its reflective screen, *Pi* reveals the interdependence of larger and smaller social and environmental systems, and *Take your time* hints at viewers' contemporaneity with one another, showing that their lives are similarly in tune with the rotation of the planet even though each of them may experience time differently. In the following section, I will analyze how these installations foster affective impulses by encouraging participants to ponder the way the presence of others influences their experience and catalyzes intersubjective processes of self-definition.

Becoming Multiple: Affective Sharing across the Mirror Interval

Cloud Gate, Take your time, and *Pi* reveal the plurality inherent in ourselves and others. Calling participants' attention to their collective bodily presence, they trigger acts of affective, behavioral, and empathetic mirroring. Despite their hard materiality, these reflective works symbolize permeable membranes that expose the contingency and mutability of interpersonal relations.

Most spectators admire *Cloud Gate, Take your time,* and *Pi* not only because of their aesthetic qualities but also because of their ability to trigger versatile participatory responses. Contributors to the online forum launched by the San Francisco Museum of Modern Art in conjunction with Eliasson's touring retrospective exhibit titled *Take your time* noted that his works made them aware of other participants' corporeal presence. User JDalldorf enthusiastically expressed a wish to see the works once again with a group of friends: "We went home making plans to bring all the friends we could gather back with us next week." Risd, another exhibition visitor, commented on the intersubjective dimension of *360° room for all colors*, a panoramic environment suffused in swiftly changing tones of color: "Far more interesting than the actual room, was eavesdropping on moma-goers going on and on about it."[28] *Take your time* challenged similar responses by exposing viewers' bodily presence to its rotating mirror eye. The arch-like shape of *Cloud Gate* also invites viewers to linger in a liminal zone where they vacillate between a highly personal experience of the sublime in the presence of chaotic reflections and a

sense of precarious belonging to a public collective audience. In her study of public participation in Millennium Park, Corrinn Conard remarks that numerous visitors assert that "it is the people surrounding the works of art that draw them to the Park rather than the works of art themselves."[29] Like Kapoor's *Cloud Gate*, Lum's *Pi* is bound to direct the passerby's gaze both toward self-reflections and toward others simultaneously engaged in watching the impact of their presence on the mirror space as they stop to read the statistical data.

All three installations signal an erosion of differences between public spaces and private spaces by conveying feelings of both intimacy and uncanniness. Through visual means, they suggest that the notion of utter freedom from social constraints is compromised. By underlining the vulnerability of all viewers to controlling spatial and temporal structures, these works showcase the potential for transformation without offering any guarantee of perfect equilibrium or autonomy. In her analysis of *Cloud Gate*, Mary Jane Jacob explains that Kapoor's work would frame a highly public form of encounter with art even if it were placed inside a museum space: "It is more than its urban park site that makes this work public; it is truly so because it engages us in an intimate and giving way, offering not one but multiple ways of experiencing it."[30] Eliasson's work similarly downplays the feeling of individual immersion by proposing an expanded perceptual field in which the bodily presence of others and their different perspectives on their surroundings become highly conspicuous. Eliasson describes museums as "spaces where one steps even deeper into society."[31] The apparently seclusive display context of art institutions turns out to offer more possibilities for public forms of participatory spectatorship. Lum shares a similar conviction and maintains that museums can provide more open space for expression and interpersonal exchanges than can many outdoor locations, which have become increasingly privatized: "I think private spaces, compromised as they are, within the museum and so on, can actually be more public than the so-called public spaces outside, which have become more and more compromised and appropriated by private interests anyway."[32] *Cloud Gate*, *Take your time*, and *Pi* undermine the distinctions between indoor and outdoor display contexts, encouraging a process of self-questioning and interpersonal inquiry.

The three works challenge deeply affective experiences, which are marked by perceptual disorientation and negotiations between different sensory registers. Despite their engaging optical qualities, they destabilize confidence in visual stimuli. The mirror images they encapsulate do not coincide perfectly with their physical counterparts: the arched shape of *Cloud Gate* modifies the proportions of bodies moving in front of it, the inclined axis of the disk in *Take your time* subverts the parallelism between the world outside and the world within the mirror frame, and the sharp contrast between the rapidly shifting reflections and the slow-changing statistical values in *Pi* casts doubt on the accuracy of visual representations. The works trigger multisensory engagement and thoughtful reflection, revealing that only glimmers of actuality can be sensed as the world undergoes continuous changes. Viewers of *Cloud Gate* feel compelled to reach out to the silver surface of the sculpture and touch it to become better aware of its actual depth and meandering outline. Out of a similar need to regain sensory balance, viewers of *Take your time* rest on the gallery floor, confounded by the striking contrast between the magnetic draw of the mirror disk and its unsurpassable distance. In the case of *Pi*, passersby experience a sensation of ambiguity because the installation disrupts the quotidian rhythm of motion in public spaces and creates friction between bodily presence, reflections, and abstract statistical values.

Cloud Gate, *Take your time*, and *Pi* correspond to the current of "precarious visualities" that art historian Christine Ross has identified in recent contemporary art practices.[33] She observes that numerous artists are staging visually puzzling situations to catalyze greater bodily awareness and restore agency to viewers by challenging them to negotiate between concurrent sensory stimuli. Perpetuating this tendency toward undermining passive immersion in visual spectacle, the reflective works of Kapoor, Eliasson, and Lum call for affective engagement and interpersonal awareness. *Cloud Gate* places viewers in the role of explorers seeking to chart a territory that at first appears to be instantaneously visible and accessible yet gradually turns out to be disquietingly complex and uncontrollable. In discussing the sensory impulses challenged by his works, Kapoor has acknowledged that he purposefully highlights the complementarity between eyesight and tactility because "there is a degree of uncertainty confronting the eye which can only be resolved by extending the hand."[34] In the process of discovering the reflective qualities

of *Cloud Gate*, viewers explore the crossovers between sensory registers and question their perceptual acuity.

By the same token, *Take your time* proposes a seemingly simple heuristic exercise by means of which visitors become conscious of the ways their body images influence their perception of spatial and temporal intervals. The installation proposes an experience similar to that offered by numerous new media works that invite participants to move or act in environments where visual referents fail to provide stable coordinates. In his analysis of digitally processed images that generate anamorphic representations of objects, theorist Mark Hansen points out that when "visual faculties are rendered useless ... we experience a shift to an alternate mode of perception rooted in our bodily function of proprioception."[35] Similarly, *Take your time* fosters affective responses by destabilizing the individual gaze and asking visitors to reflect on the potential of their bodies, which gradually adjust to challenging visual stimuli through multisensory associations and movement.

The participatory implications of *Pi* are less immediately evident at the level of the complex body sensorium. The installation places the viewer in the role of a reader of quotidian statistical information. The viewer's bodily presence in front of the mirror panels constitutes a disjunctive factor in the process of constructing a stable picture of the world based on abstract numerical data. The shifting reflections of passersby moving past *Pi* expose the degree to which statistical estimates are influenced by temporal parameters. The numerical data are ultimately a construct contingent on approximations and the degree of visibility of the facts and subjects of statistical inquiry. Upon having their reflections encompassed in the work, viewers cannot help but wonder whether they would be included or excluded from the survey pool. *Pi* dwells on this ambiguity between numerical representations and embodied subjects of surveys, which stirs up tension between the actuality and the virtuality of statistical data. This uncertainty encourages participants to interrogate the validity of the numbers in the mirror factoids and reflect on their position in relation to social and cultural categories, official and unofficial data, avowed and concealed facts.

Affect has been theorized in terms of an interval between relative equilibrium and impending motion. Whether it is conducive to actual kinetic participation or merely suggestive of it, this intensity, which precedes the registering

of emotion, fosters an actual or virtual process of self-transformation in relation to others and the environment. *Cloud Gate, Take your time,* and *Pi* encourage active observation and movement. They entail objects or interfaces with variable features that echo the transience of the world pictures or local contexts they mirror. *Cloud Gate* is experienced in motion as visitors circle it to make sense of its shape and reflective effects. The sculpture is not a flat screen; it has corporeal characteristics because it transforms and reacts to its immediate environment, thus triggering spontaneous behavior. Deleuze situates affect between perception and impending action. He considers that it anticipates motion, equating it with extreme uncertainty and unknown duration. According to him, affect is "this combination of a reflecting, immobile unity and of intensive expressive movements."[36] The affective impulse generated by *Cloud Gate* originates in the interval between an initial encounter with the sculpture and a conscious decision to use it as a device for framing one's surroundings and movements. It is at the point where one experiences a virtual projection of motion and a fascination with the potential externalization of this sensation that affect emerges. Viewers find themselves in the position of the artist before a blank canvas that can come alive when they externalize their mental pictures. Yet, in the context of *Cloud Gate*, no individual participant has control over the pool of reflections. Viewers are part of a collective audience with which they only partially identify, as the sculpture reveals the plurality and transitoriness of experiences and mirror images.

Take your time portrays the tension between virtual motion and actual motion to an even greater degree. During my visit to Eliasson's exhibition at P.S.1, I observed different affective responses challenged by the installation. From the moment I stepped into the gallery where *Take your time* was displayed, I found myself on the brink of an ineluctable immersion in an inverted space and an expanded time interval. Within its context, things seemed to change yet also stay the same because of the cyclical movement of the mirror disk. The installation combined protocinematic and cinematic effects. On the one hand, it projected images of movement, as exhibition visitors often gave in to performative impulses as if they were in front of a video camera; on the other hand, it triggered what Deleuze calls "movement-images"—that is, cinematic sequences that are created through the movement of the camera eye or through montage.[37] Visitors virtually edited what they saw by focusing on

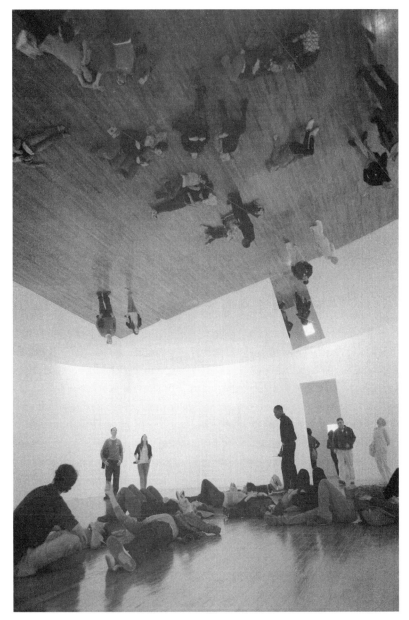

Olafur Eliasson, *Take your time*, 2008. Mirror foil, aluminum, steel, motor, control unit. Installation at P.S.1 Contemporary Art Center, Long Island City, New York. Photograph by Studio Olafur Eliasson. Courtesy of Studio Olafur Eliasson.

different segments of the perceptual field as mirror reflections continuously rotated above them. This disjunction between the function of the mirror as a prosthetic device for self-reflection and its function as a quasi-cinematic apparatus enhanced the affective potential of the work. Groups of visitors lined up next to each other and created more or less regular geometric shapes out of their bodies. Some of them joined hands or synchronized their movements to the slow tempo of the mirror rotation.

Participants' reactions frequently denoted "affective attunement," which in psychologist Daniel Stern's terms is an approximate match between the experiences of two individuals who imperfectly mirror each other's behavior.[38] Based on his studies of mother–child interaction, Stern argues that an affective impulse is transmitted only if an individual does not mechanically imitate someone else's conduct, but rather introduces some sort of variation in his or her response in order to show that he or she has comprehended the emotional engagement of the other in the behavioral act. Under its lens, *Take your time* brought to the surface such empathetic exchanges. While visiting the exhibition, I noticed two participants tilting their heads toward each other while watching their reflections. Their responses betrayed affective attunement as they gradually introduced variations in their movements rather than simply mimicking each other. Other participants were also prone to improvisation while visually and kinetically interacting with their friends. Engaging in nonverbal communication, they coordinated their bodily movements and recurrently changed their bodily posture.

Visitors who had no companions with them tended to adopt more contemplative attitudes. However, some of them also tested the ways they could introduce changes into the reflective projections, especially since the images of their bodies appeared to undergo fragmentation and recomposition along the junction lines of the mirror strips constituting the disk. They rotated their arms or moved their legs as if they were clock hands, shifting more or less to the rhythm of the gyrating mirror. This form of interaction, which exemplifies an attunement between a subject and a responsive object, heightens affective intensity. In the case of *Take your time*, the mirror simulates an embodied presence thanks to its mobility. It thus enhances the potential for participation, triggering kinetic responses that echo the affective reverberations experienced at an inner level.

Lum's *Pi* sets up an interactive situation that entails more social tension than is found in the experiential settings proposed by the other two works under discussion. Given its location in a space with a more clearly prescribed urban function, the installation does not ensure respite from the hectic pace of life. I personally came across *Pi* in the evening, at a time when the Karlsplatz Westpassage was almost deserted, and I had the opportunity to take my time and observe the way it challenges perceptual engagement and raises concerns about the impact of one's acts or the consequences of one's negligence on local and global contexts. At rush hour, the presence of numerous other people probably enhances the disorienting effect of *Pi*. Lum was certainly aware of the fact that the installation would frequently be experienced by people in motion amid the crowds. Thanks to its quasi-mimetic integration in the urban landscape, *Pi* creates a fairly smooth space that draws attention to its numerical parameters. Its disruptive potential subsists less in perceptual incongruities and more in sociopolitical implications. While the mirror surfaces of *Cloud Gate* and *Take your time* function as seemingly animated objects that distort or shift the reflections of the viewers, the mirror panels of *Pi* do not create supplementary visual effects. They reflect the body movements of those crossing the passage without morphing their images in any particular way. This does not, however, reduce the participatory dimension of the installation, which successfully catalyzes multilayered mirroring processes involving the passersby, the statistical figures, and the mirror images. Because of its position in a passageway, *Pi* strikingly unveils the limitations of reflective acts. As pedestrians move past its mirror panels, they realize that they cannot watch themselves moving without partially arresting their advancement. Thus, *Pi* draws a parallel between the imperfect perception of self-motion and the imperfect representation of world transformations via numerical values. This series of imperfect matches between visual, numerical, and embodied representations indicates that reality is perverted once it is set in a static frame that does not capture its inevitable transience.

Pi engenders the voyeuristic identification of the viewers with the people represented by the statistical information and the passersby whose reflections are encompassed by the mirrors. This imaginary sharing of emotional states, sociopolitical conditions, and even guilt because of prior social or environmental irresponsibility has a highly affective impact. Massumi locates

affect on the boundary of the real and the imaginary, equating it with "the simultaneous participation of the virtual in the actual and the actual in the virtual, as one arises from and returns to the other."[39] *Pi* conveys a sensation of entrapment between virtuality and actuality since it motivates viewers to relate to situations that occur closer to or further from home yet have an undeniable influence on their lives and the condition of the planet.

Pi astutely hints at the relativity of the data, which cannot perfectly quantify the degree of uncertainty subsistent in our lives. It elicits processes of both self-questioning and identification with others. Being in transit through Vienna, I could not help but wonder what it feels like to be an illegal immigrant working in Austria and read the number of paid hours worked by Austrians since the beginning of the year, or contemplate the figure designating the number of Austrian employees who are dissatisfied with their jobs. What is potentially left out of these estimates has as much of an affective influence on the viewers as what is included in the numerical index. By mentally picturing the mirror reflection of an illegal worker in these panels, one becomes aware of the borders subsistent in the globalized world in spite of the illusionary image of a completely networked environment free of obstacles to travel, work, and communication. The potential presence within the installation framework of those who are excluded from these estimates enhances *Pi*'s effect and affect. Lum believes that art acquires a critical function if it brings forth an empathetic experience, and he argues that "something generally only moves you if you can imagine yourself in that situation."[40] Imaginary projections are not to be discounted as self-immersive processes of questionable ethical value. They can in fact enable an enhanced comprehension of other individuals' roles in society. The mirror panels of *Pi* intensify the affective potential of the imaginary identification between the passersby and the subjects of statistics. They remind participants of the embodied presence of the individuals whose existence is influenced by the data displayed on the LED boards. Whether or not they are part of any of the potentially surveyed groups of people, passersby feel that they are somehow in touch with the experience of the people represented by the statistical data, especially since their reflections remain as anonymous as the identity of the individuals directly affected by the problems signaled by the numerical estimates.

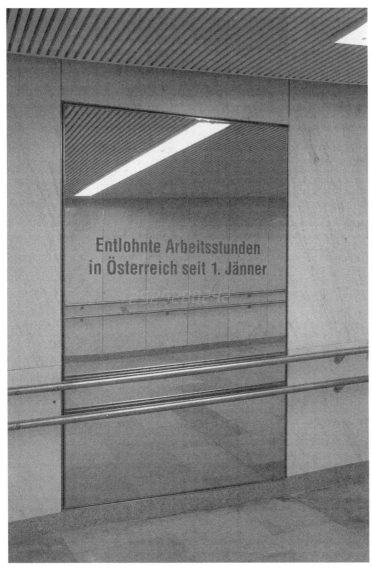

Ken Lum, *Pi*, 2006. Permanent media installation (opened December 1, 2006). West-passage of Karlsplatz/Friedrichstraße, Vienna. Detail Factoid 4: Entlohnte Arbeits-stunden in Österreich seit 1. Jänner (Paid work hours in Austria since January 1). Photograph by Joerg Auzinger. Courtesy of Ken Lum, WIENER LINIEN (Public Transport Vienna), and KÖR Kunst im öffentlichen Raum Wien (Public Art Vienna).

Just like *Pi, Cloud Gate* and *Take your time* engender empathetic relations between strangers. The openness of these works to incorporating large-scale images of their surroundings triggers a high degree of interpersonal awareness. The reflection of spectators in their mirror surfaces showcases similarities and differences between the visitors' perceptual and behavioral experiences. It also indirectly suggests a possible congruence between the affective relations established between viewers voyeuristically gazing at each other's mirror images. Within the warping space of *Cloud Gate* differences appear to become less relevant, but they do not disappear, since participants feel the need to call each other's attention to reflective effects that they observe from different perceptual angles. Numerous photographs showing participants pointing toward different areas of the sculpture reflect this enchantment with disparate perspectives. Eliasson's *Take your time* also sets up an encounter with a plurality of viewpoints. In its framework, the reflections of viewers are shifted by the revolving mirror, which repeatedly defers the viewers' identification with their own reflections and the images of others. As visitors enter the omphalos area of *Cloud Gate* or sit under the off-center mirror disk of *Take your time*, they open up toward other participants exposed to similar perceptual conditions. In a paradoxical way, the distanced reflections of their bodies bring them closer to one another and engender a process of self-inquiry based on imaginary projections of themselves in the world of others. This longing to experience the works through the eyes and minds of multiple participants corresponds to a virtual self-transformation through intersubjective negotiation. However, the mirroring of others is bound to remain incomplete, since it brings to the surface a web of uncertain relations and irresolute contradictions. Identification with others is indefinitely postponed in order to maintain the potential for multiplicity. Deleuze and Guattari associate affect with a "nonhuman becoming," or a virtual alliance with a group with whom one cannot fully identify in a real or voyeuristic way in spite of sensing a powerful degree of contingency.[41] The connections developed between the viewers of *Cloud Gate* and *Take your time* are suggestive of a similar affective experience. Despite the intense bond they feel as they share an ambiguous spatiotemporal interval, anonymous strangers do not develop a cohesive group identity because they are acutely conscious of the subtle differences between their viewpoints.

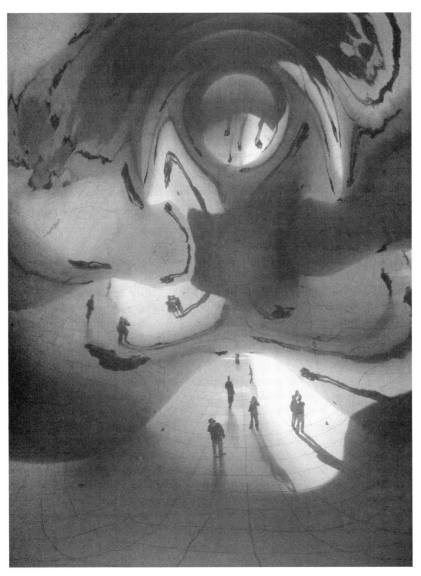

Anish Kapoor, *Cloud Gate*, 2004. Stainless steel, 10 × 20.1 × 12.8 meters. Millennium Park, Chicago. Photograph by Cristina Albu. Courtesy of Anish Kapoor, City of Chicago, and Gladstone Gallery.

Cloud Gate and *Take your time* serve as reminders of latent possibilities for social relations in contemporary societies despite the preponderant alienation of individuals submerged in fast- or slow-moving crowds populating subway stations, public parks, malls, and museums. Viewers of these works develop a feeling of familiarity with each other. This sensation resembles the loose attachment that develops between commuters who frequent the same sites. In his study of social relations between passengers waiting at the same train station, sociologist Stanley Milgram contends that individuals who regularly see each other in the same context feel they are acquainted with each other. He explains that they prefer not to engage in verbal communication in order to avoid unnecessary commitments in an environment that already demands engaged attention due to competing sensory stimuli. According to Milgram, "To become a familiar stranger a person (1) has to be observed, (2) repeatedly for a certain time period, and (3) without any interaction."[42] By interaction, he means verbal exchanges, yet he does not discount mutual observation and interpersonal reflection. Although the viewers of *Cloud Gate* and *Take your time* will not meet repeatedly within the same settings, they tend to experience an intense feeling of familiarity because of the extended duration of their experience and the convergence of their reflections within the same visual sphere. Equally vulnerable to each other's gazes, they share an affective alliance, being concomitant subjects and objects of perceptual examination. Most participants will make visual contact but refrain from starting conversations, hence respecting the unwritten pact between "familiar strangers" analyzed by Milgram.

Similar relations are evoked by *Pi*, which prompts passersby to enter into an imaginary dialogue with the mute numbers that metaphorically stand for the voices of those dissatisfied with their jobs or affected by malnourishment and environmental catastrophes. In 1992, Lum published a book containing photographs of passersby along with simple questions meant to launch the reader into speculative inquiry regarding the identities of the people in the pictures.[43] He has noted explicitly the way we stifle our desire to speak with strangers on a bus: "There's a kind of incommunicado communication going on which still rests within my mind, there is this will there but then there is also this decorum."[44] *Pi* evokes the same kind of voyeuristic relatedness to others by encouraging viewers to wonder who the subjects of the statistics are.

Affective relations, which are mentally envisioned without taking verbal or visual form, compensate for the alienating circumstances of everyday life. By watching their images unfold as if they were part of another world with a different topology and time cycle, viewers of *Cloud Gate* take part in a ludic experience that consolidates their social ties. Although there may be no verbal interaction between them, participants develop a feeling of attachment and solidarity with one another. Respondents to Conard's survey concerning public involvement in Millennium Park remarked on the conviviality triggered by this environment. One person conveyed enchantment with the voyeuristic dimension of the park: "I like watching other people with the pieces. I come to people watch more than anything else." Another emphasized empathetic belongingness with groups of visitors engaged in the same experience: "It is a magnet for people in a good mood so it creates a really nice sense of community."[45] The relations formed between spectators of Kapoor's sculpture may be temporary, but they do not lack intensity. *Cloud Gate* reveals viewers' coexistence with multiple others within societies that are subjected to more or less blatant surveillance. Their experiences may differ, yet their provisional alliance with temporary social gatherings responds to the desire for interpersonal recognition and exposes the potential force of collectivities to call into question controlling regimes. This is also the reason that *Cloud Gate* at times becomes the site of protests, such as demonstrations against the continued use of the Guantanamo Bay detention camp or in support of Bradley Manning (now Chelsea Manning) and the right to free speech. Hence, the sculpture is recognized as a powerful site for the dissemination of political messages against surveillance and the infringement of human rights.

As we choose to become part of Web 2.0 social networks even though we know that we are releasing control over our personal information, we express both our need for confirmation of the singularity of our personal views and our desire for alliance with heterogeneous groups whose members may be distant acquaintances or complete strangers. The visual interfaces set up by Kapoor, Eliasson, and Lum provide similar opportunities for affective mirroring between participants. In contrast with online networks, they do not invite participants to reveal their identities or construct avatars in order to join in. They favor becoming over fixed constructs. Viewers remain largely anonymous while nonetheless feeling in touch with others thanks to the

interplay of reflections and the virtually uninterrupted chain of visual information to which all are concomitantly contributing. The interpersonal exchanges among viewers of these works may not lead to the formation of actual relationships or acquire visible form. Nevertheless, they elicit collective awareness of belonging to complex systems whose behavior depends on the attunements or divergences between their components.

The following section discusses the cultural, social, and technological factors that contribute to the production of spaces that challenge interpersonal processes of observation and self-definition such as the ones illustrated by *Cloud Gate, Take your time,* and *Pi.* It highlights the loose processes of identification characteristic of the contemporary period and examines the collapse of homogeneous notions of singularity and collectivity.

Productive Differences and Complexity in the Mirror Sphere

Disillusionment with the cult of individuality in neoliberal countries and with the unfulfilled promises of socialist doctrine in former communist countries has contributed to a skeptical outlook on the primacy of both self-interest and collectivism. The collapse of grand narratives has deepened the mistrust of large ideological systems and has cast doubt on fixed notions of individual and group identity. Nonetheless, debates concerning participatory art practices are still suffused with binary oppositions between individuality and collectivism and contradictory relations between aesthetics and politics. As responses to *Cloud Gate, Take your time,* and *Pi* show, aesthetic self-involvement is at times considered a sign of capitulation to neoliberal forces, and collective engagement in similar behavioral acts is often read as a sign of artificially construed consensus or docility.

Far from privileging the reinstatement of a firmly positioned subject or the assimilation of individuals within cohesive groups, *Cloud Gate, Take your time,* and *Pi* underline the provisional aspects of perception, identity, and group belonging. The potential of these works for transformation thanks to their reflective qualities exposes the instability of the art object and the variable conditions of spectatorship. As explained in the preceding section, these works destabilize perfect one-to-one correspondences between the world out-

side their polished screens and the shimmering reflections projecting across their surfaces. The affective disjunctions and the ambiguous perceptual situations they produce elicit intrapersonal and interpersonal reflection.

Although their works generate perceptual ambiguity and friction between subjective and collective experience, Anish Kapoor and Olafur Eliasson have been accused of producing art that breeds passivity and caters to the desires of the spectacle society. The primary concern of some critics is that Kapoor's and Eliasson's works build on the capitalist market illusion that products are specifically created for the needs of individual consumers or that they can be customized to match individual tastes or interests. Since their works promise subjective engagement based on self-mirroring, they seem to fuel the narcissistic desires of individuals who derive satisfaction from identifying with presumably exclusive consumer objects. Ken Lum's projects are less vulnerable to this genre of critique because they directly reference social problems while using visual reflection as a reminder of viewers' position within society. Despite critical claims to the contrary, all three artists take viewers outside the comfort zone of an intimate encounter with their self-image by exposing their reactions to the gaze of others. *Cloud Gate*, *Take your time*, and *Pi* deprive viewers of privacy and confront them with the otherness inherent in themselves. Moreover, these works ask viewers to envision what their surroundings would look like from different perspectives. In this sense, they are productive of instability rather than certainty, disjunctions rather than consensus.

If the idea of individuality appears corrupted because of the way it has been used to isolate individuals and trick them into buying the dream of a personalized world of consumer products, the idea of collectivity has also been somewhat tainted because it appears that large groups of people can be easily manipulated and subordinated to ideological systems. However, this latter notion still seems to offer more possibilities for critical engagement at a time when "multitudes" may be the only forces capable of withstanding global economic forces by creating alternative networks of exchange.[46] While they are often perceived as weak and ineffective, large collectivities formed via social media often help in the dissemination of critical information and the strengthening of connections between activists. Lacking cohesiveness, they

are perceived as social gatherings held together by both close ties and disparate connections. By the same token, the viewers amassing around *Cloud Gate*, *Take your time*, and *Pi* do not form communities; rather, they form dynamic groups involving individuals from various localities and social backgrounds who are more or less likely to develop connections. These collectivities are open to change and allow for interpersonal transformation in the absence of a cohesive group identity. Alliances with such temporary collectivities are devoid of the strength of long-lasting communities based on consensus, but they manage to maintain constructive tension, building the potential for the emergence of new relations and ideas.

Kapoor, Eliasson, and Lum expect their works to engage viewers in perceiving and pondering differences while remaining aware of multiple others simultaneously negotiating their perspectives in a shared social context. Kapoor is interested in activating the imagination of the viewer. The visual plasticity of his sculptures, which change appearance or shape under the eyes of viewers, is meant to mirror the plasticity of perception and thoughts. As Homi K. Bhabha notes, quoting Kapoor:

If the mirror sucks in, it also spits out—it reflects and refluxes. Such a reading illustrates the motility embodied in the reflective surface of the mirror and exemplifies those "non-physical things, the intellectual things, the possibilities that are available *through* the material."[47]

Defying the logic of cause and effect, Kapoor's works also throw into upheaval the inner world of the subject of perception who lacks control over the complex transformations of the observed object. In the case of *Cloud Gate*, this uncertainty is intensified both by the abysmal qualities of the silver archway, which undermine a centralized all-encompassing viewpoint, and by the presence of numerous other viewers. In a 2010 issue of *Architectural Design*, an interview with Brian Massumi concerning preemptive tendencies at a time of heightened surveillance was accompanied by images of Kapoor's sculpture, which were used as illustrations of "the space of collective individuation," characterized by indetermination and interpersonal awareness.[48] Massumi cherishes the affective implications of such environments, which set on dis-

play the potential for different reactions to an otherwise communally shared spatiotemporal context. Moreover, he believes that these spaces privilege neither the subject nor the collective, exposing instead their contingency.

Eliasson's installations also build on the coincidence of multiple viewpoints, each characterized by its own specificity yet intimately connected to others through a shared social environment. The artist has discussed extensively the urgency of rendering viewers conscious of the fact that they are active producers of images rather than merely passive witnesses. He has repeatedly asserted his belief that subjective involvement can be a tool for withstanding ideological control. The need to counteract manipulation and deterministic behavioral responses has led him to give primacy to singularity. In 2003, he collaborated with Israël Rosenfeld on designing a poster for the Utopia Station of the Fiftieth Venice Biennale. It depicted a school of fish in which the individual fish had similar yet clearly distinct features and included the dictum "The only way we'll make this thing work is if I lie to you and you lie to me!" By unveiling the illusion of unanimous consensus, the poster conveyed Eliasson and Rosenfeld's skeptical attitude toward the notion of a collective utopia that reflects the desires of a perfectly homogeneous social group. In subsequent years, the idea that we are united by our singularities has come to define Eliasson's art practice to a large extent.[49] More recently, his works have increasingly called not only for self-focused awareness but also for interpersonal exchanges grounded in the realization of mismatches in perceptual and social experience. The interpersonal communion engendered by the awareness of differences and the encounter with a collectively shared perceptual context is clearly observable in *Take your time*, which reflects groups of museum visitors engaged in observing and modifying their real-time images. Although he is increasingly inclined to acknowledge the significant function of multitudes in shaping the experience of his works, Eliasson maintains the notion of individual singularity at the center of his art practice. His essay "Vibrations" signals the responsibility of the individual viewer to fulfill the role of agent in constituting perception in relation to his or her surroundings. Eliasson suggests that the beholder needs to keep in mind both the spatial context of perceptual acts and their temporal dimension in order to avoid a passive state. He invites the viewer to become

alert to what he calls the individual's "engagement sequence"—the conscious involvement of the observer in the production of the aesthetic experience.[50]

Eliasson is committed to advancing subjectivity and calling for an expanded perceptual experience in order to challenge passive immersion in the culture of spectacle. For him, subjectivity is not a stable construct but an entity that undergoes recurrent transformations, just like the spatial and temporal context of perception. He contends that self-reflection, or "the first-person perspective," needs to be supplemented by "a third-person perspective," which opens the path toward contemplating one's own otherness.[51] *Take your time* epitomizes this philosophy by offering museum visitors a view of themselves as individual subjects who can explore changes in their self-perceptions and transform their mirror images through body movements while the rotating mirror eye unveils multiple viewpoints that escape individual control.

In recent years, Eliasson's interest in the intricate ties between individuality and collectivity has become more manifest. In *Studio Olafur Eliasson: An Encyclopedia*, the artist acknowledges the influence of Jean-Luc Nancy's concept of "being singular-plural."[52] He explains that neither of the two terms takes precedence over the other: "In society, we've cultivated the extreme wish to be individual, but it's almost paradoxical to talk about individual experiences if this isn't done against a collective background."[53] The concomitant perception of oneself as an individual with personal agency and as a constitutive part of a social system is an exercise in envisioning one's intrinsic singularity and multiplicity. Eliasson's works encourage viewers to consider the relativity of their autonomy and the mutability of their self-reflection.

However, the marriage between singularity and plurality is not free of tensions or controversy. Eliasson has been accused of addressing a generic public while giving individual viewers the impression that each of them is involved in a unique way. In an article that brings to the surface the conundrum of promising both unique experiences that call forth the desiderata of capitalist societies and collective belonging to a shared social background, Anja Bock maintains that Eliasson's "subject is general rather than gendered or discursive: he missed the revolution, so to speak."[54] Peter Scott voices similar concerns in his review of Eliasson's survey exhibition. He finds that the artist's

invitation to personalizing time is in fact a virtual imitation of contemporary branding strategies that "create the illusion of meaningful participation in a larger group while offering the uniqueness of the (constructed) individual's identification" with the consumer object.[55] Yet time, kinetic possibilities, and interpersonal connections remain undetermined, since viewers experiencing Eliasson's work need to decide how long they want to experience this perceptual scenario and how they want to engage with it in the presence of a collective audience. Far from a prepackaged commodity, the installation eludes full control. Steven Psyllos, another reviewer of the exhibition, suggests that repeated visits to the installation are necessary for viewers to observe the responses of others in order to appreciate the variability of subjective experience and the shifting social dynamics. He admits that at first sight the works fulfill "the base desire of the attendees' need for instant stimulation/gratification."[56] Psyllos ultimately defends Eliasson's approach by singling out the intermingling of mental reflection and visual pleasure subsistent in the act of watching other people's responses to the installation. In addition to this, the variability in personal perception is matched by the variability in interpersonal responses, which destabilizes the process of complete identification with the reflections or the art object.

Kapoor, Eliasson, and Lum create experiential contexts that enable viewers to step out of a self-oblivious state of mind and reconsider their alliances with others. There may be no explicit call for individual or collective agency in their works, but this does not mean that they lack critical potential. The aesthetic qualities of Kapoor's and Eliasson's works make them easy targets for criticism on the grounds that they deflect attention from the social circumstances of the experience and allow visual effects to take over intersubjective exchanges.[57] James Meyer considers the two artists subservient to the demands of the culture of spectacle because of the massive size of their works, which dwarf the viewers and implicitly control them.[58] But the architectural scale so poignantly underlined by Meyer also has a positive impact: it pushes viewers outside the shell of private absorption and draws their attention to the dynamic complex systems in which they are engaged. Unlike *Cloud Gate* and *Take your time*, *Pi* has eluded criticism on account of its scale or appealing reflective attributes because it explicitly impedes socially detached

observations by making direct references to local and global conditions. Yet Lum's artistic philosophy matches that of Kapoor and Eliasson. He believes that differences need to be highlighted rather than leveled down or set in strictly delineated ethnic, class, or gender categories. Reminiscing about his experience of growing up in multicultural East Vancouver, he has observed that linguistic misunderstandings and imaginary conversations with familiar strangers can actually be meaningful and activate social awareness.[59]

Pi sets the scene for an equivocal relation to the statistical information it displays. It elicits an inquiry into the role one plays in producing the reality conveyed by the numbers. Since the etched texts are written in German, Lum indicates that the installation does not offer a presumably neutral or universal representation of the state of the world. The statistical data are provided by SORA, an Austrian social research institute, which updates the information annually based on mathematical estimates. For German-speaking people, the installation conveys a sense of comfort at the thought of belonging to a regional context where local and global realities are regularly assessed. For foreigners, be they migrants, resident aliens, or tourists, it is a reminder of the processes of deterritorialization and the constant need to decipher foreign verbal and visual signs that surround them. Nonetheless, neither group is released from the pressing need to interrogate the point of view from which the statistical questions are formulated and the way the data are compiled. Lum undermines a hegemonic perspective by alternating information relevant primarily to Austrian people with information concerning transnational problems. Thus, *Pi* erodes the stability of knowledge and the fixity of identity, triggering a persistent questioning of representation and subjectivity.

All three artists privilege variability over stasis and difference over sameness. In a 1993 dialogue with Homi Bhabha, Kapoor stated that he is hesitant about designating the void a third space located between dominant cultural identities because he feels that this would limit its nebulous field of possibilities by transforming it into a hybrid entity with fixed attributes:

> In-betweenness is a statement of cultural certainty and not one of cultural ambiguity. If we are to speak of void as in-between then it is not in-between two predefined realities, but in-between in the sense that it

is potential, that it is becoming, that it is emerging, that it is probable and possible.[60]

Kapoor refuses to believe in a compartmentalized model of the world, preferring instead the indefinite spaces of the void and the mirror, where distances are relativized and differences are always in flux. *Cloud Gate* is supposed to stand not for a boundary between two spaces but for a site of transgression of fixed differences. Its perpetual visual metamorphoses are indicative of the potential for interpersonal transformation, which depends not solely on the interaction between two individuals or two collectivities but also on an entire network of more or less familiar strangers.

Eliasson's keen interest in the temporal dimension of perceptual experience stems from a similar belief in the need for conceiving reality as an altering field that shifts with our motion as well as with that of others who are simultaneously modeling its coordinates. In spite of the artist's investment in theorizing singular-plural modes of spectatorship, art critics and historians have noted a disjunction between his avowed aim of creating works that jolt viewers out of a state of passive acceptance of reality and the apparent comforting and even pacifying effect of his installations. Meyer claims that Eliasson is an exponent of the "instrumentalization of the phenomenological tendency" recently favored by museums eager to boost their image as democratic venues and mask their ultimate subordination to the culture of spectacle.[61] Adopting a similar view, Scott argues that *Take your time* is the equivalent of "a kind of Soma or Prozac to take for reassurance in troubled times" and does not disrupt the state of individual or social slumber.[62] Affective responses do not gain visible form easily. The image of viewers lying on the gallery floor under the mirror disk of *Take your time* evokes stasis and peaceful coexistence, but the actual experience of being in that space is far from quieting or free of friction because it brings out differences and causes disorientation. The installation does not carry any explicit political reference, but its abstract and reflective character calls for self-involvement and interpersonal awareness.

Like Kapoor and Eliasson, Lum is committed to heightening individual consciousness of the mutability of subjectivity and the potential for changes

in political, cultural, and social circumstances. *Pi* parallels the approximation of data indexical of social and natural phenomena to the approximation of self-identity, which depends on a person's past experiences as well as on how the person envisions his or her present and future ties with the local and planetary context. The transitoriness of mirror images and the indeterminacy of the last ten digits of π highlight viewers' unavoidable entanglement in the transformations of society, no matter how insignificant their influence may seem when compared with ideologies or phenomena that escape human control. Lum is fascinated with the way individuals act as compasses of shifting realities. In discussing what motivates him to create mirror-based works, Lum states:

> I am interested in what constitutes the subject. Not only the subject in the work, but the subject standing in front of the mirror. And that constitution has been a recurrent theme in all my work. I insist that the subject is something in between . . . a hybrid, always in the process of transformation.[63]

Just like Kapoor, Lum rejects the notion of a fixed hybrid space or identity that combines otherwise invariable characteristics.

Ultimately, what underlies the thinking and practice of all three artists is the idea that the more conscious individuals are of their limited autonomy, the more power they have to become engaged in critical thought and action. By coming to terms with their entanglement in a mutable network of relations that affects not only the larger structures of society but also their personal lives, they can conceive ways of upsetting the normative order of things. Recent findings in neuroscience confirm that our social interdependence is not solely the consequence of ideological constructs. In fact, our sensorimotor reactions are influenced by the behavior of others, whether we are well acquainted with them or we merely observe them. As we watch the gestures of someone else, the same neurons fire in our brains as if we were performing their actions ourselves.[64] This neuroscientific discovery partly explains the affective ties formed between self and others in the context of works such as *Cloud Gate*, *Take your time*, and *Pi*. Viewers' relations to the three perceptual and conceptual situations proposed by the artists imply active personal

and interpersonal involvement. As it turns out, the contemplation of others is not conducive to self-obliteration or utter passivity. It can catalyze personal reflection through the virtual projection of oneself into someone else's position. The cells activated in this process, called mirror neurons, are situated in the premotor cortex. This discovery raises anxieties concerning social manipulation, because such cells fire independent of human volition. Yet individual agency is not totally negligible. Experiments have shown that while the same brain cells fire whether we perform a gesture or see others perform it, the intensity with which the neurons respond to the received information is greater when the individual is the agent of that specific action. In a study that eloquently presents research findings on mirror neurons and discusses the social implications of these neural processes, Marco Iacoboni explains:

> Mirror neurons are brain cells that seem specialized in understanding our existential condition and our involvement with others. They show that we are not alone, but are biologically wired and evolutionarily designed to be deeply interconnected with one another.[65]

To some, mirror neurons may simply prove once again that we can easily be subjected to manipulation, since the activation of these neural cells is not a consciously registered process. However, Iacoboni alerts us to the complexity of neural pathways and the interconnection between the premotor cortex and the limbic system, which enables us not only to sense emotions but also to establish empathetic ties. Kapoor's, Eliasson's, and Lum's mirror-based works displayed in public settings heighten the potential for sensing how viewers' acts are intimately linked with those of others even if they are not part of close-knit communities whose members share the same interests. These works confront viewers with the synchronicities and asynchronicities of experience in social settings where everyone is exposed to the gaze of multiple others.

Sociologists are astutely reflecting on how social relations have become more variable in recent decades. While in the 1970s Richard Sennett argued that Western societies had taken an introspective turn that diminished the potential for collective action, today there is less of a sense that the majority of individuals find privacy and contemplative attitudes more comforting

than interpersonal relations and interaction.[66] Despite the fact that online social networks seem to enhance the distance between people and create a fake sense of community, they continue to be hailed as effective media that can stimulate collective agency. Nonetheless, this does not mean that privacy is less valued. In an article explaining the rationale for the selection of Mark Zuckerberg, the inventor of Facebook, as *Time* magazine's 2010 person of the year, Richard Stengel stated: "Our sense of identity is more variable, while our sense of privacy is expanding. What was once considered intimate is now shared among millions with a keystroke."[67] The notion of what is public and what is private has changed significantly. As boundaries between public and private become increasingly problematic, posting images and messages on personalized online accounts, presumably viewable only by one's friends, frequently provides a feeling of virtual proximity to others.

Installations that foster mirroring processes and incorporate reflections of multiple spectators build on the same need for interpersonal recognition, yet they amplify empathetic responses by emphasizing the vulnerability of collectivities to mechanisms of surveillance. The significant difference is that these works trigger affective connections in real rather than virtual space. They similarly exemplify the impulse toward belonging to volatile groups and adopting different poses and gestures in order to avoid a fixed image, which can be more easily subordinated to the gaze of others. In a sociological study preceding the emergence of Web 2.0 technology, Michel Maffesoli identifies a departure from modern group formations based on political and economic ties, which mainly foster static notions of identity and give vent to individualism. He argues that we feel increasingly united by our differences and by processes of incomplete and unstable identification with a wider range of groups. Under these circumstances, Maffesoli believes that affective connections proliferate and individuals develop more diffuse relationships to collectivities. He contrasts this tendency to the commitment to groups with a strong sense of identity prevalent in the 1970s:

This "affectual" nebula leads us to understand the precise form which sociality takes today: the wandering mass-tribes. Indeed, in contrast to the 1970s—with its strengths such as the Californian counterculture

and the European student communes—it is less a question of belong-
ing to a gang, a family or a community than of switching from one
group to another.[68]

According to Maffesoli, these nebulous ties emphasize our intrinsic multi-
plicity. As individuals shift their alliances at a faster pace, there is a rising
concern about the weakening of both individual and collective agency. Ken
Lum's *Pi* explicitly underscores the need for affective connections to others,
irrespective of their location or citizenship status, in order to prevent a de-
cline in individual responsibility. It conveys a complex world picture perpetu-
ally in motion. The statistical data it provides offer an approximate represen-
tation of the state of various localities and the transformation of the whole
planet under the impact of changing demographics or natural phenomena
that escape human control. Lum eloquently describes *Pi* as "an allegory of
the world, the circle to which pi refers standing symbolically for the world
and its infinitely varying patterns."[69] The installation encompasses indices of
a planetary system of interrelated elements. Some correlations between the
data presented in different mirror panels are clearly visible, and others can be
intuited. For example, the number of people killed in wars over the course of
one year is closely linked with the amount of money spent on weapons during
the same period displayed in another factoid panel. Kapoor's and Eliasson's
works also allude to complex world systems. *Cloud Gate* carries cosmological
connotations through its planetary shape and its perpetual transformation
in relation to variations in atmospheric conditions. Similarly, *Take your time*
brings to mind a planetary time that escapes individual control. The slow-
moving reflective disk evokes the rotation of the Earth as it shapes temporal
consciousness and provokes disorientation, heightening participants' aware-
ness of the gravity pull.

Despite lacking references to specific social issues, Kapoor's *Cloud Gate*
and Eliasson's *Take your time* augment the visibility of interpersonal connect-
edness while undermining a privileged perspectival view that would favor in-
dividualism and allow for the institution of an unethical principle of absolute
Otherness that suppresses multiplicity and enforces subordination. These
works invite prolonged engagement with spatiotemporal intervals in which

one abandons the certitude characteristic of normative associations with others and comes to terms with the inevitable lack of complete autonomy and control in contemporary societies.

Kapoor, Eliasson, and Lum share an affinity for conceiving environments that stimulate both visual and mental reflection. Both acts are necessary to foster mirroring processes that enhance awareness of plurality instead of reducing images of self and others to static entities. Maurice Merleau-Ponty contends that when we suppress references to the visible world we distance ourselves from others, since it is the shareability of potentially congruent experiences that unites us: "As soon as one reaches the true, that is, the invisible, it seems rather that each man inhabits his own islet, without there being transition from one to the other, and we should be astonished that sometimes men come to agreement about anything whatever."[70] Jean-Luc Nancy evokes a similar idea when he argues that despite the negative implications of spectacle, it is a necessary aspect of our societies because "we present the 'I' to ourselves, to one another, just as 'I,' each time, present the 'we' to us, to one another. In this sense, there is no society without spectacle; or more precisely, there is no society without the spectacle of society."[71] The philosopher implies that we construct ourselves as subjects by taking a distance from a solely self-focused perspective and by considering the way we connect with others and our surroundings. This reflection mediated by visual spectacle should not be taken as an impediment to agency, since the realization that one is as much an object as a subject in the social world engenders a more lucid understanding of the potential roles individuals can embody in order to generate change.

Cloud Gate, Take your time, and *Pi* create interstices in which affective ties between participants can be vividly intuited. The mirror surface suggests a unitary frame characterized by synchronicity, yet the movements of the viewers, the processes of behavioral and emotional attunement, and the disjunctions between participatory responses underscore the asynchronous relations and the unpredictability subsistent in social networks. The popular appeal of Kapoor's and Eliasson's works has triggered the assumption that they are spectacular icons that undermine personal engagement by luring the masses through their sublime aesthetics. Both artists have taken a stance against this critique by pointing out that their works invite viewers to question themselves and the representations of the world instead of providing

an escape from critical reflection. In his monograph on Millennium Park, Timothy J. Gilfoyle asserts that Kapoor responds to the critique of *Cloud Gate* as a site of spectacle with the question: "How many Disneyland or theme park visitors contemplate their 'nothingness' . . . ?"[72] In the artist's view, the reflections encompassed by the sculpture are supposed to elicit awareness of the vulnerable position occupied by the individual in the large social picture. Yet this does not mean that the individual is released from responsibility, since he or she is part of multiple systems in which every cluster of nodes and even every disparate connection can induce changes. Eliasson also rejects the view that his works fulfill art institutions' need to offer installations that provoke overwhelming experiences in order to compete with cultural industries. Although he finds it hard at times to support this argument, given that many of his works have boosted the image of museums as democratic sites, he contends that he actually manages to offset the commodification of aesthetic experience by creating works that call for personal reflection:

> When I talk about a conflict of trajectories in my work it refers to the fact that in the experience industries it is generally seen as counter productive to the commercial potential of a situation if it makes you evaluate the nature of the experience in which you are engaging *while* you are engaging in it.[73]

To the immersive and subjugating spectacle of commercials claiming to echo viewers' desires and needs, Eliasson counterposes visual experiences that enhance self-awareness and critical involvement. Similarly, Lum is a firm believer in the significant function of sense experience in critically confronting individual viewers with large social structures. Even when his works take the form of banners or occupy the sites of commercial display cases, as *Pi* does in the Karlsplatz Westpassage, they stand for "a call for self-reflection, which is not really the logic of advertisement."[74] Like Eliasson, Lum believes that art can compensate for the obliteration of self-awareness in the context of the growing mass culture.

The mirror frames of *Cloud Gate*, *Take your time*, and *Pi* both unite and divide: within their reflective realm, one feels part of affective groups joined by their differences; on their thresholds, one becomes critically cognizant

of the condition of entrapment implied in any representation isolated from the wider social environment. The artworks of Kapoor, Eliasson, and Lum remind us of belonging to interconnected spaces and temporalities. Without diminishing the importance of personal reflection, these artists conceive perceptual and conceptual contexts that encourage viewers to ponder the interpersonal construction of identity and the potential for change of seemingly immutable social and political structures. Far from perpetuating utopian views of complete individual autonomy and large revolutionary transformations, these installations support the view, so forcefully expressed by Frantz Fanon, that we are at least partly responsible for creating ourselves.

Mirror Portals
Unpredictable Connectivity in Responsive Environments

*It may be helpful to think of the behavior of an organism as the
performance of an orchestral piece whose score is being invented
as it goes along. Just as the music you hear is the result of many
groups of instruments playing together in time, the behavior of
an organism is the result of several biological systems performing
concurrently.*

—Antonio Damasio, *The Feeling of What Happens*

*In the posthuman, there are no essential differences or absolute
demarcations between bodily existence and computer simulation,
cybernetic mechanism and biological organism, robot teleology
and human goals.*

—N. Katherine Hayles, *How We Became Posthuman*

The relation of humans to digital technology has conjured fears of disembodiment as well as anxieties about the risk of surrendering consciousness to computers. While N. Katherine Hayles believes that we have already reached a "posthuman condition," since we are enmeshed in complex computational systems, other critical theorists continue to insist on defining human beings in opposition to technology, in the name of a much-needed defense of the salient qualities of humanity.[1] At a time when we acknowledge our indelible connection to multitudes as a result of the proliferation of information platforms and social media, dialectical modes of self-definition are increasingly

destabilized and we are compelled to consider who we are and what we can accomplish in relation to rhizomatic information, social, and environmental systems. Although the ideals of individual autonomy and human superiority are far from abandoned, there is a growing sense that we need to account for our contingent position within the world and surpass the binary oppositions that have shaped the Western understanding of human identity.

Contemporary artists working with digital media are designing environments that invite viewers to discover their indelible connection with their surroundings by testing out the interactive possibilities of technological platforms. These artists are challenging viewers to reflect on the potential for movement, transformation, and collaboration triggered by the encounter with digital interfaces that respond to human presence in unexpected ways. Affective and behavioral mirroring processes among participants are prevalent in interactions with such environments, which often undermine reliance on visual cues and cognitive mapping to stimulate proprioceptive and multisensory modes of relating to the surroundings. Sometimes described as a sixth sense or a phenomenon that possibly mediates correlations between all the other senses, proprioception permits an experience of the relations among one's different body parts and contributes to an apprehension of one's position in space. According to philosopher Brian O'Shaughnessy, proprioception "takes a back seat in consciousness almost all of the time" and becomes apparent when one directs one's attention to corporeal presence in relation to an environment or the surface of an object.[2] In responsive environments that translate movements into sounds or correlate them with precarious images, participants' sense of defamiliarization is counteracted by a more or less conscious proprioceptive attunement to the kinetic possibilities available in the space of interaction.

Once participants decode the interactive modalities of responsive environments, the properties of those environments become increasingly analogous to those of reflective surfaces. Digital interfaces that highlight users' and computers' input and output render evident the symbiosis of information and neural systems that appear to mutate simultaneously, just as during the interplay between changing gestures and shifting mirror images. Nonetheless, perfect parallelism and constant synchronicity between human input

and anticipated technological output is often an illusion, which stems from the presumption that cybernetic systems have no memory and do not evolve with interactive processes. As this chapter will show, artists designing responsive environments sometimes purposefully contradict the notion that there is a perfect correspondence between stimulus and response in human–computer interaction. Opposing the notion that technological interfaces are neutral information platforms that ensure seamless feedback, they often reveal the variables that affect the interactive possibilities and encourage viewers to come up with creative ways of transforming the responses of the interactive platforms through performative and even collaborative acts.

Artist and theorist David Rokeby provides a lucid analysis of new media environments in terms of disjunctive reflective processes. He identifies Marcel Duchamp as the foremost precursor of new media, citing Duchamp's use of glass as visual interface in *The Glass Stripped Bare by Her Bachelors, Even* (1915–23). He also acknowledges the tremendous influence of John Cage, who shifted the focus of attention from the completed work to audience members' responses.[3] Drawing analogies between feedback loops prompted by human–computer interaction and mirroring acts, Rokeby points out that technology can enable us to question the notion of subjectivity by acting as a reflective surface that refuses to meet our expectations perfectly:

> To the degree that the technology reflects ourselves back recognizably, it provides us with a self-image, a sense of self. To the degree that the technology transforms our image in the act of reflection, it provides us with a sense of relation between this self and the experienced world.[4]

According to Rokeby, interactive technology can fulfill both the role of expanding our self-awareness and the role of extending our relations to the external environment. While he admits that such technology's similarities with mirrors are compelling, he favors the creation of feedback systems that conspicuously show that information is not always disseminated fluidly via cybernetic networks. Rokeby emphasizes the incongruities that arise in interactive systems because he believes they help users ponder the implications of their acts, the lack of neutrality of interfaces, and the indeterminate elements

that subsist even in systems based on binary codes. The responsive environments he has designed since the early 1980s tend to follow a refractive model of interaction, which he names "the transforming mirror" or "the distorting mirror."[5] Many of his works mirror back the bodily presence of participants by translating their gestures and movements into sounds, images, or words that appear to follow a prescribed code yet frequently fail to abide by the expected interactive pattern. This mismatch between participants' input and the cybernetic system's anticipated output elicits affective experiences and prompts a shift in the interaction flow by giving rise to uncertainty and improvisation. In his discussion of the sense of selfhood and agency, philosopher Jakob Howhy signals the disruptive impact of a misreading of relations between cause and effect. In such a scenario, he argues, "the feeling of mineness would be replaced by a feeling of bewilderment and alienation towards the offerings of the sensory-system—the minimal self would begin to fragment."[6] Therefore, the participant is bound to direct his or her attention toward others facing similar challenges in decoding the principles of interaction or to embrace a more intuitive response to the environment seemingly endowed with a will of its own.

In this chapter, I analyze how new media artists design responsive environments that trigger conflicting feedback loops in order to cause a suspension of belief in the capacity of interfaces to respond consistently to users' actions. Upon noticing a lack of perfect mirroring between their actions and the responses of technological systems, spectators start acting as part of the cybernetic systems rather than as external agents capable of fully controlling the systems' responses. I argue that it is in such disquieting instances that the clear-cut distinctions among animality, humanity, and technology are interrogated. Participants experience a surge in affect and catch a glimpse of the uncertainty that resides both in the fluctuating behavior of human beings and in the variability of technological devices. The puzzling incongruities that emerge during the course of their interaction with responsive environments enable them to relinquish a purely controlling mode of engagement and inquire into the possibility of collaboration within cybernetic systems. They encourage more open-ended interactive modalities that favor experience over goal-oriented behavior. The inconsistencies have the potential to

prolong an intense sense of in-betweenness. Evoking John Cage's compositions and Jean-Luc Godard's films, Deleuze and Guattari explain that process-oriented artworks are characterized by "a floating time" rather than "pulsed time or tempo," "experimentation" rather than "any kind of interpretation."[7] Similarly, responsive environments such as the ones discussed in this chapter can give vent to prolonged performative improvisation if participants choose to go beyond the stage of getting to know how they function and start acting *with* the environments instead of focusing solely on controlling them.

A disciple of robotic art pioneer Norman White, David Rokeby creates environments that inspire both a sense of proximity and a sense of distance in relation to technological interfaces. Many other new media artists, such as Myron Krueger, Luc Courchesne, Monika Fleischmann, and Wolfgang Strauss, pursue a similar interest by envisioning technology-based artworks that undermine the linearity of interactive patterns. Thus, they are significantly revising the legacy of art and technology projects created in the 1960s, which were often unfairly criticized for transforming the viewer into a sort of mechanical agent with no role in interactive systems other than that of activating preprogrammed sounds or images.

The first section of this chapter examines the development and reception of David Rokeby's *Very Nervous System* (1986–91, 2003), a quasi-invisible medium that permits users to produce sounds seemingly instantaneously through the movements of their bodies. Individual responses to this work have been discussed previously in the context of human–computer interaction, but little attention has been given to the affective and interpersonal dimension of the performative acts it has catalyzed in various display contexts. The second and third sections dwell on the unpredictable rhizomatic connections inspired by two more recent responsive environments: Christian Moeller's *Audio Park* (1995) and Rafael Lozano-Hemmer's *Under Scan, Relational Architecture No. 11* (2005). I explore how these works, which rely on participants' activation of sensory stimuli, interfere with habitual patterns of movement in public space and give rise to spontaneous congregations and, in certain instances, collective experimentation. Drawing on Deleuze and Guattari's affect theory, I discuss the alliances formed between multiple participants in responsive environments. Hence, I revise mainstream art historical narratives that discuss

the reception of such works solely in terms of binary action/reaction patterns, limited to the feedback loop established between the individual viewer and the technological interface. I find that Rokeby's, Moeller's, and Lozano-Hemmer's explorations of complex systems that catalyze emergent behavior and sociability are coextensive with their interest in retrieving spectatorial modes associated with protocinematic devices that require viewers to be actively aware of their bodily presence while taking an active role in the projection of visual and acoustic stimuli. These three artists invite participants to become playfully engaged yet stay critically alert to the mediation of their experience and the variable parameters of the cybernetic systems.

My discussion of audience responses to these artists' environments is based on my observation of video recordings that showcase a whole range of more or less performative impulses generated by the environments' sensory interfaces. My analysis of *Very Nervous System* and *Under Scan* was greatly enriched by access to ample participation documentation. Caitlin Jones and Lizzie Muller conducted interviews with David Rokeby and with visitors to a 2009 exhibition of *Very Nervous System* in order to map out the diverse responses inspired by this work.[8] Highly conscious of shifts in modes of behavior triggered by interactive platforms across time and the contingency of viewers' responses on age, professional background, and degree of prior exposure to new media art, the two researchers aimed to show the "mutability and contingency" of new media by highlighting "the dialogue between its experiential, conceptual and technical aspects."[9] In what follows, I reference the interviews conducted by Jones and Muller in order to showcase both what might be considered ideal responses to *Very Nervous System* and concrete examples of interactions that depart from the prolonged experimentation with the work envisioned by Rokeby. Similarly, my analysis of the reception of Lozano-Hemmer's *Under Scan* is anchored in examples of reactions to the work described in ethnographic interviews with participants conducted by Nadia Mounajjed in 2006.[10] Such documentation renders possible deeper insights into the interactive potential of the works, as well as into the interpersonal connections mediated by them. The interviews sometimes bring to the surface the desire of participants to experience the works with others or their tendency to imagine how others would react to the works. These responses

reveal the works' participatory character, which goes beyond the binary feedback loops established between the individual visitor and the interactive platform.

Computer Interfaces as Unfaithful Mirrors

Over the course of many years, David Rokeby developed *Very Nervous System*, a responsive environment based on a computerized system that senses motion and responds to it through acoustic signals.[11] Video cameras and image processors detect and interpret participants' kinetic presence. In response, a complex audio system including synthesizers produces sounds echoing the intensity, speed, and rhythm of all movements sensed in the environment. Despite having an intuition of the close correlations between their motions and the oscillating acoustic stimuli, visitors can hardly feel in control of the flow of acoustic sequences upon an initial encounter with *Very Nervous System*. After an extended period of interaction, they are better able to identify associations between particular movements and specific sound sequences. As the title suggests, the work emulates the intricacy of neural connections even though visitors may not immediately be able to gain insight into the complexity of the cybernetic system.

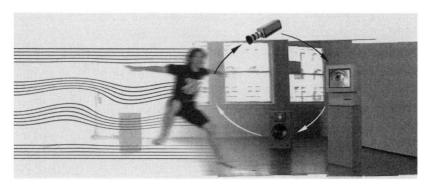

David Rokeby, *Very Nervous System*, 1986–91, 2003. Schematic montage by David Rokeby. Courtesy of David Rokeby.

Encouraging visitors to perceive themselves as part of a musical instrument rather than as independent performers playing it, *Very Nervous System* shows that there is potential for agency even in the midst of contingent relations, as one can choose to influence the acoustic signals while simultaneously being subjected to their impact on subsequent gestures. Philosopher Alva Noë rightly compares the brain to a musical instrument in his persuasive critique of computational models of the human mind that ignore the agency of the human subject, who actively modulates consciousness through perception and motion.[12] *Very Nervous System* takes such an analogy one step further by offering an environmental model that accounts for the unavoidable embeddedness of human subjects in the world, as they perpetually shape and are shaped by its flux. The attunement of the mind to the subject's actions and the context of perception can thus become perceptible at an acoustic level. Admittedly, these higher-order cognitive associations may be more or less apparent to visitors while they interact with the work. This section will discuss a whole range of responses to the environment while underlining the unmistakable affective impulses provoked by discrepancies in action–reaction patterns.

Very Nervous System exemplifies the "transforming mirrors" model of interactivity theorized by Rokeby. The mismatches that appear between performative movements and desired sounds point to the refractive—rather than simply reflective—processes that are at play in the environment. The artist maintains that while all interactive systems are based on a reflective principle, not all of them account for the multiple variables that mediate the transmission of information.[13] Therefore, only some responsive environments encourage participants to observe how their actions have been processed and potentially distorted within the cybernetic system. *Very Nervous System* compares successive raster images of the environment in order to identify variations in movement. It also examines kinetic actions for abruptness or fluidity by comparing them against information held about previous interactions with the interface. The response of the environment appears to be concomitant with participants' movements due to the different speeds of information processing in the human brain and the computer system. As Nancy Campbell notes, *Very Nervous System* proposes "an inversion of the traditional relation-

ship between dance and music," since performers move to bring sounds into being rather than adjust their motion to preexisting acoustic oscillations.[14] Nonetheless, the specific correlations between gestures and acoustic variations remain somewhat mysterious as participants gradually attune their gestures to the sounds they have already produced—they are part of the cybernetic system rather than external actors affecting it.

Rokeby repeatedly revised the interactive possibilities of the environment and experimented with different types of acoustic stimuli, including Oriental sounds, rumbling metallic reverberations, percussive tones, and everyday noises. Displaying the environment both indoors and outdoors, he tried out a whole range of behavioral responses and expanded the work's sensitivity to subtle shifts in motion. Upon exhibiting *Reflexions*, a prototypical version of *Very Nervous System*, at Digicon '83, the first international conference on digital arts, Rokeby was dismayed to discover that the environment often failed to respond to the body movements of visitors. He realized that throughout the process of experimenting with the interface, he had come to intuit the types of gestures that it could read most easily and had performed them frequently to elicit responses. Consequently, at the time of the conference, the environment could not mirror other people's performances very well. Rokeby explained that the system's lack of comprehension was the outcome not only of its inherent properties but also of the way it had been modeled by his behavior: "In my isolation, rather than developing an interface that understood movement, I had evolved *with* the interface, developing a way of moving that the interface understood."[15] By pursuing close correspondences between specific kinetic actions and sounds, he had undermined the complexity of the system and diminished its ability to interpret new information. After the conference, Rokeby became increasingly preoccupied with investigating both how the interactive platform was transforming as a result of human motion and how participants were changing their performance as a result of an enhanced understanding of its workings. Endeavoring to enter into a more symbiotic relationship with the responsive system and increase its plasticity, Rokeby abandoned his inclination toward rigorously controlling its responses and embraced performative improvisation to a greater extent. This shift toward an interactive mode no longer geared toward triggering

very specific reactions recalls the fluidity of interpersonal exchanges through which mothers loosely emulate their infants' gestures by introducing slight variations in the communicative feedback in order to emphasize empathetic relations and stimulate cognition.[16]

Intent on observing the complexity of responses to *Very Nervous System*, Rokeby has presented the environment both in mainstream art contexts and at new media festivals. In 1986, the work was on display at the Venice Biennale in the *Art, Technology and Informatics* exhibition. During the same year, Rokeby presented the project as part of the Strategic Arts Initiative's exhibition dedicated to telematic art. The responsive system offered a framework for creative exchanges of acoustic information between Paris and Binghamton, New York. Participants in each location could produce a distinct range of sounds through their movements. Their acoustic outputs commingled, as they could be heard simultaneously in both places. This dialogue at a distance via movement and sound emphasized the contingency between events and the human need for connectivity. From this perspective, *Very Nervous System* was reminiscent of Allan Kaprow's *Hello* (1969) happening, in which participants acknowledged each other's presence in places interconnected via live video feedback. The exchange of information was more controlled in Kaprow's event, however, since the artist was in charge of switching the video channels at his own will. The telematic operations of Rokeby's environment were more fluid and random, with multiple participants triggering different sounds simultaneously in the absence of a performance conductor. Reviewers of *Very Nervous System* have noted the behavioral attunement and disjunctions established not only between the individual visitors and the technological system but also between participants who act as part of ad hoc collectivities modeling the acoustic responses. In her account of the exhibition of Rokeby's environment in a public park in Manazuru, Japan, in 1990, curator Su Ditta praised the work's potential to disrupt individual and collective behavioral patterns. She commented that the carp pond area in this otherwise quiet and contemplative location turned into "a site for complex social engagement" because the interactive system challenged visitors to "study each other's reactions" and orchestrate diverse acoustic effects as part of a group.[17] In outdoor settings, *Very Nervous System* creates an enhanced awareness of the social dimension

of behavior instead of prompting a primarily dialogic type of interaction between an individual performer and the technological apparatus.

The display of the work in increasingly public locations has also prompted challenges to viewers' reflection on the interaction. In an interview with Caitlin Jones and Lizzie Muller, Rokeby explained that a high traffic flow in the environment could be problematic. According to him, when five or more visitors act within the space of *Very Nervous System* they risk losing their sense of the effects of their individual movements and thus may fail to consider their personal agency and responsibility in the cybernetic system. To counteract this issue, Rokeby has sometimes delimited the space of interaction through the use of material components such as strings hanging from the ceiling. He calls such measures "psychological barriers" that frame a space of observation of interaction and encourage visitors "to think before they enter."[18] Rokeby is also conscious of the fact that some visitors may not be inclined to act in a public performative context. Thus, in highly public display venues, he has lowered the intensity of light within the environment to ensure a more intimate and comfortable atmosphere. The sensitive threshold between public and private interactive circumstances intensifies the affective dimension of *Very Nervous System*, which prompts attunement and agency in relation to both social and technological factors.

As in the case of other reflective artworks that trigger interpersonal awareness, perceptual, behavioral, and affective mirroring processes are easily noted among participants in *Very Nervous System*: they observe how their movements are reflected by the acoustic system, often emulate each other's gestures in attempts to produce similar sounds, and feel empathetically connected to each other thanks to shared kinetic inclinations. Rokeby contends that the environment exposes more than just personal reactions to the system, since "it is not the individual interactor who is reflected in these works so much as human behavior itself."[19] In addition to becoming aware of similar behavioral impulses, participants imagine acoustic transformations they can trigger together with others. In an interview concerning her experience, Katarina, a young administrator interacting with the work in Linz in 2009, suggested that "it would be interesting to see a lot of people in there and see what happens." She also intuited that another person could trigger a significantly different acoustic response while "making the same moves."[20]

The correspondences and mismatches that inevitably appear between what is mentally envisioned and what actually occurs within the responsive environment encourage participants to connect with one another and with the interface in a more intuitive manner.

Rokeby has identified two main patterns of interaction with *Very Nervous System*: one is geared toward the discovery of deterministic relations between the components of the environment and the participant's bodily presence, and the other focuses on a more subtle and playful orchestration of the soundscape through improvised movements. He points out that upon stepping into the acoustic environment, most participants are tempted to examine to what degree they can attain control over its responses to their move-

David Rokeby, *Very Nervous System*, 1986–91, 2003. Video camera, digitizer, computer, custom software, sound synthesizer, amplifier, and speakers. Installation views at Ace Art Inc., Winnipeg, Canada, 2003. Photographs by William Eakin, Liz Garlicki, and Risa Horowitz. Image array design by Mike Carroll. Courtesy of David Rokeby.

ments. He calls this mode of engagement the "First Test of Interactivity" and observes that tentative gestures gradually transform into commanding actions once performers discover connections between certain movements and certain types of sounds.[21] Visitors' comments on their initial responses to the work testify to this desire to decode the principles of interaction. Susanna, a middle-aged chemistry teacher, stated that she "could have tried to produce different sounds, but it was . . . more interesting to find out how this functions."[22] She admitted that her interest in the technical aspects might have been influenced by her scientific professional background, but such inquisitive testing of how and when the environment responds to movements has been observed in the cases of most participants interacting with the work over limited time spans.

Those who go beyond the stage of identifying the cause-and-effect relations have somewhat different experiences. Günther, a professional musician and software engineer, was keen on playing with the environment as if it were a musical instrument and confessed that it felt as if he were "in a universe that is governed by laws that are very understandable."[23] Interestingly, he had interacted with another version of *Very Nervous System* several years earlier, and consequently on his second exposure he was more intent on exploring how subtle movements correlated with acoustic stimuli. Like Günther, Markus, a video art specialist interacting with the work, attempted to identify specific relations between a somewhat peculiar sound he had accidentally triggered and a prior movement. His experimentation with trying to replicate the acoustic effect was not fully successful. Rokeby explains that the moment participants feel they can control the environment, they are bound to fall out of tune with it by changing their behavior without even realizing it:

After the third repetition, interactors decided that the system was indeed interactive, at which point they changed the way they held their body and made a gesture to the space, a sort of command: "Make that sound." The command gesture was significantly different from the early "questioning" gestures particularly in terms of dynamics. . . . I observed a couple of people going through this cycle several times before leaving in confusion. Their body had betrayed their motivation.[24]

It follows that both the relation of participants to the system and their relation to their bodies stand under the sign of ambiguity. The perplexing lack of correspondence between cause and anticipated effect, as well as between intent and bodily expression, casts doubt on the responsiveness of *Very Nervous System* and the power of subjectivity. As participants strive to attain control, their bodies turn out to be unruly, revealing their shifting attitudes in a more powerful manner than they would expect and altering the response of the system. The precarious parallelism between gesture and sound also stems from visitors' oscillation between multiple modes of orientation in space—a proprioceptive one that results from the self-referential sense one has of the intensity and speed of bodily movement in relation to the environment and a cognitive one based on the memory of a prior gesture in a specific location. The more time one spends with *Very Nervous System*, the more aware one becomes of an intuitive orientation, thus sensing, as Brian Massumi suggests in his discussion of proprioception, that "movement is no longer indexed to position. Rather, position emerges from movement, from a relation to movement itself."[25] The quality and sequence of motion play key roles in the shaping of the acoustic spectrum of the work. To come to terms with the proprioceptive dimension of interaction with the work, visitors need to relinquish the belief that they can fully control it as if it were a machine and become better aware of their own bodies in relation to the sound fluctuations.

Participants' affective engagement intensifies when inconsistencies emerge during their interaction with the interface. This experience heightens awareness of corporeal presence and disrupts the Cartesian search for a causal relation between stimulus and response. It brings to mind Massumi's analogy of affect with "microshocks," which momentarily shift the balance of things and foreshadow the potential for transformation.[26] Upon suddenly sensing that either the system has failed them or their bodies have not abided by their commands, participants experience exactly such "microshocks" as they find themselves on the brink of transformation without being able to foresee accurately the next acoustic outcomes of their gestures. These moments of uncertainty generate critical distance, stimulating individuals to question well-grounded assumptions. Massumi finds disjunctive tension to be a significant catalyst for the renegotiation of relations: "In that moment of interruptive

commotion, there's a productive indecision. There's a constructive suspense. Potentials resonate and interfere, and this modulates what actually eventuates."[27] During their interaction with *Very Nervous System*, participants gradually come to understand that both their behavior and the system's responses are extremely precarious. In their documentation of audience responses to the work, Jones and Muller asked visitors whether they could define their relation to the environment in terms of control. Several of them pointed out that "control" does not represent an adequate concept in this context and were more inclined to describe the interaction in terms of "influence."[28] The subtle modulation of both kinetic and acoustic responses calls into question unidirectional subject–object relations between an individual agent and a supposedly subordinate cybernetic system that exists apart from it.

Another source of affective tension for visitors is the virtual mirroring that occurs between what is sensed acoustically and what is imagined at a visual, kinetic, and tactile level. Rokeby explains that participants in *Very Nervous System* "find themselves imagining the feel of it [the system] against their body, imagining the space filled with sound particles."[29] By imagining a tactile encounter between themselves and the interface at a mental level, they become engaged in a quasi-synesthetic perceptual mode that expands the potential for sensing fine differences between similar signals or movements. Gabi, a curator with knowledge of new media, explained that upon her first encounter with the work she felt compelled to close her eyes in order to be more attuned to the environment. She noted that she wanted to "feel what happens" rather than focus on how the work comes to respond to movements.[30] Privileging a proprioceptive mode of engaging with the work, she was less intent than other participants on the visual reference points for the components of the installation: the video camera, the speakers, the hardware concealed in a white box. Philosopher Mark B. N. Hansen suggests that environments that preclude reliance on the visual decoding of spatial coordinates engender "a shift to a perceptual modality anchored in affect, proprioception, and tactility—anchored, that is, in the bodily infrastructure out of which vision emerges."[31] *Very Nervous System* contributes precisely to such a multisensory experience, disrupting the perception of physically bounded elements and inspiring a deeper realization of the intimate contiguity between

participants and the space of interaction. Participants act *with* the environment rather than simply against the background defined by its visible and invisible components. In order to stimulate proprioceptive orientation by subverting viewers' reliance on visual cues for interaction purposes, Rokeby has often chosen to use white speakers and obscure the visibility of the video camera through the use of light.[32] He suggests that he wants to generate "stereoscopic proprioception" by stimulating visitors to sort out their spatio-temporal relations to the environment through gaining a deeper sense of how their bodies feels in relation to it and how the fluctuating audioscape reverberates in relation to their presence.[33]

More closely correlated with this proprioceptive experience is the playful mode of interaction identified by Rokeby. Unlike the mode driven by the identification of specific relations between what the participant does and the effects prompted, the playful mode implies the adoption of a more improvisational approach. Participants who embrace this mode relinquish the ideal role of conductor of an invisible orchestra and give freer rein to their movements, virtually dancing to the sounds they are producing. As they cease focusing their attention on the impact of each and every movement, they enter into a more fluid dialogue with the system. Interviews with visitors interacting with the work have revealed that some are more inclined than others toward this free play. Participants with prior knowledge of new media art appear to leave behind more easily the inquiry into cause-and-effect patterns and virtually move with the work instead of defining themselves apart from it. The act of relinquishing the desire for control may also emerge from a faster understanding of the rules of interaction. Considering the ties between agency and perception, Howhy points out that "the immediate conscious sense of being in control during agency transpires as the feeling of not having to perform active on-line control of what we predict well."[34] He calls the alternation between the conscious repetition of a certain behavioral pattern to attain predictable effects and the gradual relinquishing of strict control as one masters an action "the seesaw between self-reflection and attentional immersion."[35] This smooth transition is observable when participants in *Very Nervous System* reach an interactive stage at which their actions are no longer driven by the identification of cause-and-effect relations among

their movements, the video cameras, the computer, and the speakers. The creative potential of the work is fully achieved only if visitors spend enough time in the environment to become proprioceptively attuned to its acoustic reverberations and come to terms with the more or less predictable flow of transformations in the cybernetic system.

Rokeby believes that the relation between mind and body is put to the test in different ways by the two interactive modes. While in the first case participants give priority to intent by focusing primarily on rationalizing the interaction with the system, in the second case they allow their bodies to respond to it in a more flexible manner. The artist explains that this genre of interaction is characterized by spontaneity: "This approach involves opening oneself to suggestion, allowing the music of the system to speak back through one's body directly, involving a minimum of mental reflection, and thus tightening the feedback loop as much as possible."³⁶ Rokeby remarks that this performative mode is not free from misconceptions, since participants may tend to act as if they are no longer responsible for the transformations of the sound environment. Instead of favoring either of these two kinds of engagement, he suggests, participants should try to switch back and forth between them in order to observe the indeterminacy of their behavior and the cybernetic system. Thus, Rokeby attempts to disclose mistaken beliefs about the notion of interactivity. He suggests that "interaction is about encounter rather than control," because for a new media environment to be truly interactive, both the computerized system and the participants need to undergo transformations.³⁷ In order to emphasize this idea of mutual influence, the artist calls the visitors who adopt performative roles in the context of *Very Nervous System* "interactors" rather than "users," as such participants are usually called in analyses of new media reception.³⁸

Very Nervous System provides access to a broad range of acoustic effects that cannot be fully predicted. Its responses depend on more than just a predetermined scheme because the network morphs as the system's memory of past feedback expands. Heinrich Falk maintains that the aesthetic dimension of an invisible system such as Rokeby's environment, which lacks fixed formal features and depends on human interaction, derives from its mutability: "The perception of beauty in interactive situations can therefore be described

as the experience of potentiality."[39] Aesthetic enchantment also originates in the realization that what one experiences while interacting with the system is simply a tiny part of the myriad gestural and acoustic possibilities. The dissonances and affinities between the ways the system responds to different performers enhance its affective impact. The intuition that the potential for change cannot be fully encompassed at an individual level enhances participants' uncertainty as well as their sense of connectivity. However, art historian Söke Dinkla finds the social dimension of Rokeby's work problematic because it presumably disrupts the individual participant's reflection on his or her relation to the interface. Dinkla notes that it is often unclear whether the user or the interface exerts more control over the stimuli produced in responsive environments and contends that "the suggestive power of interactive correlation is only disturbed by the fact that Rokeby . . . creates environments which allow the presence of more than one visitor."[40] Perpetuating the entrenched ideal of the private aesthetic experience, Dinkla suggests that exhibition visitors would be better able to raise critical questions about the effect of *Very Nervous System* if they interacted with the environment individually. Yet it is equally important that participants consider a broader range of variable factors that influence the way they affect and are affected by cybernetic systems. Binary relations between individual users and machines are more likely to trigger Cartesian explanations for the system's behavior, whereas relations established between multiple participants and multiple signals more blatantly unveil the unpredictability and contingency of both social and technological systems.

Upon noticing the imperfect correspondences between their movements and the environment's sounds, ad hoc performers realize that both they and the technological system act as "transforming mirrors." *Very Nervous System* is not an autonomous device but a posthuman cybernetic network. It is the outcome of the virtual synapses formed between the human nervous system and the central processing unit of the computerized system. The symbiotic relations triggered by the environment undermine a deterministic model of interaction and bring to the surface both the plasticity of participants' behavior and the mutability of the acoustic system.

Rokeby discloses the deeply ingrained presumptions about computers. In

a lecture at the Gwangju Biennale of 1996, he explained that he intends to subvert the widely accepted binary oppositions between humanity and computerized systems through the design of responsive environments that contradict participants' expectations about human–computer interaction:

> Because the computer is purely logical, the language of interaction should strive to be intuitive. Because the computer removes you from your body, the body should be strongly engaged. Because the computer's activity takes place on the microscopic scale of silicon wafers, the encounter with the computer should take place in human-scaled physical space. And because the computer is objective and disinterested, the experience should be intimate.[41]

Rokeby upsets conventional assumptions concerning the relation between humanity and computers by highlighting the fact that technological devices can stage unpredictable encounters that are similar to those that happen in public contexts. In *Very Nervous System*, the computerized platform of interaction often responds in a surprising manner. The feedback it provides resembles less a literal transcription of participants' movements and more a new message that constitutes an empathetic response to the kinetic signals.

Very Nervous System creates a field of potentiality in which participants merge with the interface as if it were a prosthetic device functioning in tandem with their movements. Under these circumstances, the radical opposition between humans and computers is shattered, and participants let go of their Cartesian assumptions about the responsive environment. With their declining faith in the possibility of attaining control over the system comes an enhanced awareness of their precarious roles. Transforming with the system, participants momentarily come to terms with a nebulous field of contingent relations that Massumi associates with a surge in affective experience and the moment that precedes the emergence of subjectivity: "Before the subject, there's an in-mixing, a field of budding relation too crowded and heterogeneous to call intersubjective. It's not at a level where things have settled into categories like subject and object."[42] Acting as part of the cybernetic network rather than as outsiders of it, participants realize the unavoidable

interdependence between themselves and their surroundings. The public encounter with *Very Nervous System* does not preclude an understanding of the ethical implications of interaction; on the contrary, it is as part of small groups that exhibition visitors become better aware of the fact that the flux of information is analogous to the flow of social exchanges that shape our societies and cultures. Moreover, the environment's web of acoustic signals is influenced not only by the kinetic traces of the bodies interacting with it at present but also by the memory of past gestures that have affected its potential for feedback over the course of time.

Rokeby proposes a temporary suspension of binary categories of self-definition. As participants oscillate between attaining control over *Very Nervous System* and attuning their gestures to its acoustic oscillations, they are becoming familiar with the possibilities and constraints of the post-human condition, defined by Hayles in terms of "mutually constitutive interactions between the components of a system," be they human or technological.[43] Rokeby encourages participants to negotiate their roles in *Very Nervous System* and avoid committing themselves to a unique interactive pattern. Although he favors performative improvisation, he does not support an utter dissolution of differences between the components of the system because he senses that such differences are necessary to prevent a state of complete immersion that may result in loss of responsibility. Commenting on the balance of power within Rokeby's environments, new media theorist Erkki Huhtamo astutely notes that "the interactor is not an absolute master, while *Very Nervous System* cannot be said to have real '(will)power.'" He wonders whether this genre of rapprochement between the interface and the participants may "eventually lead to the tightening of the cybernetic feed-back loop—a merger, cyborg logic," yet he leaves this question open-ended.[44] Indeed, Rokeby does not advocate for leveling down all the distinctions between humans and computers. According to him, technology fulfills the role of a "philosophical prosthesis" that enables humans to gain a better awareness of themselves and the social, material, and virtual networks to which they belong.[45] Rokeby prefers that humans and computers mirror each other imperfectly, so that participants consider the reasons the interactive platform does not respond to their actions as they expect.

The open-ended and unpredictable character of encounters with new media environments such as *Very Nervous System* initiates an affective experience that shakes participants' sense of selfhood and control, creating the potential for a subsequent reconsideration of identity from a less ego-driven perspective. During the past two decades, Rokeby has continued to create works that challenge viewers to consider how technology imperfectly reflects their performative actions or cognitive abilities. His *Giver of Names* (1990–present) installation invites visitors to ask a computerized platform to name mundane objects that they set on a pedestal. The inability of the computational system to recognize these simple items and the bizarre correlations it creates between their attributes in order to name the objects take visitors by surprise. The disjunctions between the concepts they associate with the objects and the concepts the computer assigns bring to light the plasticity of meaning and the potentially nonlinear character of associations between visual and verbal signifiers within information networks.

Building on similar ambiguous relations between stimuli and responses, Rokeby's installations *Silicon Remembers Carbon* (1993–2000) and *n-Chant* (2001) further reveal the inconsistencies that emerge in all cybernetic systems as a result of the noise that interferes with one-to-one correspondences. In these works, the social dimension of participants' interaction with the cybernetic system is highly evident and enhances the unpredictability of the feedback offered by the technological system. In *Silicon Remembers Carbon*, digital images are projected onto a bed of sand. Gallery visitors' shadows and live video images intermix with prerecorded silhouettes, beckoning participants to question their notions of reality. Similarly, *n-Chant* plunges gallery visitors into a confounding cybernetic system where the original meanings of messages are rapidly obliterated. A colony of seven computers exchange information in a quasi-ritualistic manner by repeating words in unison until visitors interfere with their chant. By pronouncing words into microphones placed in front of the monitor screens, participants disrupt the information flow. The computers rapidly pick up the uttered words and transform them through new verbal associations, as in a Chinese whispers game. The more visitors interact with the system concomitantly, the more chaotic the computers' acoustic responses become. Rokeby's installation showcases the proliferation

of dissent within a cybernetic environment and indicates that transformation is contingent on imperfect mirroring acts, which completely change the flow and content of messages as well as the dynamics of social relations.

As will be shown in the following sections of this chapter, other new media artists have embraced a similar interest in designing interactive systems that subvert participants' expectations by drawing parallels between the unpredictability of social systems and the nonlinearity of information systems. Pondering human desire to retain control over technology, Rokeby asserts that "sometimes control is not what you want, sometimes you want something that is like control but has a bit of a curve to it—something that reflects some of the complex, unexpected, surprising responses of things in the real world."[46] His new media environments unveil the increased propensity for transformation, interpersonal exchanges, and reflection in unpredictable contexts, where one is taken outside familiar territory and hesitates between the desire for self-assertion through performative action and the impulse toward attuning one's actions to those of others.

The Poetics of Participation in Open-Ended Systems

Like David Rokeby, new media artists Christian Moeller and Rafael Lozano-Hemmer create environments in which spectators establish affective connections while interacting with technological interfaces that call their attention to shifting spatial coordinates and sensory stimuli. In these spaces, participants intuitively learn the rules of half-real, half-virtual perceptual games and realize that they have limited control over the effects of open-ended systems. In the fashion of GRAV artists who designed interactive labyrinths for outdoor spaces in Paris in the 1960s, Moeller and Lozano-Hemmer conceive interactive platforms that inspire interpersonal awareness and push passersby out of their habitual comfort zones in public settings.

In the remaining two sections of this chapter, I analyze Moeller's *Audio Park* and Lozano-Hemmer's *Under Scan, Relational Architecture No. 11*, two outdoor environments that respond to the presence of passersby and stimulate them to discover their contingent position in relation to technological and social networks. I argue that in spite of their quite overt surveillance implica-

tions and the public venues in which they are displayed, these works create an intimate atmosphere in which people experience a strange familiarity with each other and the sensory stimuli that arise in relation to their movements.

Both Moeller and Lozano-Hemmer have interdisciplinary backgrounds, which has probably steered their interest toward the design of complex responsive systems. Moeller initially specialized in architecture but eventually decided to pursue the design of new media environments, which can elicit multisensory engagement and interpersonal exchanges more directly than can architectural structures. Taking an even more drastic turn in his career path, Lozano-Hemmer shifted his attention from primarily scientific training in physical chemistry to artistic inquiry into emergent forms of social behavior prompted by interconnected biological and technological networks. Both artists have presented their works in outdoor spaces where passersby are less inclined to abide by the usual norms associated with introspective encounters with artworks generally privileged in museum settings. In 1994, Lozano-Hemmer started a series of works under the title *Relational Architecture*, a term that designates environments that challenge the relatively fixed boundaries of buildings or public squares by triggering heightened forms of interaction with their physical and ideological implications. Similarly, Moeller has created new media works that destabilize the fixed coordinates of architecture and upset the usual codes of behavior in public space.

Both artists regularly work in partnership with programmers, mechanical engineers, and light designers to create responsive environments. They share an interest in inspiring performative modes of participation. Conscious of the intimidating effect of imposing architectural structures, they prefer to design works that are well adapted to human scale and collapse the distance between passersby and their surroundings. Unlike public sculptures, which inevitably acquire iconic status due to their permanence, Moeller's and Lozano-Hemmer's works have a more elusive presence and engender a higher degree of spontaneous behavior, since they are displayed only for limited periods. Both artists avoid prescribing rules of interaction because they want participants to discover intuitively the way the environments function and become aware of their complexity by observing the plethora of responses that can be elicited in a social context. By inviting passersby to congregate

around precarious visual and acoustic stimuli that are contingent on the participants' movement, these works call attention to the less visible social ties with strangers that shape people's behavior in public space. The ethereal relations these environments prompt echo the need for connectivity with others in physical space at a time when we increasingly rely on palliative bonds with people mediated by social media.

Moeller's *Audio Park* environment was commissioned by V2, Institute for Unstable Media, for the Museum Park in Rotterdam, a quite deserted site in spite of its proximity to art institutions. The artist designed a wooden platform measuring 262 by 262 feet in which he embedded light sensors. Tall towers located around the stagelike setting cast light beams at dusk and projected sound waves, thus producing a quasi-mystical atmosphere. Moeller placed the light sensors asymmetrically on the platform and signaled their presence by means of green planks and arrows. When objects or bodies interfered with the flux of light projecting across the sensors, the ambient sound became distorted as new sounds were produced. Sometimes the acoustic environment sounded like the interior of a void hall echoing the acoustic effect of the slightest footsteps; at other times it sounded like a pulse or a screeching noise produced by machines. Whether organic or mechanical, syncopated or prolonged, the sounds maintained an otherworldly character due to their occasional dissonance. Their qualities depended on the rhythm and speed of participants' movements. The sounds produced in this way intertwined with an electronic acoustic composition created by musician Pete Namlook as well as with randomly selected radio broadcasts. Hence, no individual or group could attain complete control over the variable acoustic signals.

Moeller's *Audio Park* resembles the interactive scenario envisioned by David Rokeby for *Very Nervous System*. Both responsive environments cultivated heightened sensory and behavioral awareness by acting as distorting mirrors for participants' input. Nonetheless, there are also significant differences between them. Whereas Rokeby maintained the invisibility of the responsive interface to a great extent, Moeller signaled its presence in a conspicuous manner by marking the locations of the sensors. From this point of view, interaction with *Audio Park* was somewhat less intuitive than that with *Very Nervous System*. Moreover, the feedback loop between the input and

the output of the system was somewhat less immediate in Moeller's environment. Hence, participants had a greater sense of control over the system.

Like *Very Nervous System* and *Audio Park*, Lozano-Hemmer's *Under Scan* eschewed manipulation and did not immediately provide a key to its operational principles. The project was commissioned by the East Midlands Development Agency, which hoped to strengthen connections between people living in this British region known for its industrial heritage. By means of robotic devices, Lozano-Hemmer projected hundreds of video portraits of East Midlands inhabitants onto the pavement of public squares. The environment was set up for a period of ten days in five cities within the region: Derby, Leicester, Lincoln, Northampton, and Nottingham.[47] Only the technological

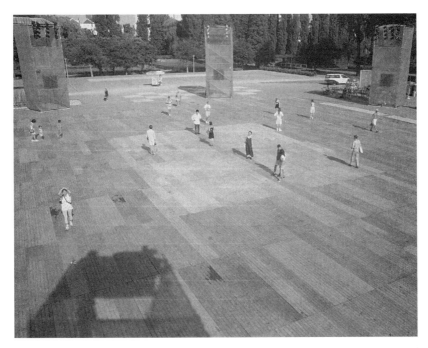

Christian Moeller, *Audio Park*, 1995. Museum Park, Rotterdam, the Netherlands. Courtesy of Christian Moeller.

equipment traveled between these locations; the video portraits were specific to each display context. Lozano-Hemmer worked with local filmmakers to record the performative gestures of volunteers willing to have their images encompassed in the environment. The video portraits were not immediately visible, being concealed from the public eye by intense light projections. Like Moeller, Lozano-Hemmer relied on light variations and bodily movements to activate the expanded sensory content of the environment. As people walked in the square, their footsteps were tracked by a computer system that antici-pated their trajectories and activated the video recordings. The ethereal quali-ties of the film clips, which appeared against the elongated shadows of the passersby, emphasized the contingency between self and others. The figures in the video portraits appeared to try to communicate with the passersby. Some performers blew kisses, winked, or enthusiastically opened their arms, whereas others adopted more threatening poses, seemingly seeking libera-tion from their spaces of confinement. The portraits remained alive only as long as onlookers maintained their shadows over the projections, thus sug-gesting the need for people to dedicate time and attention to engaging with others. Every seven minutes and thirty seconds, the lights switched off and a flickering electronic grid appeared on the pavement, bringing all other video projections to a halt. Its matrix structure blatantly disclosed the surveillance implications of the environment.

New media environments activated or augmented by participants' shad-ows encourage both playful interactions and poetic reflections on the no-tion of the human body as interface endowed with prosthetic-like qualities. Moeller and Lozano-Hemmer have repeatedly relied on ethereal traces of corporeal presence to invite reflection on our innate otherness and the in-timate ties we have with our surroundings. Just like masks, shadows both conceal and reveal multiple facets of identity while offering the illusory yet often comforting sensation that individuals can maintain a certain degree of anonymity. In responsive environments, shadows frequently stimulate an interrogation of binary differences between self and others and under-mine the possibility for instantaneous recognition of identity so necessary for enforcing surveillance. In 1997, Moeller designed *Camera Music/Kinetic Shadows*, an installation that translated kinetic gestures into graphic signs.

Rafael Lozano-Hemmer, *Under Scan, Relational Architecture 11*, 2005. Brayford University Campus, Lincoln, United Kingdom. Photograph by Antimodular Research. Courtesy of Antimodular Research.

A computerized system captured the video images of visitors' movements and projected them onto a screen as a series of interconnected spikes that stood for dynamic markers of human bodies. Not only did the abstract forms act similarly to shadows, but they also resembled musical notes in that they activated sound patterns contingent on people's positions in relation to the projection screen.

Like Moeller, Lozano-Hemmer has taken an interest in the creative potential of shadow projections. His shadow-based responsive environments catalyze inventive gestures, but they also carry darker undertones. In 1997, he created *Re:Positioning Fear, Relational Architecture No. 3*, an installation meant to stir discussions about the devastating effects of terror on the human psyche. The artist projected the text of online conversations on the topic of fear onto the walls of a former military arsenal building in Graz, Austria. Bleached out by intense light, the messages could be read only when participants' magnified shadows were projected against the walls. Acknowledging the influence of F. W. Murnau's silent movies, Lozano-Hemmer claimed that this environment was intended not only to invite participants to ponder the consequences of terror but also to inspire an actual sensation of fear. While its eerie qualities were undeniable, participants overcame the sense of horror by coming up with inventive performative gestures that allowed them to uncover more and more of the textual information projected onto the building. In an interview with José Luis Barrios, Lozano-Hemmer recalled that "the installation was converted into an ad hoc carnival and nobody thought for one minute about fears, plagues or invasions. This was one of the most entertaining errors of my career."[48] This so-called error inspired the creation of subsequent environments based on the interplay between video and shadow projections, such as *Body Movies, Relational Architecture No. 6* (2001) and *Frequency and Volume, Relational Architecture No. 9* (2003). These works inspire convivial responses, yet they also carry grimmer implications. Some participants' evident urge to attain control over these environments at the risk of interfering with the experience of others or blocking the communicative exchange altogether discloses the inevitable burgeoning of hegemonic relations under regimes of surveillance that can guarantee the anonymity of those in power. This antagonistic potential is often disregarded in critical responses to such envi-

ronments, which are generally associated with conviviality and the presumed collapse of hierarchies between participants' roles.

Both Moeller and Lozano-Hemmer situate viewers in spaces where the boundaries of visibility and invisibility are ambiguous. Being seen may be an intimidating experience, but it can also be a reassuring experience in places where one feels unsafe. For *Audio Park*, Moeller constructed a stage for participants' interaction with photosensitive cells in order to provide a heightened sense of security in an area of the city that passersby generally avoided because of rising concerns about drug-related crimes.[49] His environment encouraged people to congregate in the Museum Park even during evenings by setting the scene for an event that literally placed passersby in the spotlight. The towerlike scaffolding surrounded by green net panels produced sounds even when people were not around. Once people stepped on the sensors embedded in the floor, they transformed the environment into an instrument with changing acoustic tonalities. Thus, Moeller eschewed a primarily visual spectacle. Sound elements took the place of iconic spatial coordinates; they did not constitute a fixed acoustic topography, since they were modulated by participants' movements and combined with audio snippets from live radio broadcasts.

Moeller's audioscape showed that space is not an abstract entity with fixed boundaries but a social product. Far from being the result of a perfect alignment of contiguous puzzle pieces, the environment encompassed both harmonious and incongruous sounds that implicitly hinted at the convergent and divergent relations established in any dynamic system. Even when groups of participants sought to create a certain rhythm within its context, dissonances did not disappear from the complex system. This fluctuating set of relations brings to mind Henri Lefebvre's statement that "social space implies actual or potential assembly at a single point, or around that point," but it does not necessarily entail a consensus.[50] Moeller did not configure *Audio Park* as a perfectly harmonious acoustic environment; rather, he provided the tools for passersby to enact self-directed acoustic happenings that could be disruptive.

Lozano-Hemmer's *Under Scan* offered a bit less room for improvisation yet similarly relied on a shifting web of relations. It did not entail strictly defined

goals or prescribed performative roles. The artist has often reflected on the need for subverting the feeling of control exerted over social exchanges in public space:

I'm interested in setting up a platform that can still get out of control. It is very important that in a public space no one will tell you how to act, and with media art including my own you are often given instructions. . . . This is something I have tried to avoid.[51]

Through its unpredictability, *Under Scan* facilitated chance encounters between people who might never have met face-to-face despite having frequently crossed paths. While it undeniably highlighted regional connectivity, the work did not transform local participation into a mere subsidiary to regional policy objectives because it did not prescribe specific modes of social exchange.

Moeller's and Lozano-Hemmer's responsive environments encouraged critical reflection on surveillance in public space. In *Audio Park*, the towers projecting light gave participants the impression that the space was closely guarded. The correlations between responsive environments and a state of increased surveillance were even more obvious in *Under Scan* because the movements of people were actually tracked by a live camera and could be watched on a small monitor located in the vicinity of the installation area. In these images, participants were viewed from above and appeared as minuscule beings moving in a video game environment. By openly displaying the surveillance technology, Lozano-Hemmer undermined the authority and effectiveness of the supervision apparatus. Moreover, he upset the expectations of passersby who were tempted to believe that the people in the video projections were performing in real time. Some interviewed participants even found it disappointing that their own video images were not projected live in the square.[52] Such expectations show how deeply ingrained surveillance tactics and live interactive scenarios have become. In an essay focusing on the concept of *Under Scan*, the artist wondered: "What would happen if every single camera in public space became a projector? What if instead of taking images of us, and assume we are suspicious, the tracking system offered us images?"[53] The

disruptive effect of *Under Scan* would probably have been significantly different if the figures that suddenly intruded into passersby's shadows had been broadcast live.

Moeller and Lozano-Hemmer conspicuously displayed the technological components of their works in order to favor distanciation over immediacy. Thus, they encouraged passersby to question what they sensed and how the sensory signals were transmitted via technological interfaces. In *Audio Park*, visitors became part of an ad hoc group of protagonists who activated clearly marked sensors and responded to the sounds produced by others, without necessarily communicating with them verbally. Some sensors were positioned close together and enabled group interaction, whereas others were more isolated.

By the same token, the visual projections in *Under Scan* were quite spaced out. Up to fourteen different portraits selected from the video recordings could be accessed simultaneously in the public squares. Passersby often approached the shadows of others in order to observe video portraits. In the ethnographic documentation of the work, it was noted that viewers preferred to witness the projections as part of small groups that facilitated the interpersonal negotiation of relationships with the performing subjects. Nadia Mounajjed delineated the encounters between passersby mediated by the images: "The video portraiture initiated conversations between participants; some were talking with the portrait or about it with others while interacting with it."[54] Both *Audio Park* and *Under Scan* highlighted the looseness and unpredictability of relations that can be established between perfect strangers in public spaces. Since Moeller and Lozano-Hemmer avoided using excessive visual and audio stimuli, their environments were characterized by an intimate atmosphere that encouraged people to approach others. The works stimulated a feeling of what Mark Seltzer calls "stranger-intimacy," which is "bound up not merely with the conditions of urban proximity in anonymity but also with its counterpart: the emergence of intimacy in public."[55] Some of the people in the portraits took off their clothes or adopted sensuous poses, knowingly staging intimate encounters with the imagined passersby who would stop by them. As shadows needed to overlap video projections in order to activate them, a virtually palpable connection was established between the

bodily representations of the performers and those of the viewers. In her report on participants' responses to *Under Scan*, Mounajjed noted, "Many users confirmed that the installation has changed their perception of the site; for those people, the space became 'friendlier,' 'livelier,' more intimate and inviting."[56] *Audio Park* also invited participants to cross the boundary between the public and the private sphere. Many people sat near the light sensors, touching them with their hands or feet. Moeller was surprised by the intimate mood aroused by the sound and light environment. Trying to explain what drew people near the stage, he stated, "I believe that the wooden deck, lit by the bright lights created a color temperature similar to the familiar ambience of our family living rooms in the evening."[57] Thus, Moeller attributed the affective impact of the installation not only to participants' interaction with the sensors but also to the subtle visual and haptic effects of the environment.

The tactile sensations catalyzed by the two environments returned participants to a more primordial connectivity to their surroundings. Bodily proximity was a condition for the activation of the video projections in *Under Scan*, but it was more than just an instrumental means for accessing content. The simulated tactile encounter between the viewer's shadow and the performer's video image appearing in its space spurred affective impulses, viscerally evoking the interdependence between self and others. Similarly, the activation of the light sensors in *Audio Park*, either directly through participants' touch or indirectly through their shadow projections, created a more intense awareness of the embodied character of experience. By asking participants to bring the environments into being through their movements in space, Moeller and Lozano-Hemmer made a compelling call for the rediscovery of the role of the body in mediating perception and cognition, as well as in enabling empathetic connections to others. The phenomenological inquiries invited by their works are reminiscent of Merleau-Ponty's reflections on the way the primordial role of touch prompts an enhanced awareness of the limitations and possibilities of one's experience in the world: "As the subject of touch, I cannot flatter myself that I am everywhere and nowhere; I cannot forget in this case that it is through my body that I go to the world, and tactile experience occurs 'ahead' of me, and is not centred in me. It is not I who touch, it is my body."[58] Participants' exploration of *Under Scan* and *Audio Park*

was at first intuitive, implying a kinetic search for a renewed understanding of their surroundings, which seemed to refuse to reveal their full sensory potential to the participants' gazes. In fact, the surroundings could not be mapped out through sight alone, but necessitated a consideration of the circumstances under which one can perceive, interpret, and transform sensory stimuli. This was more evident in the case of Moeller's acoustic environment, but it was also implicit in participants' interaction with Lozano-Hemmer's work, given the fact that the video projections appeared on the pavement only when motion was detected and passersby chose to maintain their shadows over the performers' bodies.

Audio Park and *Under Scan* held the promise of face-to-face encounters with others. The desire to share public space with others subsists in the consciousness and the unconscious of many people, especially at a time when we have grown increasingly distant from one another. Philosopher Gaston Bachelard suggests that adults grow increasingly accustomed to mundane living situations and that this habituation prevents them from gaining access to the affective dimension of reality. *Audio Park* and *Under Scan* probably reminded people of long-forgotten convivial places and childhood games. Their ambience was somewhat reminiscent of Bachelard's nostalgic description of images of intimate shelters recurrent in poetry: "By means of the light in that far-off house, the house sees, keeps vigil, vigilantly waits. When I let myself drift into the intoxication of inverting dreams and reality, that faraway house with its light becomes for me, before me, a house that is looking out."[59] Just as the stage in *Audio Park* became a refuge where participants could regain a lost sense of intimacy, the public squares in which *Under Scan* was installed beckoned viewers to reconnect with their more or less subconscious impulses, seemingly embodied by the volunteer performers in the projections.

Moeller's and Lozano-Hemmer's projects enabled participants to reflect on the alienation that is frequently experienced in urban contexts. They disrupted the usual trajectories of passersby in search of shortcuts to their destinations, calling their attention to the potential empathetic relations they overlook when they isolate themselves from others. Technology has frequently been vilified as the ultimate cause of this decline in face-to-face interaction, but Moeller and Lozano-Hemmer have shown that it can actually contribute

to a rediscovery of connectivity to both place and people. By demonstrating that motion has direct effects on the way we perceive things and interact with people, the artists suggest that we can truly inhabit a place when we linger in it for a sufficient amount of time or when it becomes a site for intimate encounters with others. In a 2002 interview with Alex Adriaansens and Joke Brouwer, Lozano-Hemmer contended: "'Placelessness' and 'multiplace' are terms concerning the conditions of the artwork, but also of ourselves, and of architecture. . . . Locality, like identity, is a performance."[60] Some passersby turned into ad hoc performers in the stagelike space of *Under Scan* while they reacted to the behavior of the people in the portraits. Similarly, participants in *Audio Park* inadvertently turned into musical composers or members of an orchestra lacking a conductor as they improvised different acoustic effects through their movements.

Despite the fact that they relied on recent technology, both environments catalyzed primeval experiences that closely resembled protocinematic experiments or intuitive modes of charting the boundaries of one's environment. The presence of technological components was visible yet unobtrusive; the affective engagement the works elicited was intense yet not always immediately observable. *Audio Park* and *Under Scan* played havoc with the smooth correlations between bodily movements and perceptual acts in order to underline their deep interconnections as well as their disjunctions. Consequently, passersby no longer took for granted the unity of sense experience. They became aware of the process through which they synthesized various sensory stimuli and spontaneously reacted to visual and acoustic variations. In *Techniques of the Observer*, Jonathan Crary explains that spectators of the nineteenth century were far from passive subjects of spectacle. He notes that they were physically involved not only in the viewing of moving images but also in the actual production of those images, through the manipulation of such protocinematic instruments as the phenakistiscope and the zootrope.[61] Moeller's and Lozano-Hemmer's environments recalled these earlier genres of aesthetic experience that required viewers to become engaged in the activation of sensory stimuli. They gave participants a chance to rediscover what it feels like to create sounds or set images in motion by means of their own kinetic involvement. While *Under Scan* staged a quasi-cinematic experience,

the encounter with *Audio Park* was more theatrical, with participants turning into ad hoc musical performers on a stage.

Under Scan rekindled the public's fascination with protocinematic experiments, as shadows turned into projection screens for video portraits. This type of experience contrasts with the more conventional cinematic scenarios described by film theorist Christian Metz in *The Imaginary Signifier*. According to Metz, cinematic projections both resemble and differ from reflective interfaces in significant ways: on the one hand, they can trigger self-reflective processes by encouraging viewers to identify with the characters that appear on the screen; on the other, they undermine this mirrorlike parallelism established between the subjects and the objects of perception because audience members cannot see themselves seeing while watching the movie and cannot manipulate their point of view as freely through their motion.[62] Unlike cinemagoers, participants in *Under Scan* and *Audio Park* did not become oblivious to their bodily presence in space; rather, they turned into catalysts of sensory stimuli. By literally making the images and sounds dependent on participants' movement, the artists suggested that spectators are always active producers of their perceptual experiences.

In addition to these correlations with protocinematic experiments, Moeller's and Lozano-Hemmer's environments recalled modes of cinematic spectatorship from the 1920s. Their performative and social implications were somewhat reminiscent of Dada cinema, which triggered uninhibited reactions and raised spectators' awareness of the social dimension of the viewing experience. Thomas Elsaesser forcefully argues that a "certain physicality and body-presence of the first cinema audiences is what might be called the Dada element in film."[63] He opposes this spectatorial mode to the immersive quality of surrealist movies that encouraged a process of closer identification between the viewer and the object of perception. I would argue that Moeller's and Lozano-Hemmer's environments actually managed to stimulate both forms of spectatorship, since they simultaneously triggered impulsive behavior and voyeuristic contemplation, given the fact that participants tried to get in tune with the responses of the cybernetic systems.

In *Under Scan*, some passersby turned to aggressive behavior toward the portraits projected. They purposefully stamped on images of heads and limbs

when they saw that the people in the portraits appeared to refuse to respond to their commands. These spectators often chose to react violently in order to stir feedback. Their behavior may have been motivated by their disappointment that video game rules of interaction did not apply in this case. Even the way the encounters between spectators and portraits were staged implied some level of subliminal aggression, since it presupposed the virtual fusion of the corporeal presence of ad hoc participants and volunteer performers as the projections of their body images overlapped. Some participants in *Audio Park* also engaged in brutal actions as they tried to exert as much pressure as they could on the light sensors. Their behavior appeared less vicious than that of the *Under Scan* participants, however, since they were interacting with sensors rather than with video representations of other people.

In addition to challenging these aggressive reactions, which were somewhat reminiscent of responses to Dada events, *Audio Park* and *Under Scan* elicited experiences evocative of surrealism by intertwining images and sounds whose sources remained somewhat puzzling, at least at first.[64] Spectatorial responses to *Under Scan* alternated between convivial and hostile attitudes toward the performing subjects. Similarly, people walking on the deck of *Audio Park* freely experimented with different interactive modalities. Some of them moved across the sensors and let go of voluntary control over the acoustic responses, whereas others sat down next to them and touched them occasionally in a gentle or harsh manner.

Another aspect linking the two installations to Dadaism and surrealism was their unpredictability. Passersby who came across *Under Scan* did not know whether they would encounter the portraits of friendly or hostile persons in their shadows. Likewise, ad hoc performers in *Audio Space* did not know whether the sounds they planned to trigger through their movements would intertwine harmoniously with those activated by others. Like many other contemporary artists, Moeller and Lozano-Hemmer experimented with prototypical images or sounds that solicit heightened bodily engagement without offering any promise of individual control. In the next section, I expand the analysis of *Audio Park* and *Under Scan* by examining the ways in which they prompted affective impulses as a result of unpredictable variations in open-ended systems.

Affective Impulses in Rhizomatic Networks

Upon encountering *Audio Park* and *Under Scan*, passersby were caught up in interactive situations with unknown stakes. Given the alternation between predictable and unpredictable responses, each of the environments loosely resembled both a video game platform and a self-generating amoebic body that put human creativity and adaptive behavior to the test. Feedback was contingent on both a dynamic technological network and a fluctuating set of interpersonal relations established among participants. Conspicuously impeding individual control, the two works revealed the misconceptions that underlie relation between humans and technology: participants in *Under Scan* were disappointed with the lack of live feedback between themselves and the performers in the video projections; similarly, passersby soliciting specific acoustic responses from *Audio Park* had to come to terms with the fact that they could influence only a small part of the variable cybernetic system. The responses of the technological platforms were not the only ones that took participants by surprise. Their behavioral expectations were also somewhat contradicted by the reactions of participants who acted impulsively in their attempts to solicit more specific responses from the systems.

Increasingly aware of the fact that they constituted merely one of the sources of indetermination in the cybernetic system, many participants derived pleasure from faulty interactive situations that called for a reassessment of their roles and the construction of imaginary participatory scenarios that built on the limitations of the system. Passersby could not discover all of the thousand video portraits in *Under Scan*, but they felt it was somewhat likely they could one day have a face-to-face encounter with a person they spotted in their shadows in the square. Similarly, participants in *Audio Park* could not get to know all the sounds that composed the fluctuating acoustic environment, but they felt an affinity with the other users of the acoustic system whenever the sounds they activated momentarily synchronized.

The desire for recognition of one's bodily presence noticeable in participants' interactions with *Audio Park* and *Under Scan* also stood at the core of film experiments of the 1960s. Lozano-Hemmer's instructions for the production of the video portraits for *Under Scan* are reminiscent of Andy Warhol's recording of *Screen Tests* (1964–66), for which individuals performed

mundane actions or simply gazed intently at the recording device. Lozano-Hemmer delegated the recording of the *Under Scan* video portraits to film-makers from the East Midlands. They informed volunteers that they were to self-direct their performance while looking into a monitor showing images of their performance. The only condition was that each performer was to look directly at the camera at one moment during the recording to engage a potential interlocutor. The portraits were filmed from a height of 8.2 feet. The volunteers performed while lying on a rectangular piece of black cloth that could easily be edited out of the video images. Hence, the figures could appear to emerge from the public square pavement, which momentarily turned into a cinematic screen. The neutral background, the nondiachronic images, the lack of sound, and the fixed camera of the portraits in *Under Scan* vividly recall the attributes of Warhol's *Screen Tests*. The lack of performative directions elicited an intense encounter with the film apparatus. The volunteer performers addressed an imaginary viewer while being highly aware of the camera eye. They acted as if they were trying to defy the limitations of the setting and the fixity of the camera lens. David James's observations on structural films also apply to Lozano-Hemmer's recording rules for the video portraits in *Under Scan*: "The camera is a presence in whose regard and against whose silence the sitter must construct himself. As it makes performance inevitable, it constitutes being as performance."[65] Some performers in *Under Scan* abruptly decided to stand up and challenge the flatness of the image, thus forcing close-up encounters with potential observers. A woman pointed a flashlight at the camera as if to communicate to viewers that they themselves were being watched, and a young girl with braids appeared to imitate the piercing gaze of the Medusa head, threatening to petrify curious viewers. Many people twisted their bodies into awkward poses or mimicked spontaneous reactions of surprise, terror, or rebellion.

The encounters provoked by *Under Scan* were highly intense because passersby sensed that their presence was both a condition for the cinematic projections and an apparent object of close scrutiny for the subjects in the video portraits. By far the most intense moments in the videos were the ones in which performers turned their eyes toward the camera, seemingly trying to communicate their isolation. At these points, their movements seemed to

slow down or come to a complete standstill, as if they had suddenly realized that they could transmit what they were experiencing only through provoking a mutual exchange of gazes with potential viewers. The performers called for an affective confirmation of their presence while mirroring the bluntness of the camera eye and beckoning passersby to respond to them.

In *Under Scan*, the relations among spectators, shadows, and the figures in the portraits were both reflective and refractive. The shadow, a somewhat loose marker of the self, turned into a screen for the other, represented in this case by the performers who temporarily invaded its virtual space. Passersby established an interpersonal relation to the images of anonymous figures. They recognized themselves in some of the performers' acts, but they also defined themselves in contrast to them. The absence of sound in the videos catalyzed a more primeval form of connectivity that stimulated self-recognition in the other's image. In his discussion of mirroring effects prompted by silent avant-garde film portraits of the 1960s, Paul Arthur suggests that spectators feel the urge to identify with the subjects in the images to compensate for the lack of a narrative and for the neutrality of the background: "As if staring into a mirror, we gradually become aware of how the sitter's posture and fidgeting might parallel our own confining situation. As in other silent studies, consciousness of the weight and physiotemporal restriction of bodies produces an eerie jolt of self-recognition."[66] Yet identification processes in *Under Scan* were also partly suspended because of the crude realization of the asynchronicity between performers' gestures and viewers' presence despite their virtual spatial proximity.

The affective experience was intensified by the spatial confinement of the figures in the portraits and the condition of restricted mobility imposed on the behavior of passersby, who needed to maintain their shadows above the video portraits to keep them visible. The moment participants decided to abandon them, the images of the people in the projections started to fade away, as if their subsistence depended on the potential for visual communication with others. The confined space they temporarily shared with the video portraits deepened spectators' illusion of being in sync with the volunteer performers. In his theory on cinema, Deleuze asserts that "the more the image is spatially closed, even reduced to two dimensions, the greater is its

capacity to open itself on to a fourth dimension which is time."[67] The video portraits rendered passersby highly aware of the duration of their experience precisely because the portraits interfered with their movements. As they took time to observe the performances of the individuals in the videos, viewers could not help but wonder whether the people in the portraits could actually see them or react to their motions. Hypothetical as the situation was, it catalyzed participants' desire to connect with these individuals by striving to notice signs of empathy that are not easily perceptible. In the absence of any possibility of verbal communication with the people in the *Under Scan* videos, spectators focused closely on changes in performers' facial expressions and bodily posture. Since the physical presence and movement of the observers made possible the appearance of the video portraits, the environment revealed the prevailing human need for interpersonal recognition and the less immediately visible bond with familiar strangers in public space.

Audio Park also prompted affective impulses as a result of contingent relations established among participants who modulated the responses of the environment simultaneously. Reminiscent of earlier art and technology projects, such as Howard Jones's *Sonic Games Chamber* (1968), Moeller's interactive platform solicited participants' movement to instill a higher degree of variability in the cybernetic system. In contrast with some artists of the 1960s who hid the signs of technological mediation, Moeller fully exposed the interface by clearly marking the locations of the sensors. He also enhanced the unpredictability of the system by enabling the convergence of acoustic responses produced in situ with live radio broadcasts and Pete Namlook's ambient composition. The experience that Moeller envisioned depended largely on a diffuse collectivity of participants who modulated the acoustic ambience by diminishing light intensity through their movements. Individual participants could not always identify with the sounds they produced since the sounds commingled with so many other acoustic impulses. The impossibility of predicting the exact results of their interactions with the system triggered an affective experience. Participants resorted to intuitive modes of interaction with the sensors and other people. They listened to the acoustic ambient, hoping they could identify sounds that were similar to the ones they had produced. The discontinuous acoustic sequences challenged par-

ticipants to yearn for a temporal continuum. This may be one of the reasons many of them lingered on the deck for a prolonged period, witnessing the performance of other passersby lured by the otherworldly sounds and lights. Moeller noted that "the piece had regulars; hundreds of people, every evening, literally occupying the place and making it their own."[68] Thus, they were transforming what used to be merely a site lacking identity into a place where they could rediscover the acuity of their senses and feel that they temporarily belonged to an ad hoc collectivity.

The two environments highlighted both the ability to gain self-awareness by defining oneself in relation to the Other's gaze and the inability to exert individual control over a complex system of information. Participants in both works were thus compelled to seek recognition of their presence while lacking any guarantee that the responses they received would mirror the acoustic effects they sought to provoke in *Audio Park* or the empathetic visual exchanges they wanted to initiate with the people in the *Under Scan* video projections. Many of the participants' reactions could be seen as manifestations of the desire for self-mirroring or self-transformation. Some passersby tried to take photos of their shadows and the projected portraits. One of the performers in the videos eagerly searched for his self-portrait until he eventually managed to come across it and photograph it. A large number of people responded to the portraits by emulating their gestures, hence creating partially distorted reflections of their performance. As verbal communication was temporarily put on hold in *Under Scan*, body language became the privileged medium for generating interpersonal relations and conveying emotions. When the expected gestural feedback failed, some passersby became disappointed with the lack of correspondence between their actions and the reactions of performers and started to behave aggressively, virtually torturing the portraits as if punishing them for their inability to speak back. One participant who was interviewed confessed his perverse pleasure at getting in close proximity to the figures in the projections despite knowing that he could not directly influence the communication stream: "I was behaving stupidly because I wanted to stand on them. I don't know why but when you see them it just brings out this feeling inside that you want to jump on them. I don't know why."[69] Aggressive reactions toward the projections in the shadows also

reflected a desire to defy distance and retrieve a primeval tactile connection to the portraits through direct bodily contact.

In *Audio Park*, many participants reacted in equally impulsive ways. They repeatedly pressed the sensors with increasing force to make the sounds last longer or to create more pronounced rhythmic acoustic patterns. Some participants used not only their bodies but also other objects to interact with the environment. In a video documenting responses to the work, a little girl can be seen trying to activate a sensor with the pointed corner of a paper sheet, as if a different kind of body would elicit a different response, and a young man skateboards across the sensors to test what sounds he can produce when the speed of the interaction changes.[70] Just as in the case of David Rokeby's *Very Nervous System*, participants wanted to exert more influence over the sounds. They wanted the deck to be more of an instrument—an object that would accurately echo their purposeful modulations of behavior to attain specific effects. However, such attempts at gaining control more often than not ended in failure. *Audio Park* participants were highly conscious of the fact that they acted as a group or a pack and not solely as individuals. They wanted to generate sounds that mirrored their actions, but the signals they produced were not independent from those created by others or from the live radio broadcasts integrated in the acoustic system. Every sound merged with other sounds produced or broadcast on the deck in more or less harmonious ways. Participants' attempts to replicate sound patterns produced by others or to alter their rhythm slightly in the hope of initiating an indirect dialogue resembled wild calls in the forest or e-mails forwarded to groups of people one may not actually know. The interaction with the sensors was not so much a process of self-representation as it was a mode of making one's presence known to others and a call for empathetic response. Affective affinities arose as sound sequences temporarily overlapped or were heard at more regular intervals. One person's movements had repercussions on the entire sound environment. As Deleuze and Guattari explain in their writings on animality, affect always implies a connection to a multiplicity: "The affect is not a personal feeling, nor is it characteristic; it is the effectuation of a power of the pack that throws the self into upheaval and makes it reel."[71] As can also be seen in Moeller's environments, affective relations often emerge from a

process of imperfectly mirroring a collectivity to which one does not belong and with which one vainly aspires to identify fully.

The kinds of alliances established between *Audio Park* participants as they attempted to connect to the signals produced by others were also observable in *Under Scan*. Many volunteer performers did not represent their human selves in the video self-portraits. Instead, they attempted to bring to the surface their indelible otherness. The video portraits did not appeal to eyesight alone. They called on passersby not only to sense the gaze of the performers but also to relate to the quivering of their skin in front of the camera. Many performers acted instinctively, shifting the positions of their bodies nervously as if they were unable to decide how they wanted to be seen by others. They stylized their movements, adopted awkward bodily postures, or changed their facial expressions unexpectedly. Some of them acted as though they were animals or insects, frantically moving their limbs as if caught in a trap. Their actions were not simply imitative; rather, they synthesized the idea of bodily or psychic alterity, thus impeding easy identification. Even though they turned their gaze toward passersby, trying to connect with them at an empathetic level, their performance sometimes verged on the anomalous, interfering with the habitual norms of public behavior. Performers who embraced such unconventional roles tried to form alliances with audience members who had become oblivious to their otherness. Some passersby reacted to the alien call of the ad hoc performers and spontaneously responded to them by moving erratically or by maintaining seemingly uncomfortable static poses because they found it hard to abandon established norms of conduct in public space.

Under Scan triggered alliances not only with the animalistic behavior of some of the performers but also with the robotic mechanism tracking the positions of passersby. During the "interlude" phase, when the virtual tracking grids turned into light beams projecting across the square, spectators became highly conscious of their coupling with the technological interface.[72] For many people, this aspect of the environment represented the most engaging part of the work. Passersby started moving across the multiple intersections of the shifting grids during this interval, and their behavior became more dynamic. Once their ties with the portraits were broken, they no longer had

to maintain fairly static postures and unleashed kinetic impulses that they had previously suppressed. Lozano-Hemmer has described the "interlude" as a period of respite in which passersby were liberated from the gaze of the people in the video projections: "The portraits had a lot of power, they had agency, and they could be quite invasive. But during the interlude people were relieved from that gaze, they instead related to one another, to a more familiar situation."[73] Since the gaze has frequently been associated with inflicting guilt and passing moral judgments on the viewer, the volunteer performers' intense looks may have impeded more spontaneous interactive modes.

The interlude was not initially conceived as a primary component of the installation. At this stage in *Under Scan*, the computer system automatically readjusted. During the interlude, passersby felt immersed in a space where

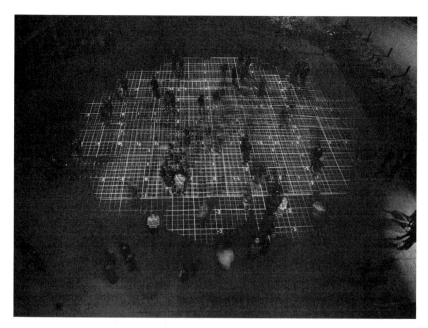

Rafael Lozano-Hemmer, *Under Scan, Relational Architecture 11*, 2005. Brayford University Campus, Lincoln, United Kingdom. Photograph by Antimodular Research. Courtesy of Antimodular Research.

bodily boundaries were challenged. They found it somewhat difficult to retrieve a sense of orientation in the midst of the shifting light patterns. In an interview, one of the participants described the experience in the following way:

> Suddenly you have no point of reference and suddenly all these grids appear that become your reference to movements. Even if you are standing still, you feel like you're sort of swimming in space. . . . You feel like you're sort of moving through the darkness.[74]

As visual coordinates became unstable, participants resorted to proprioception to recover a sense of direction. The disorienting grids that replaced the portraits evoked the multiplicity of the evanescent pack of projections. Participants could not fully identify with any of these geometric structures, which were constantly transforming. When they finally stabilized they became invisible and light flooded the square again. During the interlude, people entered into a quasi-symbiotic relation to the computerized system. Their reactions reinforced the analogies among humans, animals, and machines. They reflected Brian Massumi's view that "the pseudopod is a better model of the technological supplementation of the human body than the reigning model of the 'prosthesis.'"[75] The technicity of participants' bodies was momentarily suspended. The interface engulfed participants' bodily presence; they were encapsulated within its virtual womb and responded to its nervous impulses. Their bodies were contiguous with it, and they could no longer define themselves in binary opposition to the system. As the grids projected over their bodies, distinctions between part and whole were blurred. Participants realized even more clearly that they were part of the system and could not possibly occupy the position of detached observers of its responses. Only the small screens disclosing the surveillance tracking system in the vicinity of the responsive environment could grant participants access to such an external perspective.

Audio Park also made participants think of the complex connections between humans and technology in terms of transformations. The ambient sounds of the installation evolved in relation to people's movements and

mingled with Namlook's prerecorded composition and randomly selected radio broadcasts. All these combined signals formed an acoustic rhizome that impeded individual control. As Deleuze and Guattari emphasize in their discussion of human alliance with animals, a rhizome cannot be construed from the outside, and hence it cannot be preordained: "Make a rhizome. But you don't know what you can make a rhizome with, you don't know which subterranean stem is effectively going to make a rhizome, or enter a becoming, people your desert. So experiment."[76] Both Lozano-Hemmer and Moeller purposefully withheld complete control over their respective responsive environments. Participants became part of open-ended systems that developed most when the degree of unpredictability of performative and communicative gestures increased.

In *Audio Park* and *Under Scan*, the rhizomatic patterns were neither purely human nor purely technological. Moeller's acoustic environment was constantly fluctuating, being a bricolage of sounds transmitted from proximate and remote locations. Commenting on *Audio Park*, Andreas Broeckmann remarked the complexity of the acoustic variations and their hybrid origins: "The combination of chance and uncontrolled natural effects with the concrete and yet uncoordinated actions of multiple users, creates surprising aesthetic results that oscillate between ambient noise and sublime expressiveness."[77] *Under Scan* was an equally intricate hybrid environment. It expanded unpredictably as the result of participants' diverse responses to the video portraits as well as to the labyrinth of scanning grids projected onto the pavement during the interlude. Moreover, the interpersonal relations that emerged between passersby conversing about the work amplified the variability of the work and its affective potential. According to Lozano-Hemmer, entropic transformations are still possible in preprogrammed environments. He believes that an installation is successful when it offers surprises both to its author and to the public. As he stated in an interview, "The machine can have certain autonomy and expression because you simply capture the initial 'algorithmic conditions' but do not pre-program the outcome." He enthusiastically added that for him this is a "gratifying post-humanist message."[78] The posthuman condition consequently does not only inspire fears of isolation and disembodiment but also grants new opportunities for uncovering symbioses between human and technological systems.

Moeller and Lozano-Hemmer propose rhizomatic modes of affective participation. Inside their responsive environments, dialectical modes of self-definition are suspended and a sense of belonging can be reestablished as long as participants perceive themselves as part of variable systems that modulate emotion, perception, and behavior. Furthermore, *Audio Park* and *Under Scan* conveyed a compelling impression that participants shared with other passersby not only the same public space but also the constraints of surveillance—constraints that need to be interrogated at both the individual and the collective level.

Conclusion
Networked Spectatorship

One of the defining transformations that has marked the transition from modern to contemporary art has been the development of interpersonal modes of art spectatorship. The questioning of the autonomy of the art object furthered by the rise of conceptual art in the 1960s has been accompanied by the interrogation of the privacy and autonomy of the individual viewer. The encounter with modern art, which is oriented primarily toward a parallel relation between the beholder and the art object, has been supplemented by ways of looking at art that render viewers alert to the public dimension of aesthetic experience and the variations they can bring to the perception of the artwork. Since the 1960s, these transformations have been evident across a wide range of media, including sculpture, performance, art and technology projects, and video art. They can be seen clearly in the context of artworks with reflective qualities, which act as interfaces between multiple spectators seeing themselves seeing and acting as part of spontaneous congregations. The simultaneous interaction of beholders with the artwork and with each other has become an important component of what is now a shared viewing experience that elicits interpersonal exchanges, collaborative gestures, and impromptu performative acts.

Art practices that stimulate mirroring processes have contributed significantly to a turn toward more public modes of engagement with art. Even though they elicit interpersonal relations, these works have been associated mainly with acts of self-focused perception and narcissistic inclinations. The

mediated affective and perceptual relations they inspire among viewers have generally been left out of hierarchies of meaningful art participation, which tend to privilege verbal exchanges or provocative encounters between representatives of different social groups. The categories of "relational art" and "participatory art" have certainly broadened our understanding of the aesthetics of social encounters facilitated by artists, but they have also enforced at times dichotomous relations between visually or technologically mediated exchanges among art participants and more immediate communicative acts.

This book suggests that while most works with reflective and responsive characteristics engender a more nebulous field of interpersonal relations than do artworks that are usually considered "participatory," they have the potential to heighten awareness of individual agency and social contingency. They trigger modes of spectatorship characterized by affectivity, indirectness, and versatility, as well as performative gestures and social encounters that highlight participants' quotidian entanglement in complex networks. A significant number of them purposefully invite analogies between blatantly public exhibition settings and conditions of surveillance and behavioral control that extend beyond gallery settings. Accordingly, the perceptual field delimited by reflective or responsive interfaces often acts as a metaphor for shared sociopolitical conditions that impose limitations on individual and collective behavior. Moreover, it elicits actual interpersonal alliances and even collaborative or competitive acts as participants try to configure the images or acoustic signals encapsulated in the works as part of diffuse groups. While short-lived, these relations spur intense affective impulses and prompt critical reflection on free will, social expectations, and individual and collective agency.

In this book, I have primarily discussed art practices with mirroring and responsive qualities that catalyze the formation of temporary collective audiences and trigger feelings of unease as a result of perceptual disruption, public exposure, and unexpected performative responses. The physicality of the encounter with others in the reflective realm of artworks designed by Michelangelo Pistoletto, Joan Jonas, Dan Graham, Anish Kapoor, or Rafael Lozano-Hemmer strengthens the affective dimension of the aesthetic experience and prompts a critical evaluation of one's voluntary or involuntary

conscription into networks that may extend the purview of surveillance and social control. These artists' works stimulate an enhanced understanding of the contingency of our choices and the responsibility we bear for the mis-construction of reality when we fail to consider our individual roles within larger systems.

In order to show the participatory attributes of reflective artworks that situate viewers on the threshold between aesthetic immersion and engage-ment in interpersonal exchanges, I have focused on a range of performances, sculptures, environments, and installations that inspire mirror affect by lit-erally placing viewers in the spotlight in shared reflective spaces. However, there is also a significant array of works with mirroring qualities that call for a more private experience in order to challenge self-scrutiny. For instance, Agnes Denes, Kader Attia, and Iván Navarro incorporate reflective surfaces in their works to ask viewers to envision alliances with more or less specific collectivities that are afflicted by such problems as ecological imbalances, he-gemonic politics, and social inequities. Although their works call for a more private aesthetic experience, they also generate affective processes and sig-nal an ethical need for the perpetual renegotiation of individual roles in rela-tion to others.

Reflective Media, Then and Now

It is by no means accidental that the emergence of increasingly networked modes of spectatorship and the proliferation of works with mirroring quali-ties in the 1960s coincided with the rise of performative art genres such as happenings, Fluxus events, actions, and performances. Performances are gen-erally considered significant precursors of the participatory art turn, whereas minimalist sculpture, art and technology projects, and video art tend to be relegated to the domain of one-to-one art interaction despite the obvious in-terpersonal exchanges a significant number of these works catalyze. Artists working in the 1960s frequently chose to employ reflective materials in order to trigger a counterreaction to abstract expressionism or *art informel* by ban-ishing highly subjective forms of artistic expression from the act of art pro-duction. Relinquishing some degree of control over the work, they used more

impersonal media (e.g., Mylar, reflective foil, or mirror screens) to generate an increasingly variable aesthetic experience and enhance viewers' roles in the process of art reception. The social movements of the 1960s in Europe and the United States paved the way for the consolidation of art practices that called for interpersonal alliances among spectators not only in terms of shared identities but also in terms of looser ties based on affective experiences. At the same time, the design and rapidly expanding dissemination of technological devices, such as handheld video cameras and closed-circuit television, which simultaneously enable self-expression and active supervision, strengthened the tendency toward reflecting on the plasticity of identity and the constraints individuals face in intricate social systems.

If phenomenological concerns tended to override the social critique implicit in reflective art projects during the 1960s, in the 1970s the analogies between mirror or video screens and sociopolitical frameworks became increasingly overt. As process-based art practices started to develop and the controlling aspects of mass media and video technology became strikingly apparent, artists were intent on using reflective interfaces to subvert the desire for complete immersion in visual spectacle and the inclination toward personal identification with the views presented on television. They plunged art participants deeper into the public sphere rather than give them the illusion of freedom from sociopolitical constraints. Artists Dan Graham and Lynn Hershman cultivated interpersonal relations by staging disjunctive mirroring processes between viewers and artworks, with the explicit purpose of unmasking the mechanisms of surveillance and consumerism and showing the lack of complete autonomy of individuals. Their works placed participants in catch-22 situations in which they had to negotiate their roles and evaluate the degree of control they had over how they acted in society.

The salient presence of mirroring processes in art practices from the past five decades speaks to pronounced changes in art production and reception that correspond to shifting notions of interaction, identity, privacy, and publicness. While in the 1960s artists employing mirrorlike materials often aimed to inspire psychic involvement (e.g., Stanley Landsman, *Infinity Room*, 1968; E.A.T., Pepsi Pavilion, 1970), artists working in more recent decades have been more inclined toward using these materials to create interpersonal

engagement and raise consciousness of individual responsibility even in the midst of entanglement in complex systems (e.g., Ken Lum, *Photo-Mirror* series, 1998; Olafur Eliasson, *The Weather Project*, 2003). Impeding a totally private experience or a playful public one that completely adumbrates individual agency, the contemporary artists whose works I have analyzed in this book confront viewers with incongruous experiences: narcissistic absorption and voyeuristic projection, immersive contemplation and performative engagement, introspection and interpersonal exchanges with other museum visitors. They set the stage for contrasting modes of spectatorship in order to awaken the sense of personal agency and heighten awareness of social interdependence.

Since the 1960s, we have witnessed a gradual change from interactive works that primarily imply binary forms of feedback between the object/the responsive interface and the viewer to works that elicit increasingly complex relations, being purposefully designed to come under the influence of spectatorial actions and variable environmental factors. Some artists of the 1960s conceiving cybernetic systems initially envisioned one-to-one feedback between the individual viewer and the artwork, only to realize that the situation they had planned out was open to a larger set of correlations between concurrent spectatorial responses.

In recent years, a growing number of artists have created works that require the presence of multiple participants in order to be activated or become complete. For example, new media artist Scott Snibbe designs environments that are responsive only when more than one visitor is present. In the context of *Body Functions* (2003), at least two participants need to step on a shifting system of projected grids in order to animate it through their concomitant movements. Equally intent on inspiring contingent relations between visitors, artist Tomás Saraceno has conceived *In Orbit* (2013), an environment formed of nets and PVC balls that is suspended in midair. With every step participants take, they alter the pressure exerted on the weblike structure that sustains them aboveground. They experience a visceral sense of vulnerability as they are caught in this precarious orbit and realize that their physical balance is contingent not only on the robustness of the structure conceived by the artist but also on the movements of other visitors. By heightening sensory

and social awareness, the work draws attention to the need for balance and sustainability within complex environmental systems.

Mutual Recognition in Reflective Disjunction

Contemporary artists using mirrors or responsive interfaces often purposefully configure spaces in which viewers realize their limited autonomy from the rest of society. Unable to retrieve a sense of absolute sovereignty over perceptual and social circumstances, art viewers who encounter such works oscillate between the impulse to attain a higher degree of individual control over the work and the need to account for the presence and input of others partaking in the aesthetic experience. They are compelled to examine their degree of agency and dependence on others because they are confronted with their unavoidable inscription within visual systems that evoke the boundaries and hierarchies of economic, political, and social networks in a more or less direct manner.

During the 1960s, the proliferation of artworks with reflective qualities giving rise to questions about individual and aesthetic autonomy coincided with cognitive scientists' increasingly fervent inquiry into interpersonal perception, group creativity, and emergent behavior. The discovery of mirror neurons in the premotor cortex in the 1990s further consolidated the need to take into consideration the social dimension of cognition and triggered questions regarding the limitations imposed on free will. The notion that we are simulating the movements of others in our minds as we observe them has been both disquieting and promising. While the study of the role of mirror neurons has showcased the contingency of subjective perception and action, it has also unveiled the quintessential role of sociality in learning processes and has offered scientific evidence of the ethical dimension of encounters with others, previously theorized by philosophers Martin Buber and Emmanuel Levinas.[1]

Works that catalyze mirroring processes in public settings heighten interpersonal awareness and cultivate empathetic connections between perfect strangers. They also constitute spatial and social models that encourage participants to consider correlations between their place within the work and their

function within broader sociopolitical contexts. Joan Jonas's mirror-based performances, Howard Jones's acoustic environments, and Dan Graham's installations stimulate participants to acknowledge their contingent position within open-ended systems and develop strategic ways in which they can actively model the proposed situation, both at an individual and at a collective level. I have called this entanglement of viewers in affective alliances with others *mirror affect* in order to delineate the paradoxical qualities of encounters with reflective works and responsive environments that call concomitantly for self-scrutiny and collective attunement. The term *mirror affect* is essentially an oxymoron: on the one hand, it suggests a perfect correspondence, similar to that existing between a person and his or her reflection in a nondistorting mirror; on the other hand, it points to the ineluctable differences that exist between self and others despite strong connections. Drawing on Deleuzian philosophy, which associates affect with an incomplete becoming built on one's desire to establish an alliance with others,[2] I have examined modes of spectatorship that both promise and defer processes of identification between copresent participants, thus stimulating intense perceptual and emotional experiences. Olafur Eliasson's *Take your time* and Rafael Lozano-Hemmer's *Under Scan* engage viewers in precarious visual systems that elicit empathetic mirroring and behavioral attunement. Nonetheless, they also unveil the lack of perfect coincidence between self and others, thus enabling critical reflection on subjectivity, agency, and ethical implications of the gaze. Such works indicate the concomitant need for self-awareness and collective consciousness in societies that face a higher degree of vulnerability as a result of the accelerated proliferation of contingent relations.

Far from offering merely a pacifying illusion of coexistence thanks to seemingly perfect parallelism between self and others, works that trigger mirror affect catalyze refractive processes, pushing individuals to consider the unavoidable distinctions that exist between the way they perceive themselves and the ways others perceive them or between the roles they choose voluntarily and the ones they embrace inadvertently. Contemporary artists have created works that elicit this genre of response in order to deepen awareness of personal and interpersonal responsibility, sensitize viewers to the variability of aesthetic experience, and unveil the less immediately visible ties that

connect them to others. Artworks that build on this inclination challenge viewers to explore the potential for self-transformation and acquire critical distance from the social or political systems in which they are entangled.

Facing the Challenges of Complexity

Since contemporary artworks with reflective properties are often purposefully designed to generate complex spectatorial responses, prior models of art reception analysis need to be thoroughly revised in order to take into consideration how art experience is influenced by the versatile correlations established among the affective, perceptual, and behavioral responses of multiple art spectators. While in the 1960s curators and art critics such as Jane Livingston and David Antin were deeply concerned about the deterministic implications of works that encourage participants to act in specific ways to activate responsive interfaces, in recent decades it has become less problematic to think of art galleries as technological or social laboratories in which visitors test out the participatory potential of artworks as part of diffuse collectivities. This transformation is partly informed by the fact that many contemporary artists, including Eliasson and Lozano-Hemmer, blatantly unveil how their installations or new media environments have been constructed, thus doing away with the romance of technology. This shift in art criticism has also been prompted by the deepening realization that technological and social systems shape each other's responses in a complex manner. Both are characterized by emergent behavior, often transforming unpredictably and showing that the system envisioned by the artist is more than the sum of its technological components or an ideal set of responses to the work.

More and more, contemporary artists conceive the audience as a heterogeneous group of art visitors with looser or stronger connections based on their diverse psychological and social profiles. In their turn, audience members increasingly expect contemporary artworks to incorporate their performative gestures or provide feedback. Such expectations concerning art experience are shaped by the public's extensive use of digital interfaces to perform quotidian tasks and communicate with others. Major art museums are capitalizing on these transformations in order to showcase their growing accessi-

bility. In addition to exhibiting more artworks that shed light on their public dimension, art institutions are creating online platforms where visitors can discover additional information about exhibitions and leave comments on their encounters with the artworks. Tate Modern created interactive videos of the installations of Rachel Whiteread, Carsten Höller, and Doris Salcedo to enable online museum visitors to select the angles from which they want to see the works and even to watch other visitors approach the works and inspect their components.[3] Embracing a similar endeavor to generate interaction and enable people to examine a full range of responses to artworks, SFMOMA set up a website for Eliasson's *Take your time* exhibition that allows viewers to post blog entries about their encounters with specific artworks.[4]

This trend toward using technology to showcase the diversity of viewpoints on exhibitions has been synchronous with a trend toward inviting visitors to create their own visual responses to artworks in museum collections. Several institutions have asked art viewers to submit photographs inspired by artworks, which then may be used in exhibitions or in advertising campaigns.[5] By reserving the right to select the pictures that are most representative of creative responses, art institutions preserve their function as tastemakers. They also reinforce the aura of the objects in their collections, since visitors' photographic responses tend to be displayed and perceived as inherently inferior in quality to the original artworks that catalyzed the creative feedback.

As the message of art has become more and more contingent on artworks' reception, the sources of information on art experience have diversified tremendously. While gathering data on the interpersonal dimension of encounters with contemporary art, I have examined conventional art historical documents such as catalog essays, interviews, and reviews, but I have also resorted to less orthodox sources, such as visitor surveys, blog posts, and photos on Flickr. The public availability of image databases and personal testimonies concerning art experience has opened new avenues for the investigation of responses to art.

Increasingly networked modes of art production and reception are consonant with shifts in processes of self-definition. As sociologist Michel Maffesoli has suggested, identities have become more mutable in contemporary societies

because individuals define themselves in relation to larger numbers of groups with whom they share similar creeds or empathetic ties and to which they may feel committed only for short spans of time. The increased variability of affiliations with others, which Maffesoli describes in terms of an "affectual nebula," has been heavily influenced by the accelerated speed of mass communication and has contributed to the emergence of a more fluctuating sense of identity.[6]

Contemporary artworks with mirroring properties function as interfaces that stimulate participants to ponder the plasticity of selfhood and social ties. These works often inspire viewers to acquire both a sense of shared vulnerability in the face of societies of surveillance and a sense of potential empowerment through self-transformation. They call for a lucid and repeated assessment of alliances with others and reveal the increased disillusionment not only with the cult of subjective individuality but also with the cult of collectivities driven by a strictly defined set of ideals. Works such as Eliasson's *Take your time*, Lum's *Pi*, and Lozano-Hemmer's *Under Scan* frame precarious situations in which viewers examine their more or less fluctuating ties with others. They inspire both hope in a potentially shared condition, which might alleviate individual alienation and mistrust, since the promise of belongingness to a comforting collectivity may prove untenable or too short-lived. From this perspective, the works are symptomatic of the contemporary condition of "cruel optimism," defined by Lauren Berlant in terms of a desire to maintain attachment to the fantasy of a better or more secure life even though one is perfectly aware of the fact that this wish cannot be fulfilled.[7] Faced with this condition, contemporary artists are interested in bringing into the public eye not only the needs of specific communities, but also the desires and insecurities of diffuse collectivities of art viewers, thus boosting the potential for affective relatedness and heightening awareness of shared problems that call for individual responsibility and collective effort.

At a time of growing uncertainty, artists are challenging the controlled seamlessness of social ties by creating works that engender discrepant relations between viewers and cybernetic systems. By tracing multiple changes in the production and reception of works that trigger reflective processes, I have

outlined a theory of mirror affect, which explains the emotional, behavioral, and mental attunement between art viewers involved in a shared experiential field that publicly exposes their distinct images or responses while simultaneously disclosing the limits of individual autonomy.

This book lays the ground for a revision of the current historical account of how modern art became contemporary by showing how the interrogation of the autonomy, materiality, and permanence of the art object has been accompanied by an opening of spectatorial experience to a more complex set of variable factors that shape the appearance of the artwork. I hope that this discussion will open the way for new interpretive approaches to art reception that take into account the complexity of interpersonal responses to artworks and the way changes in art spectatorship reflect new modes of self-definition in relation to increasingly heterogeneous and volatile group formations.

Contemporary art currently provides a rich ground for debates concerning the relations between individual and collective behavior, emotion and cognition, consciousness and agency. Artworks that trigger mirroring processes among viewers contribute to an enhanced awareness of the plasticity of human consciousness, cybernetic networks, and social ties. They call for subtle negotiations between control and playfulness, distance and proximity, aesthetic immersion and performative behavioral responses. Above all, they showcase the emergence of new modes of art spectatorship that imply not only reflection on sensory information but also careful consideration of the viewer's role as active producer of experience, together with multiple others concomitantly engaged in affective, perceptual, and cognitive exchanges.

Acknowledgments

This book would not have been possible without the wise mentoring and wholehearted support of many people. To a great extent, it is the product of many encounters with others that have been more or less mediated by reflective artworks or discussions about them.

First and foremost, I am grateful to my doctoral adviser, Professor Terry Smith, for encouraging me to think of the world picture of contemporary art and providing helpful guidance during the writing of the manuscript. I learned from him that art historians should not fear to consider the global scale of transformations in art and society even when such processes seem to defy definition or categorization. His careful consideration of the general and the particular, centers and peripheries of the art world, local contexts and planetary concerns, will continue to guide my research and writing. Second, I am grateful to Professor Frances Connelly, whose academic mentorship and wise advice enabled me to navigate the paths of publishing my first book-length project. I am tremendously indebted to the collegial atmosphere of both the University of Pittsburgh, where I completed my PhD, and the University of Missouri–Kansas City, my second academic home in the United States, which granted me the opportunity to bring my book to completion.

Special thanks go to Barbara McCloskey, for stimulating me to think about the relation between democracy and spectacle; Kirk Savage, for his astute observations on the context of interactions with reflective surfaces in art; and Josh Ellenbogen, for introducing me to modern theories of perception. My familiarity with film theory and Deleuzian philosophy is greatly

indebted to Adam Lowenstein. I am grateful to Okwui Enwezor for enhancing my understanding of the complexities of the postcolonial condition. His poetic and political reflections on the writings of Frantz Fanon and postcolonialism will continue to inspire my thinking on alterity and interpersonal relations.

I first became aware of the correlations between responses to reflective media and the activation of mirror neurons thanks to a question raised by Anne Garréta of Duke University at the conference "Machines and Machinations," which took place at Cornell University in 2009. Becoming familiar with my interest in the rhizomatic affective connections established among participants in new media environments, Anne encouraged me to consider the neuroscientific basis of interpersonal perception. I continued to explore the neuroscience of cognition and emotion in the Cognitive Science Workshop organized at Stanford University in 2011 with the support of the Andrew Mellon Foundation. I felt privileged to be involved in heated discussions between humanists and scientists about epistemology, language, and visual cognition. I am thankful to all the "brain-campers" for their enthusiastic pursuit of interdisciplinary queries that have continued to preoccupy me throughout the writing of this book.

The cultural studies program at the University of Pittsburgh expanded my interest in interdisciplinarity. I am especially thankful to Giuseppina Mecchia for steering the discussion of graduate students in the PhD thesis-writing group. I learned a lot from presenting my research in this academic group, as well as from attending cultural studies seminars that cultivated my interest in applying theoretical knowledge at an interdisciplinary level. The Department of History of Art and Architecture at the University of Pittsburgh offered me significant support for fulfilling my research needs; I am indebted for the generous funding of my travels to archives, exhibitions, and conferences.

I am deeply grateful to numerous art and educational institutions that provided crucial resources for my research: the Center for Art and Media (ZKM) in Karlsruhe, the Generali Foundation in Vienna, the Frick Fine Arts Library of the University of Pittsburgh, the Getty Research Institute, the Los Angeles County Museum of Art, the Special Collections of the Stanford University Libraries, the Spencer Art Library, and the Archives of the Nelson-Atkins Museum of Art in Kansas City.

Many revisions to earlier versions of the manuscript were inspired by insightful conversations I had with Anne Collins Goodyear, Todd Cronan, David Freedberg, Caroline Jones, John Klein, Christine Ross, Jessica Santone, Dawna Schuld, Gregory J. Seigworth, Edward Shanken, Kristine Stiles, Roberto Tejada, and Philip Ursprung. I extend my warmest gratitude to the artists who generously responded to my questions about their works: Lynn Hershman Leeson, Les Levine, Ken Lum, Christian Moeller, David Rokeby, and Ira Schneider. I am very grateful to those who went out of their way to support my search for image rights acquisition: Emily Bates (Gavin Brown's Enterprise), Catherine Belloy (Marian Goodman Gallery), Kristy Caldwell (Castelli Gallery), Ludovic Carpentier (Daniel Langlois Foundation), Clare Chapman (Anish Kapoor Studio), Bruno David (Bruno David Gallery), Martin Enoch (Studio Olafur Eliasson), Marco Farano (Pistoletto Foundation), Erica Garber (Art Resource), Joe Houston (Hallmark Corporation), Allison Ioli (Vaga Rights), Julie Martin (Experiments in Art and Technology), Paolo di Marzio (National Gallery of Modern and Contemporary Art, Rome), Lindsay McGuire (Pace Gallery), Margaret McKee (The Menil Collection), Rebecca Naegele (Greene Naftali Gallery), Fujiko Nakaya, Linda Pellegrini (Marion Goodman Gallery), Emily Park (Getty Research Institute), Ricky Renier (KÖR Kunst), Hannah Rhadigan (Artists Rights Society, New York), Alexandra Schoolman (Henrique Faria Fine Art), Piper Severance (LACMA), Stacey Sherman (Nelson-Atkins Museum of Art), Julie Schilder (VAGA Rights), Leah Talatinian, Mattie Taormina (Special Collections at Stanford Library), Holly Wright (Nelson-Atkins Museum of Art), the Courtauld Institute of Art, and the Robert Rauschenberg Foundation.

I thank editors Doug Armato and Richard Morrison from the University of Minnesota Press for considering the publication of this book. The assistance of Erin Warholm-Wohlenhaus and Laura Westlund has been invaluable in the process of finalizing the manuscript. I am extremely grateful to the two anonymous book reviewers and the members of the Committee on the Press at the University of Minnesota Press for their sharp-witted comments. Their suggestions helped me in my final revisions. I am especially grateful to Judy Selhorst for her attentive and thorough copyediting of this publication.

My formation as an art historian would not have been possible without the guidance of Dan Popescu and Irina Cios (University of Bucharest), Jonathan Vickery (Warwick University), Kathleen Wren Christian, Drew Armstrong, and Frank Toker (University of Pittsburgh). This study would have certainly been less rich in interdisciplinary correlations had it not been for my early exposure to cultural studies theories and philosophy in the programs of American studies and European cultural studies at the University of Bucharest. My intellectual curiosity was greatly stimulated by seminars with Ioana Luca Algiu and Sabina Draga Alexandru, as well as with many other accomplished professors. I owe much of my zest for image and text interpretation to my high school English teacher Nicoleta Ionita. Her pedagogical dedication, motivational talks, and academic mentorship have inspired many generations of students.

Many colleagues and friends offered scholarly advice and reassurance whenever I faced challenges in pursuing this long-term research project. I am especially indebted to my former graduate school colleagues Robert Bailey and Izabel Galliera for their astute comments and suggestions at different stages in the writing of my PhD thesis. I am particularly grateful to Izabel for her friendship and wholehearted moral support. I owe gratitude for companionship and passionate engagement in intellectual conversations to Ricky Allman, Barry Anderson, Beatrice and Romeo Anghelache, Vlad Basarab, Shalmit Bejarano, Jessica Boruski, Kenneth Brummel, Marilyn Carbonell, Stefanita Ciobotaru, Valentin Ciobotaru, Brianne Cohen, Laura Conde, Heidi Cook, Rebecca Dubay, Erin Dziedzic, April Eisman, Julia Finch, Jessica Glaser, Leonor Jurado, Alex Lefter, Jessica Lin, Irina Livezeanu, Courtney Long, Camila Maroja, Amelia Nelson, Jan Schall, Dawna Schuld, Hyeyoung Shin, Raechell Smith, Adelina Stefan, Veronica Szabo, Mihaela van der Schaar, and Madalina Veres. I am thankful for many friends who have stayed in touch with me even if we live on different continents. I owe gratitude to Nicoleta Pacala, whose intelligent questions about how we sense, think, and remember have often pushed me to seek further explanations of the way we relate to others at an affective and cognitive level. I am grateful to Maia Chankseliani, Gabriela Debita, Simona Gîrleanu, Otilia Haraga, Lavinia Hîrsu, Ana-Maria Iosif, Diana Luca, and Maria Vornicu for their continued friendship.

Last but not least, I thank my family for their unflagging support of my studies. I am indebted to my mother, Rodica Gheorghiu, for familiarizing me with art from an early age and enabling me to acquire a great appreciation of the sciences. This book is dedicated to her. Without her unwavering optimistic spirit, I would surely have found it immeasurably harder to bring this project to fruition. I am grateful to Paul Bogdan, my partner in life, studies, and travels, for his encouragement, patience, and friendship. He has greatly motivated me to pursue my academic goals with unflinching ambition. His arduous dedication to research has been highly inspiring, as have been our numerous conversations about complex systems, entropy, and unpredictability.

Notes

Introduction

1. Roberta Smith, "With a Jury of Their Peers," *New York Times*, September 30, 2010; and online addendum, "Editors' Note," *New York Times*, October 7, 2010, http://www.nytimes .com. The editors explained that the staged photographs were taken at the suggestion of MoMA officials and were in violation of the newspaper's ethical standards.

2. Claire Bishop, "Participation and Spectacle: Where Are We Now?" (lecture for the Creative Time Summit, "Living as Form," September 23, 2011), http://dieklaumichshow.org /pdfs/Bishop.pdf.

3. Nicolas Bourriaud, *Relational Aesthetics* (Dijon: Les Presses du Réel, 2002), 113.

4. Claire Bishop, ed., *Participation* (Cambridge: MIT Press, 2006); Claire Bishop, "Relational Antagonism," *October* 110 (Fall 2004): 51–79.

5. Claire Bishop, *Artificial Hells: Participatory Art and the Politics of Spectatorship* (London: Verso, 2012), 2.

6. Claire Bishop, *Installation Art: A Critical History* (London: Routledge, 2005).

7. Bishop, *Artificial Hells*, 1.

8. Frank Popper, *Art of the Electronic Age* (New York: Harry N. Abrams, 1993), 8.

9. Guy Debord, *Society of the Spectacle* (Detroit: Black & Red, 1983).

10. Jacques Rancière, *The Emancipated Spectator* (London: Verso, 2009).

11. Bourriaud, *Relational Aesthetics*, 59.

12. Grant Kester, *Conversation Pieces: Community and Communication in Modern Art* (Berkeley: University of California Press, 2004).

13. See Jack Burnham, "System Esthetics," *Artforum* 6, no. 1 (September 1967): 30–35; Jack Burnham, "Real Time Systems," *Artforum* 8, no. 1 (September 1969): 49–55.

14. Claire Bishop, "Digital Divide: Claire Bishop on Contemporary Art and New Media," *Artforum* 51, no. 1 (September 2012): 436.

15. Bourriaud, *Relational Aesthetics*, 78.

16. Edward Shanken, "New Media and Mainstream Contemporary Art: Toward a Hybrid

Discourse?" (paper delivered at the conference "Transforming Culture in the Digital Age," Tartu, Estonia, April 15, 2010).

17. Bourriaud, *Relational Aesthetics*, 44.

18. Boris Groys, "Politics of Installation," *e-flux Journal*, no. 2 (January 2009), http://www.e-flux.com/journals.

19. Rancière, *Emancipated Spectator*, 7.

20. For an excellent historical survey of artworks representing or including reflective surfaces from ancient times to the present, see Slavko Kacunko, *Spiegel. Medium. Kunst: Zur Geschichte des Spiegels in Zeitalter des Bildes* (Munich: Wilhelm Fink, 2010).

21. C. Daniel Batson, "These Things Called Empathy: Eight Related but Distinct Phenomena," in *The Social Neuroscience of Empathy*, ed. Jean Decety and William Ickes (Cambridge: MIT Press, 2009), 10.

22. Maurice Merleau-Ponty, *The Visible and the Invisible*, ed. Claude Lefort, trans. Alphonso Lingis (Evanston, Ill.: Northwestern University Press, 1968), 59.

23. R. D. Laing, *Self and Others* (Baltimore: Penguin Books, 1971), 82.

24. M. Guy Thompson offers an ample comparison of Jacques Lacan's and R. D. Laing's approaches to psychotherapy and intersubjectivity. He argues that while Lacan's perspective is anchored in Hegel's philosophy concerning the desire for self-recognition in relation to others, Laing's theories are inspired by the philosophy of intersubjectivity developed by Husserl, Heidegger, and Sartre. See M. Guy Thompson, "Phenomenology of Intersubjectivity: A Historical Overview and Its Clinical Implications," in *Relational and Intersubjective Perspectives in Psychoanalysis: A Critique*, ed. Jon Mills (Lanham, Md.: Jason Aronson, 2005), 35–70.

25. The writings of R. D. Laing were highly popular in the second half of the 1960s in the United States. According to Maurice Berger, Robert Morris read Laing's book *The Divided Self: A Study of Sanity and Madness* (London: Tavistock, 1960). See Maurice Berger, "Wayward Landscapes," in *Robert Morris: The Mind/Body Problem* (New York: Solomon R. Guggenheim Foundation, 1994), 28. Dan Graham references Laing's theories as a source of inspiration for the performance *Two Consciousness Projection(s)* (1972). See Dan Graham, "Mark Francis in Conversation with Dan Graham," in *Dan Graham*, ed. Birgit Pelzer, Mark Francis, and Beatriz Colomina (London: Phaidon, 2001), 16.

26. Both Bourriaud and Groys refer to communities in describing convivial encounters between art participants. Bourriaud, *Relational Aesthetics*; Groys, "Politics of Installation." See also Bishop, *Participation*.

27. Gustave Le Bon, *The Crowd: A Study of the Popular Mind* (London: T. F. Unwin, 1896).

28. Ralph H. Turner, "Collective Behavior," in *Handbook of Modern Sociology*, ed. Robert E. L. Faris (Chicago: Rand McNally, 1964), 382–425.

29. This type of thinking was also advanced by psychoanalyst W. R. Bion, who considered that there are basically two types of groups: "basic-assumption groups" established as a result of empathetic relations and "work groups" established as a result of shared tasks

or interests. See Wilfred R. Bion, *Experiences in Groups, and Other Papers* (New York: Basic Books, 1961).

30. Turner, "Collective Behavior," 416.

31. Marco Iacoboni, *Mirroring People: The New Science of How We Connect with Others* (New York: Farrar, Straus and Giroux, 2008), 111.

32. See Jennifer H. Pfeifer and Mirella Dapretto, "Mirror, Mirror, in My Mind: Empathy, Interpersonal Competence, and the Mirror Neuron System," in Decety and Ickes, *Social Neuroscience of Empathy*, 183–97.

33. Daniel N. Stern, *The Interpersonal World of the Infant: A View from Psychoanalysis and Developmental Psychology* (New York: Basic Books, 1985).

34. Ibid. Stern initially considered using the term *mirroring* to define this relationship. However, he thought that it does not truly capture the behavioral variability implicit in affective exchanges and that it emphasizes temporal simultaneity rather than sequential acts. Only if the response of the interlocutor adds something to the communicative thread, rather than being a mere imitation of the original signal, can it convey the fact that the feeling state has truly been understood and reciprocated.

35. Ibid., 160–61.

36. Gilbert Simondon, *L'Individuation psychique et collective* (Paris: Aubier, 1989), 106, my translation.

37. Deleuze and Guattari's theory of affect is associated both with "becoming animal" and with art making. Deleuze and Guattari argue that the process of art creation is a becoming, which entails an affective connectivity to the object, plant, or animal that stirs the creative impulse. Hence, the artwork is not an imitative representation; rather, it reflects the transformation undergone by the artist as he or she selects the quintessential aspects of the subject matter and forcefully expresses them through the use of different media. See Gilles Deleuze and Félix Guattari, "1730: Becoming-Intense, Becoming-Animal, Becoming-Imperceptible," in *A Thousand Plateaus: Capitalism and Schizophrenia*, trans. Brian Massumi (Minneapolis: University of Minnesota Press, 1987), 232–309; Gilles Deleuze and Félix Guattari, "Percept, Affect, and Concept," in *What Is Philosophy?*, trans. Hugh Tomlinson and Graham Burchell (New York: Columbia University Press, 1994), 163–200.

38. Gilles Deleuze, *Cinema 1: The Movement-Image*, trans. Hugh Tomlinson and Barbara Habberjan (London: Athlone Press, 1986), 65.

39. Hal Foster, in Hal Foster, Sylvia Lavin, Thomas Demand, Hilary Lloyd, Dorit Margreiter, Steven Holl, Philippe Rahm, Hans Ulrich Obrist, and Julian Rose, "Trading Spaces. A Roundtable on Art and Architecture," *Artforum* 51, no. 2 (October 2012): 208.

40. Jill Bennett, *Empathic Vision: Affect, Trauma, and Contemporary Art* (Stanford, Calif.: Stanford University Press, 2005).

41. Jennifer Doyle, *Hold It against Me: Difficulty and Emotion in Contemporary Art* (Durham, N.C.: Duke University Press, 2013), 71–72.

42. See Brian Massumi's reflections on Stelarc's performance *Fractal Flesh* in *Parables for the Virtual: Movement, Affect, Sensation* (Durham, N.C.: Duke University Press, 2002), 120–21.

43. Mark B. N. Hansen, *New Philosophy for New Media* (Cambridge: MIT Press, 2004), 142.

1. Mirror Frames

1. Nora Sayre, *Sixties Going on Seventies* (New York: Arbor House, 1973), 14.

2. Robert Morris, in *Robert Morris: Mirror Works, 1961–1978*, exhibition catalog (New York: Leo Castelli, 1979), 5.

3. Robert Morris, "The Present Tense of Space," *Art in America* 66, no. 1 (January/February 1978): 70–81.

4. Ibid., 80.

5. Morris contrasts the features of small-scale sculptural objects and large-scale sculptures with the characteristics of "new sculpture," which parallels the scale of the human body. See Robert Morris, "Notes on Sculpture, Part II," *Artforum* 5, no. 2 (October 1966): 20–23.

6. Robert Morris, "Notes on Sculpture, Part 3: Notes and Non Sequiturs," *Artforum* 5, no. 10 (Summer 1967): 29.

7. Annette Michelson, "Robert Morris—An Aesthetics of Transgression," in *Robert Morris*, exhibition catalog (Washington, D.C.: Corcoran Gallery of Art, 1969), 35.

8. Morris, "Notes on Sculpture, Part II," 23.

9. Robert Morris, "Notes on Sculpture, Part IV: Beyond Objects," *Artforum* 7, no. 8 (April 1969): 51.

10. Allan Kaprow, "The Shape of the Art Environment: How Anti Form Is 'Anti Form,'" *Artforum* 6, no. 10 (Summer 1968): 33.

11. Morris, "Notes on Sculpture, Part 3," 29.

12. Roald Nasgaard, "Introduction," in *Structures for Behavior: New Sculptures by Robert Morris, David Rabinowich, Richard Serra and George Trakas*, exhibition catalog (Toronto: Art Gallery of Ontario, 1978), 45.

13. Alex Potts, *The Sculptural Imagination: Figurative, Modernist, Minimalist* (New Haven, Conn.: Yale University Press, 2000), 247.

14. In her discussion of Morris's collaborations with Simone Forti, art historian Anna Chave eloquently notes that art critics treated the objects designed by the male artist for performances as protosculptures yet labeled the ones designed by the female artist mere theatrical props. See Anna C. Chave, "Minimalism and Biography," *Art Bulletin* 82, no. 1 (March 2000): 156.

15. Quoted in Maurice Berger, *Labyrinths: Robert Morris, Minimalism, and the 1960s* (New York: Harper & Row, 1989), 121.

16. Quoted in Barbara Reise, "A Tail of Two Exhibitions: The Aborted Haacke and Robert Morris Shows," *Studio International* 182, no. 935 (July/August 1971): 30.

17. Morris, "Notes on Sculpture, Part IV," 53.

18. Anton Ehrenzweig, *The Psychoanalysis of Artistic Vision and Hearing: An Introduction to a Theory of Unconscious Perception* (New York: George Braziller, 1965), 173.

19. Marshall McLuhan and Quentin Fiore, *The Medium Is the Massage: An Inventory of Effects* (New York: Bantam Books, 1967), 145.

20. For more information on Morris's thoughts on changes in perception, see Robert Morris, "The Artist Speaks: Robert Morris," interview by E. C. Gossen, *Art in America* 58, no. 3 (May/June 1970), 106.

21. Two such works are *Untitled*, 1977, four mirrors, each 6 × 12 feet, and painted plywood (Louisiana Museum) and *Untitled*, 1977, four mirrors and 12 × 12 inch timbers (Portland Center for the Visual Arts, Oregon).

22. Samaras mentions his earlier exploration of the impact of mirror environments on human consciousness in his 1969 letter to the Albright-Knox Art Gallery. See Ethel Moore, ed., *Letters from 31 Artists to the Albright-Knox Art Gallery* (Buffalo, N.Y.: Buffalo Fine Arts Academy, 1970), 36–40.

23. Donald Kuspit, "The Aesthetics of Trauma," in *Unrepentant Ego: The Self-Portraits of Lucas Samaras*, exhibition catalog, ed. Marla Prather (New York: Whitney Museum of American Art, 2004), 49, 50.

24. Lucas Samaras, quoted in Kim Levin, *Lucas Samaras* (New York: Harry N. Abrams, 1975), 69.

25. In a 1966 interview with Alan Solomon, Samaras affirmed that his participation in happenings had to do both with his interest in theater and "with a sort of comradeship; we were all a group of people who somehow liked each other, so that being in a Happening was pleasing, in retrospect, from a friendship point of view." Lucas Samaras, "An Interview with Lucas Samaras," by Alan Solomon, *Artforum* 5, no. 2 (October 1966): 41.

26. Geneviève Boulanger-Balleyguier, "Les Étapes de la reconnaissance de soi devant le miroir," in *Image spéculaire du corps*, ed. Jacques Corraze (Toulouse: Privat, 1980), 139, my translation.

27. Lucas Samaras, in *Lucas Samaras*, exhibition catalog (New York: Whitney Museum of America Art, 1972), n.p.

28. Samaras, "Interview with Lucas Samaras," 43.

29. In 2004, Camille Utterback created a series of works in which the movements of visitors are tracked by a camera. The images are then transmitted to a computer program that generates painterly lines and dots. Participants seemingly paint abstract expressionist compositions with their body movements. Only one person at a time interacts with the work, but that person's actions become part of an endlessly morphing canvas that can incorporate traces of bodily movements of multiple participants who previously interacted with the work.

30. Rosemary Geistorfer Feal and Carlos Feal, *Painting on the Page: Interartistic Approaches to Modern Hispanic Texts* (Albany: State University of New York Press, 1995), 10.

31. Levin, *Lucas Samaras*, 71.

32. Kusama constructed her first mirror environment in 1965. It was titled *Infinity Mirror Room (Phalli's Field)* and consisted of a room covered with mirror panels only on the inside and filled with thousands of phallic-like shapes overlaid with red polka dots.

33. Barbara Haskell, "Two Decades of American Sculpture: A Survey," in *200 Years of American Sculpture*, exhibition catalog (New York: Whitney Museum of American Art, 1976), 295.

34. Barbara Rose, *A New Aesthetic* (Baltimore: Garamond-Pridemark Press, 1967), 11.

35. Jameson argues that the period thought of as the 1960s actually extends up to 1974 and encompasses feminist movements and uprisings in Latin American countries. See Fredric Jameson, "Periodizing the 60s," in *The 60s without Apology*, ed. Sohnya Sayres, Anders Stephanson, Stanley Aronowitz, and Fredric Jameson (Minneapolis: University of Minnesota Press, 1984), 184.

36. Michelangelo Pistoletto, "Minus Objects," in *A Minus Artist* (Florence: Hopeful Monster, 1988), 12.

37. Michelangelo Pistoletto, quoted in Dave Hickey, "A Voice in the Mirror: Critical Reflections in the I/Eye of the Artist," in *Michelangelo Pistoletto*, exhibition catalog (Meriden, Conn.: Meriden Gravure, 1983), 9.

38. Maurice Merleau-Ponty, *Phenomenology of Perception*, trans. Colin Smith (1962; repr., London: Routledge, 2003), 421.

39. Claire Gilman, "Pistoletto's Staged Subjects," *October 1*, no. 124 (Spring 2008): 54.

40. Michelangelo Pistoletto, "Denys Zacharopoulos in Conversation with Michelangelo Pistoletto," in *Zeit-Räume*, ed. Michelangelo Pistoletto, Monika Faber, and Lorand Hegyi (Vienna: Museum Moderner Kunst Stiftung Ludwig, 1995), 155.

41. R. D. Laing, *The Politics of Experience* (New York: Ballantine Books, 1968), 73.

42. The name was inspired by a remark made by Colnaghi, who jokingly asserted that he felt "exactly like a lion in a cage." He implied that he had internalized the rules of society to such an extent that he could no longer make free choices. See Pistoletto's account of the foundation of Zoo in Germano Celant, *Identité italienne: L'Art en Italie depuis 1959* (Paris: Centre Georges Pompidou, 1981), 260.

43. Zoo members demarcated the area of play from that of the audience by drawing a circle with chalk. Zoo members took turns playing the role of the Minus Man—a provisional ruler of the group who had the right to propose imaginative plots that would unfold over predetermined periods of time.

44. Germano Celant, in Pistoletto et al., *Zeit-Räume*, 156.

45. Pistoletto explained: "The word performance, as far as I am concerned, is inappropriate, because my work is not based on individual expression but on the idea of encounters, dialogues with other players in the artistic field, in locations, which are not specifically devoted to art." Quoted in Marco Farano, "From the Mirror Paintings to the Year One: A Chronicle," in *Michelangelo Pistoletto: Azioni materiali*, exhibition catalog (Cologne: König, 1999), 247.

46. The title *Oad Lau* comes from a Moroccan phrase meaning "watering place."

47. Joan Jonas, in *Joan Jonas: Performance Video Installation, 1968–2000*, exhibition catalog, ed. Johann-Karl Schmidt (Ostfildern: Hatje Cantz, 2001), 70.

48. Douglas Crimp, "De-synchronization in Joan Jonas's Performances," in *Joan Jonas: Scripts and Descriptions, 1968–1982*, ed. Douglas Crimp (Berkeley: University Art Museum, University of California, 1983), 8.

49. Alva Noë, *Out of Our Heads: Why You Are Not Your Brain, and Other Lessons from the Biology of Consciousness* (New York: Hill & Wang, 2009), 64.

50. Bruce Ferguson, "AmerefierycontemplationonthesagaofJoanJonas," in *Joan Jonas Works 1968–1994*, exhibition catalog (Amsterdam: Stedelijk Museum, 1994), 15.

51. Thompson, "Phenomenology of Intersubjectivity," 40.

52. J. L. Dronsfield, "Place and Privacy in the Work of Joan Jonas," in *Joan Jonas*, exhibition catalog (Southampton: John Hansard Gallery in association with Wilkinson Gallery, 2004), 28.

53. Joan Jonas, "Scenes and Variations: An Interview with Joan Jonas," by Joan Simon, *Art in America* 83, no. 7 (July 1995): 101.

54. R. D. Laing, H. Phillipson, and A. R. Lee, *Interpersonal Perception: A Theory and Method of Research* (London: Tavistock, 1966), 5.

55. Otto Piene, in *Light Ballet*, exhibition catalog (New York: Howard Wise Gallery, 1965).

56. Quoted in Jack Burnham, *Beyond Modern Sculpture: The Effects of Science and Technology on the Sculpture of This Century* (New York: George Braziller, 1968), 251.

57. For example, Nouvelle Tendance artist Pohl Uli explained that he used acrylic glass in his practice because this material conveys a lack of controlling subjectivity. He argued that objects based on this material helped him become anonymous. See *Propositions visuelles du mouvement international: Nouvelle Tendance* (Paris: Musée des Arts Decoratifs, 1964), n.p.

58. See Alex F. Osborn, *Applied Imagination: Principles and Procedures of Creative Thinking* (New York: Scribner, 1953); Laing et al., *Interpersonal Perception*.

59. Burnham, *Beyond Modern Sculpture*, 363.

60. Rosalind E. Krauss, *Passages in Modern Sculpture* (Cambridge: MIT Press, 1981), 230.

61. The catalog features extensive descriptions of the curatorial concept, the design of the works, and the complex participatory responses. It includes citations of viewers' oral testimonies and curatorial responses to exhibition reviews. Ralph T. Coe, *The Magic Theater: Art Technology Spectacular*, exhibition catalog (Kansas City: Circle Press, 1970).

62. Ibid., 246.

63. Ibid., 171.

64. Jane Livingston, "Kansas City," *Artforum* 7, no. 1 (September 1968): 66.

65. Stephen Bann, "The Magic Theater," *L'Oeil*, nos. 164–65 (August/September 1968): 43, my translation.

66. Morse Peckham, *Man's Rage for Chaos: Biology, Behavior, and the Arts* (Philadelphia: Chilton, 1965), 61.

67. Alfred Frankenstein, "Magic Theater in Kansas City," *San Francisco Chronicle*, June 2, 1968.

68. Howard Jones, in Coe, *Magic Theater*, 186–87.

69. Jane Livingston, "Kansas City," *Artforum* 7, no. 1 (September 1968): 67.

70. Coe, *Magic Theater*, 224.

71. Andrew A. Tapsony, "The Magic Theatre," *Kansas City Star*, May 21, 1968.

72. George Ehrlich, "'The Magic Theatre' Exhibition: An Appraisal," *Art Journal* 29, no. 1 (Autumn 1969): 40.

73. Quoted in Coe, *Magic Theater*, 159.

74. See Bion, *Experiences in Groups*.

75. See Jean Maisonneuve's critique of Bion's theory of groups in Jean Maisonneuve, *La Dynamique des groupes* (Paris: Presses Universitaire de France, 1973), 76–79.

76. Betsy Broun, in Coe, *Magic Theater*, 157.

77. LACMA aimed to act as a mediator between the artists and the corporations in order to ensure that the two parties reached consensus about the contractual terms of their collaboration. The Art and Technology program developed over a period of four years and resulted in two exhibitions: one in the U.S. pavilion at the Osaka Expo of 1970 and one at LACMA in 1971. The artists and the corporations had to reach mutual agreement on the general framework of their collaborations and sometimes even on the specific projects that were to be undertaken.

78. In discussing the process of artist selection in the report on the program, Tuchman asserted: "If anything, we may have been prejudiced against those artists who had been deliberately employing the tools of new technology for its own sake." See Maurice Tuchman, ed., *A Report on the Art and Technology Program of the Los Angeles County Museum of Art, 1967–1971* (Los Angeles: Los Angeles County Museum of Art, 1971), 17.

79. Max Kozloff, "The Multimillion-Dollar Art Boondoggle," *Artforum* 10, no. 2 (October 1971): 76.

80. David Antin, "Art and the Corporations," *ARTnews* 70, no. 5 (September 1971): 26.

81. Jonathan Benthall, *Science and Technology in Art Today* (New York: Praeger, 1972), 114.

82. See Billy Klüver, "Theater and Engineering—An Experiment: 2. Notes by an Engineer," *Artforum* 5, no. 6 (February 1967): 32.

83. Billy Klüver, quoted in Simone Whitman, "Theater and Engineering—An Experiment: 1. Notes by a Participant," *Artforum* 5, no. 6 (February 1967): 30.

84. The Pepsi-Cola Corporation initially planned a series of rock concerts for Expo '70 because it was trying to attract young audiences. However, the budget was too low and the allocated space too small for this purpose. The pavilion was already under construction when E.A.T. signed the contract with the Pepsi-Cola Corporation. The Japanese firm Takenaka Komuten designed the architecture of the pavilion, which was supposed to function as Pepsi's headquarters in the Kansai area. See Billy Klüver, Julie Martin, and Barbara Rose, eds., *Pavilion* (New York: E. P. Dutton, 1972).

85. Despite this hope, the relations between E.A.T. and Pepsi-Cola were fraught with tension over financial and programming issues. The collaboration came to an end much sooner than expected when the corporation refused to pay the artists to create sound and light programs throughout the entire period of the Osaka Expo.

86. Merleau-Ponty, *The Visible and the Invisible*, 156–62.

87. Robert Breer, quoted in Nilo Lindgren, "Into the Collaboration," in Klüver et al., *Pavilion*, 5.

88. Robert Rauschenberg, quoted in Calvin Tomkins, "Outside Art," in Klüver et al., *Pavilion*, 114.

89. See my discussion of E.A.T. artists' interest in undermining visual spectacle in Cristina Albu, "Between Expanded Consciousness and Expanded Bodies: Spectatorial Engagement with Invisible Architecture," *Athanor* 28 (Fall 2010): 85–93.

90. See Pamela Lee, *Chronophobia: On Time in the Art of the 1960s* (Cambridge: MIT Press, 2004).

91. Billy Klüver, "The Pavilion," in Klüver et al., *Pavilion*, x; Barbara Rose, "Art as Experience, Environment, Process," in Klüver et al., *Pavilion*, 99.

92. Michel Foucault, "Space, Knowledge, and Power: Interview with Paul Rabinow," in *The Foucault Reader*, ed. Paul Rabinow (New York: Pantheon Books, 1984), 239–56.

93. Both Barbara Rose and Elsa Garmire use this term to refer to the inverted holographic images in their respective essays in *Pavilion*. Rose, "Art as Experience," 60–104; Elsa Garmire, "An Overview," in Klüver et al., *Pavilion*, 173–206.

94. Gene Youngblood, *Expanded Cinema* (New York: E. P. Dutton, 1970).

95. Ibid., 416.

96. Rose, "Art as Experience," 101.

97. Vance Packard, *The Naked Society* (New York: David McKay, 1964), 11.

98. See the video art categories proposed by Allan Kaprow in "Video Art: Old Wine, New Bottle," *Artforum* 12, no. 10 (June 1974): 48; and the video art taxonomies outlined in Ira Schneider and Beryl Korot, eds., *Video Art: An Anthology* (New York: Harcourt Brace Jovanovich, 1976). Several articles presenting video art taxonomies are also included in Gregory Battcock, ed., *New Artists Video: A Critical Anthology* (New York: E. P. Dutton, 1978).

99. Rosalind Krauss, "Video: The Aesthetics of Narcissism," *October* 1 (Spring 1976): 59.

100. Vito Acconci's *Centers* (1971), the most salient example of a video work Krauss provided to support her theory about the inherent narcissism of the medium, comes short of proving her argument. As the artist points with his index finger at his self-image in the monitor for an extended period of time, he is directing his attention to a virtual viewer, hence seeking to define himself in relation to others. The plural noun in the title of this work also suggests a process of displacement and decentering of subjectivity and not merely an immersive state of self-contemplation triggered by the otherness inherent in oneself.

101. Youngblood, *Expanded Cinema*, 337; Kaprow, "Video Art," 46.

102. David Ross, "The Personal Attitude," in Schneider and Korot, *Video Art*, 247.

103. Bruce Nauman, "Nauman Interview, 1970," by Willoughby Sharp, in *Please Pay Attention Please: Bruce Nauman's Words—Writings and Interviews*, ed. Janet Kraynak (Cambridge: MIT Press, 2003), 113.

104. Eliseo Verón, "La obra" (1967), *Ramona*, nos. 9–10 (2000–2001): 46.

105. Andrea Giunta, *Avant-Garde, Internationalism, and Politics. Argentine Art in the Sixties* (Durham, N.C.: Duke University Press, 2007), 159.

106. Les Levine, "An Interview with Les Levine," by Brydon Smith, in *Slipcover* (Toronto: Art Gallery of Ontario, 1966), n.p.

107. Les Levine, quoted in David Bourdon, "Plastic Man Meets Plastic Man," *New York Magazine*, February 10, 1969, 46.

108. Les Levine, "Urban Guerrilla Learning," in "New Learning Spaces and Places," *Design Quarterly*, nos. 90–91 (1974): 30.

109. Les Levine, quoted in Youngblood, *Expanded Cinema*, 340.

110. Michael Polanyi, *Personal Knowledge: Towards a Post-critical Philosophy* (New York: Harper Torchbook, 1964).

111. In the late 1960s, group exhibitions including video art were organized at the Walker Art Center (*Light | Motion | Space*, 1967); the Institute of Contemporary Arts, London (*Cybernetic Serendipity*, 1968); and the Museum of Modern Art, New York (*The Machine as Seen at the End of the Age of Mechanical Reproduction*, 1968). The first art museum video department was established at the Everson Museum of Art in Syracuse, New York, in 1972.

112. Paul Ryan, cited in Jud Yalkut, "TV as a Creative Medium at Howard Wise," *Arts Magazine* 44, no. 1 (September/October 1969): 20–21.

113. Paul Ryan to Howard Wise, March 2, 1969, Paul Ryan Papers 1943–2008, Archives of American Art, Smithsonian Institution, Washington, D.C., http://www.aaa.si.edu.

114. See William H. Whyte, *The Organization Man* (New York: Simon & Schuster, 1956), 51.

115. Richard Kostelanetz, "Artistic Machines," *Chicago Review* 23, no. 1 (Summer 1971): 124.

116. On "reference groups," see Dorwin Cartwright and Alvin Zander, "Groups and Group Membership: Introduction," in *Group Dynamics: Research and Theory*, 3rd ed., ed. Dorwin Cartwright and Alvin Zander (New York: Harper & Row, 1968), 53.

117. David Antin, "Video: The Distinctive Features of the Medium," in Schneider and Korot, *Video Art*, 176.

118. Michael Shamberg, "Television—the Medium: Taking Waste out of the Wasteland," *Time*, May 30, 1969, 74.

119. Richard Sennett, *The Fall of Public Man* (New York: Alfred A. Knopf, 1977), 223.

120. Frank Gillette, "Masque in Real Time," in Schneider and Korot, *Video Art*, 219.

121. Ira Schneider and Frank Gillette, "An Interactive Experiment," *Radical Software* 2, no. 5 (Winter 1973): 13.

122. Douglas Davis, "Video Obscura," *Artforum* 10, no. 8 (April 1972): 71.

123. Kaprow, "Video Art," 48.

2. Mirror Screens

1. Sennett, *Fall of Public Man*, 339.

2. Lucy Lippard, *Get the Message? A Decade of Art for Social Change* (New York: E. P. Dutton, 1984), 25.

3. Hershman invited Graham to exhibit within the framework of *The Floating Museum* (1974–78), an alternative exhibition platform that commissioned artists to create site-specific works in public spaces. However, their plans for this project never came to fruition.

4. Generally, Graham's and Hershman's works have been brought together within exhibition contexts focusing on the intersection between art and technology (e.g., *Future Cinema: The Cinematic Imaginary after Film*, ZKM, Karlsruhe, November 16, 2002—March 30, 2003) or on participatory tendencies in contemporary art (e.g., *The Art of Participation: 1950 to Now*, San Francisco Museum of Modern Art, November 8, 2008–February 8, 2009). While Graham appears as a prominent figure in most art historical narratives dwelling on the 1970s, owing to his critical revision of minimalism and the self-referentiality of conceptual art, Hershman is more rarely acknowledged for her contributions to this decade. She is primarily noted for the design of the first interactive laser disc installation, *Lorna* (1979–84), and for her performative works that disclose the constraints placed on the existence of women in American society during the 1970s.

5. In 1972, Gregory Bateson signaled the threat posed by the notion that we need to echo perfectly the attributes of the social systems to which we belong. He argued that individuals need to assess their ties to social contexts on a regular basis and seek to develop complementary relations to them instead of becoming so attuned to the mechanisms of these contexts that their self-awareness diminishes. Gregory Bateson, *Steps to an Ecology of Mind* (San Francisco: Chandler, 1972).

6. Kate Mondloch, *Screens: Viewing Media Installation Art* (Minneapolis: University of Minnesota Press, 2010), 62.

7. Dan Graham, "Essay on Video, Architecture and Television," in *Video-Architecture-Television: Writings on Video and Video Works, 1970–1978*, ed. Benjamin H. D. Buchloh (Halifax: Press of Nova Scotia College of Art and Design/New York: New York University Press, 1979), 67–69.

8. Dan Graham, in "Interview with Dan Graham, Chrissie Iles and Fary Carrion-Murayari," by Rodney Graham, in *Dan Graham: Beyond*, exhibition catalog (Los Angeles: Museum of Contemporary Art, 2009), 96.

9. Lynn Hershman, "Interview with Lynn Hershman," by Alanna Heiss, *Currant* 2, no. 2 (August–October 1976): 44.

10. For *Dante Hotel* (1973–74), Hershman booked a hotel room in San Francisco's North Beach neighborhood for a nine-month period. The residents of the environment were two wax female figures whose life stories could be decoded based on their possessions, audio recordings, and pictures, which composed the hotel mise-en-scène characteristic of that

area of the city. To gain access to the installation, visitors took the key to the room from a receptionist. *Dante Hotel* offered both a portrait of the wax figures and a portrait of the local socioeconomic environment. Hershman also created installations at the Chelsea Hotel, the Plaza Hotel, and the Central YWCA in New York.

11. A small number of Graham's works dealt with more specific social issues or took place in more closely defined settings. His performances *Two Consciousness Projection(s)* (1972) and *Identification Projection* (1977) highlighted power relations between individuals representing different genders. Some of his installations of the 1970s targeted more specific audience groups, such as Citicorp employees in *Video View of Suburbia in an Urban Atrium* (1979–80) and individuals frequenting a number of galleries located in the same New York area in *Projections on a Gallery Window* (1979). Yet, as their titles show, these works were by no means conceived as portraits of specific groups.

12. Graham has mentioned coming under the influence of Margaret Mead's writings while he was still a teenager. See Graham, "Mark Francis in Conversation with Dan Graham," 10. In interviews he has also made repeated references to Gregory Bateson's theories on schizophrenia and memory. See Kim Gordon's interview with the artist in *Dan Graham: Beyond*, 170.

13. Hershman has asserted that one of the texts that was instrumental in her conceptualization of *25 Windows* was Erving Goffman's *The Presentation of Self in Everyday Life* (New York: Anchor Books, 1959). Lynn Hershman, e-mail correspondence with author, May 5, 2011.

14. Michel Foucault, *Discipline and Punish: The Birth of the Prison*, trans. Alan Sheridan (New York: Pantheon Books, 1977).

15. Walter Benjamin, *The Arcades Project*, trans. Howard Eiland and Kevin McLaughlin (Cambridge, Mass.: Belknap Press of Harvard University Press, 1999), 42.

16. Hershman mentions this analogy in a short video documenting the installation. The video was not shot by the artist, but subsequently she worked on editing it and adding audio comments, which sometimes overlapped her responses to questions raised by the interviewer. The mismatches between these intertwining narratives highlighted even more the surrealist overtones of the installation. The video documentation of *25 Windows* is available on the DVD accompanying the book *The Art and Films of Lynn Hershman Leeson: Secret Agents, Private I*, ed. Meredith Tromble (Berkeley: University of California Press, 2005).

17. Hershman, e-mail correspondence with author, May 5, 2011.

18. The leader of this trend was Robert Currie, display director for the Henri Bendel store, who earned fame for the shocking content of his window displays, which included dramatic scenes of death, seduction, and aggression.

19. Rosemary Kent, "Drama Department: Comedy, Sex and Violence in Store Windows," *New York Magazine*, May 24, 1976, 82.

20. For the installation *Forming a Sculpture/Drama in Manhattan* (1974), Hershman booked a cheap room at the Chelsea Hotel for a three-month period and paid a woman to live in it. In addition to this living character and her personal belongings, the room included wax figures and a series of everyday objects.

21. Laing, *Politics of Experience*, 53.

22. Graham, "Mark Francis in Conversation with Dan Graham," 17.

23. Hershman, e-mail correspondence with author, May 5, 2011.

24. Dan Graham, "Performer Audience Mirror," in *Theatre* (published by author, 1977), n.p.

25. Ibid.

26. Laing, *Politics of Experience*, 95.

27. Sennett, *Fall of Public Man*, 327.

28. Foucault, *Discipline and Punish*, 148.

29. Ibid., 201.

30. Graham, "Performer Audience Mirror," n.p.

31. Massumi, *Parables for the Virtual*, 25.

32. Graham, "Performer Audience Mirror," n.p.

33. Peter Buirski and Pamela Haglund, *Making Sense Together: The Intersubjective Approach to Psychotherapy* (Northvale, N.J.: Jason Aronson, 2001), 60.

34. Thierry de Duve, "Dan Graham and the Critique of Artistic Autonomy" (1983), in *Dan Graham*, ed. Alex Kitnick (Cambridge: MIT Press, 2011), 77.

35. Robert A. M. Stern, Thomas Mellins, and David Fishman, eds., *New York 1960: Architecture and Urbanism between the Second World War and the Bicentennial* (New York: Monacelli Press, 1995), 597.

36. Birgit Pelzer, "Double Intersections: The Optics of Dan Graham," in Pelzer et al., *Dan Graham*, 57.

37. Hershman, e-mail correspondence with author, May 5, 2011.

38. Hershman invented Roberta Breitmore in 1974. Strongly denying that Roberta was simply a performative role she embodied, the artist acted as this persona in public space and persuaded three other women to transform into Roberta by adopting her appearance, demeanor, and dress code. The invented identity was shaped by her social encounters. Hershman gathered material evidence of Roberta's existence by collecting such documents as records from her psychiatric sessions, newspaper announcements, and diary statements. By recording the narrative of Roberta, she was in fact also writing a history of women's struggle in the 1970s.

39. Michel Foucault, "Of Other Spaces," in *Rethinking Architecture: A Reader in Cultural Theory*, ed. Neil Leach (London: Routledge, 1997), 334.

40. Debord, *Society of the Spectacle*, thesis 147.

41. Ibid., thesis 160.

42. Benjamin, *Arcades Project*, 42.

43. Graham, "Essay on Video, Architecture and Television," 72.

44. Paul Ryan, *Cybernetics of the Sacred* (Garden City, N.Y.: Anchor Press, 1974), 33.

45. R. D. Laing, *Knots* (New York: Pantheon Books, 1970), 87.

46. Amelia Jones, "Roberta Breitmore Lives On," in Tromble, *The Art and Films of Lynn Hershman Leeson*, 110.

47. Lynn Hershman, quoted in Laura Parnes, "Lynn Hershman Leeson, History = Future," *P.S.1 Newspaper Special Edition, WACK!* (Winter/Spring 2008), http://momaps1.org; Lynn Hershman, "Private I: An Investigator's Timeline," in Tromble, *The Art and Films of Lynn Hershman Leeson*, 33.

48. Deleuze and Guattari, "1730," 239.

49. Foucault, *Discipline and Punish*, 204.

50. Dan Graham, "Notes on Public Space/Two Audiences," *Tracks* 3, no. 3 (Fall 1977): 58.

51. Graham, in "Interview with Dan Graham," 95.

52. Gilles Deleuze and Félix Guattari, "Introduction: Rhizome," in *A Thousand Plateaus*, 23.

53. Benjamin, *Arcades Project*, 11.

54. Lynn Hershman, *Chimaera: Monographie* (Hérimoncourt, France: Centre International de Creation Video Montbeliard Belfort, 1992), 111.

55. Simon Wilson, "The Venice Biennale," *Burlington Magazine* 118, no. 883 (October 1976): 724.

56. Jurgen Ruesch and Gregory Bateson, *Communication: The Social Matrix of Psychiatry* (New York: W. W. Norton, 1968), 279.

57. Ibid., 280.

58. Moira Roth, "Toward a History of California Performance: Part One," *Arts Magazine* 52, no. 6 (February 1978): 102.

59. Turner, "Collective Behavior," 413.

60. Laing, *Politics of Experience*, 97.

61. De Duve, "Dan Graham and the Critique of Artistic Autonomy," 66.

62. Mark Francis, "A Public Space: Context and History," in *Dan Graham: Beyond*, 185.

63. Stern, *Interpersonal World of the Infant*, 152.

64. Dan Graham, in *Dan Graham: Public/Private*, exhibition catalog (Philadelphia: Moore College of Art and Design, 1993), 34.

65. Simondon, *L'Individuation psychique et collective*, 116.

66. Laing, *Politics of Experience*, 96.

67. Massumi, *Parables for the Virtual*, 120.

68. Deleuze and Guattari, " 1730," 239.

69. Dan Graham, "Schema (Afterthought)," in *Dan Graham: Works and Collected Writings*, ed. Gloria Moure (Barcelona: Ediciones Polígrafa, 2009), 69.

70. Bateson, *Steps to an Ecology of Mind*, 332.

71. Hershman, "Interview with Lynn Hershman," 50.

3. Mirror Intervals

1. Terry Smith, *The Architecture of Aftermath* (Chicago: University of Chicago Press, 2006).

2. Nicholas Baume, "Floating in the Most Peculiar Way," in *Anish Kapoor: Past, Present, Future*, exhibition catalog, ed. Nicholas Baume (Cambridge: MIT Press, 2008), 26. Regarding Kapoor as a late modernist with minimalist tendencies, see Partha Mitter, "History, Memory, and Anish Kapoor," in Baume, *Anish Kapoor*, 107.

3. See Terry Smith, *What Is Contemporary Art?* (Chicago: Chicago University Press, 2009).

4. Anish Kapoor, in Homi Bhabha and Anish Kapoor, "A Conversation: June 1, 1993," in *Anish Kapoor*, exhibition catalog (Tel Aviv: Tel Aviv Museum of Art, 1993), 60.

5. Anish Kapoor, "Mythologies in the Making: Anish Kapoor in Conversation with Nicholas Baume," in Baume, *Anish Kapoor*, 50.

6. *Svayambh* is a Sanskrit term meaning self-generation. Kapoor's *Svayambh* consists of a block of red wax that is moved almost imperceptibly along rails between galleries. The sculpture seems to transform itself throughout this process by taking on the shapes of the doorways.

7. Olafur Eliasson, "Studio," in *Studio Olafur Eliasson: An Encyclopedia*, ed. Anna Engberg-Pedersen (Cologne: Taschen, 2009), 381.

8. An example of this is the afterimage experiment conducted at Zeiss Grossplanetarium in Berlin in 2006. Eliasson organizes such experiments during some of his talks in order to explain the way viewers turn into coproducers of the works through their perceptual engagement.

9. *White Sight* could also be labeled an intervention. Levine created it for a charity ball held at the Museum of Modern Art in New York. The disruptive effects of this environment, as well as the dismay felt by the participants, are described in David Bourdon, "Disposable Art," *Life*, August 22, 1969, 62–67.

10. Olafur Eliasson, "Landscape," in Engberg-Pedersen, *Studio Olafur Eliasson*, 253.

11. Ken Lum, in Marnie Fleming, "The Resolute Moment: A Conversation with Ken Lum about His Most Recent Work," in *Ken Lum: Recent Work*, exhibition catalog (Oakville, Ont.: Oakville Galleries, 1994), 7.

12. The *Portrait Logos* series from 1984 is a relevant example. It juxtaposes images of accomplished workers presumably satisfied with their achievements with invented logos carrying their family names.

13. Ken Lum, in *Ken Lum: Photo-Mirrors*, exhibition catalog, ed. Lisa Gabrielle Mark (Toronto: Walter Philips Gallery and the Banff Center for the Arts, 1998), 18.

14. Augé defines "non-places" as "spaces where people coexist or cohabit without living together." Marc Augé, *An Anthropology for Contemporaneous Worlds*, trans. Amy Jacobs (Stanford, Calif.: Stanford University Press, 1999), 110.

15. Ed Uhlir, quoted in Shanthi Shankarkumar, "A Silver Bean for Chicago," *Rediff* on the Net, November 26, 1999, http://www.rediff.com.

16. Michel de Certeau, *The Practice of Everyday Life* (Minneapolis: University of Minnesota Press, 1984).

17. The documentation for *Pi*, compiled by Art in Public Space Vienna, states: "According to the brief, the City Light showcases that are normally used for advertising purposes and are big enough for large-format posters are to serve as the main visual elements of a coherent and over-arching artistic design." Art in Public Space Vienna, "A Sign for Karlsplatz—A Square for Art," in *Ken Lum: Pi* (Vienna: Art in Public Space Vienna, 2006), 3, http://www.publicartvienna.at.

18. Ken Lum pointed out this requirement of the brief in e-mail correspondence with author, May 4, 2015.

19. The installation includes fourteen statistical estimates, also called factoids, concerning the following issues: malnourished children in the world, people in love in Vienna today, people killed in war since January 1, paid hours worked by Austrians since January 1, HIV infections worldwide since January 1, amount of garbage produced in Vienna since January 1, people dissatisfied with their jobs in Austria, world population, growth of the Sahara (in hectares), books borrowed in Vienna since January 1, people killed or maimed by land mines, schnitzels eaten in Vienna since January 1, days until Chernobyl is considered safe, and amount of money spent on military armament since January 1 (in euros).

20. Lum explained these changes to the initial plan in e-mail correspondence with author, May 4, 2015.

21. Art in Public Space Vienna, "Jury Argumentation," in *Ken Lum: Pi*, 11.

22. Comments on SoothBrush blog, accessed October 30, 2010, http://www.soothbrush.com.

23. This description of the perceptual experience within the space of *Take your time* is based on observations I made during my visit to the exhibition on April 18, 2008.

24. Hannah Arendt, *Between Past and Future: Eight Exercises in Political Thought* (New York: Penguin Books, 1993), 13.

25. Olafur Eliasson, in Olafur Eliasson and Luca Cerizza, "A Conversation between Olafur Eliasson and Luca Cerizza," in *TYT [Take your time]*, vol. 2, ed. Olafur Eliasson and Luca Cerizza (Cologne: König, 2009), 88.

26. Ken Lum, "Something's Missing," *Canadian Art* 23, no. 3 (Winter 2006): 60.

27. Lee, *Chronophobia*.

28. Comments on the SFMOMA website for the exhibition, accessed August 12, 2009, http://www.sfmoma.org.

29. Conard provides several examples of visitors' comments concerning the intersubjective awareness catalyzed by *Cloud Gate*. See Corrinn Conard, "Where Is the Public in Public Art? A Case Study of Millennium Park" (master's thesis, Ohio State University, 2008).

30. Mary Jane Jacob, "Being with Cloud Gate," in Baume, *Anish Kapoor*, 123.

31. Olafur Eliasson, "Vibrations," in *Your Engagement Has Consequences: On the Relativity of Your Reality* (Baden: Lars Müller, 2006), 72.

32. Ken Lum, "'I Say, Come On! Open Your Eyes!': An Interview with Ken Lum," by Cathy Busby, in *National Gallery of Canada Review*, vol. 2 (Ottawa: NGC/MBAC, 2001), 104.

33. Christine Ross, "Introduction: The Precarious Visualities of Contemporary Art and Visual Culture," in *Precarious Visualities: New Perspectives on Identification in Contemporary Art and Visual Culture*, ed. Olivier Asselin, Johanne Lamoureux, and Christine Ross (Montreal: McGill-Queen's University Press, 2008), 3–16.

34. Anish Kapoor, quoted in Clare Farrow, "Anish Kapoor: Theatre of Lightness, Space and Intimacy," *Art and Design*, no. 33 (1993): 53.

35. Hansen, *New Philosophy for New Media*, 203.

36. Deleuze, *Cinema 1*, 88.

37. Ibid., 24.

38. Stern, *Interpersonal World of the Infant*, 141–42.

39. Massumi, *Parables for the Virtual*, 35.

40. Ken Lum, "Ken Lum," interview by Evan McArthur, *Transcript: A Journal of Visual Culture* 2, no. 1 (1996): 30.

41. Deleuze and Guattari, "Percept, Affect, and Concept," 173.

42. Stanley Milgram, "The Familiar Stranger: An Aspect of Urban Anonymity," in *The Individual in a Social World: Essays and Experiments* (Reading, Mass.: Addison-Wesley, 1977), 51–53.

43. Ken Lum, *Speculations* (Ghent: Imschoot, 1992).

44. Lum, "Ken Lum," 29.

45. Quoted in Conard, "Where Is the Public in Public Art?," 160, 162.

46. Michael Hardt and Antonio Negri, *Empire* (Cambridge, Mass.: Harvard University Press, 2000), 393–413.

47. Homi K. Bhabha, "Anish Kapoor: Making Emptiness," in *Anish Kapoor*, exhibition catalog, ed. Jean de Loisy and Adrian Locke (London: Royal Academy of Arts, 2009), 174.

48. Brian Massumi, "The Space-Time of Pre-emption: An Interview with Brian Massumi," by Charles Rice, *Architectural Design* 80, no. 5 (September/October 2010): 33.

49. Gitte Orsoku argues, "The only thing we have in common is that we are different" is one of "Eliasson's most distinctive *statements* in his confrontation with subjectivity's enforced regimentation." Gitte Orsoku, "Inside the Spectacle," in *Olafur Eliasson: Minding the World*, exhibition catalog (Ostfildern: Hatje Cantz, 2004), 23. Similarly, Carol Diehl points out that Eliasson hopes that his works will bring to the surface the singularity of each viewer's perception. Carol Diehl, "Northern Lights," *Art in America* 92, no. 9 (October 2004): 113.

50. Eliasson, "Vibrations," 59–74.

51. Ibid., 72.

52. Olafur Eliasson, "Weather," in Engberg-Pedersen, *Studio Olafur Eliasson*, 451–52.

53. Ibid., 465.

54. Anja Bock, "Olafur Eliasson: Blurring Spectacle and Critique," *Art Papers* 32, no. 6 (November/December 2008): 26.

55. Peter Scott, "Bread and Circuses: The Mayor, the Waterfalls, and the Art of Neo-liberalism," *Art Monthly*, no. 322 (December 2008/January 2009): 8.

56. Steven Psyllos, "Repeat Viewing Recommended: On Olafur Eliasson's *Take your time*," *New York Arts Magazine*, May 6, 2008, http://www.nyartsmagazine.com.

57. Jeff Huebner maintains that Kapoor's *Cloud Gate* stands for the epitome of narcissistic infatuation in the context of the Millennium Park project: "The Bean could be seen as being about perception, ephemerality, spirituality—as something sublime. Yet I see it and think that perhaps only a city like Chicago, rightfully big-shouldered yet historically insecure about its own artistic accomplishments, could have produced such a monument to sublimely self-reflexive boosterism. . . . Kapoor offers us 'psycho-physical validation.'" Jeff Huebner, "Millennium Pork and the Bean," *Public Art Review*, no. 35 (Fall/Winter 2006): 70. Eliasson's *Take your time* exhibition at MoMA was prefaced in the *New Yorker* by this statement: "If leadership in installation art for the masses were an elected position, the Icelandic-Danish dab hand would be a shoo-in." "Going on about Town," *New Yorker*, May 19, 2008, 14.

58. James Meyer, "No More Scale: The Experience of Size in Contemporary Sculpture," *Artforum* 42, no. 10 (Summer 2004): 222–23.

59. Lum, "'I Say, Come On! Open Your Eyes!,'" 93.

60. Kapoor, in Bhabha and Kapoor, "A Conversation: June 1, 1993," 55.

61. Meyer, "No More Scale," 226.

62. Scott, "Bread and Circuses," 8.

63. Ken Lum, in Kitty Scott, "Ken Lum Works with Photography," in *Ken Lum Works with Photography*, exhibition catalog, ed. Kitty Scott and Martha Hanna (Ottawa: Canadian Museum of Contemporary Photography, 2002), 15.

64. The first publication to present the outcomes of research on this type of neurons is G. di Pellegrino, L. Fadiga, L. Fogassi, V. Gallese, and G. Rizzolatti, "Understanding Motor Events: A Neurophysiological Study," *Experimental Brain Research* 91, no. 1 (October 1992): 176–80.

65. Iacoboni, *Mirroring People*, 267.

66. Sennett, *Fall of Public Man*, 5.

67. Richard Stengel, "Only Connect," *Time*, December 15, 2010, http://www.time.com.

68. Michel Maffesoli, *The Time of the Tribes: The Decline of Individualism in Mass Society*, trans. Don Smith (London: Sage, 1996), 76.

69. Lum, "Something's Missing," 55.

70. Merleau-Ponty, *The Visible and the Invisible*, 14.

71. Jean-Luc Nancy, *Being Singular Plural* (Stanford, Calif.: Stanford University Press, 2000), 67.

72. Timothy J. Gilfoyle, *Millennium Park: Creating a Chicago Landmark* (Chicago: University of Chicago Press, 2006), 347.

73. Olafur Eliasson, in Olafur Eliasson and Ina Blom, "Bright Shadows: A Conversation," in *Your Engagement Has Consequences*, 173.

74. Ken Lum, "Interview with Ken Lum," by Robert Statinski and Frans-Josef Petersson, September 2004, https://www.whywedoit.wordpress.com.

4. Mirror Portals

1. N. Katherine Hayles, *How We Became Posthuman: Virtual Bodies in Cybernetics, Literature, and Informatics* (Chicago: University of Chicago Press, 1999).

2. Brian O'Shaughnessy, "Proprioception and the Body Image," in *The Body and the Self*, ed. José Luis Bermúdez, Anthony Marcel, and Naomi Eilan (Cambridge: MIT Press, 1998), 175.

3. David Rokeby, "Transforming Mirrors: Subjectivity and Control in Interactive Media," in *Critical Issues in Electronic Media*, ed. Simon Penny (Albany: State University of New York Press, 1995), 135.

4. Ibid., 133.

5. Ibid., 138; David Rokeby, "The Construction of Experience: Interface as Content," in *Digital Illusion: Entertaining the Future with High Technology*, ed. Clark Dodsworth Jr. (New York: ACM Press, 1998), 37.

6. Jakob Howhy, "The Sense of Self in the Phenomenology of Perception and Agency," *Psyche* 13, no. 1 (2007): 8.

7. Deleuze and Guattari, "1730," 267.

8. Jones and Muller conducted two different types of interviews with visitors: video interviews in which viewers were encouraged to describe their experience of the work while watching video recordings of their prior interaction with it and interviews with participants while they were inside the installation. These recordings are available on the Daniel Langlois Foundation website, http://www.fondation-langlois.org.

9. Caitlin Jones and Lizzie Muller, "Between Real and Ideal: Documenting Media Art," *Leonardo* 41, no. 4 (August 2008): 419.

10. Nadia Mounajjed, "Interviews with the Public," in *Under Scan*, exhibition catalog (Montreal: Antimodular Research, 2007).

11. Rokeby started experimenting with light cells and synthesizers to produce this new medium in 1981. He eventually switched from using electronic boards to employing an Apple II computer. *Very Nervous System* had two precursors: *Reflexions*, presented at Digicon (Vancouver) in 1983; and *Body Language*, displayed at A Space Gallery (Toronto) in 1985. It was first presented under its current title at the Venice Biennale in 1986. This version

was further developed until 1991 and is known as the classic one. A new version of *Very Nervous System* was created in 2003. It brings together two ranges of sounds that can be accessed at different times. A detailed timeline of the work can be found on the Daniel Langlois Foundation website, http://www.fondation-langlois.org.

12. Noë, *Out of Our Heads*, 64.

13. Rokeby, "Transforming Mirrors," 148.

14. Nancy Campbell, "The Giver of Names," in *The Giver of Names*, exhibition catalog (Guelph, Ont.: Macdonald Stewart Art Centre, 1998), 10.

15. Rokeby, "Construction of Experience," 31.

16. As discussed previously, Daniel Stern argues that mothers do not simply imitate their infants' movements and gestures; rather, they emulate the rhythm of the gestures while introducing variations in their patterns in order to show comprehension and improve the infants' cognitive skills. See Stern, *Interpersonal World of the Infant*.

17. Su Ditta, "Between Chaos and Order: The Garden and the Computer in the Work of David Rokeby," in *David Rokeby*, exhibition catalog (Oakville, Ont.: Oakville Galleries, 2004), 11.

18. David Rokeby, interview by Lizzie Muller and Caitlin Jones, September 2, 2009, in *"Very Nervous System*: Documentary Collection," Daniel Langlois Foundation, http://www.fondation-langlois.org.

19. Rokeby, "Transforming Mirrors," 151.

20. Katarina, audience member, interview by Ingrid Spörl, September 2009, "Video-Cued Recalls," in *"Very Nervous System*: Documentary Collection."

21. Rokeby, "Construction of Experience," 34.

22. Susanna, audience member, interview by Lizzie Muller, September 2009, "Video-Cued Recalls," in *"Very Nervous System*: Documentary Collection."

23. Günther, audience member, interview by Lizzie Muller, September 2009, "Video-Cued Recalls," in *"Very Nervous System*: Documentary Collection."

24. Rokeby, "Construction of Experience," 35.

25. Massumi, *Parables for the Virtual*, 180.

26. Brian Massumi, "Of Microperception and Micropolitics: An Interview with Brian Massumi," by Joel McKim, *INFLeXions*, no. 3 (October 2009): 4, http://www.senselab.ca/inflexions.

27. Ibid., 5.

28. See Alexander (software developer), audience member, interview by Lizzie Muller, September 2009, "Semi-structured Interviews," in *"Very Nervous System*: Documentary Collection."

29. David Rokeby, "The Harmonics of Interaction," *Musicworks*, no. 46 (Spring 1990), http://www.davidrokeby.com/harm.html.

30. Gabi, audience member, interview by Lizzie Muller, September 2009, "Semi-structured Interviews," in *"Very Nervous System*: Documentary Collection."

31. Mark B. N. Hansen, *Bodies in Code: Interfaces with Digital Media* (New York: Routledge, 2006), 200.

32. These installation specifications were used for the display of *Very Nervous System* in the *Invisibile* exhibition organized at the Museo d'Arte Contemporanea, Palazzo delle Papesse, Siena, Italy (2004).

33. Rokeby, interview by Muller and Jones, September 2, 2009.

34. Howhy, "Sense of Self," 4.

35. Ibid., 12.

36. Rokeby, "Harmonics of Interaction."

37. Rokeby, "Transforming Mirrors," 148.

38. Rokeby distinguishes between these two terms in an endnote to his essay "Transforming Mirrors." I share Rokeby's concern about the misinterpretation of this concept. In this chapter, I have strategically chosen to use the terms *participants* and *ad hoc performers* to refer to "interactors" with responsive environments in order to call into question the distinctions drawn between participatory art and new media at the level of the dichotomy established between "participation" and "interaction."

39. Heinrich Falk, "The Aesthetics of Interactive Artefacts—Thoughts on Performative Beauty," in *DIMEA '07: Proceedings of the 2nd International Conference on Digital Interactive Media in Entertainment and Arts* (New York: ACM, 2007), 63.

40. Söke Dinkla, "The History of the Interface in Interactive Art" (paper presented at the International Symposium on Electronic Art, Helsinki, 1994), http://kenfeingold.com/dinkla_history.html.

41. David Rokeby, "Info Art" (lecture delivered at the Gwangju Biennale, 1996), http://www.davidrokeby.com/install.html.

42. Massumi, "Of Microperception and Micropolitics," 4.

43. Hayles, *How We Became Posthuman*, 11.

44. Erkki Huhtamo, "Silicon Remembers Ideology, or David Rokeby's Meta-interactive Art," in *Giver of Names*, 23.

45. David Rokeby, "The Computer as a Prosthetic Organ of Philosophy," *Dichtung Digital*, no. 3 (2003), http://www.dichtung-digital.de.

46. David Rokeby, in Catherine Richards and Nell Tenhaaf, eds., *Virtual Seminar on the Bioapparatus* (Banff, Alta.: Banff Centre for the Arts, 1991), 89.

47. In addition to this series of exhibitions in urban spaces, *Under Scan* was exhibited in the Mexican Pavilion at the Fifty-second Venice Biennale in 2007. It was also re-created in Trafalgar Square, London, in 2008. Two hundred video portraits were filmed at Tate Modern for this purpose.

48. Rafael Lozano-Hemmer, "Reflections around Loose Ends," interview by José Luis Barrios, in *Some Things Happen More Often Than All of the Time*, exhibition catalog (Madrid: Turner, 2007), 145.

49. Christian Moeller, *A Time and Place: Media Architecture, 1991–2003* (Baden: Lars Müller, 2004), 89.

50. Henri Lefebvre, *The Production of Space* (Oxford: Blackwell, 1991), 101.

51. Rafael Lozano-Hemmer, in "Case Study: 'Vectorial Elevation'—Public Arts Project: Rafael Lozano-Hemmer," in *The New Media Handbook*, ed. Andrew Dewdney and Peter Ride (London: Routledge, 2006), 201.

52. Mounajjed, "Interviews with the Public," 97.

53. Rafael Lozano-Hemmer, "*Under Scan* Concept," in *Under Scan*, 11.

54. Nadia Mounajjed, Chengzhi Peng, and Stephen Walker, "Ethnographic Interventions: A Strategy and Experiments in Mapping Sociospatial Practices," *Human Technology*, no. 3 (February 2007): 84.

55. Mark Seltzer, "The Serial Killer as a Type of Person," in *The Horror Reader*, ed. Ken Gelder (London: Routledge, 2000), 100.

56. Mounajjed, "Interviews with the Public," 92.

57. Moeller, *Time and Place*, 89.

58. Merleau-Ponty, *Phenomenology of Perception*, 369.

59. Gaston Bachelard, *The Poetics of Space* (Boston: Beacon Press, 1994), 34.

60. Rafael Lozano-Hemmer, "Alien Relationships with Public Space," interview by Alex Adriaansens and Joke Brouwer, in *TransUrbanism*, ed. Joke Brouwer and Arjen Mulder (Rotterdam: V2/NAi, 2002), 157.

61. Jonathan Crary, *Techniques of the Observer: On Vision and Modernity in the Nineteenth Century* (Cambridge: MIT Press, 1990), 129–33.

62. Christian Metz, *The Imaginary Signifier: Psychoanalysis and the Cinema* (Bloomington: Indiana University Press, 1977), 45.

63. Thomas Elsaesser, "Dada/Cinema," in *Dada and Surrealist Film*, ed. Rudolf E. Kuenzali (New York: Willis, Locker & Owens, 1987), 18.

64. In an article discussing multiple correlations between surrealism and new media art, Marsha Kinder states that "dreams are the ultimate model of interactive database narrative." Such a model also inspires Moeller's and Lozano-Hemmer's installations. See Marsha Kinder, "Hot Spots, Avatars, and Narrative Fields Forever: Buñuel's Legacy for New Digital Media and Interactive Database Narrative," *Film Quarterly* 55, no. 4 (Summer 2002): 2–15.

65. David James, quoted in Paul Arthur, *A Line of Sight: American Avant-Garde Film since 1965* (Minneapolis: University of Minnesota Press, 2005), 31.

66. Ibid., 34.

67. Deleuze, *Cinema 1*, 17.

68. Moeller, *Time and Place*, 89.

69. Quoted in Mounajjed, "Interviews with the Public," 96.

70. The video documenting the installation is available at http://www.christian-moeller.com.

71. Deleuze and Guattari, "1730," 240.

72. "Interlude" is the term Lozano-Hemmer uses to refer to the periodic transformation of the environment.

73. Rafael Lozano-Hemmer, "Interview with Rafael Lozano-Hemmer," by Nadia Mounajjed, in *Under Scan*, 30.

74. *Under Scan* participant, interview in *Under Scan* DVD produced in conjunction with the exhibition catalog.

75. Brian Massumi, "Expressing Connection: Relational Architecture," in *Alzado Vectorial: Arquitectura Relacional No. 4/Vectorial Elevation: Relational Architecture No. 4*, exhibition catalog (Mexico City: Ediciones San Jorge, 2000), 191.

76. Deleuze and Guattari, "1730," 251.

77. Andreas Broeckmann "Public Spheres and Network Interfaces," in *The Cybercities Reader*, ed. Stephen Graham (New York: Routledge, 2004), 380.

78. Lozano-Hemmer, "Reflections around Loose Ends," 145.

Conclusion

1. See Martin Buber, *I and Thou* (New York: Scribner, 1958); Emmanuel Levinas, *Entre Nous: On Thinking-of-the-Other*, trans. Michael B. Smith and Barbara Harshav (New York: Columbia University Press, 1998). Empathy is contingent on the wiring between the prefrontal cortex and the limbic system. The area of the prefrontal cortex in which mirror neurons are located is closely interconnected with the limbic system, which is the center of primary emotions (involuntary emotions such as fear, anger, and happiness). In addition, both areas of the brain are involved in the formation of secondary emotions, which imply higher-order processing—that is, associations with information previously stored in the brain.

2. See Deleuze and Guattari, "1730," 256–309; Deleuze and Guattari, "Percept, Affect, and Concept," 163–99.

3. The videos are available at the Tate website: http://www.tate.org.uk.

4. The blog is available at http://sfmoma.wordpress.com.

5. For a more extensive discussion of this topic in correlation with the advertising campaign "It's Time We Met" launched by the Metropolitan Museum of Art in 2009 and the *Oh Snap! Your Take on Our Photographs* exhibition at Carnegie Museum of Art in 2013, see Cristina Albu, "Photogenic Art: Precarious Participation and Documentation," in *The Permanence of the Transient: Precariousness in Art*, ed. Camila Maroja, Caroline Menezes, and Fabrizio Augusto Poltronieri (Newcastle upon Tyne: Cambridge Scholars, 2014), 2–16.

6. Maffesoli, *Time of the Tribes*, 72.

7. Lauren Berlant, *Cruel Optimism* (Durham, N.C.: Duke University Press, 2011).

Index

Abramovic, Marina, 3, 26
abstract expressionism, 2, 71, 253
Acconci, Vito, 110, 277n100
acoustic feedback: light and, 74–75, 226; movement and, 78–79, 211, 231, 244
aesthetics, 82, 219–220; commodification and, 201; dialogical, 11; invisibility and, 219; politics and, 4, 10, 188; privacy and, 32, 41, 50, 73, 253; publicness and, 69–70, 73, 251; reflective materials and, 53; relational, 8, 13, 252; spectatorship and, 25, 27; of systems, 12, 156
affect, 177–78; alliances and, 22, 138, 150, 245, 257; attunement and, 23–24, 149, 180, 257, 271n34; becoming animal and, 151, 184, 244, 271n37; contemporary art history and, 25–27; group belonging and, 198–99, 201, 249, 260; group psychology and, 80; indetermination and, 25, 190, 216, 221, 242; intersubjectivity and, 124, 150, 160, 189, 248; mirroring and, 17, 138, 200, 204, 213; multiplicity and, 151, 174, 199, 244; neuroscience and, 196–97; psychotherapy and, 126; virtuality and, 27–28, 182, 186, 216; visuality and, 27, 195, 217. *See also* mirror affect
agency, 152, 167, 193, 206, 261; communal,

105, 198; control and, 218; gaze and, 246; individual, 197, 213, 255; interaction and, 15, 78, 252; mediation and, 200; mirroring acts and, 22, 134; self awareness and, 106, 257; sensory experience and, 176, 191; systems and, 6, 29, 192, 210, 256; technology and, 72; time and, 171; video and, 92, 96, 97, 100, 106; weakening of, 199
Aitken, Doug, 155
ambiguity, 177, 184, 216; cultural, 194; intersubjectivity and, 59, 66, 131, 189; perceptual, 22, 29, 158, 231; reflective qualities and, 33, 49, 111, 176; of roles, 56; systems and, 226
Anastasi, William, 110
anonymity, 70, 163, 233, 241; participants and, 22, 184, 187; power relations and, 230; reflections and, 57, 111, 143, 182; shadows and, 228
Antin, David, 83, 104, 258
Antonakos, Stephen, 74
arcades, 114, 134
Arikha, Avigdor, 82
Art & Language, 32
art and technology projects, 29, 34, 91, 94; collectivity and, 68, 72, 91; commission

systems 6, 76, 193, 203, 209; of neural systems, 197; unpredictability and, 84, 157, 188, 248

conceptual art, 11, 35, 156, 162, 251

consciousness, 36, 72, 195, 204, 273n22; of the artist, 72, 106; collective, 121, 126, 148, 157, 257; corporeal, 241; enactment of, 64; flux of, 97, 210; heightened states of, 125; historical, 142; metaphor of, 90; selectivity of, 40, 115, 118; technology and, 203; of time, 92, 171, 199

consumerism: control and, 126; critique of, 29, 107, 110, 127, 254; *mise en abyme* of, 134; self-perception and, 129; society of, 131, 153; spectacle and, 125; temporal disjunction and, 136

contemporary art, 106, 261; modern art and, 3, 31, 251; new media and 13; reception of, 15

contingency, 184, 204, 210, 212, 221; of art reception, 36, 208, 224, 230, 242; of artworks, 12, 35, 39, 40, 252, 259; of behavior, 22, 149, 253; collectivity and, 18, 191; of consciousness, 64; contemporaneity and, 158; of perception, 28, 160, 256; of reflections, 33, 57, 90; of social relations, 12, 53, 176, 228, 234; systems and, 220, 239, 257

control: agency and, 218; over art content, 11; awareness of, 12; closed-circuit television and, 93, 99, 103, 118; collectivity and, 187; consumerism and, 126, 131; cybernetic systems and, 6, 71, 76, 157, 206; of experience, 43, 112, 114, 122; ideal of, 200; ideology and, 191, 196; interaction and, 219, 222; kinetic art and, 72; limits of, 4, 50, 209, 223, 243; movement and, 48, 75, 78; performance and, 117, 121, 211; playfulness and, 53, 261; reflections and, 23, 67, 111, 122, 253–54; responsive

environments and, 214–17, 220, 227, 238; social, 28, 107, 109, 123–25, 162; spectacle and, 133; subversion of, 232, 248; surveillance and, 126, 252–53; technology and, 83, 91, 104, 224, 239; time and, 199; unpredictability and, 254; variability and, 27, 30, 40, 192–93, 226; voyeurism and, 139

Courchesne, Luc, 207

creativity, 46, 170; of art viewers, 259; group, 20, 61, 148, 256; interaction and, 69, 91, 205, 212, 230; intersubjectivity and, 160; limitations of, 102, 219; Nouvelle Tendance and, 71; self-reflection and, 97; video and, 101, 105

Crimp, Douglas, 62

Cruz-Diez, Carlos, 160

cybernetics, 32, 71, 94, 136, 152

cybernetic systems: agency and, 213; control and, 222, 239; disorder and, 84, 223–24; dynamic character of, 205, 210, 220; kinetic engagement and, 71, 74, 242; open-ended, 76, 106, 255; participation and, 72, 105, 206, 211, 217; posthumanism and, 203; unpredictability, 219, 223, 260; video and, 99, 104

Dada, 3, 238; cinema and, 237

Dalí, Salvador, 3, 115

Damasio, Antonio, 203

Debord, Guy, 10, 131, 133

de Certeau, Michel, 167

de Duve, Thierry, 126, 148

delay, 140, 165, 171

Deleuze, Gilles: affect, 24–25, 178, 244; becoming, 138–39, 151, 184, 271n37; cinema, 241–42; perception, 141; rhizome, 248; time, 207

Denes, Agnes, 253

diffuse collectivities: affect and, 198, 260;

Cristina Albu is assistant professor of contemporary art history and theory at the University of Missouri–Kansas City. She studies interconnections among contemporary art, phenomenology, and cognitive sciences.